150 Best New Kitchen Ideas

150 Best New Kitchen Ideas

Manel Gutiérrez

HARPER
DESIGN
An Imprint of HarperCollinsPublishers

150 BEST NEW KITCHEN IDEAS
Copyright © 2015 by LOFT Publications

HarperCollins books may be purchased for educational, business, or sales promotional use.
For information, please e-mail the Special Markets Department, at SPsales@harpercollins.com.

First published in 2015 by:
Harper Design
An Imprint of HarperCollins*Publishers*
195 Broadway
New York, NY 10007
Tel.: (212) 207-7000
Fax: (855) 746-6023
harperdesign@harpercollins.com
www.hc.com

Distributed throughout the world by:
HarperCollins*Publishers*
195 Broadway
New York, NY 10007

Editorial coordinator: Claudia Martínez Alonso
Art director: Mireia Casanovas Soley
Editor and texts: Manel Gutiérrez (@mgutico)
Layout: Cristina Simó Perales

ISBN 978-0-06-239612-9

Library of Congress Control Number: 2015932548

Printed in China
First printing, 2015

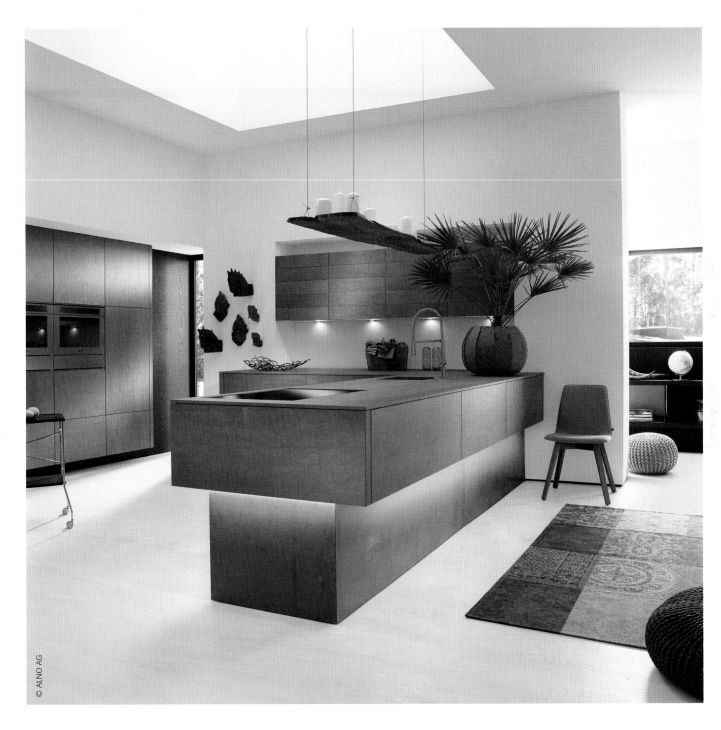

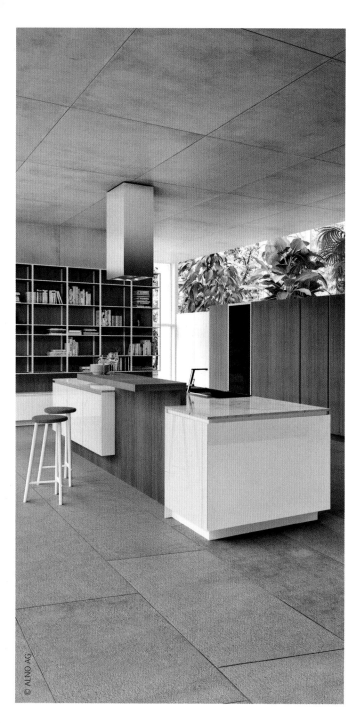

Contents

© ALNO AG

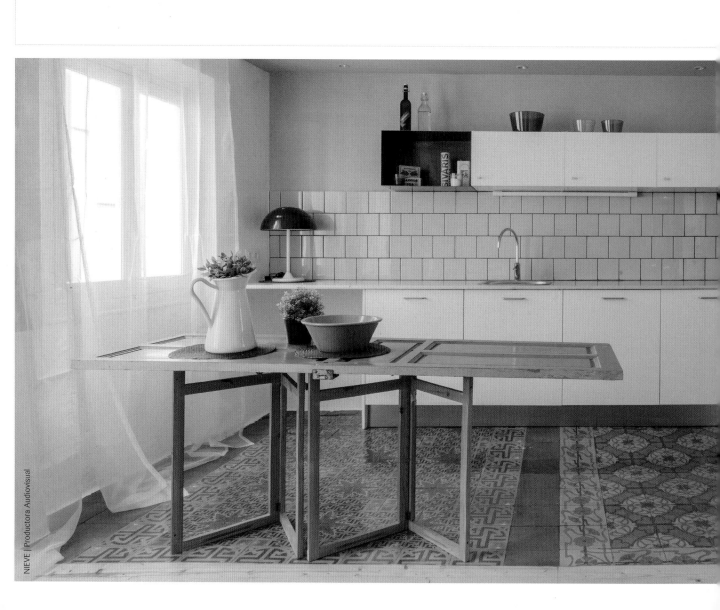

Introduction

The kitchen has always been a comfortable meeting space. Early humans gathered around the communal fire to take refuge from the cold and consume their cooked food, and this strong social sense of the kitchen has undoubtedly persevered until the present day. Progressive changes in the human way of life, the evolution of the home and increasing complexities in the way we prepare and process foods have, however, served to transform the kitchen into a highly functional space, adapted to the individual needs of the activities that take place within it. As a result, its design has always demonstrated characteristics that are different from the other spaces within the home.

However, with lifestyle changes and the evolution of the home configuration to accommodate contemporary needs, the disconnection between the kitchen and other living spaces is rapidly disappearing. The kitchen is no longer considered a marginal space and is progressively integrated into the overall design of a home. Nowadays it is a comfortable place for social gathering and has direct contact with the other rooms in the house, providing a series of links and synergies.

The popularity of loft housing combined with an increase in open kitchens, with the ability to create a feeling of spaciousness in the smallest of spaces, has led to the kitchen becoming a key consideration in home design. By using new materials and finishes, and integrating new technologies, the kitchen now shares its design and aesthetic with the rest of the home, in particular the common living areas, maintaining its intrinsic characteristics and even exporting them to the other rooms.

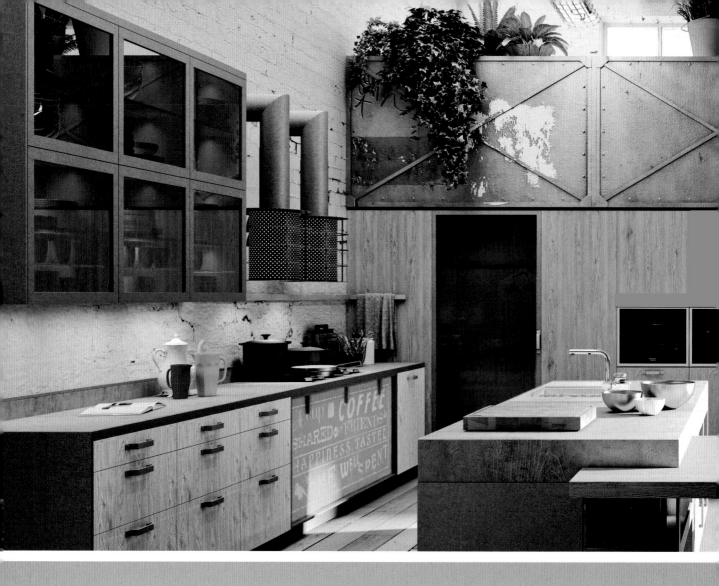

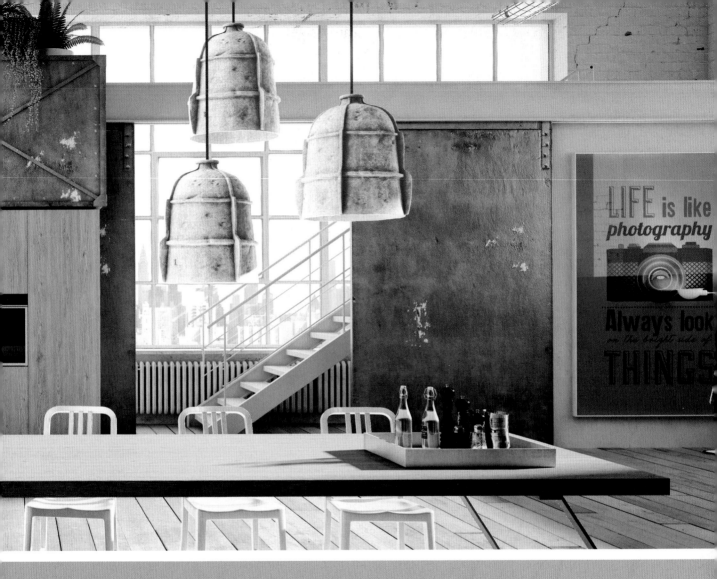

KITCHENS

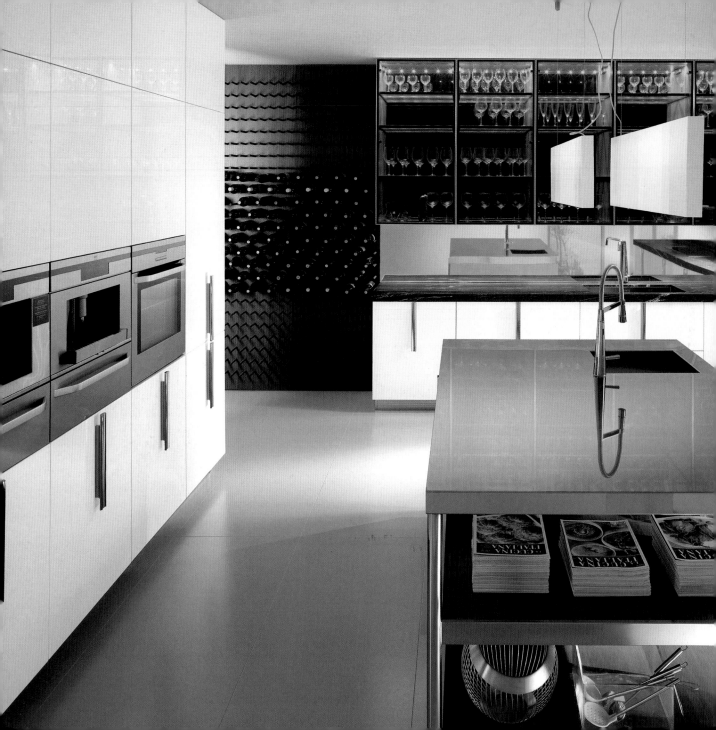

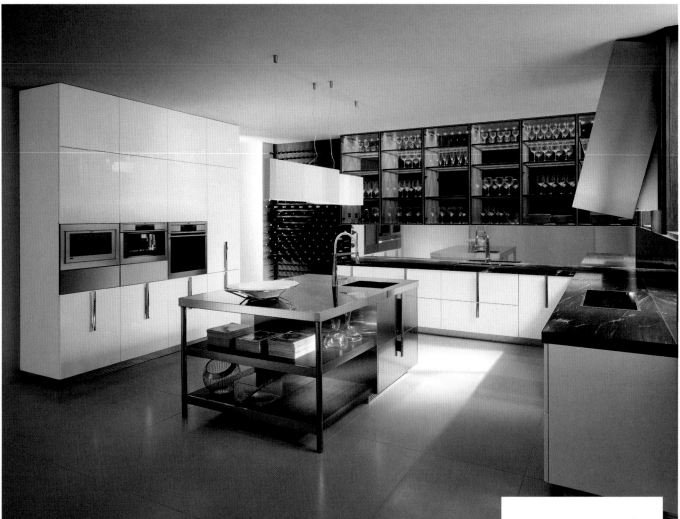

Ice Gloss

This elegant kitchen with its glossy lacquer and glass finishes is one of the beautiful Barrique Ernestomeda design solutions. As is typical of this model, the use of wood is not a concession to classicism, since when it is combined with such sophisticated materials as the steel and lacquered surfaces, it creates a kitchen that holds a subtle balance between elegance and high functionality.

Model: **Barrique**
Manufacturer: **Ernestomeda**
Photography: © **Ernestomeda**

Bottles in the Barrique wine rack rest lightly on stakes that are inserted into the paneling.

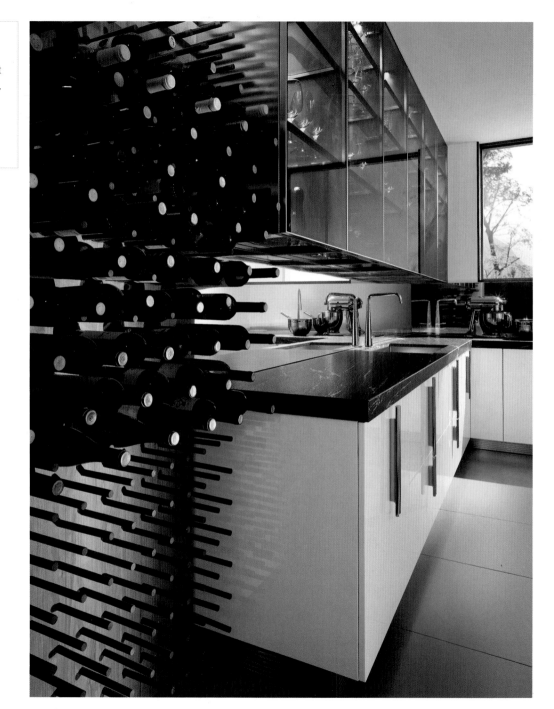

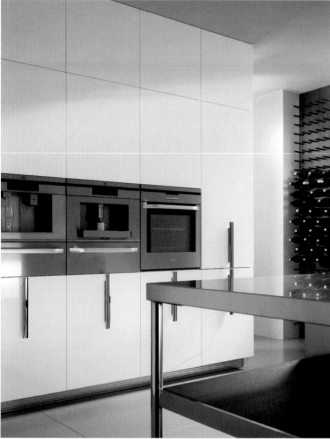

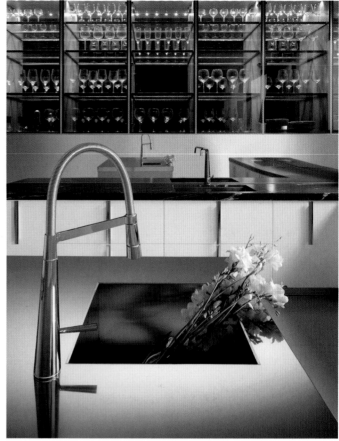

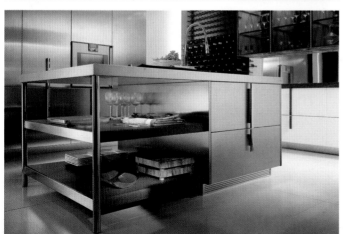

002

Wall cabinets can be configured in many different ways, housing a variety of objects in a comfortable and accessible way.

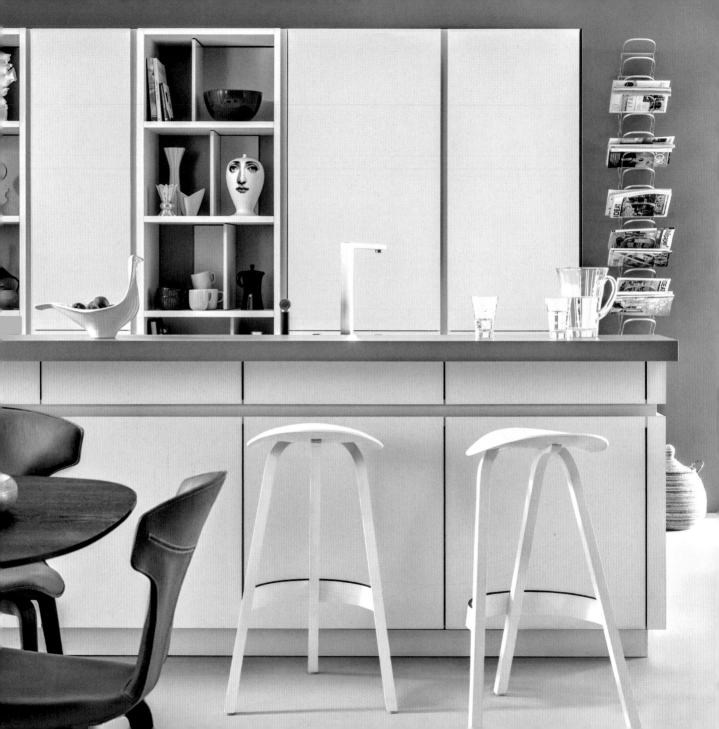

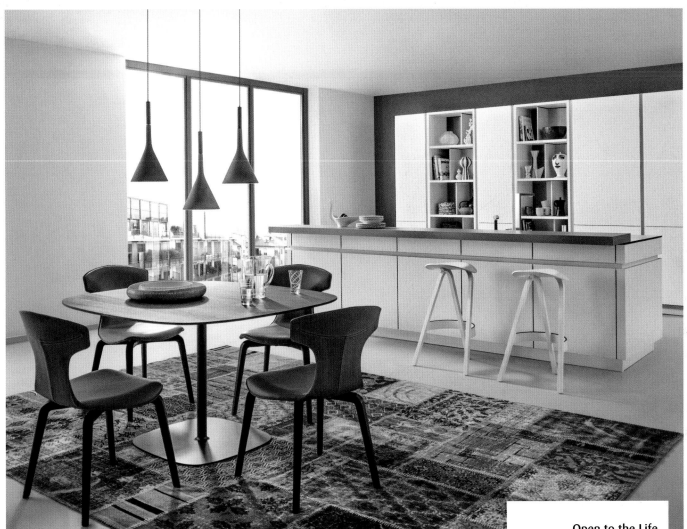

Model: **CERES I CORE-A**
Manufacturer: **LEICHT**
Photography: © **LEICHT**
Küchen AG

The LEICH Ceres l Core-A design is a clear example of how contemporary kitchens have lost their traditional aesthetics in order to integrate better with the rest of the home. Nowadays, kitchen furniture does not rely simply on doors and drawers as its main components, but incorporates attractive shelves on which to display decorative elements that are more commonly associated with a living room than a kitchen.

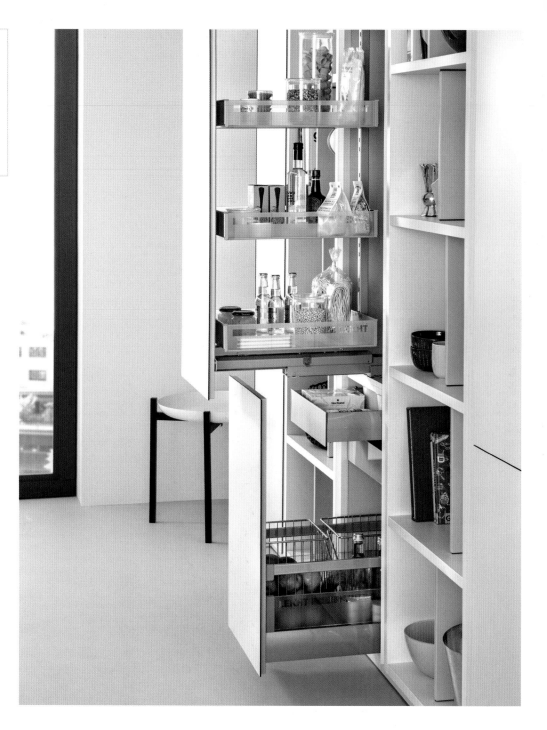

Variable angular elements
in mint-green hues add color
and freshness.

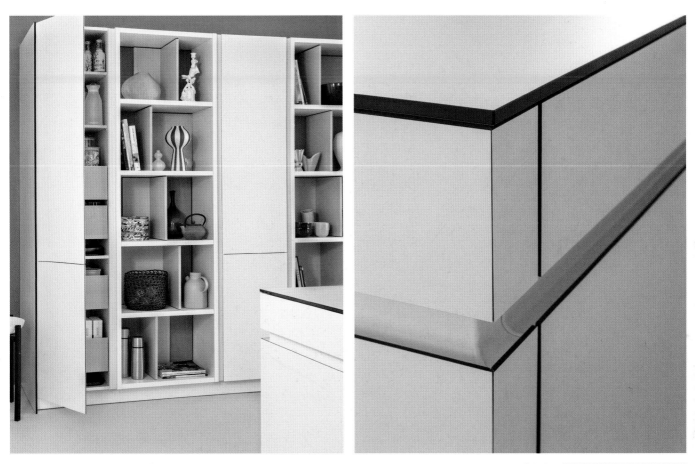

004

The horizontal and vertical trims, produced in the same material as the fascia, provide easy access to the cupboard contents.

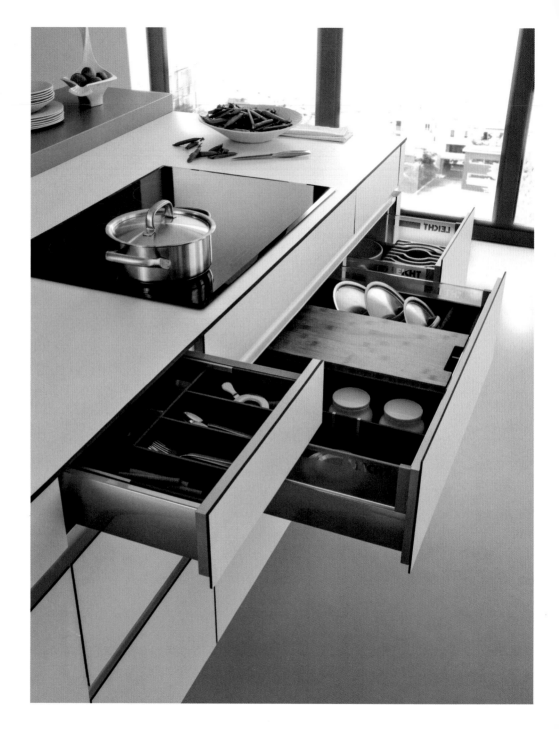

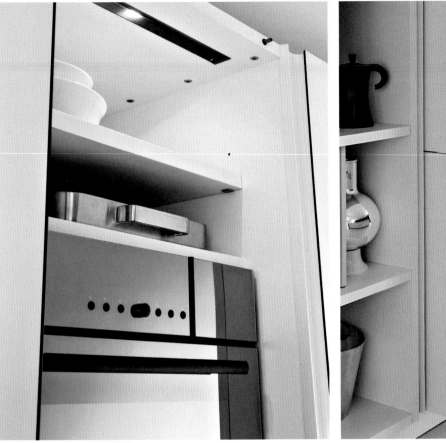

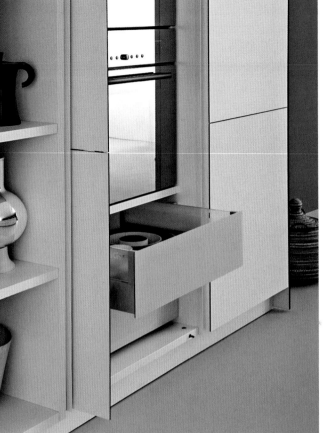

With the kitchen becoming a place in a home where a family and friends can gather, good storage solutions keep the room tidy, making the kitchen a pleasant room to be in.

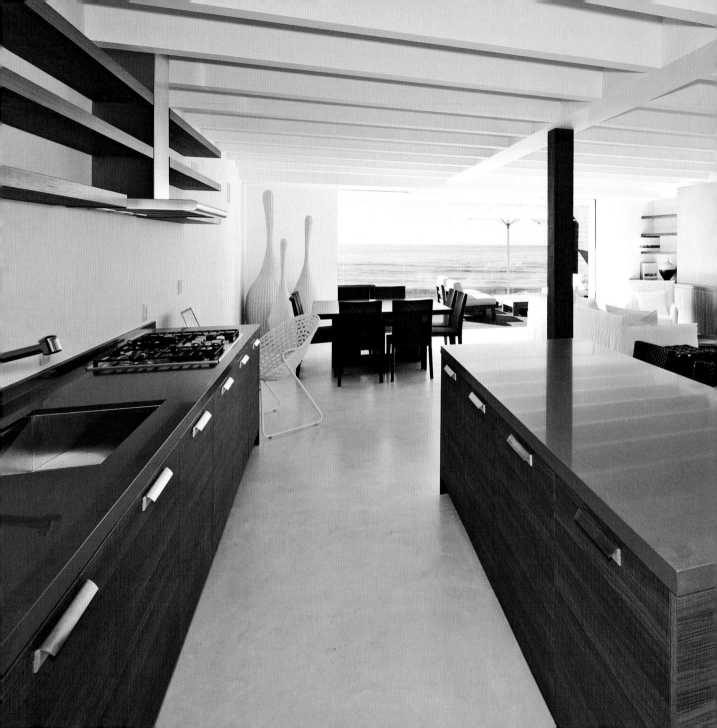

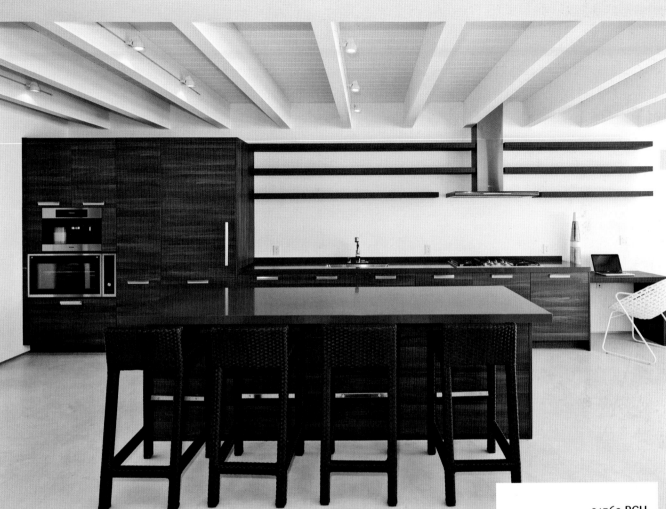

21562 PCH

Architect: OTD Design &
Development
Location: Malibu, California
Photography: © OTD Design &
Development

If anything stands out in this home it is its privileged location, right on the beachfront in the gorgeous enclave of Malibu in California. This spectacular location drives the whole design of the house and, as you would expect, it also dictates the configuration of the kitchen—it is open and oriented toward the spectacular wooden deck that sits right on the sandy beach.

First floor

Ground floor

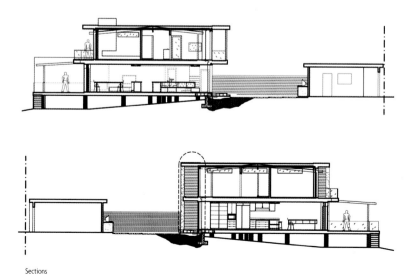

Sections

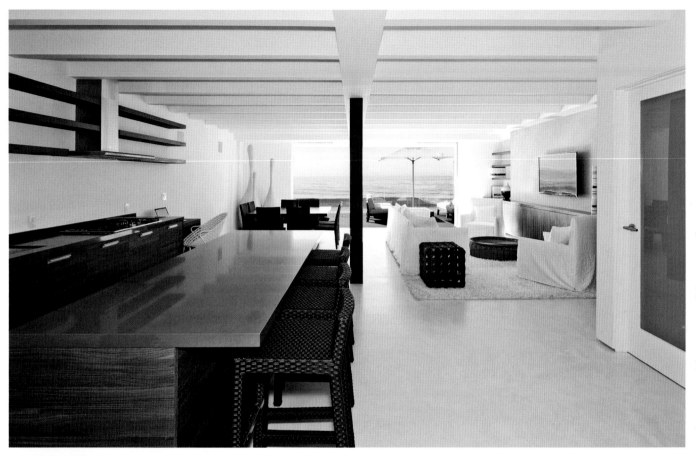

005

The island is the heart of the kitchen: size and finish are consistent with the overall design.

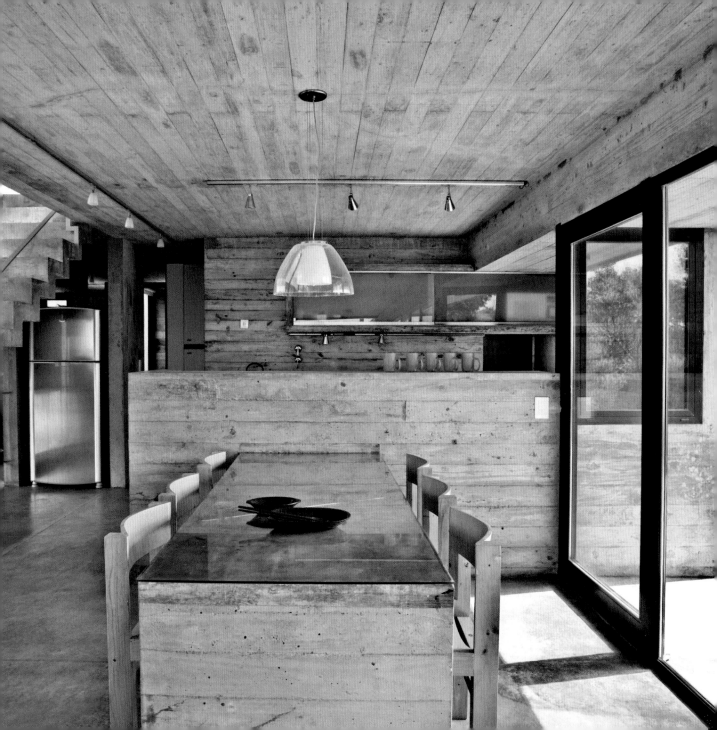

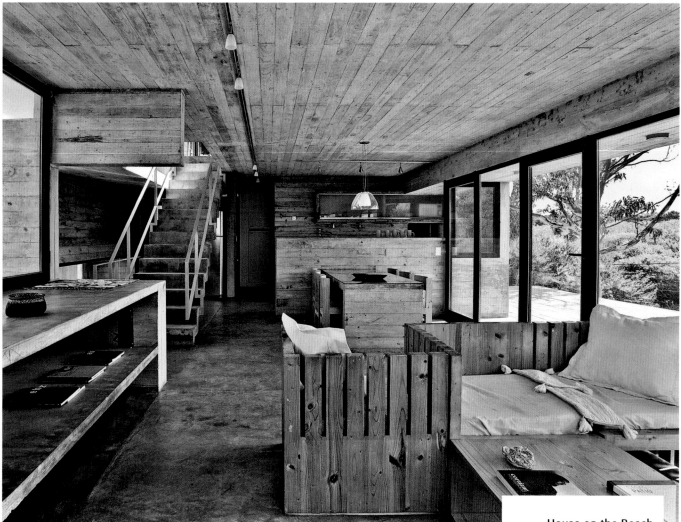

BAK Architects specialize in building concrete homes. The expressive quality of concrete combined with its resistance and impermeability render any superficial finishes unnecessary. This means low building costs and no need for future maintenance. Without a doubt, these are characteristics that adapt perfectly to the needs of the kitchen.

Architect: BAK Arquitectos
Location: Mar Azul, Argentina
Photography: © Guillerme Morelli

The color and texture of
the concrete framework
and wooden boards have
both a forceful and
imitative presence.

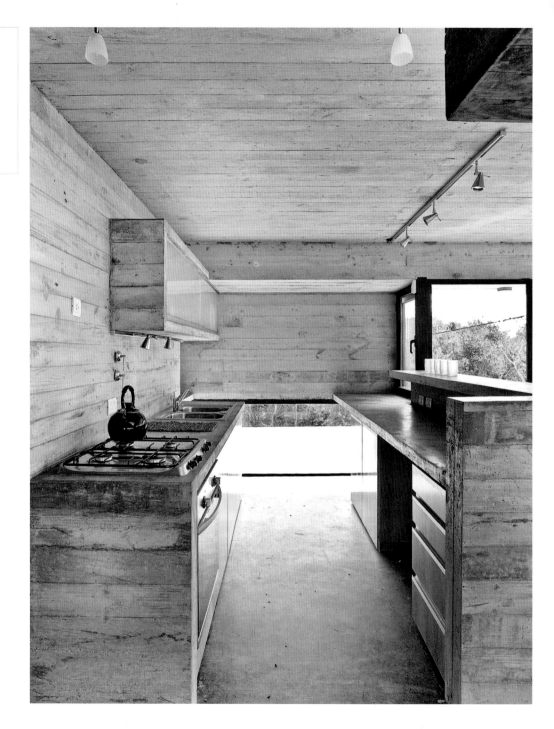

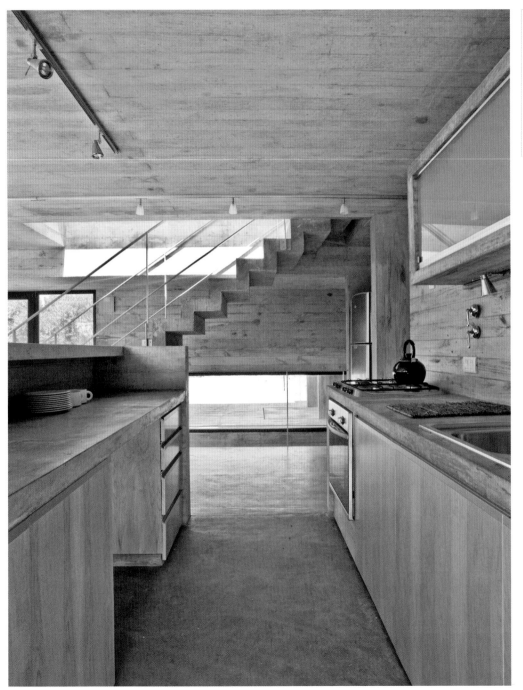

Canadian pine, which has been reclaimed from packing crates, was used in the fabrication of the cabinets. The wood adds warmth when combined with the concrete.

Section

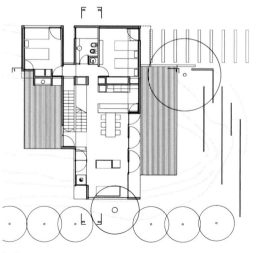

First floor

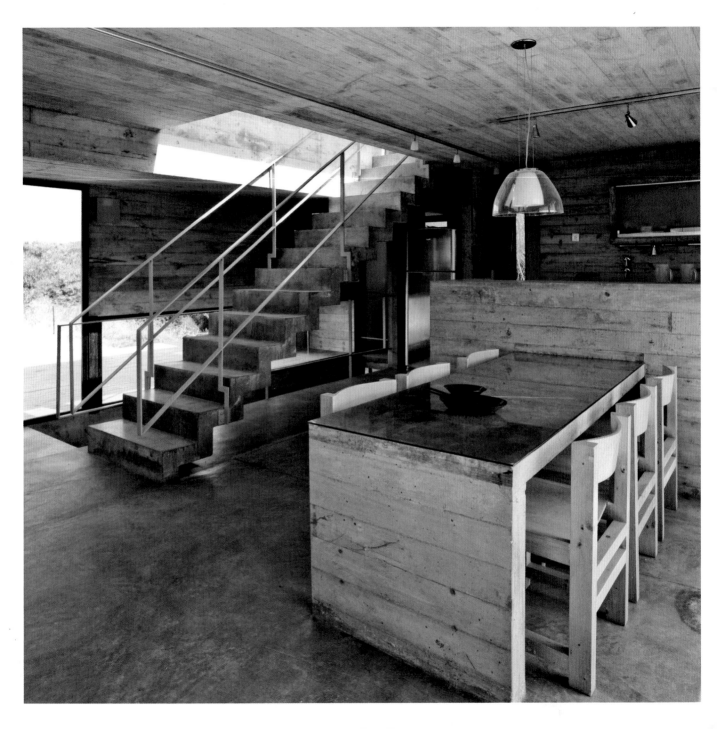

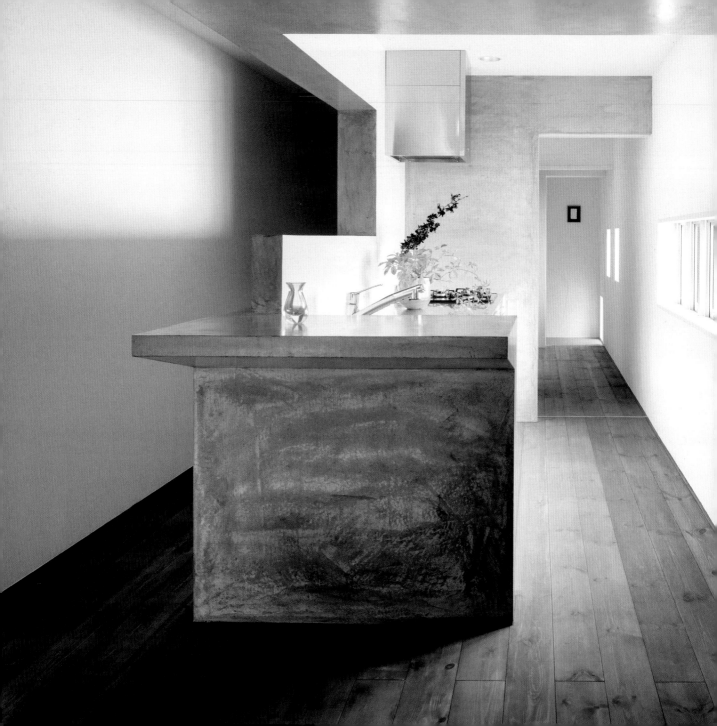

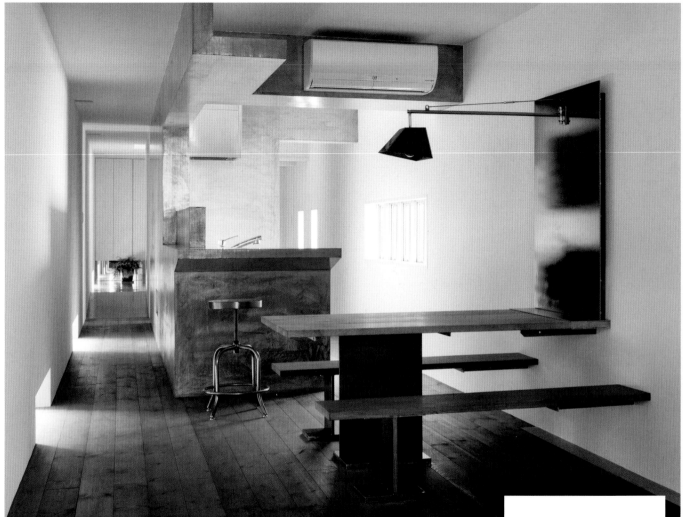

Promenade House

Architect: FORM/Kouichi
Kimura Architects

Location: Shiga, Japan

Photography: © Takumi Ota,
© Kei Nakajim

This Japanese house is governed by its unique restrictions. At 2.7 meters (nearly 9 feet) wide by 27 meters (88 feet) long, its dimensions create a rather peculiar home. The interior space is structured as a long, narrow corridor, ensuring the owner is aware of the geometry of the site. As you would expect, the kitchen adapts to these peculiar features with great subtlety.

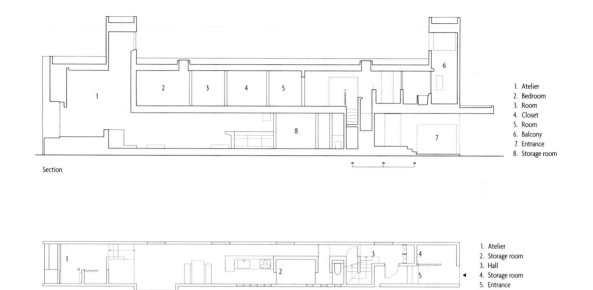

Section

1. Atelier
2. Bedroom
3. Room
4. Closet
5. Room
6. Balcony
7. Entrance
8. Storage room

Ground floor

1. Atelier
2. Storage room
3. Hall
4. Storage room
5. Entrance

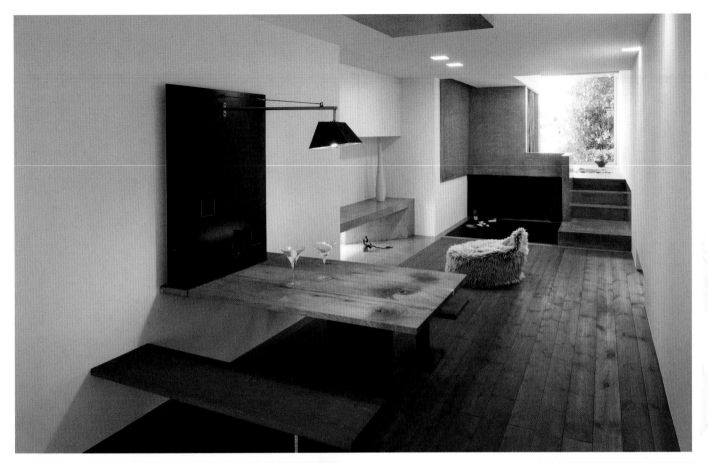

008

There is no doubt that an open kitchen is the ideal solution for small spaces: it increases spaciousness and light and creates a connection with the living and dining rooms.

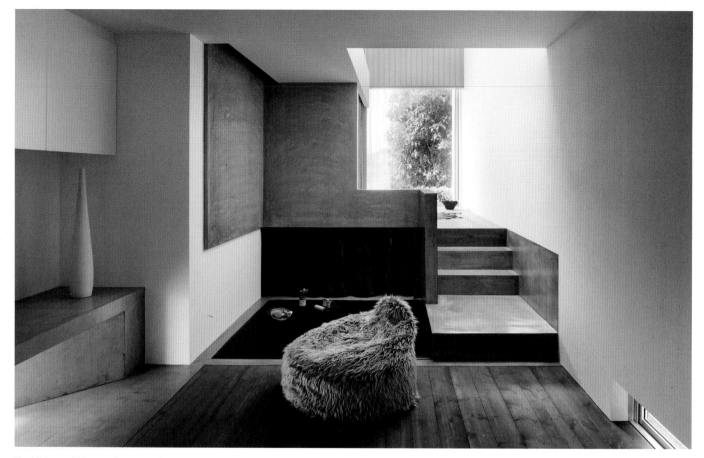

The kitchen, which occupies a central
space in the layout, accentuates the
linearity of the home, separating
the living areas from the private rooms.

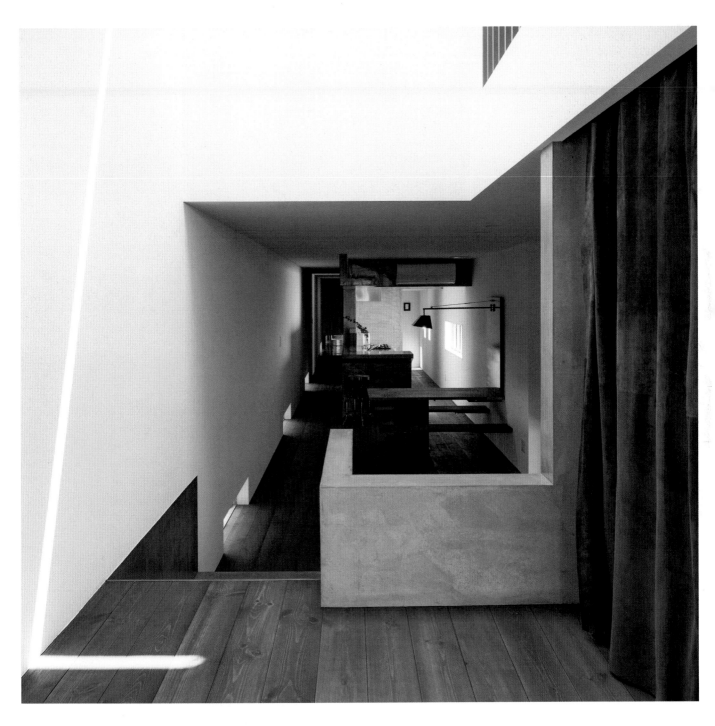

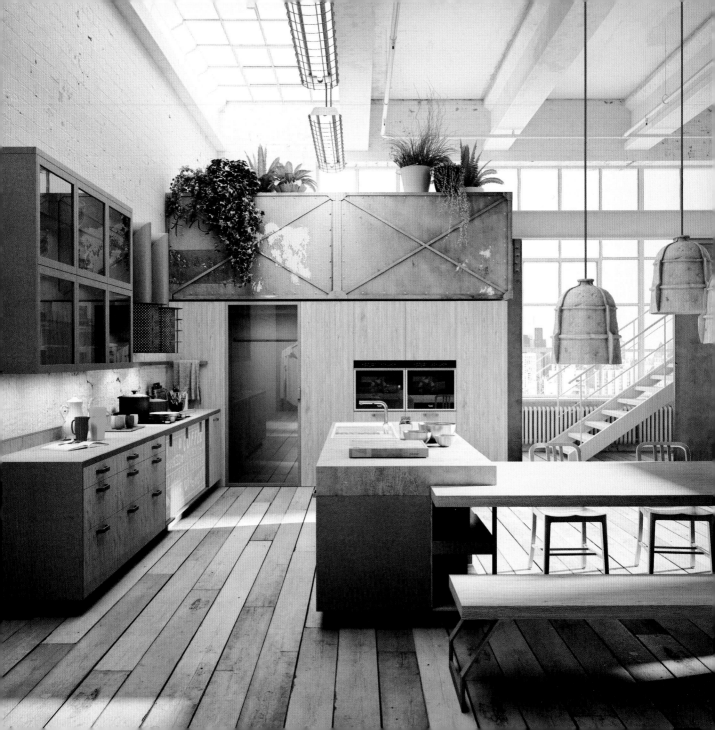

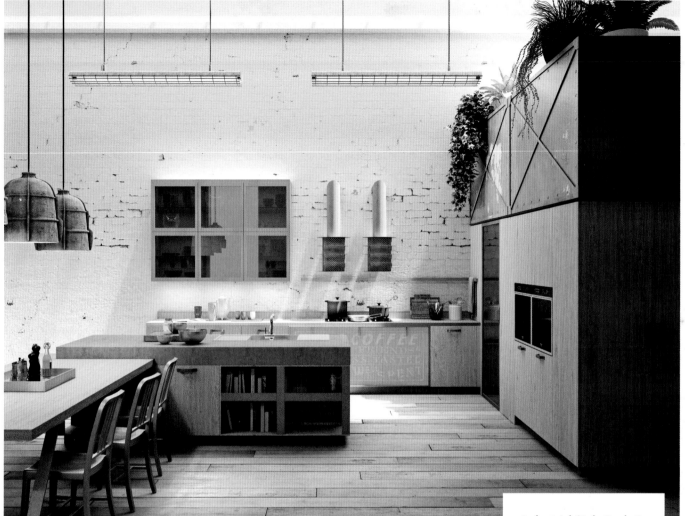

Industrial Style Evolution

Code Evolution is a kitchen design that recalls a vintage aesthetic, decidedly industrial with touches that will appeal particularly to fans of Nordic design. The stylish Snaidero kitchen plays with different materials, linking, combining and personalizing them with a high-quality, youthful, contemporary look that pays attention to the latest design trends.

Model: Code Evolution
Manufacturer: Snaidero
Photography: © Snaidero

The hoods conjure up images of
the glow of portside lighthouses
and lend an industrial feel to
the design.

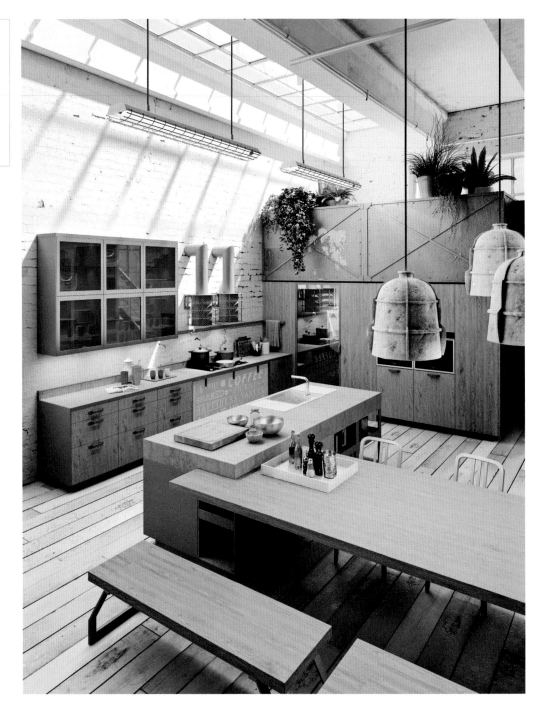

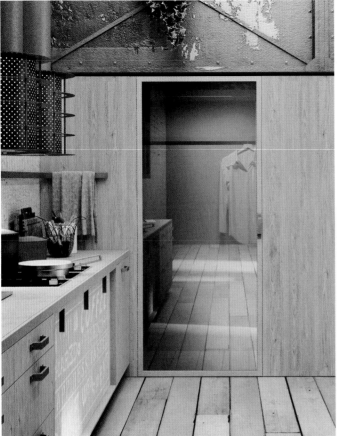
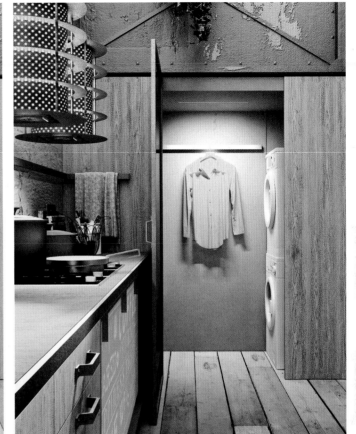

010

The tinted glass doors of the laundry room adjacent to the kitchen enhance the suburban loft feel.

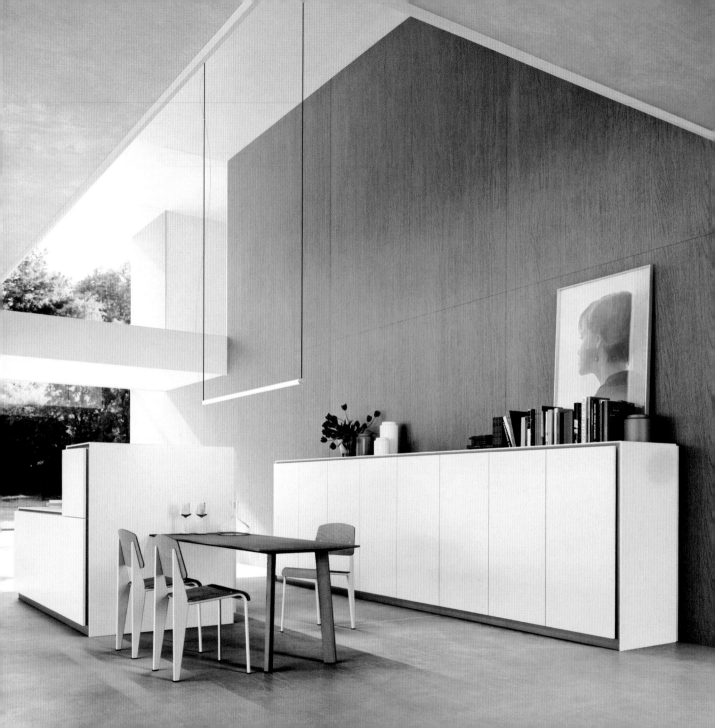

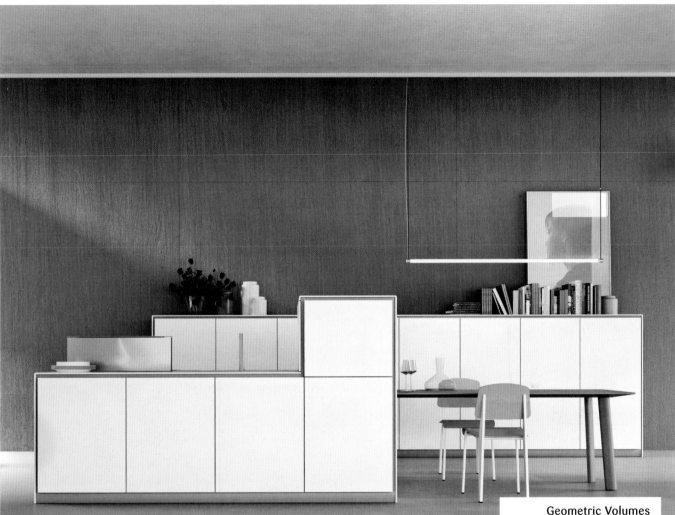

Model: **Elle**
Manufacturer: **Snaidero**
Photography: © Snaidero

Snaidero's Elle design proposes an evolution of the kitchen space: a concept that comes from careful architectural study and finishes up with different layout solutions, characterized by a series of specific innovative components. This project is distinguished by its remarkable attention to detail, a project of proportions and series of planes that re-create the kitchen with originality.

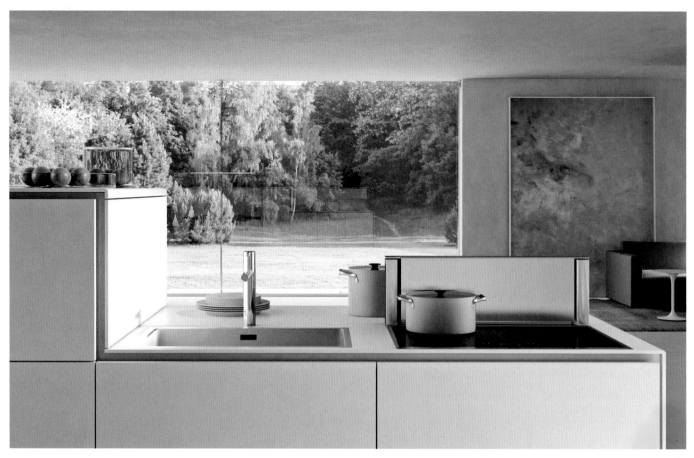

011

With the doors overhanging the countertops, the door handles are more functional and easier to clean.

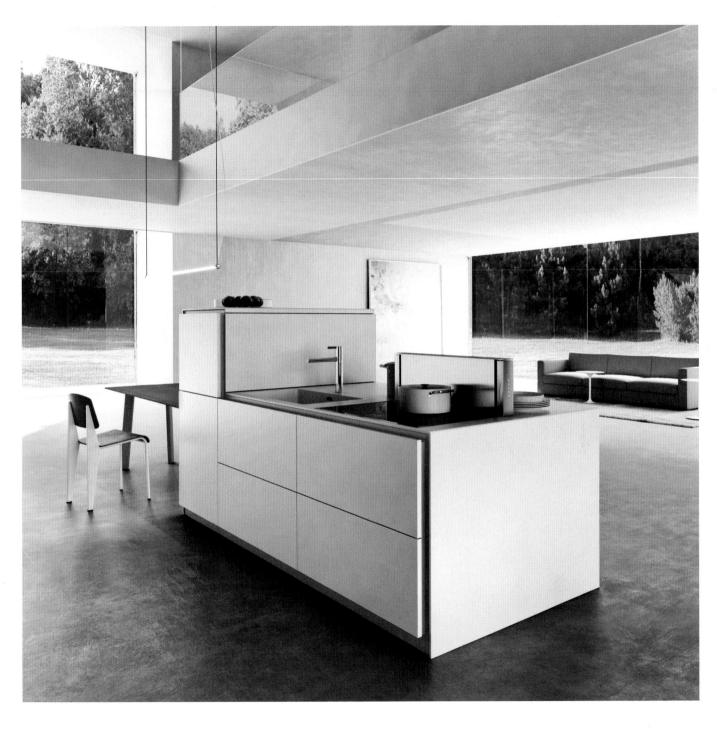

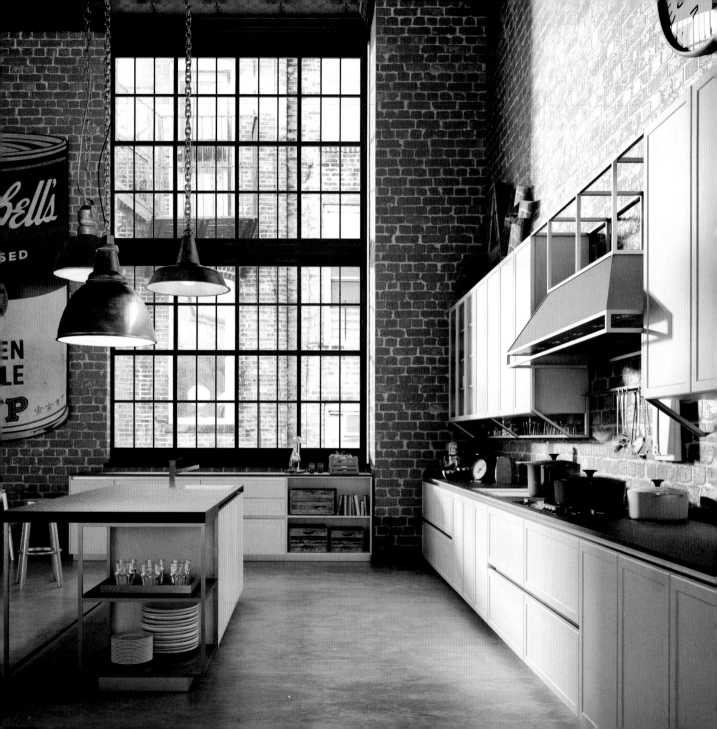

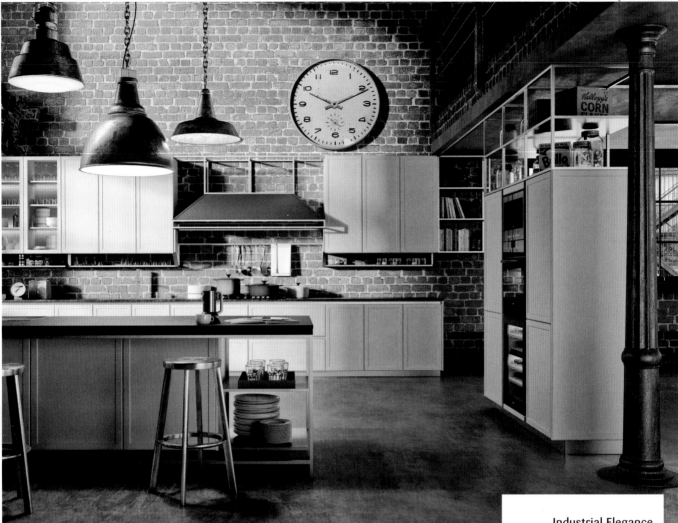

Discretion and elegance, warmth and personality: Frame is the refined expression of urban living, with industrial-style touches in the use of materials, and a well-balanced composition of open and closed storage units. This kitchen is sympathetic to its budget and to the environment without compromising on the quality of its materials and finishes.

Model: **Frame**
Manufacturer: **Snaidero**
Photography: © **Snaidero**

Use a combination of open shelving and closed cabinets to add visual interest to your kitchen.

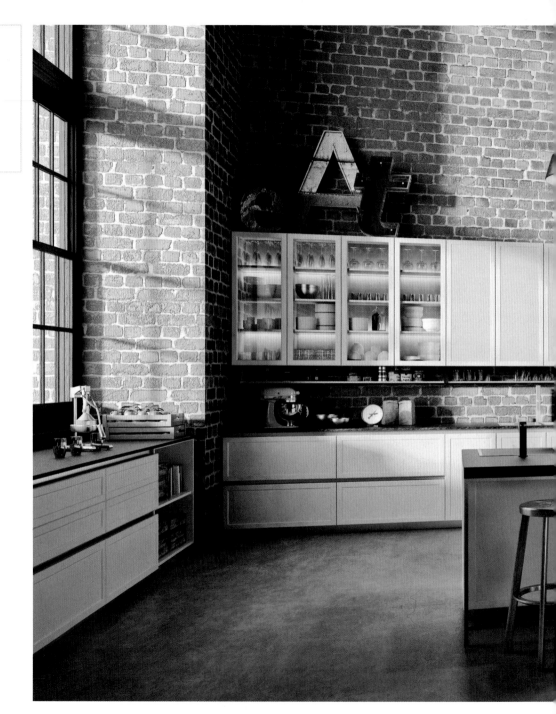

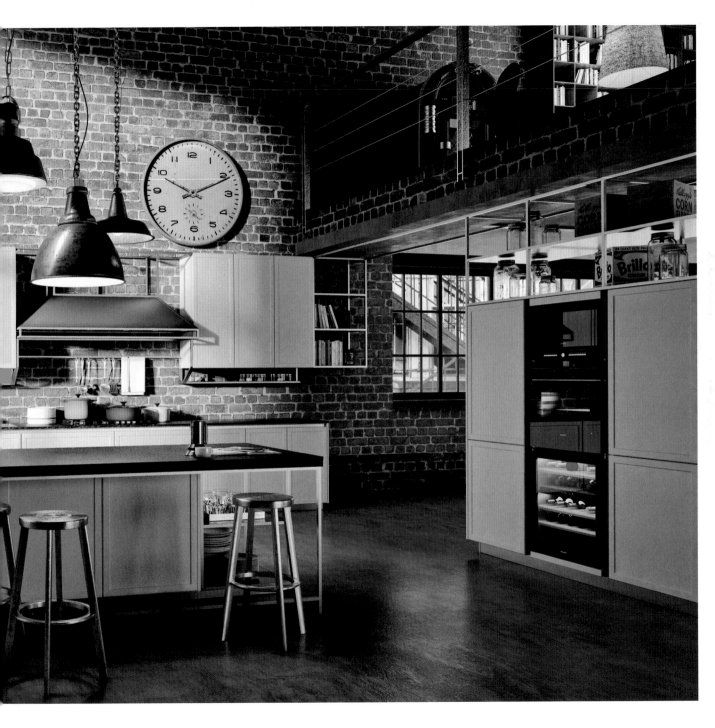

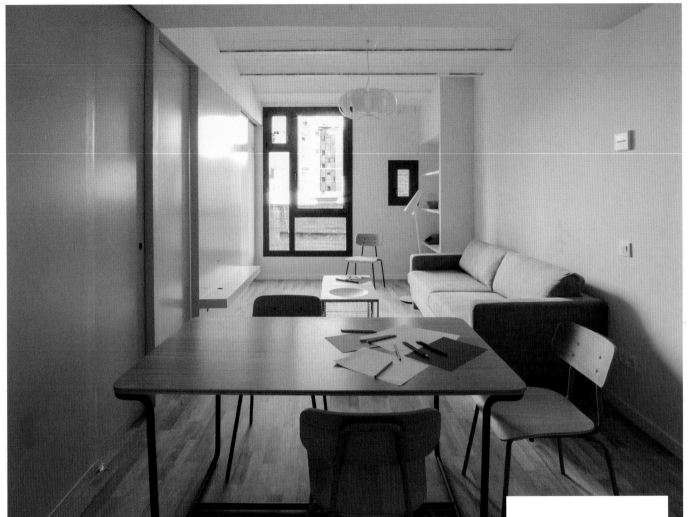

The Apartment

Nook Architects produce a home that is designed with regular-shaped spaces to make the most of a limited-width facade and which is easily duplicable without leading to a sense of boredom. They encourage end users to customize their home to their individual style and needs. In this case, the kitchen, dining and living room are located in the wider area, creating a central nucleus to the home.

Architect: Nook Architects
Location: Barcelona, Spain
Photography: © NIEVE |
Productora Audiovisual

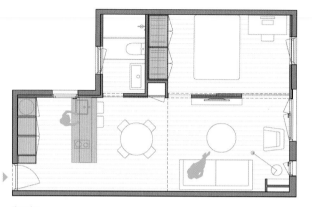

Floor plan

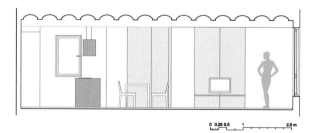

0 0.25 0.5 1 2.5 m

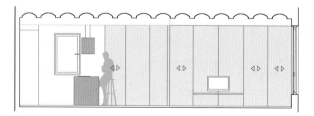

Sections

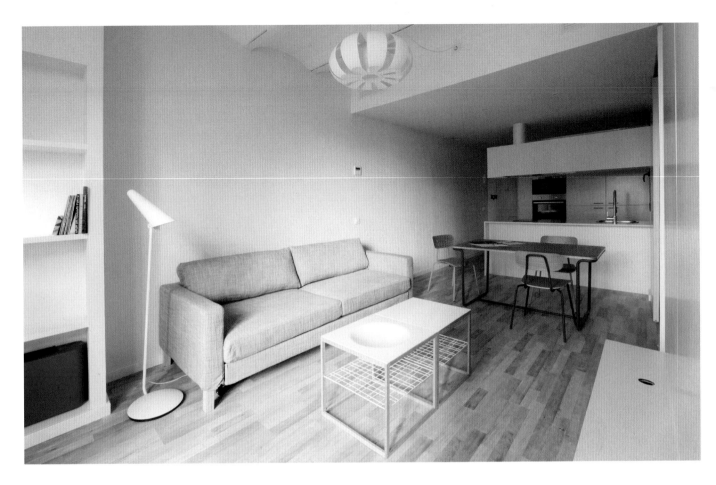

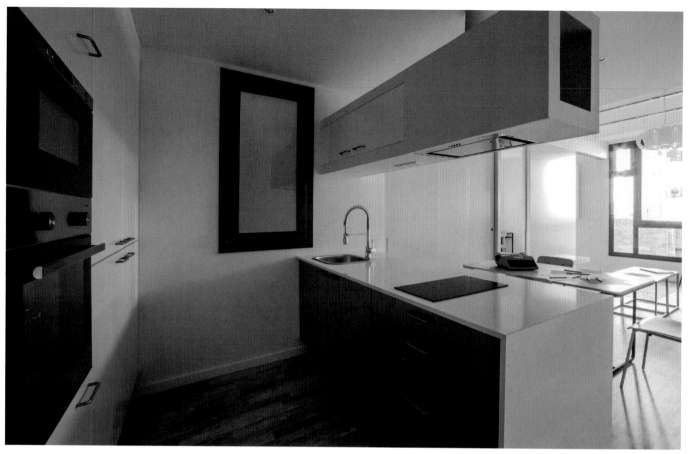

013

Full-height kitchen cabinets
offer many storage options
and can integrate appliances
such as ovens and refrigerators,
contributing to a uniform look.

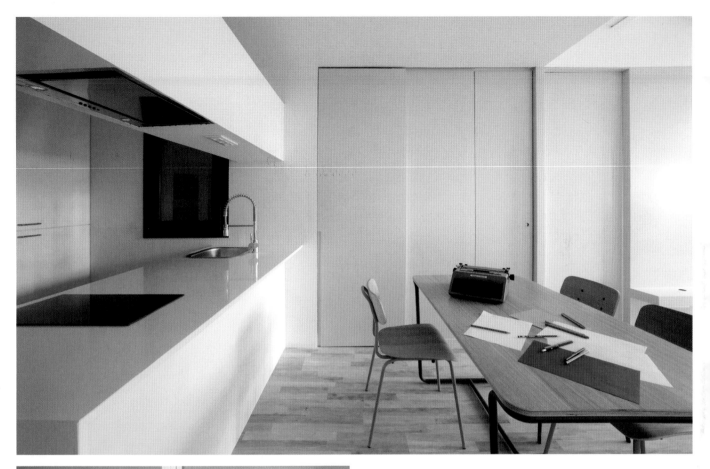

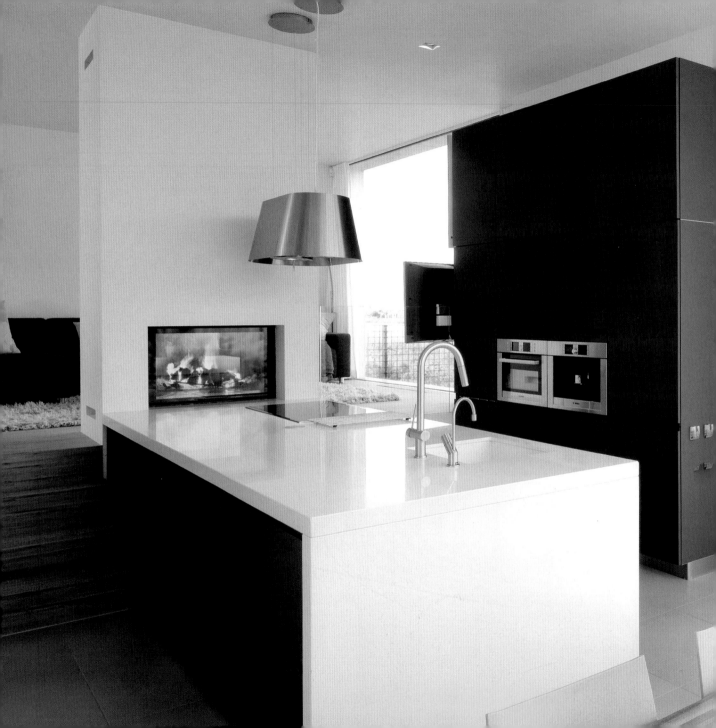

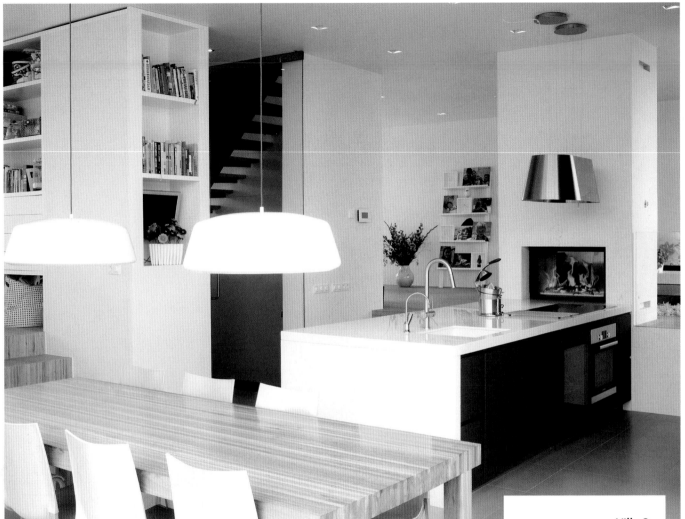

Villa S2

Situated on the island of IJburg, Villa S2 is a tall, spacious house laid out over three floors, completely open to the waterfront. All the rooms have views over the water and surrounding greenery, thus emphasizing the interior space. The most important spatial connection of the entire project occurs in the kitchen, which is linked to the elevated terrace.

Architect: MARC architects

Location: Amsterdam, The Netherlands

Photography: © Raphaël Drent

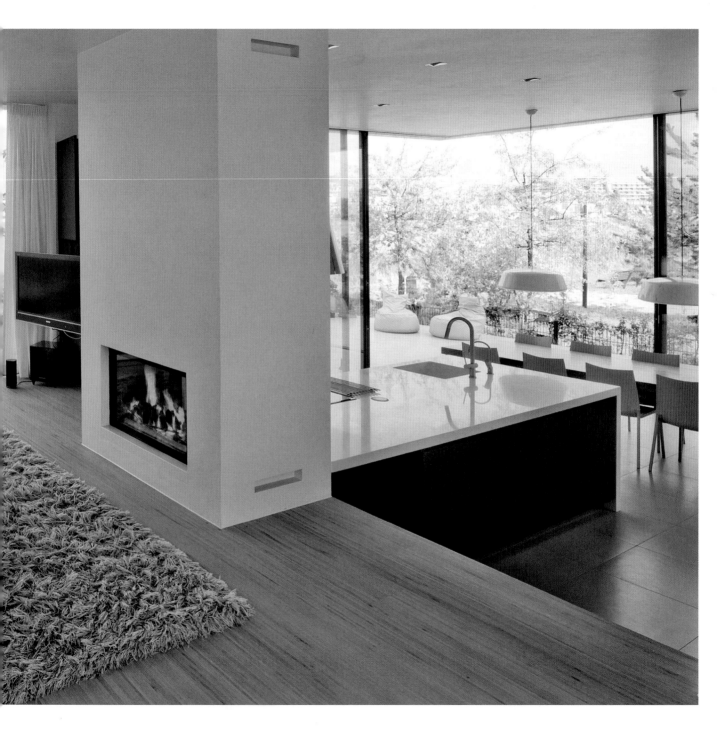

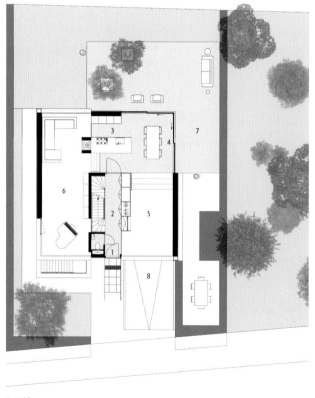

1. Entrance
2. Hall
3. Kitchen
4. Dining room
5. Children's playroom
6. Hall / office
7. Terrace
8. Ramp

Ground floor

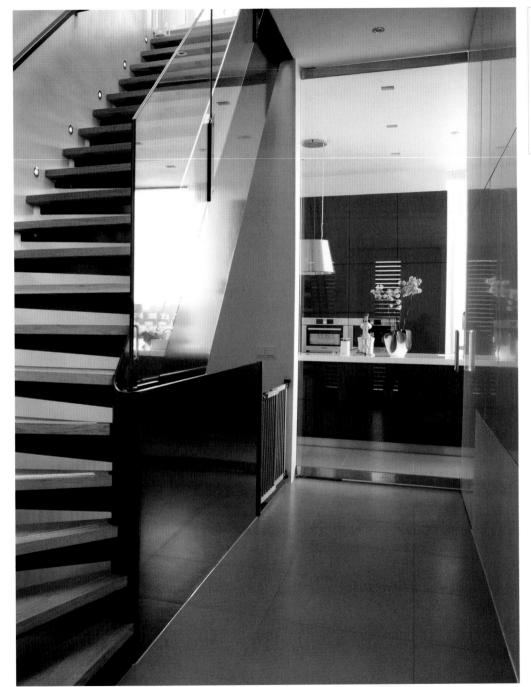

There is no reason why a kitchen should not have style. Tie its design to the overall home decor for a complete and uniform atmosphere.

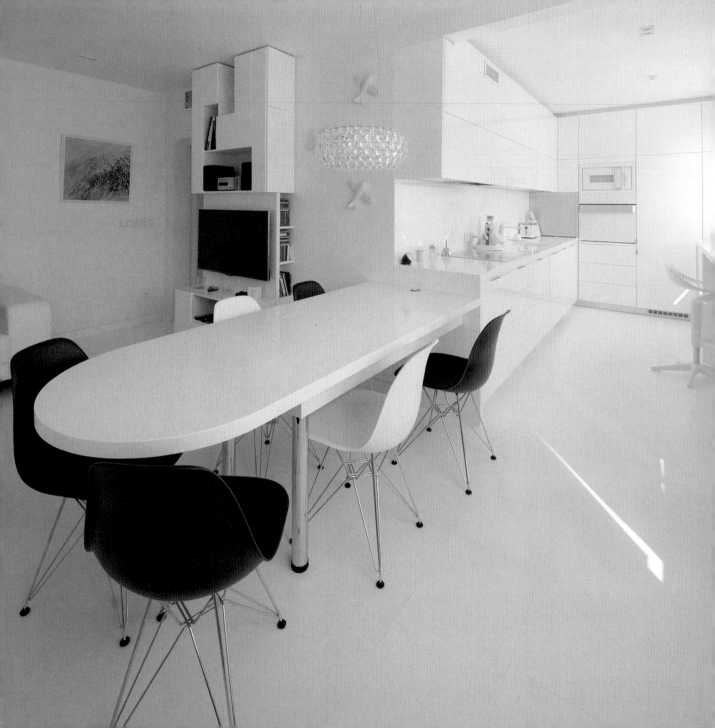

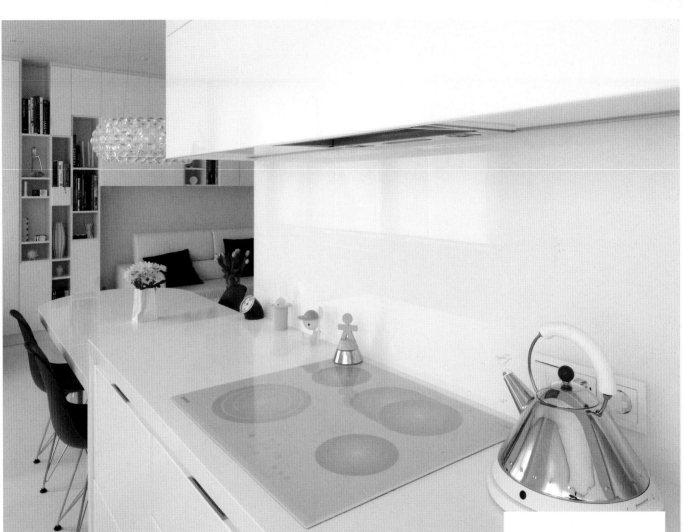

White Kitchen

Architect: Eva Bradáčová
Location: Prague, Czech Republic
Photography: © Jiří Ernest

This truly unique interior is based on the dreams and desires of its owners. It is completely white, including every room in the house, even the kitchen. The use of white is common in kitchen furniture and finishes. However, this design goes a step further in its attempt to please the customers—there is no concession to other colors, nor any possible combination.

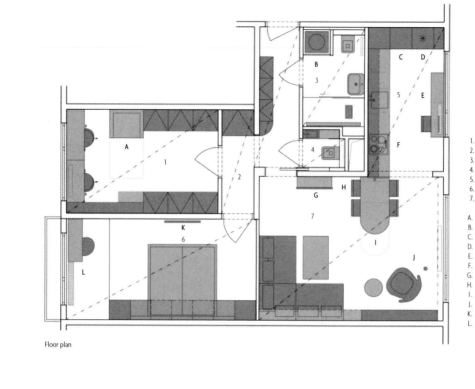

1. Office
2. Hall
3. Bathroom
4. Toilet
5. Kitchen
6. Bedroom
7. Living room

A. Sofa sleeper
B. Washing machine/Dryer
C. Ovens
D. Fridge
E. Breakfast table
F. Cooker
G. TV
H. 3D wall covering
I. Extendable dining table
J. Design floor lamp
K. TV
L. Toilet table

Floor plan

A thorough planning of this small kitchen
enclosed on three sides includes a
combination of floor-to-ceiling cabinets
with integrated appliances and overhead
cabinets above a long countertop that
extends to the dining table.

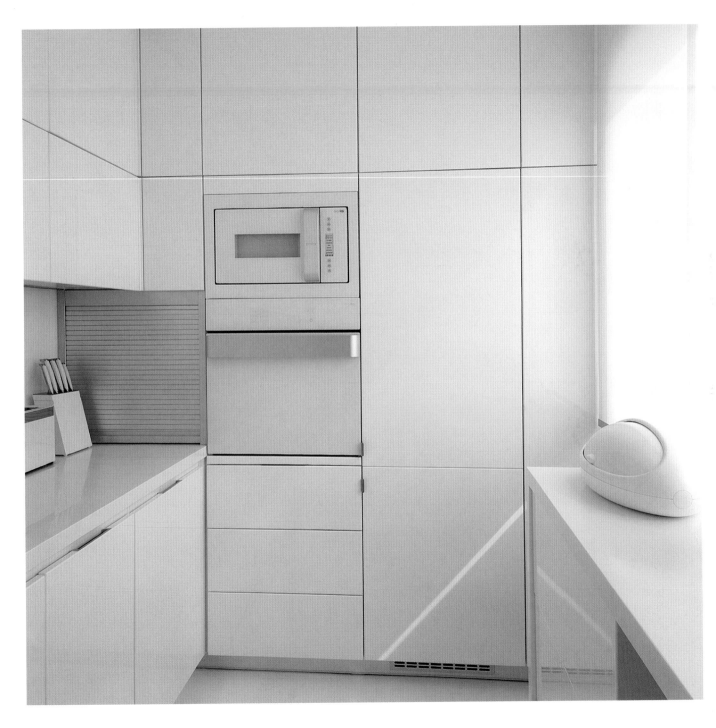

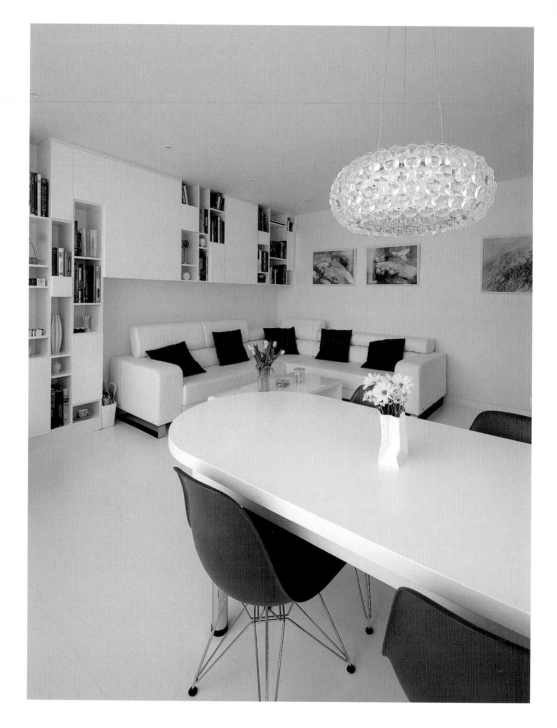

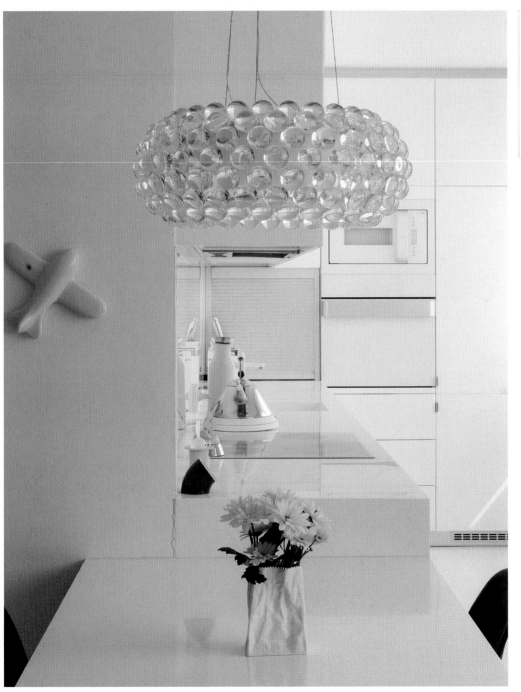

White has many benefits: it looks harmonious and creates a sensation of cleanliness. Combined with red it is unbeatable.

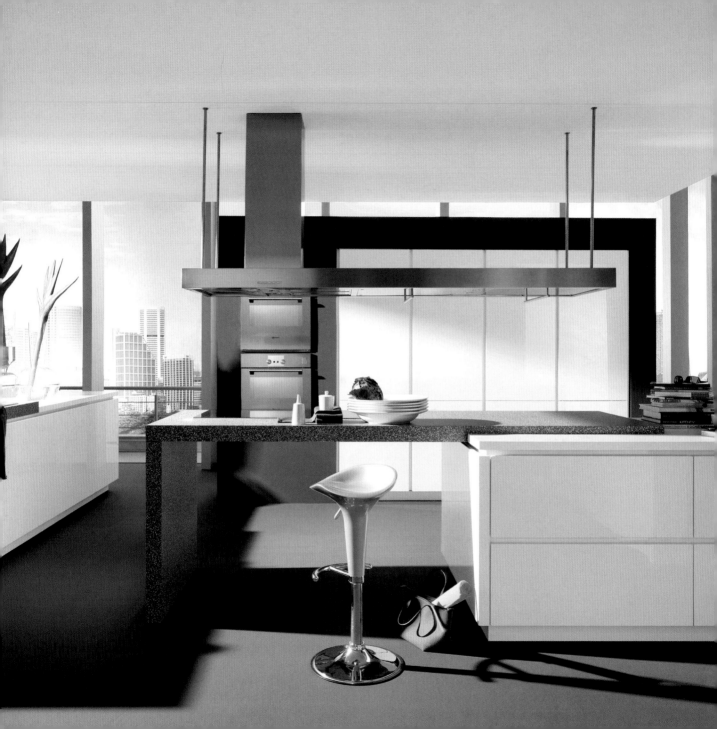

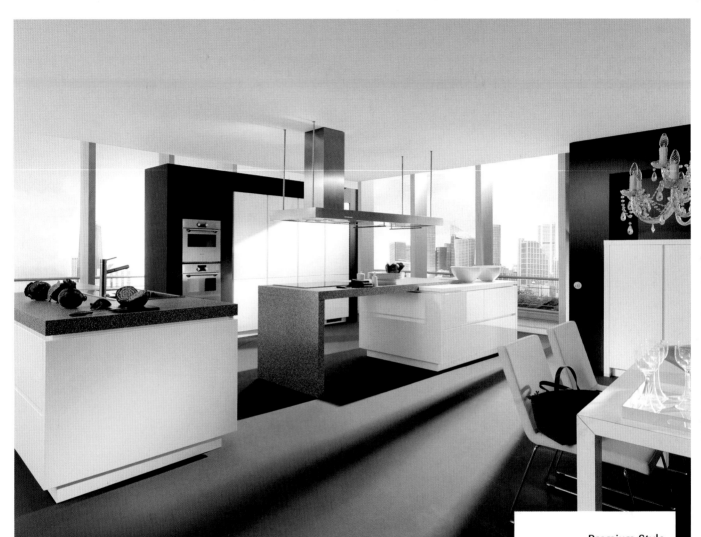

Pure and sophisticated. The multilayer coating gives the surfaces a beautiful and intense sheen. The design is clean. Alno's kitchen is a handle-free Premium category model, constructed to the highest standards of workmanship. The use of hidden LED lights in the handle grooves creates a fantastic play of light and shadows, and combines perfectly with the general lighting of the kitchen.

Model: **Alnostar Highline**
Manufacturer: **Alno**
Photography: © **Alno AG**

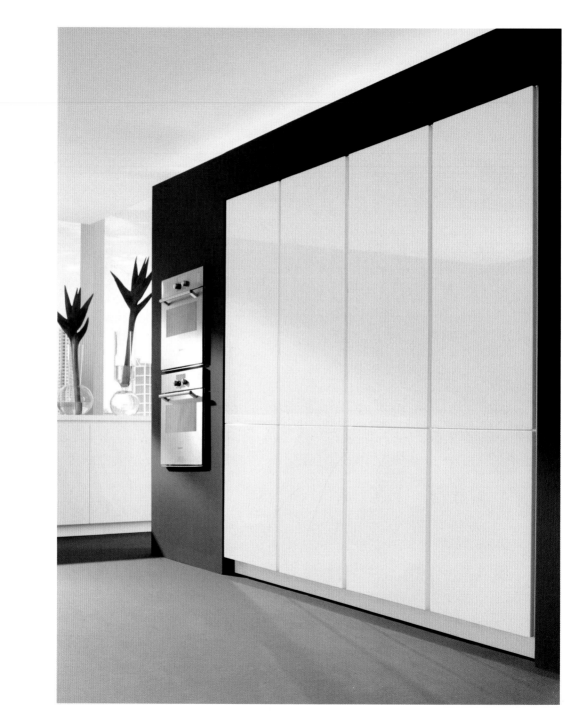

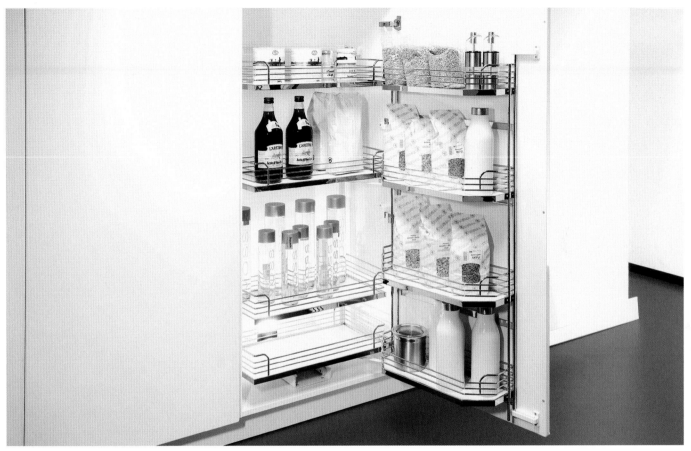

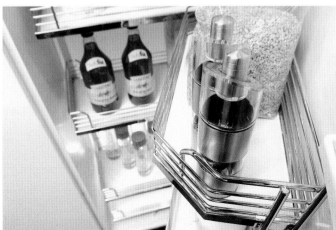

016

Interior equipment needs to be functional. More order means more space.

017

The hidden handles, which cover the entire front of the kitchen cabinets, create easy access to their contents.

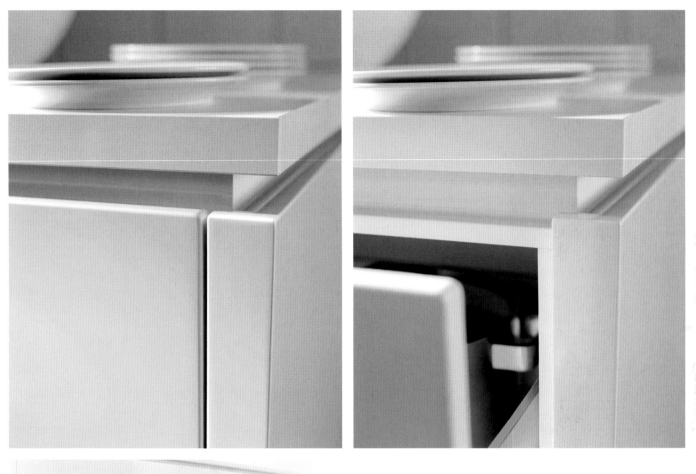

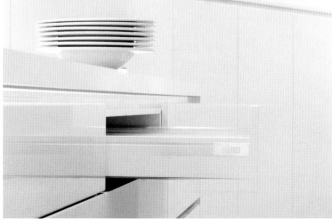

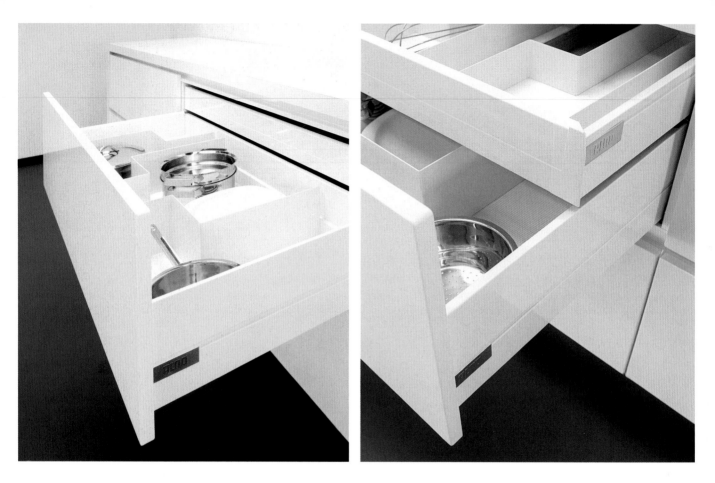

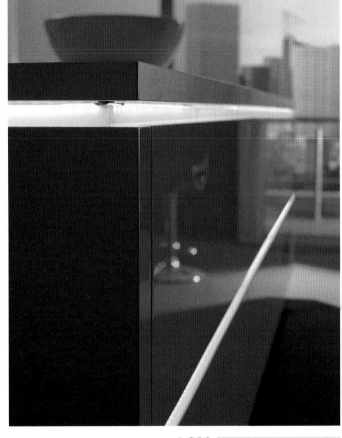

018

Installing an LED light strip facilitates access to the hidden handles and produces a striking effect.

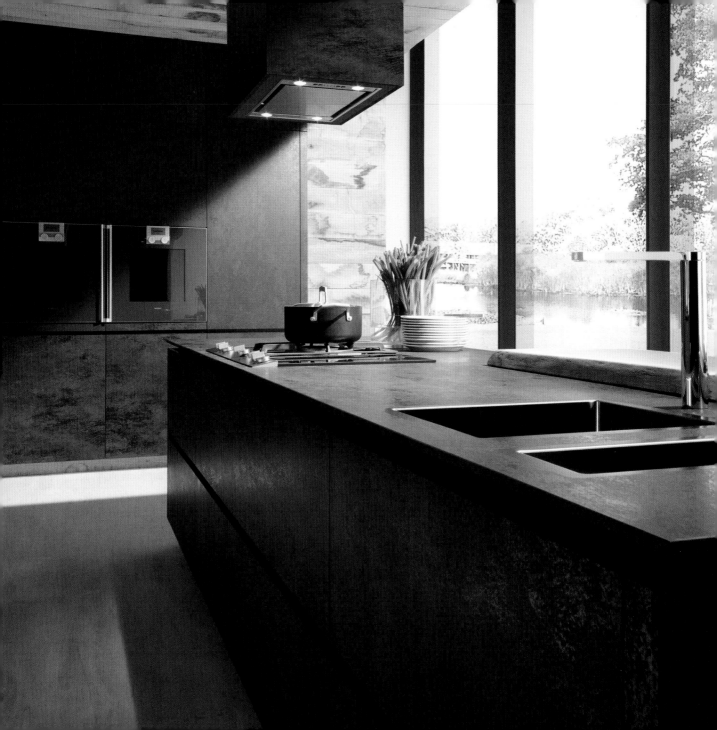

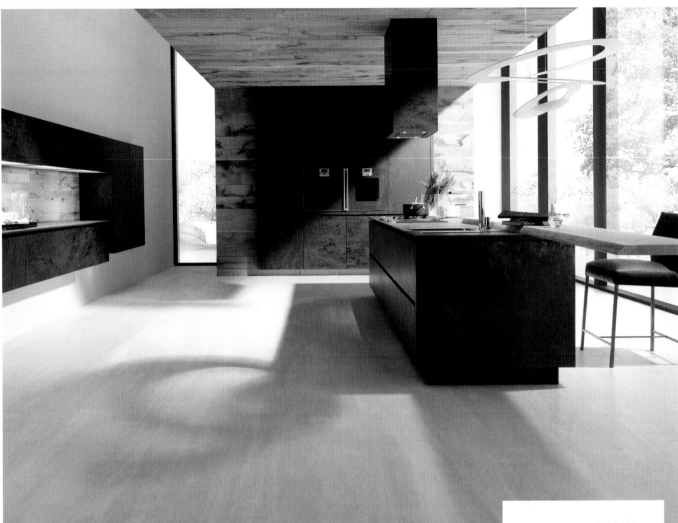

The natural rock gives the lines distinguished clarity. The natural ceramic provides an elegant, high-quality finish and allows for ample design possibilities. What is more, its special qualities mean that it is resistant to heat, stains and scratches. This is undoubtedly an original and hard-wearing design solution for contemporary kitchens.

Oxide Nero

Model: **Alnostar Cera**
Manufacturer: **Alno**
Photography: © Alno AG

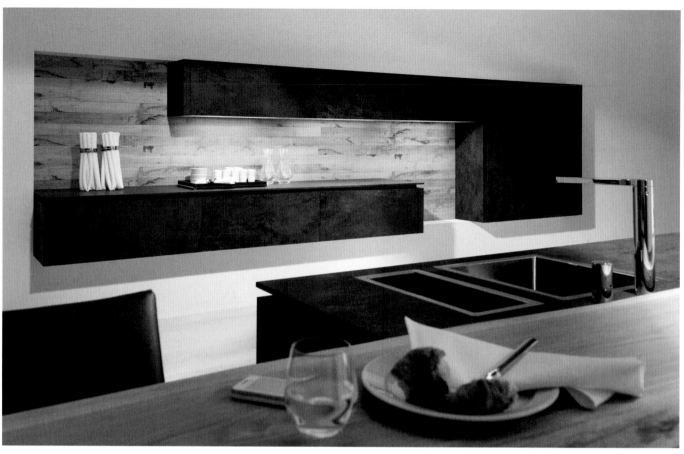

019

The clean, simple shapes
are enhanced further by the
absence of handles, even
in materials such as ceramic.

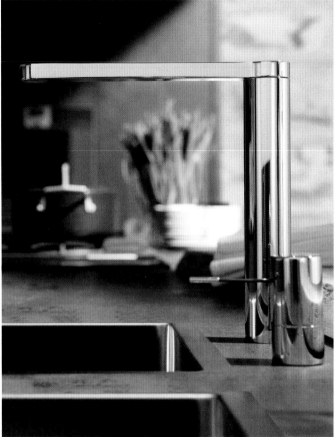

020

Materials such as the stainless
steel faucets and sink combine
just as well with ceramic
as they do with wood.

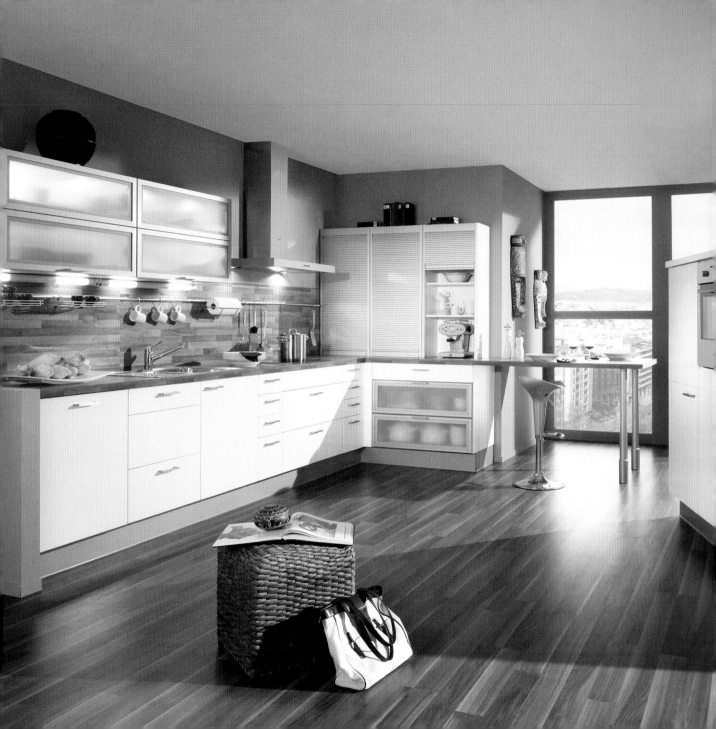

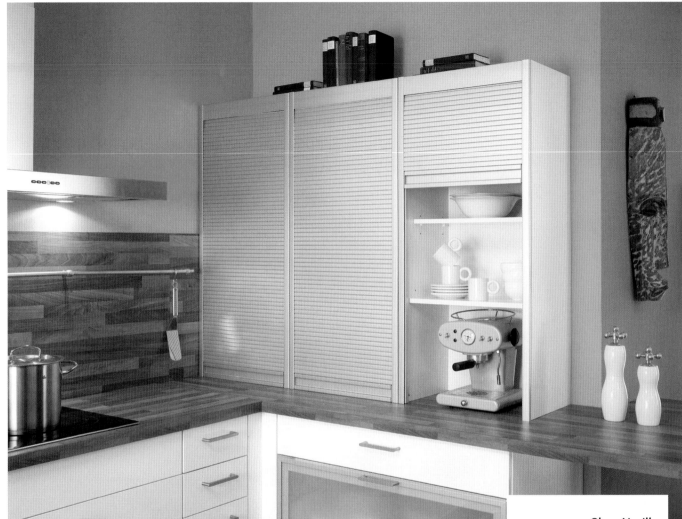

Gloss Vanilla

Model: **PN230**
Manufacturer: **Pino**
Photography: © **Pino**

It all depends on knowing how to choose the right space. This is the case for cooking, but also when it comes to furnishing your kitchen. Follow your five senses and design the kitchen you have always dreamed of. With his PN230 model, Pino provides all the amenities you need with no stress. And of course, better does not always mean more expensive.

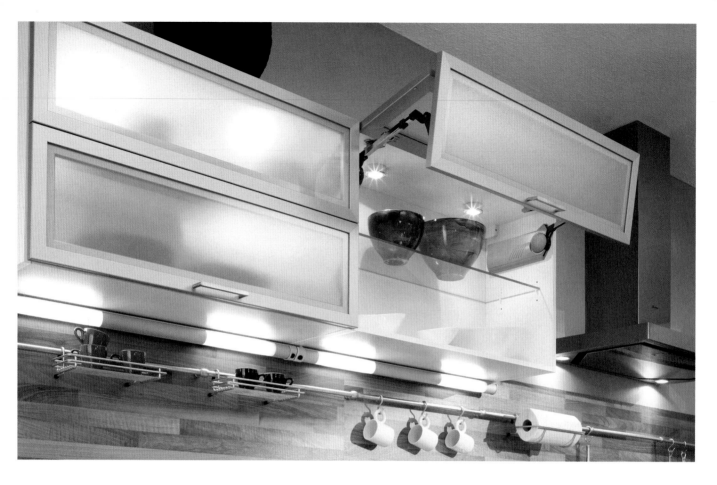

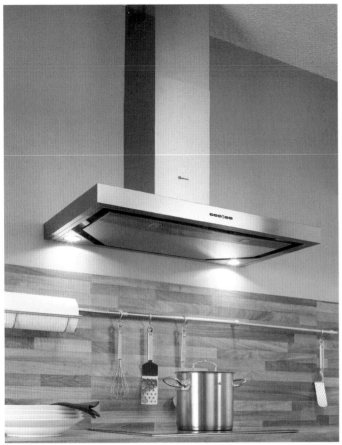

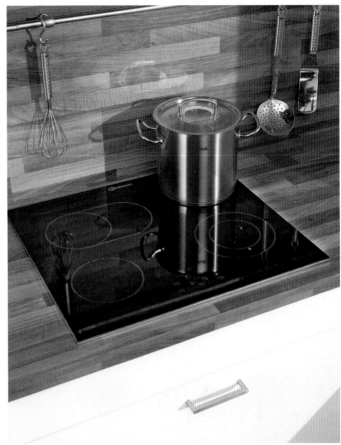

021

The color contrast between the different surfaces reaches beyond the kitchen furniture to the walls.

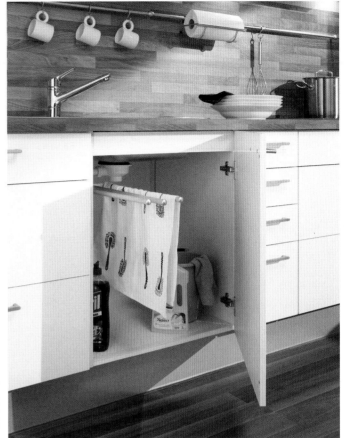

Paneled appliances are a popular means of not breaking the visual continuity of the kitchen.

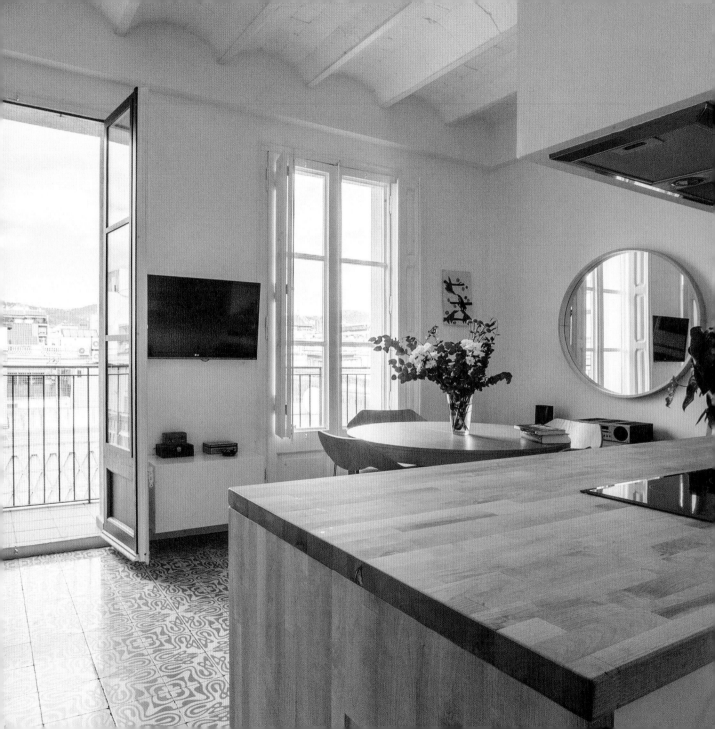

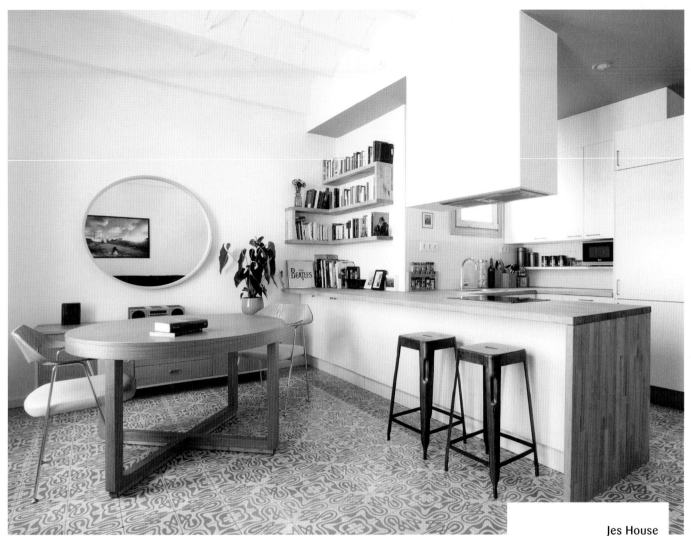

Nook Architects' functional challenge for the redesign of this home was to take into account their clients' lifestyle. The kitchen had to be open to a spacious living room, which was achieved through freeing up space by combining the bathroom with the main bedroom. The result is a neutral and bright atmosphere that floods the living area, kitchen and other rooms of the house.

Jes House

Architect: **Nook Architects**
Location: **Barcelona, Spain**
Photography: © **NIEVE |
Productora Audiovisual**

Axonometric view

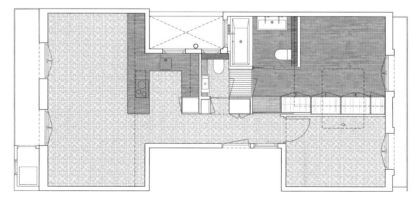

Floor plan

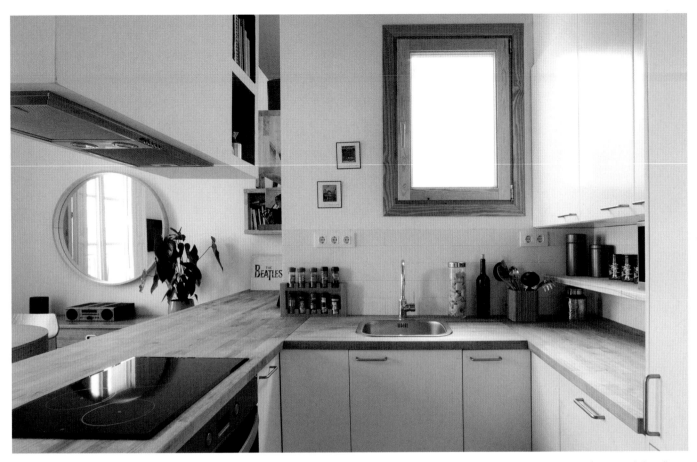

An existing window into a lightwell provides natural light to the kitchen and to the adjacent living spaces thanks to the open plan of the house.

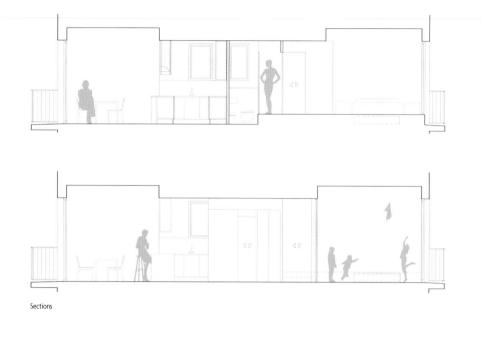

Sections

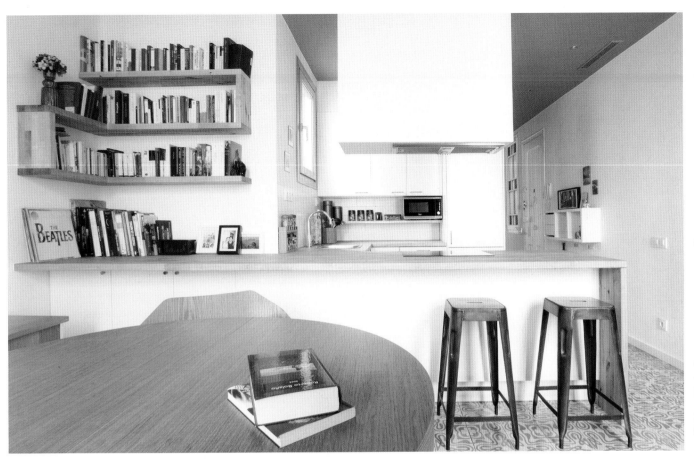

In confined spaces, an open kitchen is perfect for creating more space and comfort.

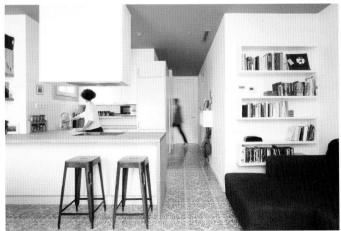

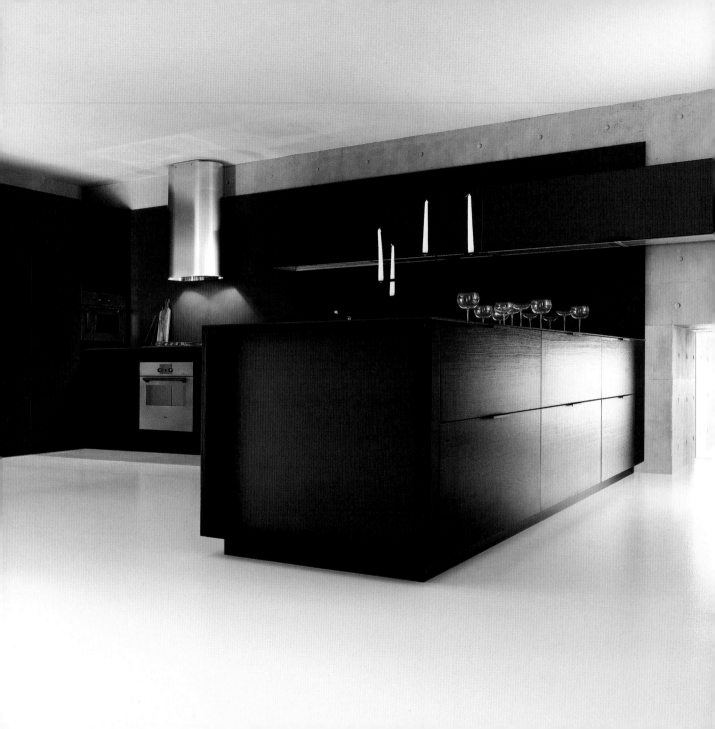

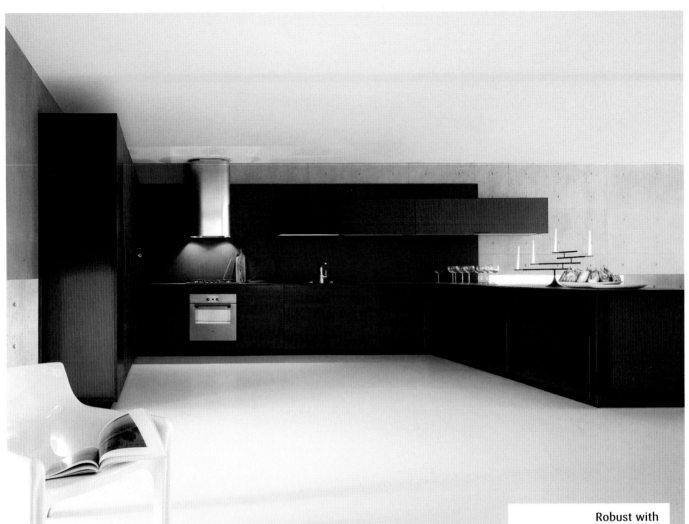

Model: Yara
Manufacturer: Cesar
Arredamenti
Photography: © Cesar
Arredamenti

With the Yara design, Cesar creates a kitchen that demonstrates enormous strength through its large shapes, essential lines and 2.5 centimeters (1 inch) door thicknesses. This is the kitchen of someone who loves the synthesis of contemporary design, elevated by high-quality finishes. This project reaches directly to the heart, becoming the physical and metaphorical center of the home in which it is set.

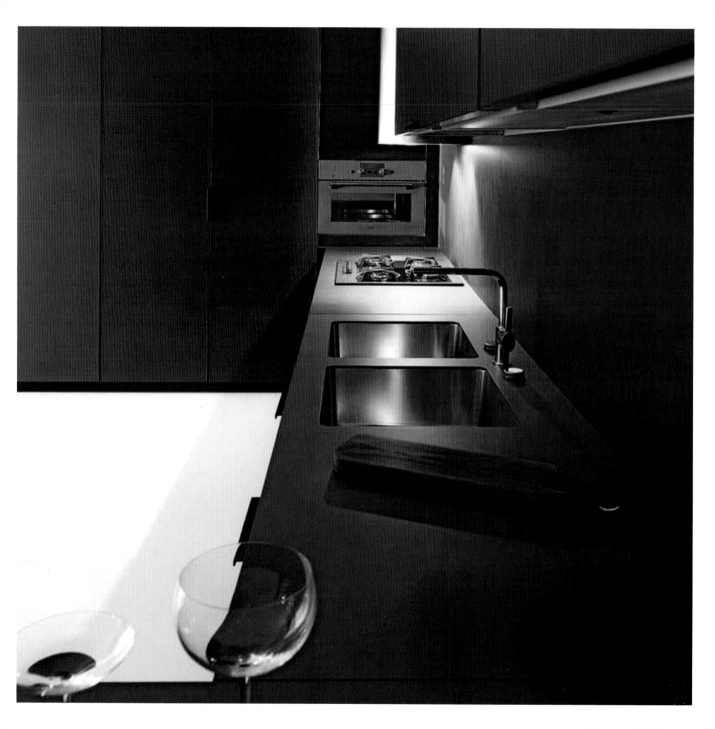

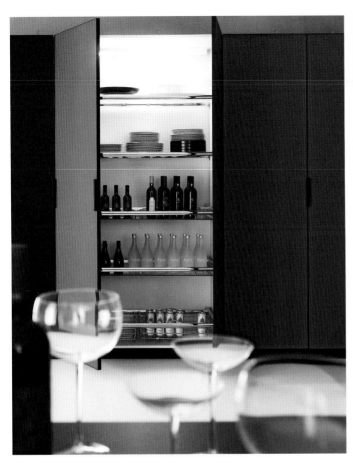

024

The beauty of the high columns is increased with the large terracotta glass doors and brown aluminum handles.

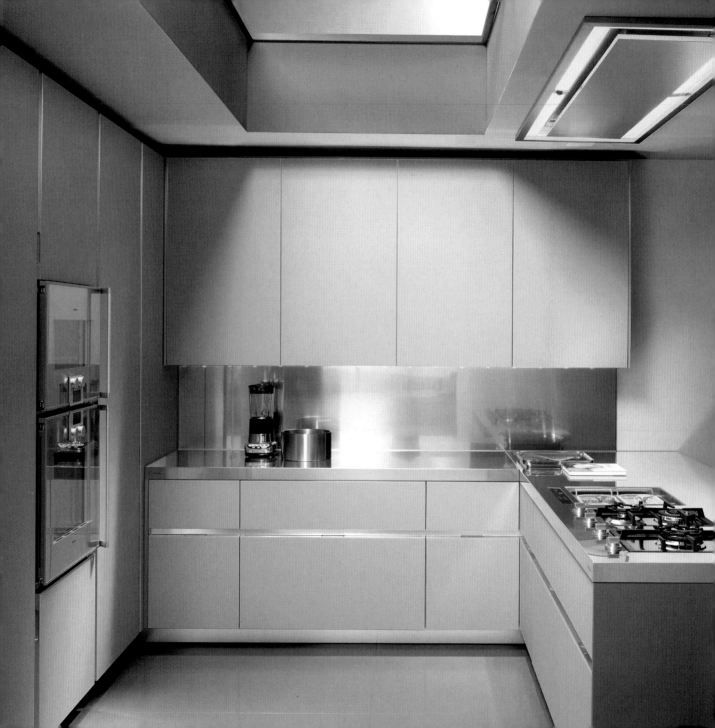

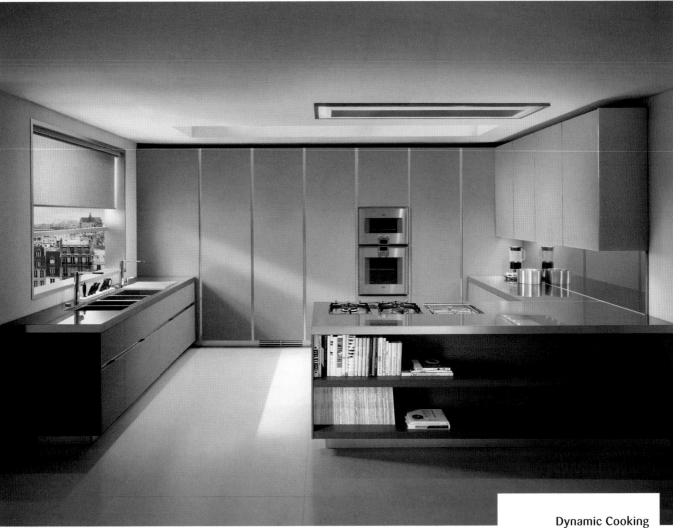

Dynamic Cooking

Elektra Vetro was the brainchild of designer Pietro Arosio and was the result of a plan that emphasized design as a means of expressing aesthetics and optimizing functionality. Of the Ernestomeda kitchens, this is the one that best interprets the new demands of everyday life: the increasing use of the kitchen as a dynamic place in which to live as well as work.

Model: **Elektra Vetro**
Manufacturer: **Ernestomeda**
Photography: © **Ernestomeda**

This full-height cabinet is fitted with integrated lighting that turns on automatically when doors are opened brightening up the usually dark cabinet interiors.

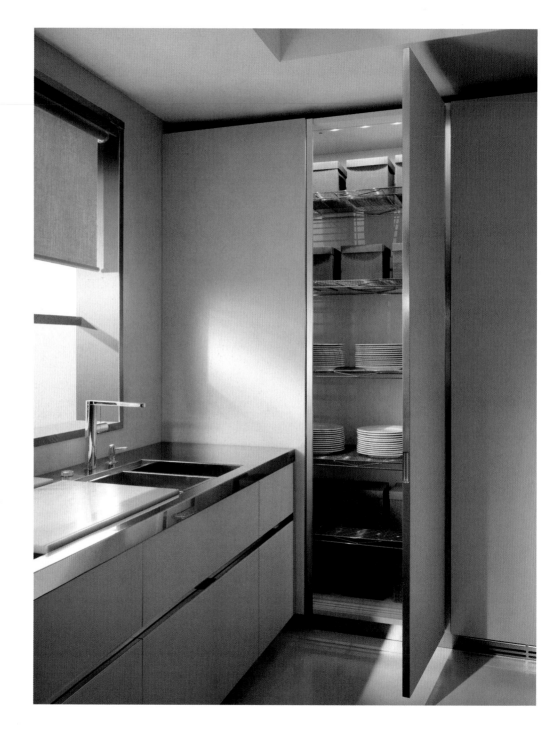

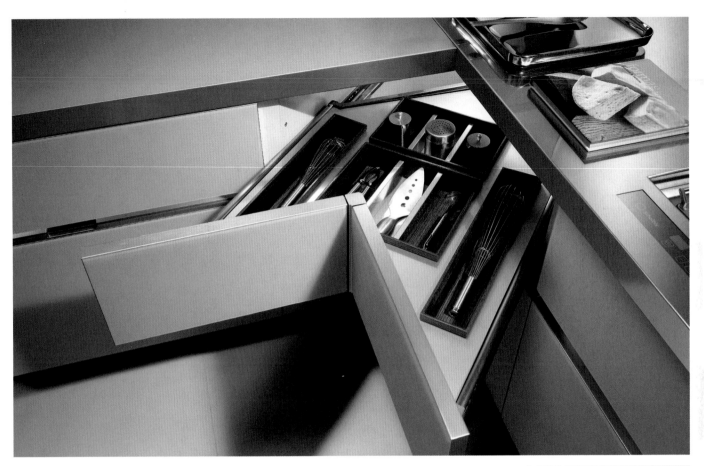

025

The unique design of a corner drawer makes the most of space that otherwise would be dead.

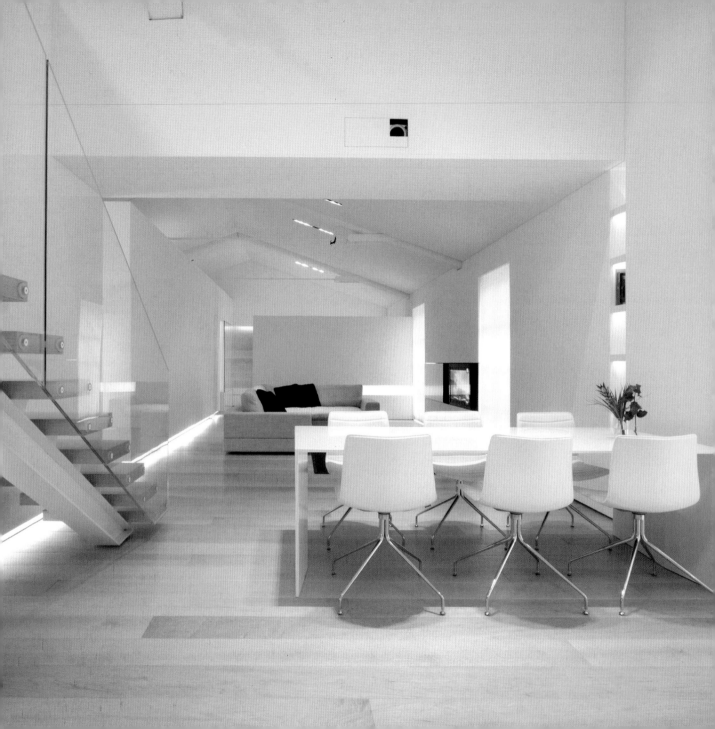

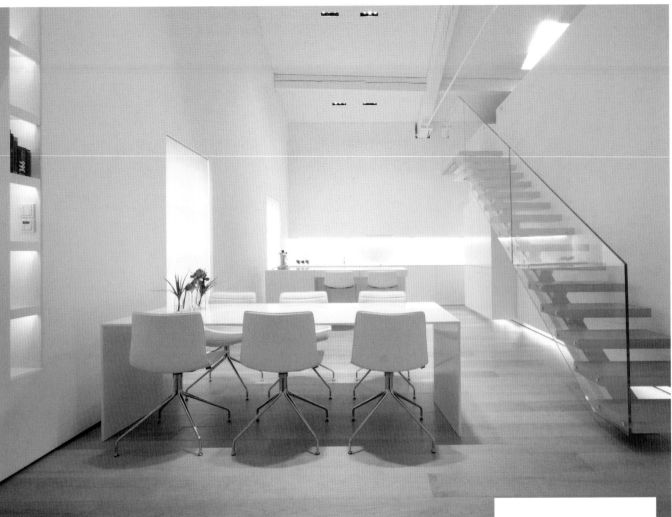

Como Loft

Architect: Jacopo Mascheroni/
JM Architecture

Location: Como, Italy

Photography: © Jacopo
Mascheroni

Located in a former monastery, the principal idea when designing this dazzling loft was to keep the shell intact and place a closed box inside it, which would contain a bedroom and two bathrooms while leaving an open space for the main functions. Thus, the kitchen is in the main gallery together with seating areas and living room, and items such as the basins, beds and dining table have been made to measure.

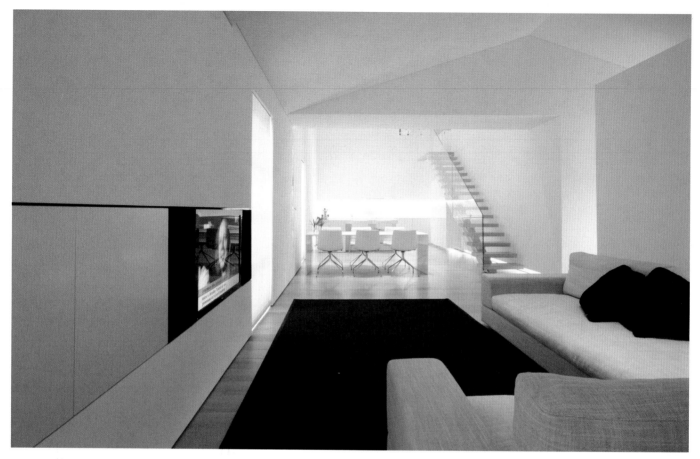

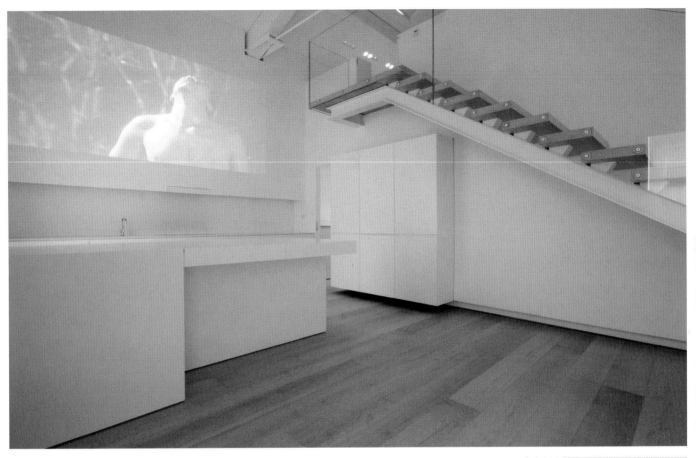

026

The solid Corian® surfaces work in any space. This versatile material can be shaped in any form and dyed in a wide variety of colors.

Section

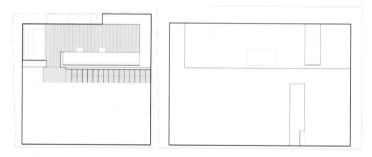

Upper floor

Main floor

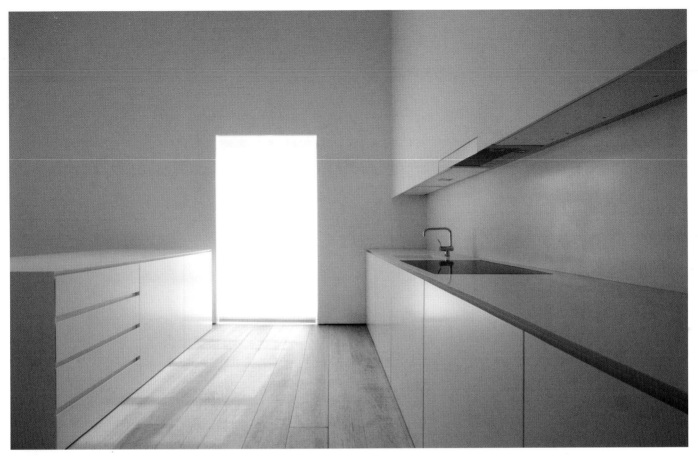

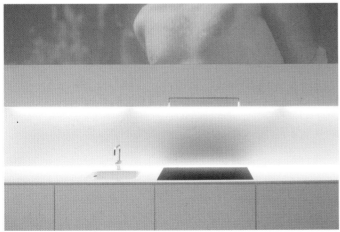

027

A motorized system enables the high kitchen units to be hidden behind a wall that slides down from above.

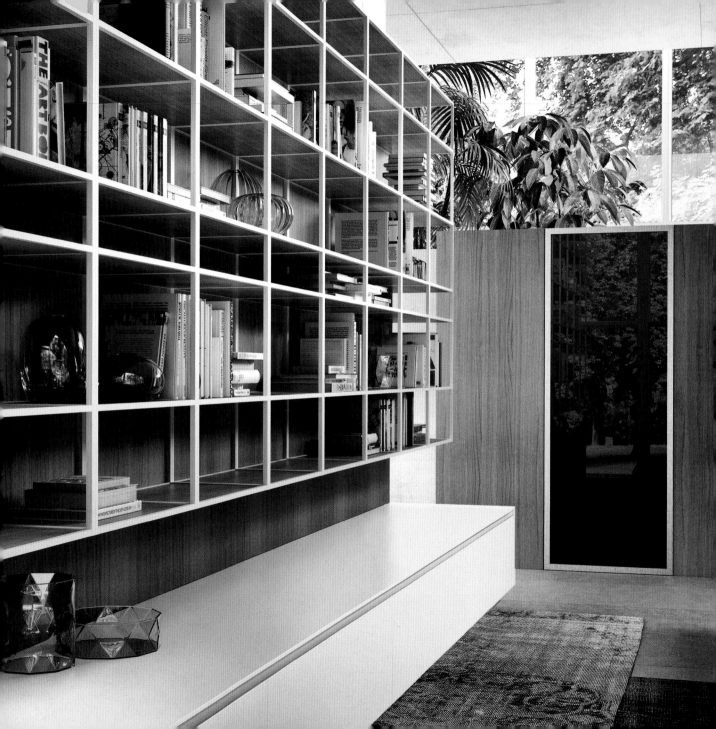

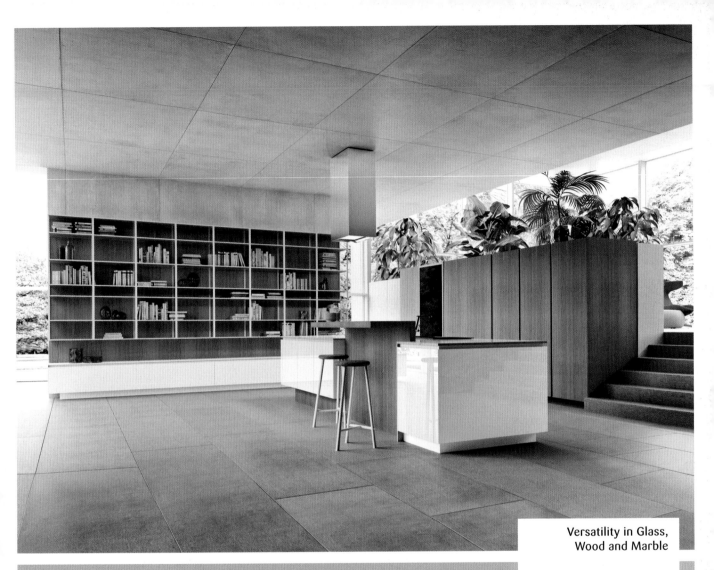

Versatility in Glass, Wood and Marble

Model: Way
Manufacturer: Snaidero
Photography: © Snaidero

The Snaidero Way design is strict in its proportions, minimalist in its lines of composition and highly sophisticated in its choice of finishes and colors. The Way project represents a design style that is utterly architectural and precise. The furnishings complement each other, and the composition acquires value through its apparent simplicity that reflects a precise study of detail.

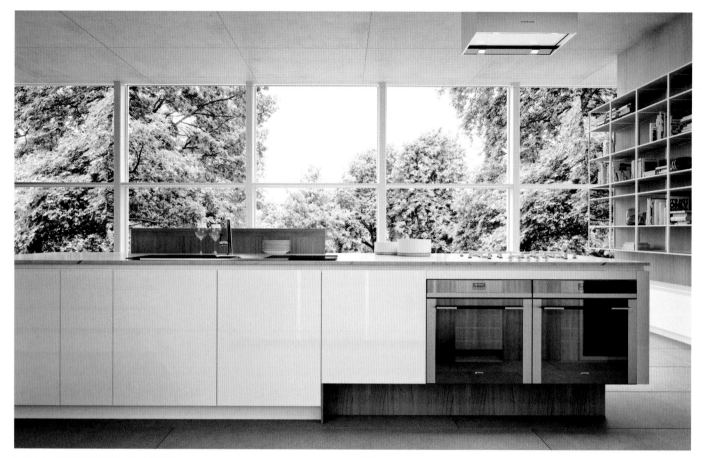

028

The recessed plinth in the base units offers better ergonomics at the work station as well as creating a suspended effect.

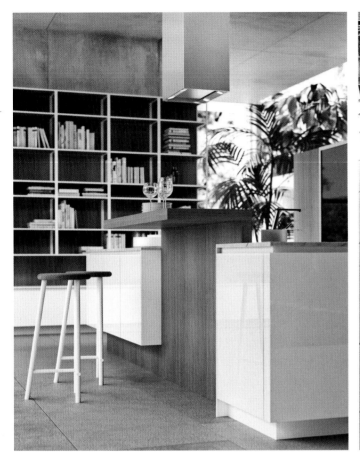

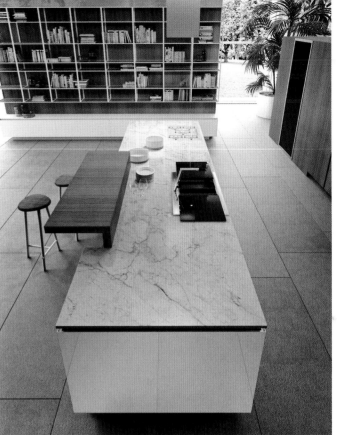

A minimalist design pairs with the use of richly veined marble and exotic wood to provide this open kitchen with an elegant, yet functional atmosphere.

Greenway

Located at one end of a large room, the kitchen acts as a counterweight to the area that is situated at the other end. How is this achieved? By dividing the original apartment into areas that are separate but linked through a central passage that creates an optical extension of the space.

Architect: JUMA Architects
Location: Ghent, Belgium
Photography: © Luc Roymans

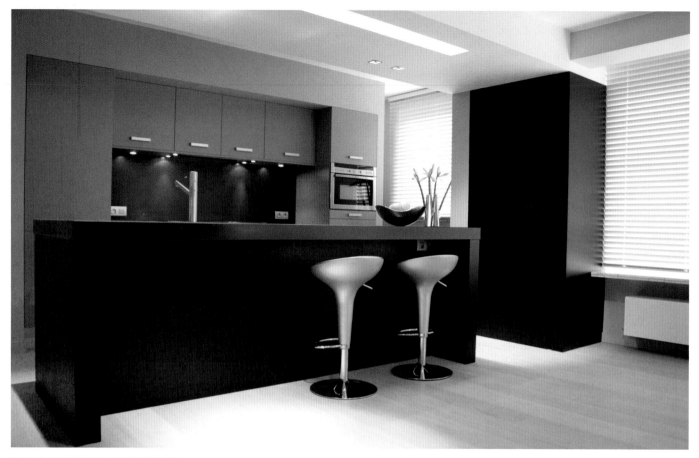

029

A large island can transform
a kitchen, creating extra space
for work.

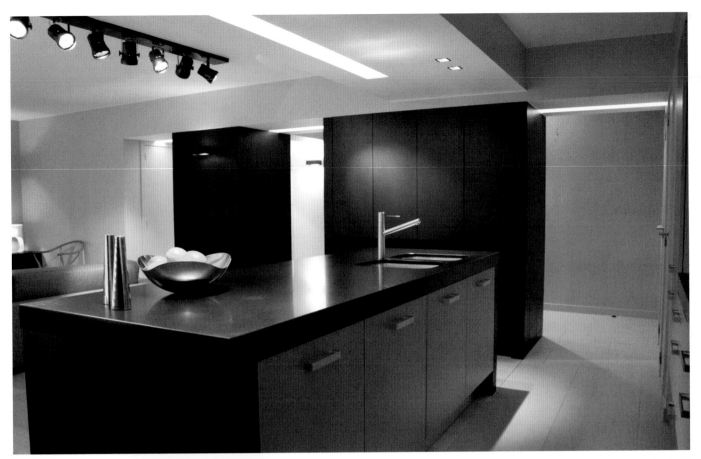

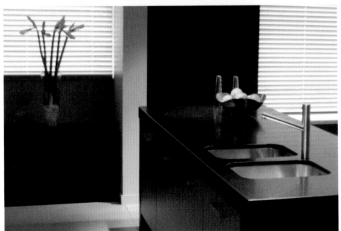

030

Installing a sink in the island calls for a detailed drawing of the plumbing system.

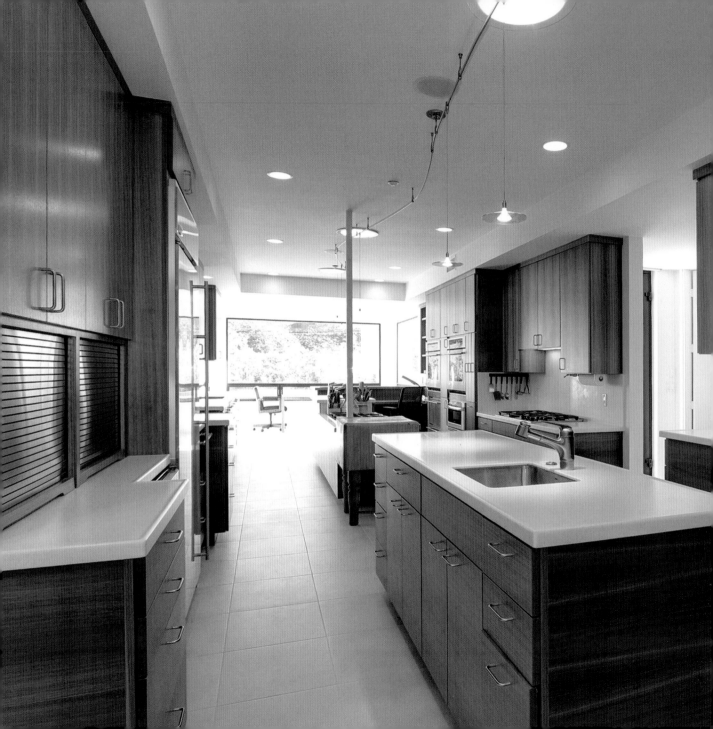

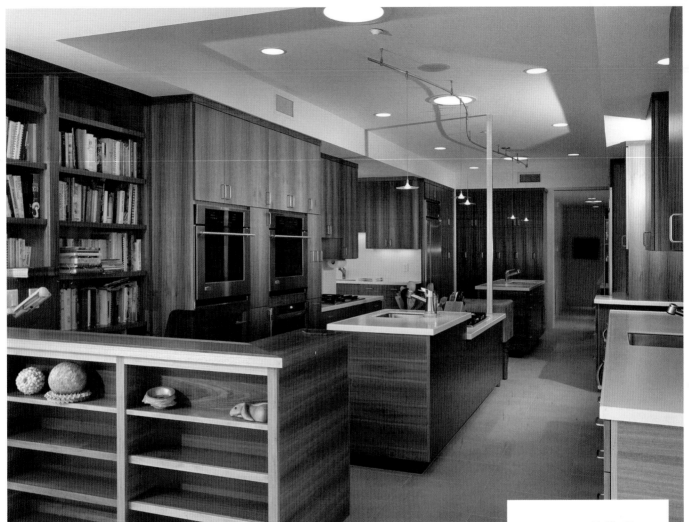

The kitchen designed by Silva Studios Architecture for their Hollis House project integrates seamlessly into an environmentally friendly and totally sustainable home. Located in a long gallery, it is oriented toward large windows that enable the room to maximize the natural light. Like the rest of the house, the furniture is made from Lyptus wood derived from a sustainable source.

Hollis House

Architect: Silva Studios
Architecture

Location: Poway, California

Photography: © James Jaeger
Photography

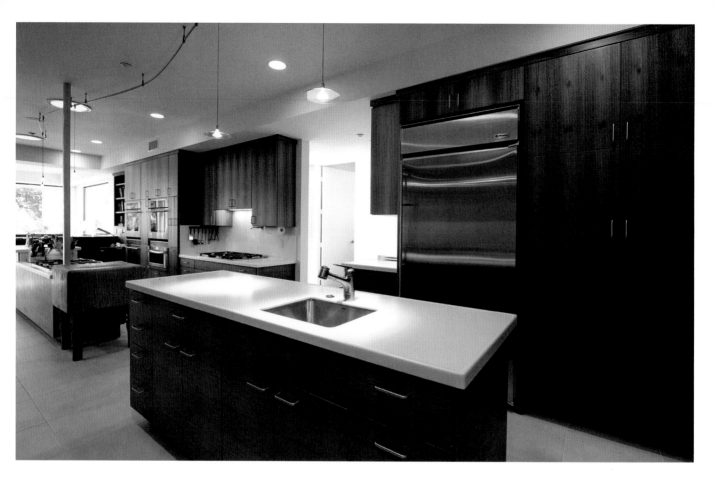

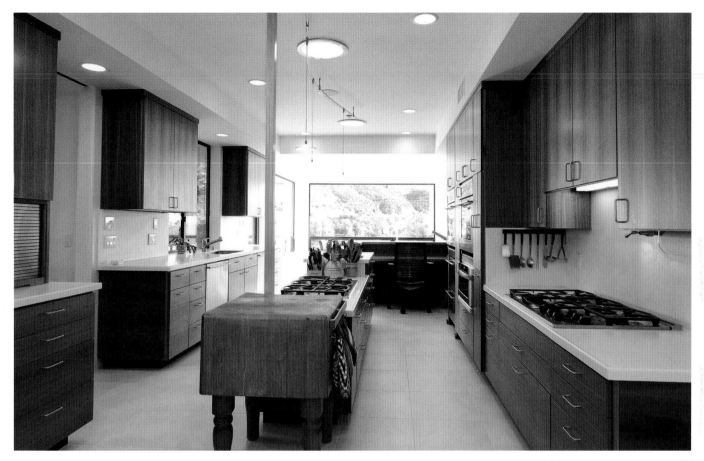

031

If space allows, it is a good idea to use more than one island dedicated to different tasks. This allows more than one cook to use the kitchen simultaneously.

Section

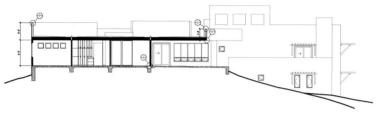

Section

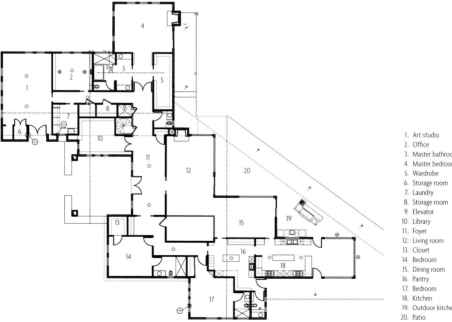

Floor plan

1. Art studio
2. Office
3. Master bathroom
4. Master bedroom
5. Wardrobe
6. Storage room
7. Laundry
8. Storage room
9. Elevator
10. Library
11. Foyer
12. Living room
13. Closet
14. Bedroom
15. Dining room
16. Pantry
17. Bedroom
18. Kitchen
19. Outdoor kitchen
20. Patio

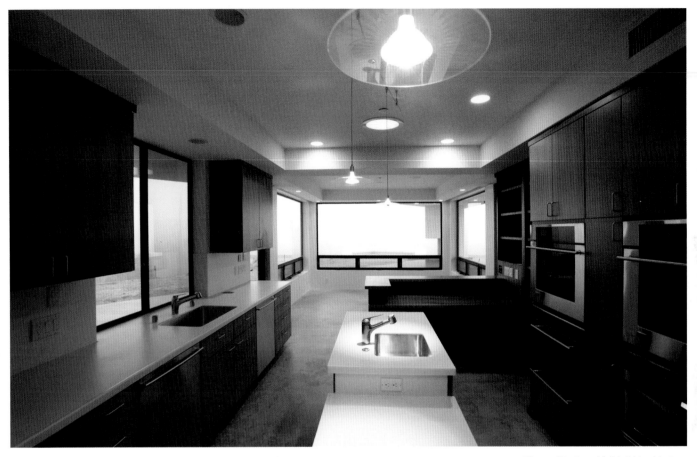

The combination of full-height cabinets, undercounter storage and open shelving offers flexible options in kitchen design.

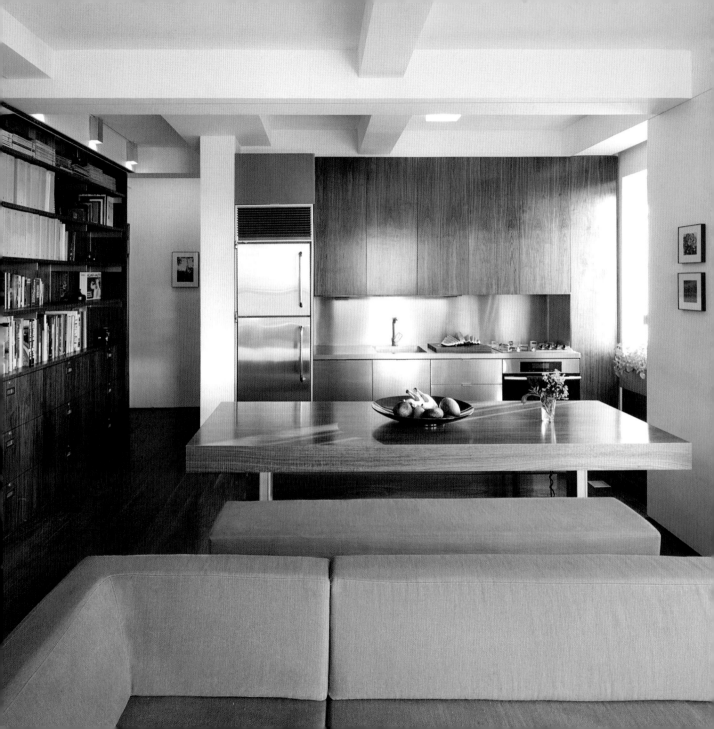

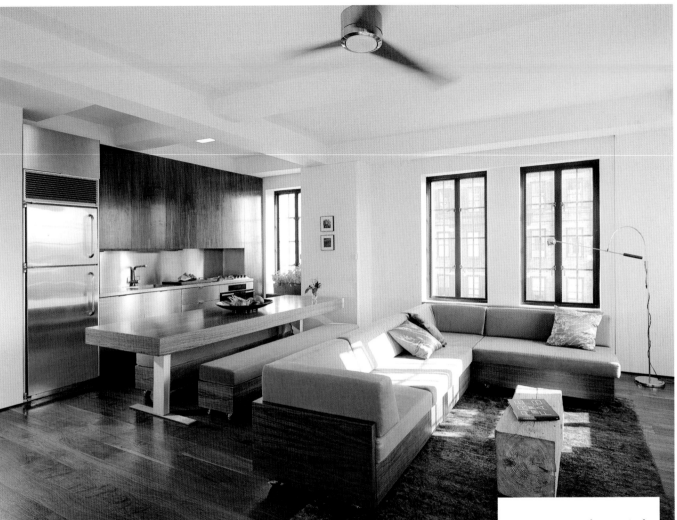

Transformer Loft

Architect: **Studio Garneau**
Location: **New York, New York**
Photography: © Bart Michiels,
© Robert Garneau

When renovating this intriguing New York home, the design solution was to create a flexible and adaptable mini-loft that would offer all the functionality of a single wide-open space. The resulting spaces are all made to measure, adapting perfectly to the constantly changing needs of the occupants.

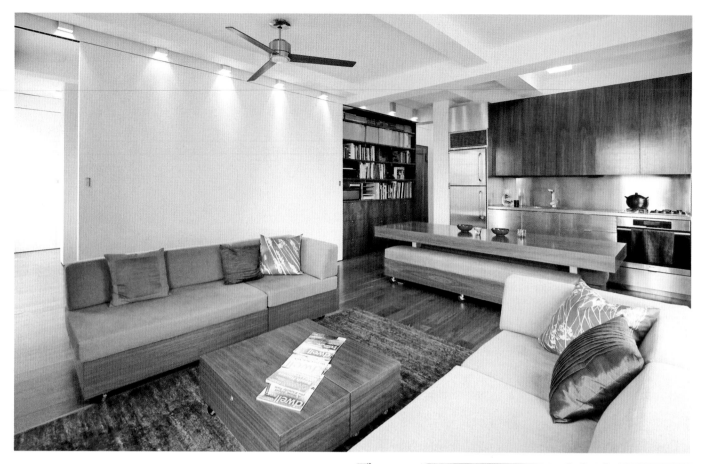

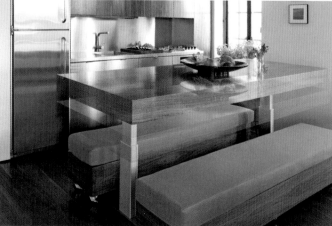

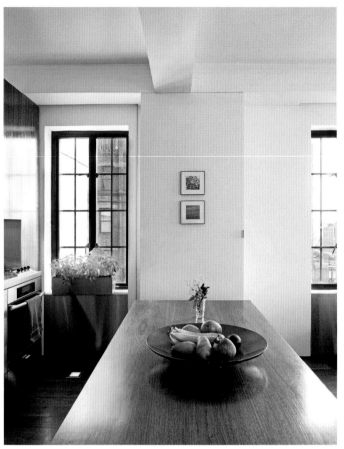

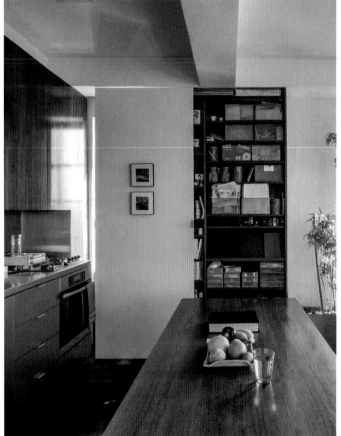

The kitchen island defines the space between the kitchen and the living room. It doubles as a worktop and as a dining table thanks to the mechanism that adjusts its height.

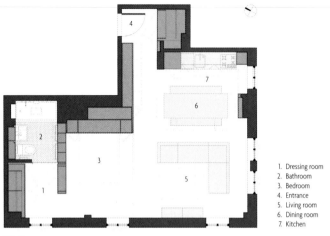

Floor plan

1. Dressing room
2. Bathroom
3. Bedroom
4. Entrance
5. Living room
6. Dining room
7. Kitchen

Sections

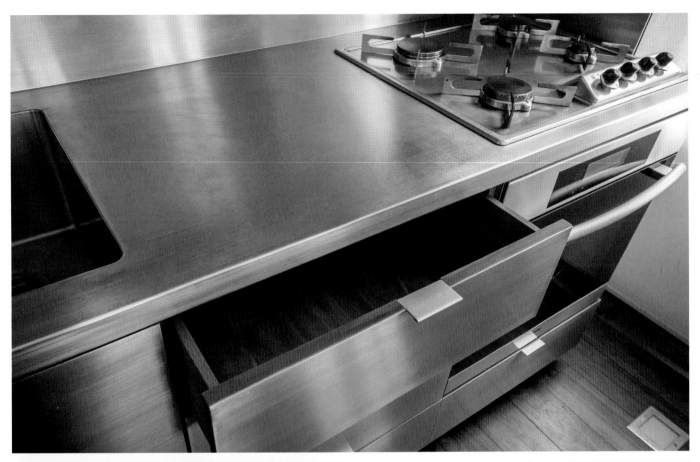

At the push of a button a table becomes a counter/island with hidden storage inside.

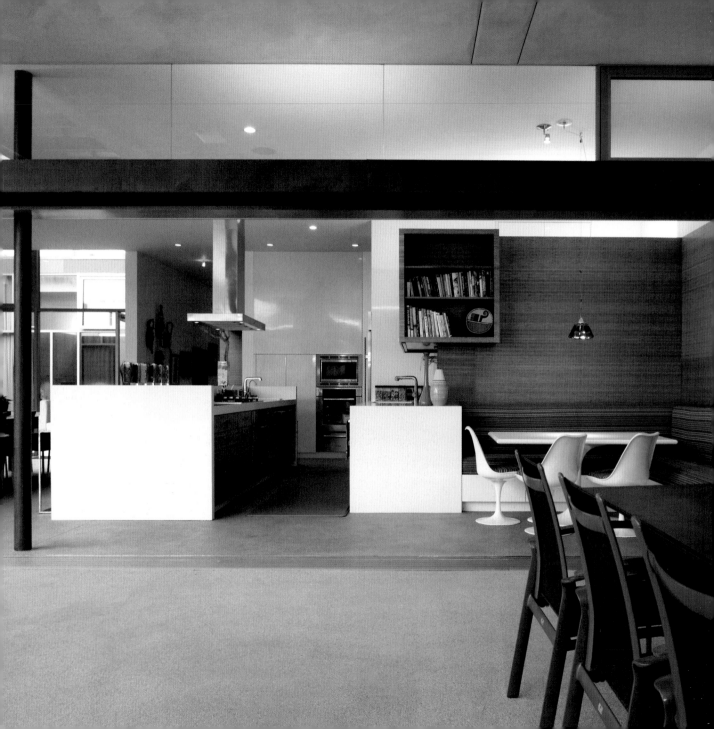

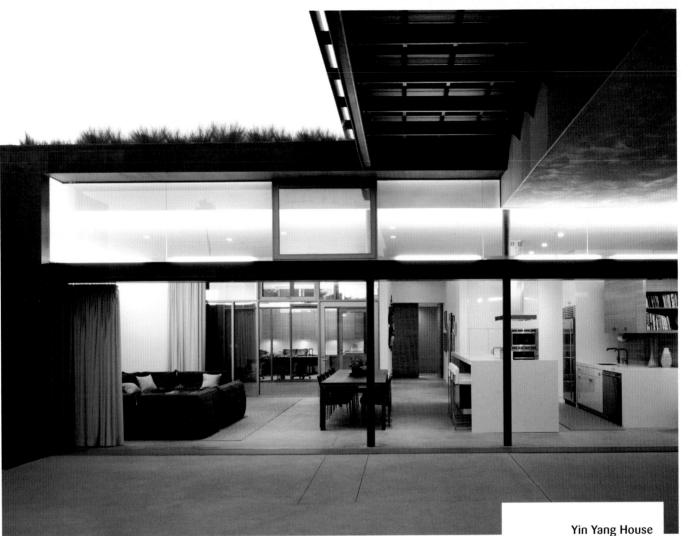

Yin Yang House

The Yin Yang House is organized around a series of courtyards and other open spaces that integrate seamlessly into the layout of the house. Within this carefully planned structure, the kitchen forms the heart of the house, with an open workspace that provides the owner, who is an accomplished chef, with a place to chat with friends while preparing a meal.

Architect: **Brooks + Scarpa**
Location: **Venice, California**
Photography: © **John Linden**

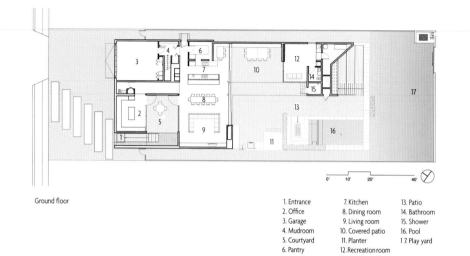

Ground floor

1. Entrance	7. Kitchen	13. Patio
2. Office	8. Dining room	14. Bathroom
3. Garage	9. Living room	15. Shower
4. Mudroom	10. Covered patio	16. Pool
5. Courtyard	11. Planter	17. Play yard
6. Pantry	12. Recreation room	

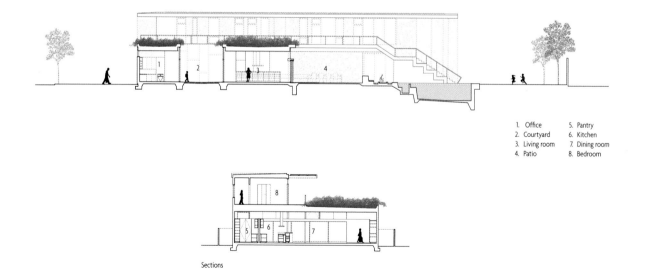

1. Office	5. Pantry
2. Courtyard	6. Kitchen
3. Living room	7. Dining room
4. Patio	8. Bedroom

Sections

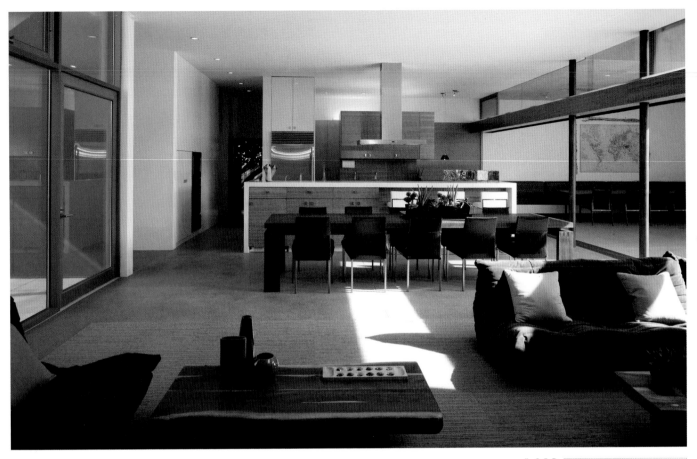

033

Walls disappear in an open kitchen, and the relationship between spaces becomes fluid: a nod to socializing.

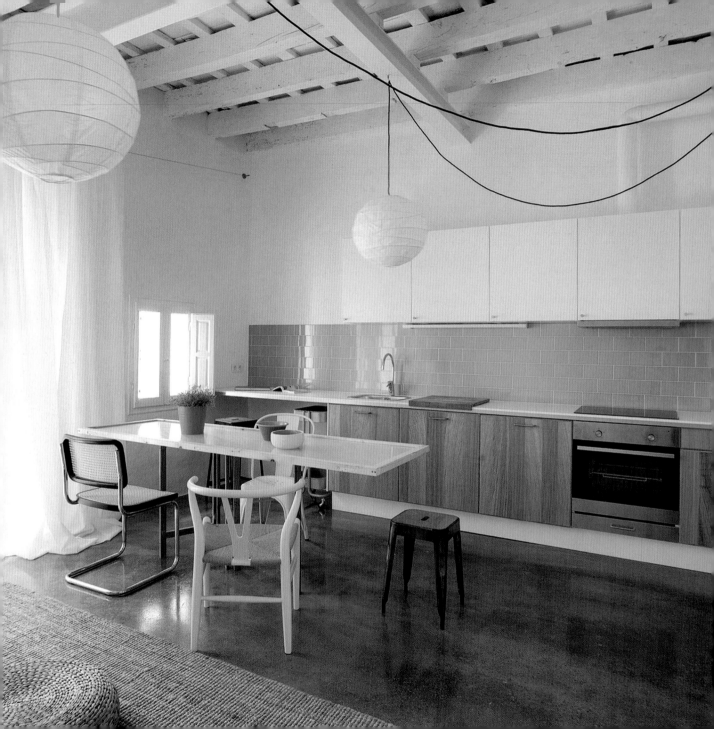

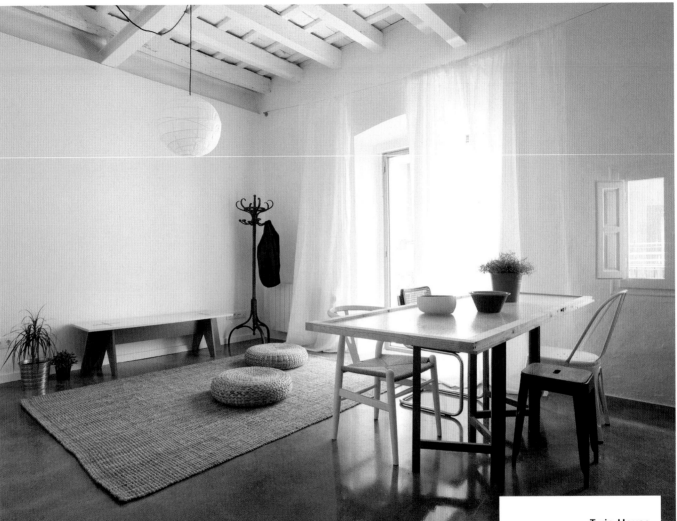

Twin House

Located in Barcelona's Gothic Quarter, this home is in fact two adjacent apartments that have been combined to create a single dwelling. In the new arrangement, the kitchen has been installed in the space in a subtle and respectful way. It is as though it were just another piece of living room furniture, a horizontal form with low fridge and freezer to avoid the appearance of a vertical column, with integrated, camouflaged white top cupboards.

Architect: **Nook Architects**
Location: Barcelona, Spain
Photography: © **NIEVE** | Productora Audiovisual

Floor plan

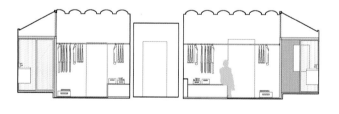

Sections

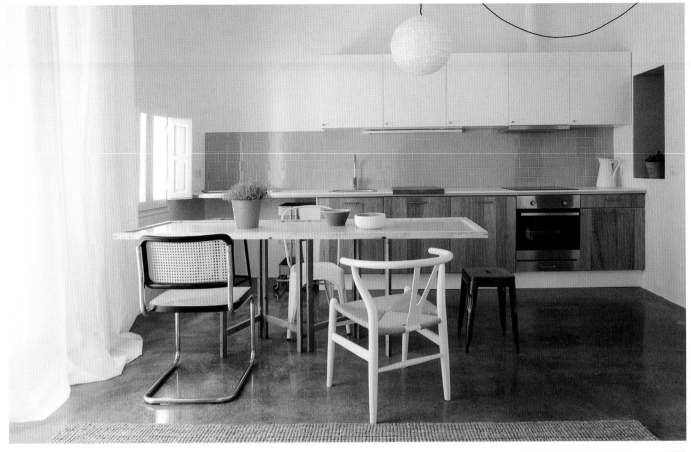

034

Horizontal tiles enhance
the fundamental dimensions
of the kitchen, while the
green tone adds freshness
to the design.

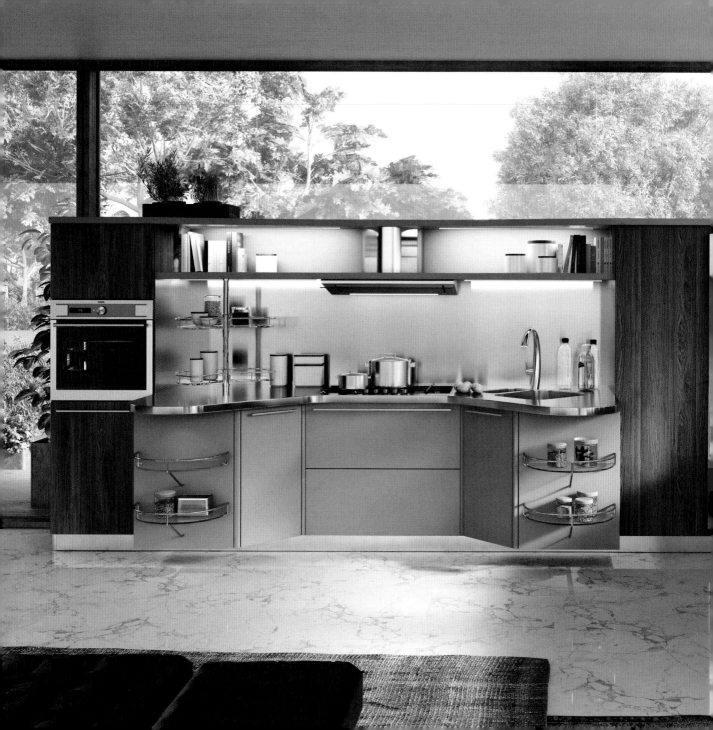

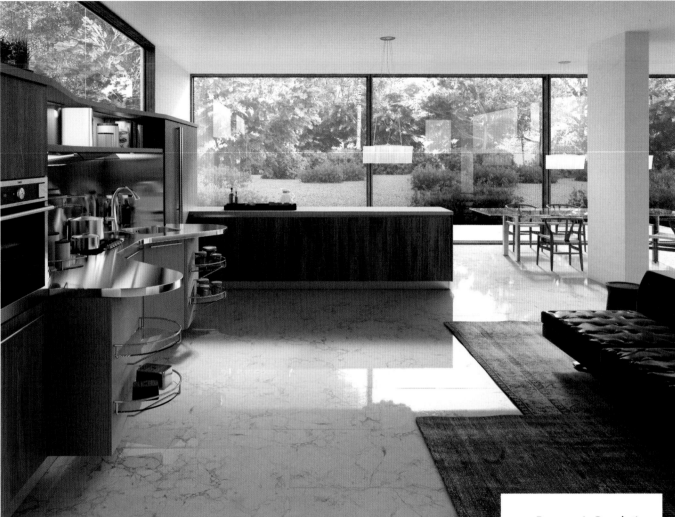

The Skyline 2.0 design falls outside the normal conventions. Detached from the composition in modules, it uses space intelligently even in restricted areas. Snaidero proposes a kitchen concept adapted to a modern lifestyle that is suitable for small or shared spaces as well as for larger areas. It is fully customizable in terms of dimensions, maintaining aesthetics and emotional feel.

Model: Skyline 2.0
Manufacturer: Snaidero
Photography: © Snaidero

Inward-angled semi-recessed
LEDs provide continuous diffuse
lighting in the work area.

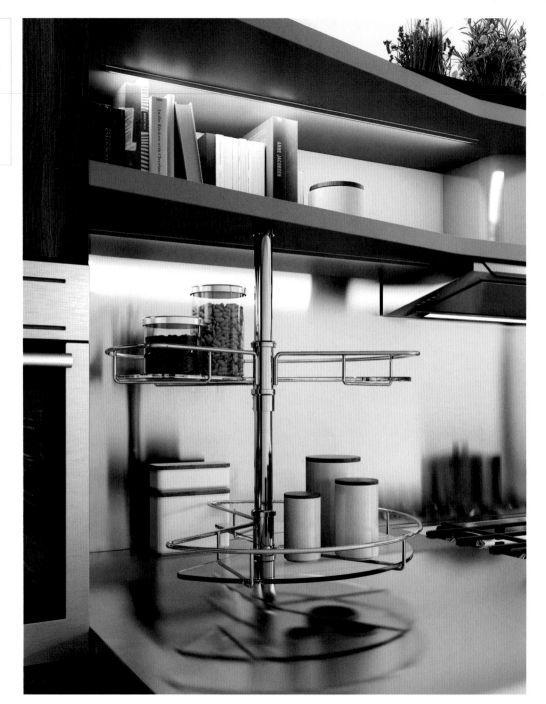

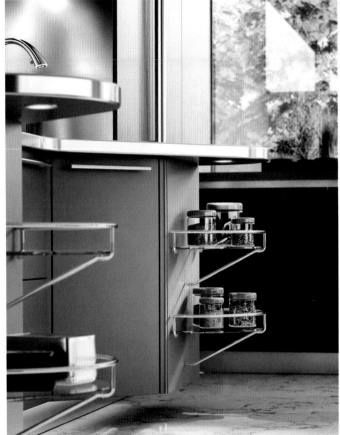

036

The worktop, with its interplay of concave and convex shapes, fosters a highly ergonomic feel.

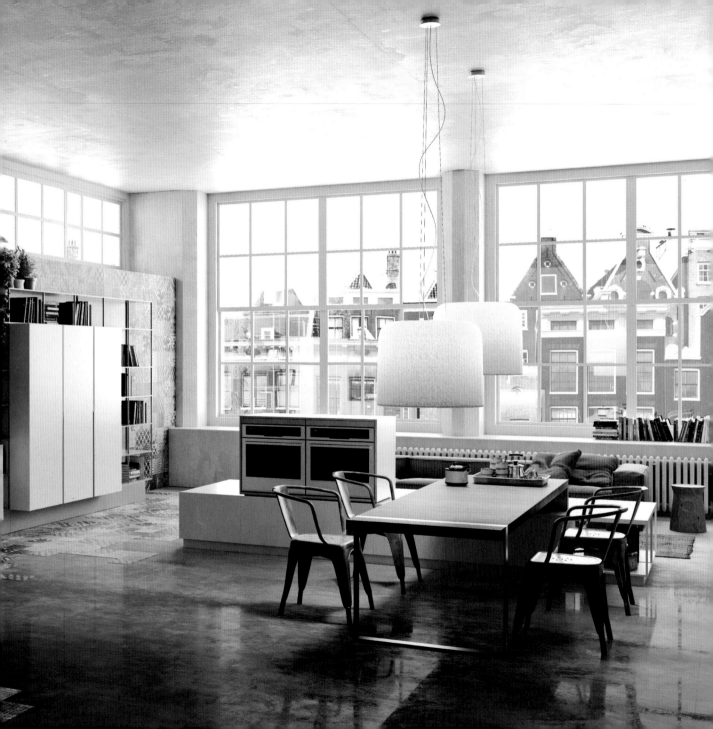

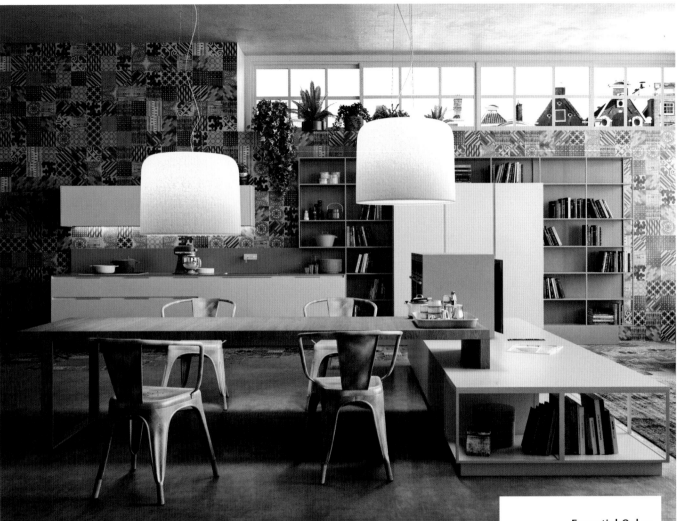

Orange Evolution is the evolution of the modern kitchen with its essential forms toward a more refined concept that creates style through details. The space is defined by large monochrome furniture units combined with color elements that are selected according to a personalized palette. The color becomes the complement that highlights the grace of the details.

Model: Orange Evolution
Manufacturer: Snaidero
Photography: © Snaidero

037

Bring some zest into your kitchen with colorful wall tiles. As shown in the image, the mosaic-like wall covering works well with the minimalist kitchen equipment and living room furniture.

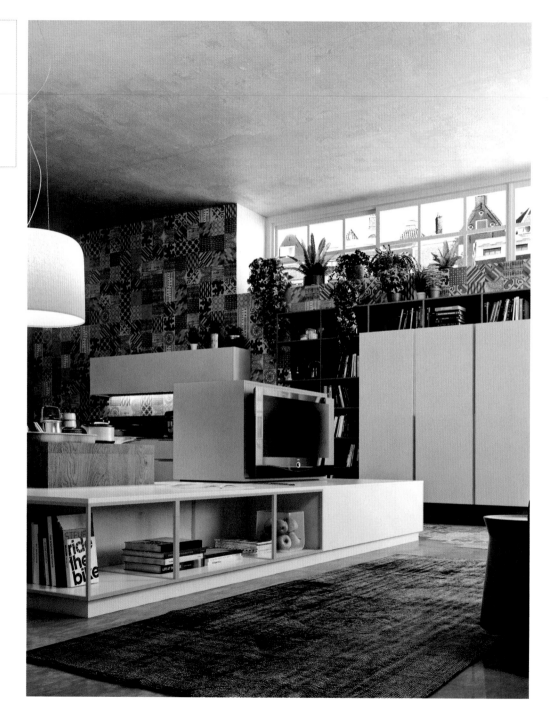

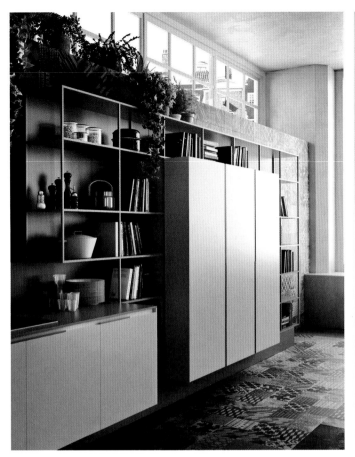

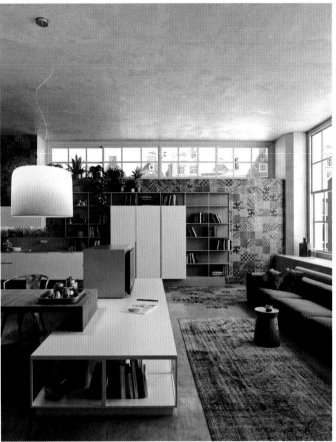

038

The aluminum bookcase has a vaguely oriental style and provides continuity between kitchen and living room.

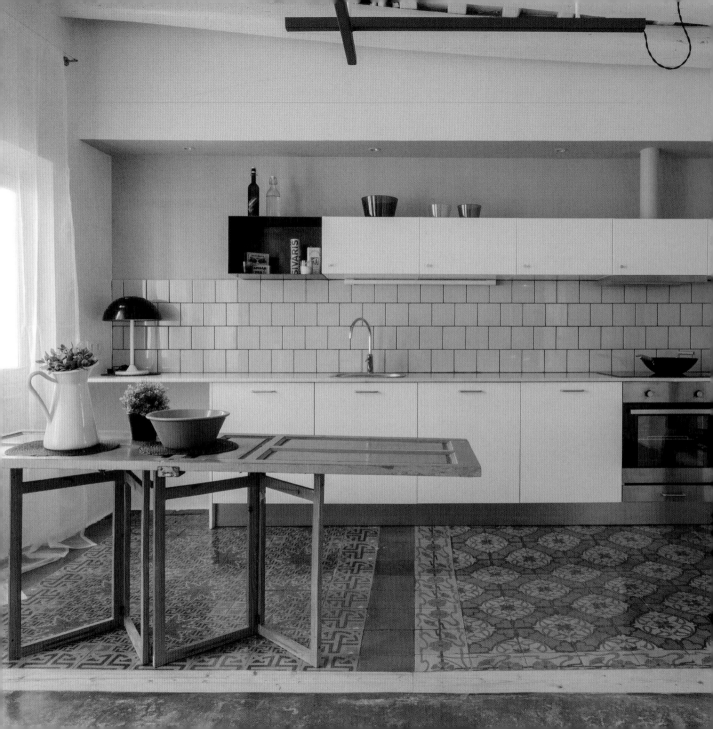

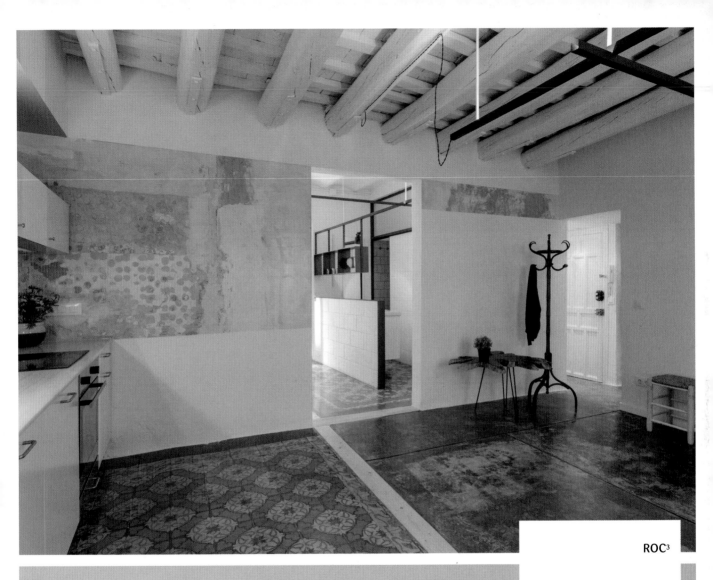

ROC³

Architect: **Nook Architects**

Location: Barcelona, Spain

Photography: © NIEVE |
Productora Audiovisual

Renovating this property has had a subtle impact on its space, but it manages to combine the levels of comfort that one desires today with the harmony of the building's history. In this sense, the kitchen turns to simplicity and functionality. It does not aim to stand out against the rest of the home and therefore perfectly complements the space that recalls the original spirit of the farmhouse.

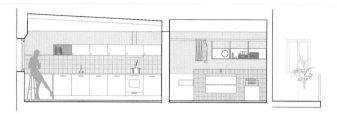

Sections

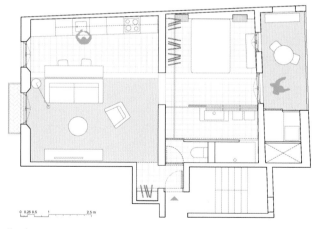

0 0.25 0.5 1 2.5 m

Floor plan

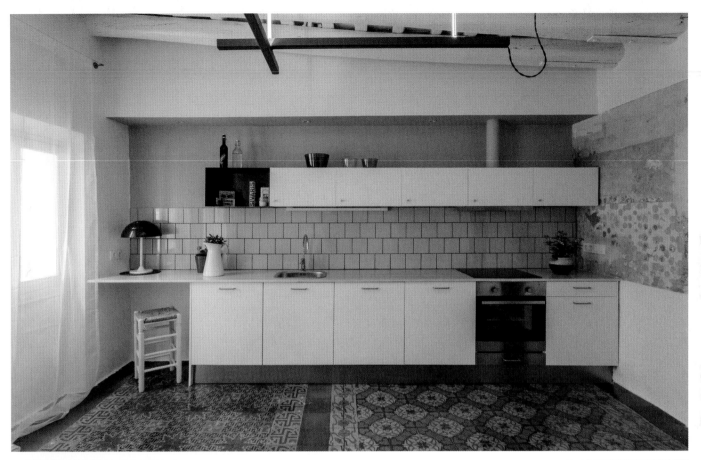

Similar items can be used in different rooms of the house. For instance, the black box shelf used in the kitchen is a larger version of the one used in the bedroom as a bedside table.

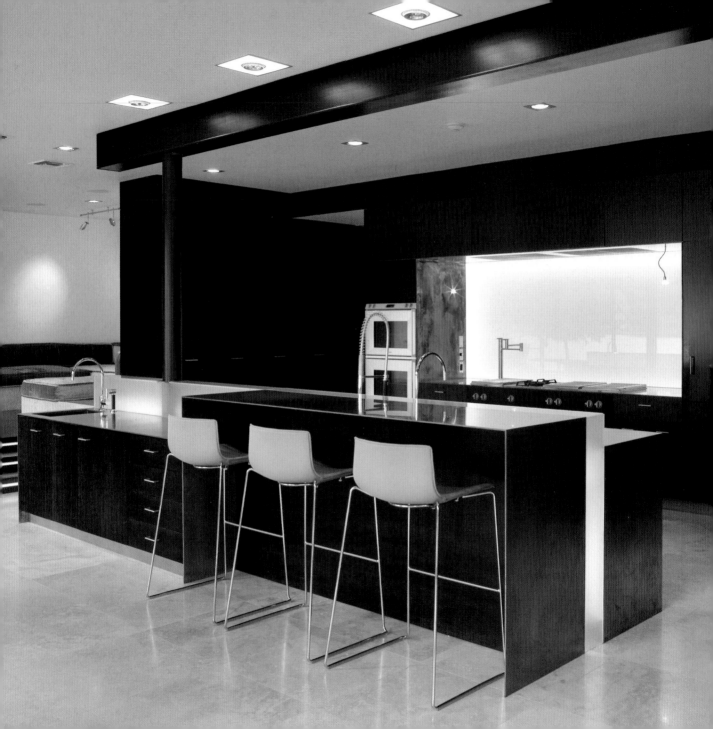

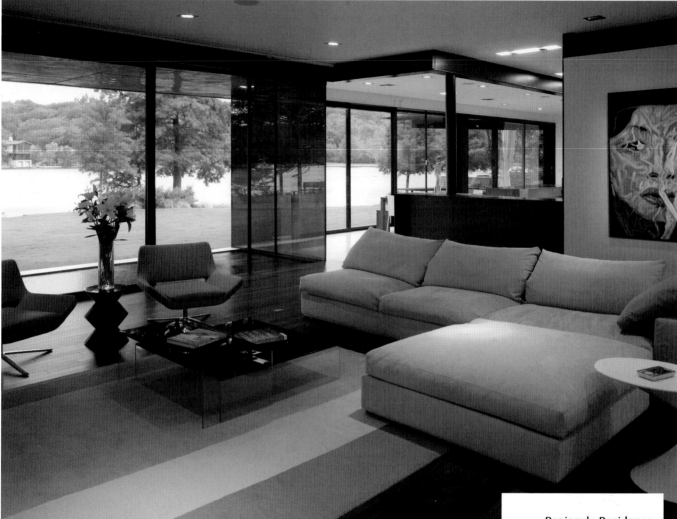

Peninsula Residence

The complete renovation of this property achieved something that the original design had overlooked—open views to nearby Lake Austin and a close relationship with surrounding natural scenery. The new living spaces retain a visual relationship with the exterior. The kitchen is located in the center of the downstairs living area and enjoys views and natural light that pour in through the large windows in the facade.

Architect: **Bercy Chen Studio**
Location: **Austin, Texas**
Photography: © **Paul Bardagjy**

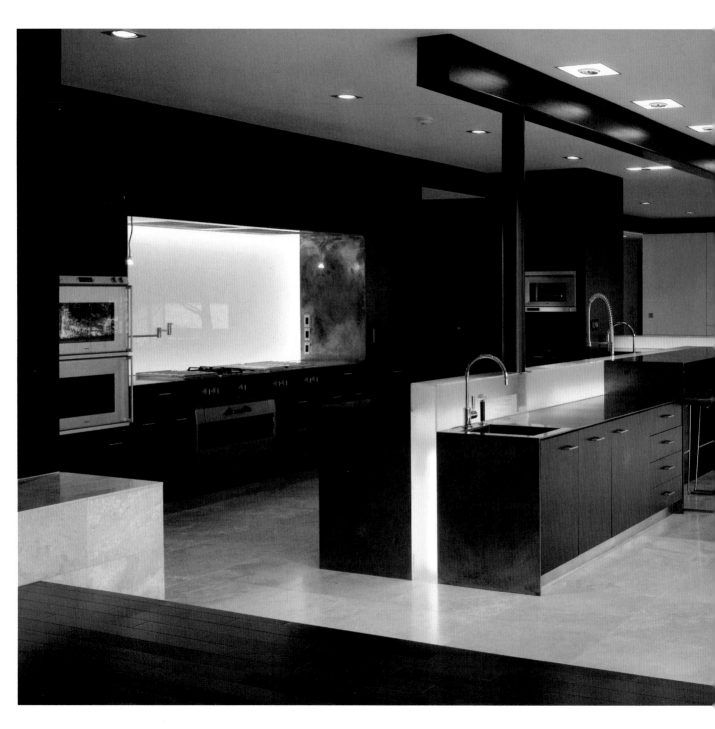

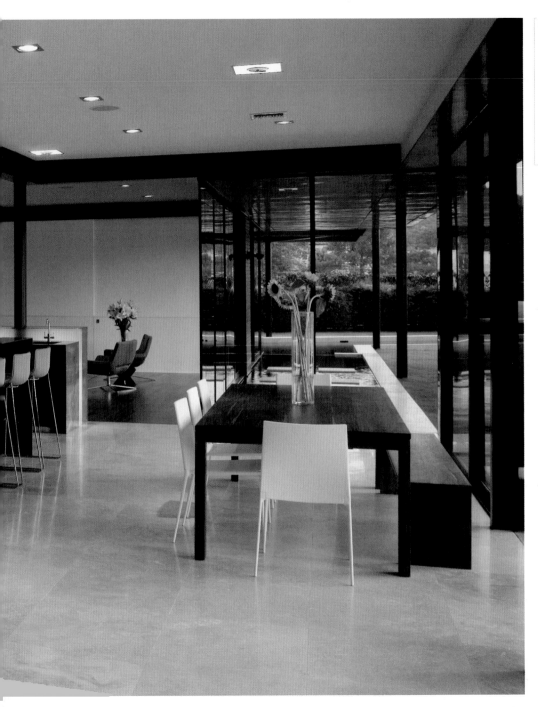

The orientation of the kitchen is fundamental: it should maximize light and provide sufficient natural ventilation.

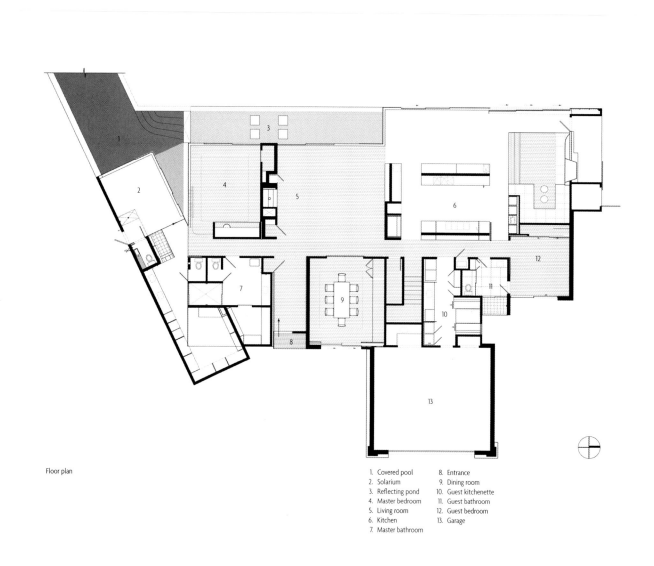

Floor plan

1. Covered pool
2. Solarium
3. Reflecting pond
4. Master bedroom
5. Living room
6. Kitchen
7. Master bathroom
8. Entrance
9. Dining room
10. Guest kitchenette
11. Guest bathroom
12. Guest bedroom
13. Garage

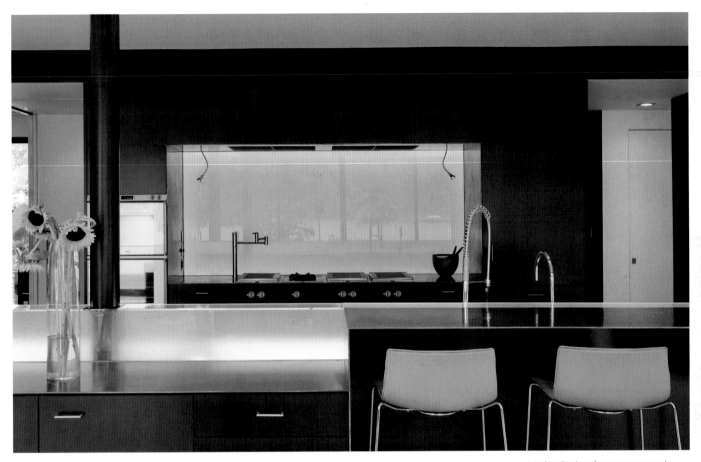

Modern kitchen faucets are a good balance of design and technology. With respect to functionality, the size of a faucet should work with the size of the sink it is intended to be mounted on.

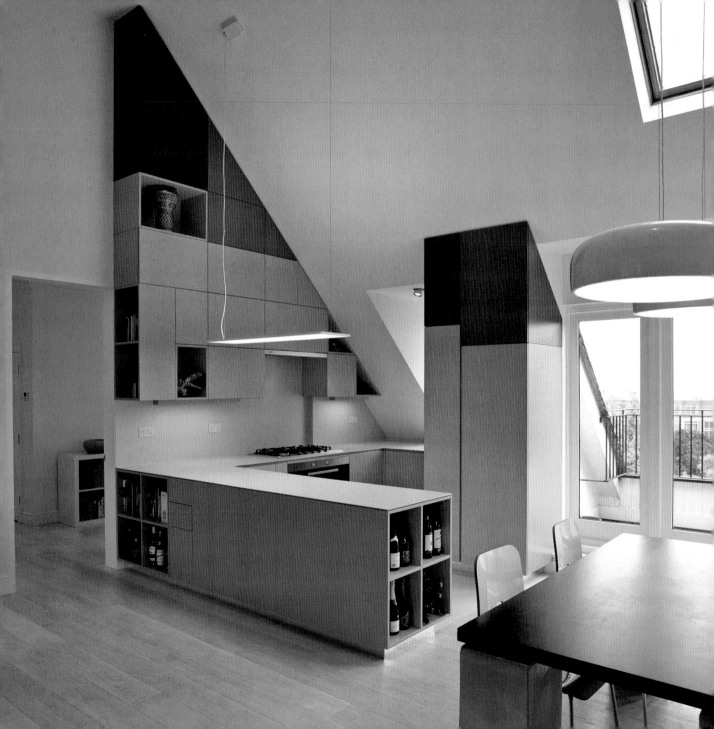

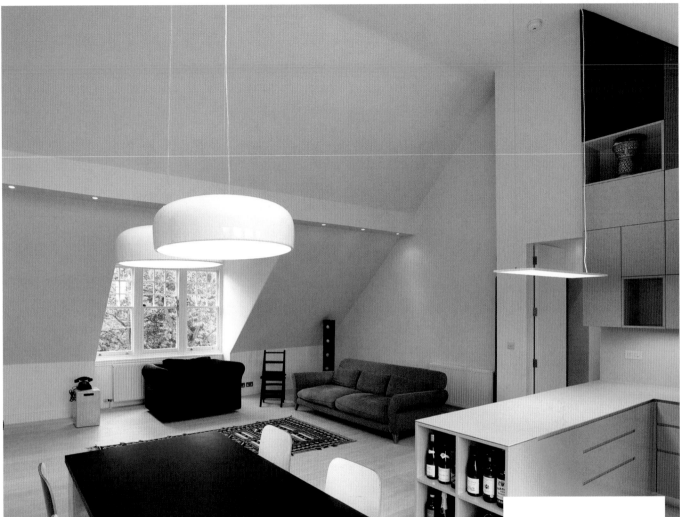

Orange Iceberg

Architect: **Draisci Studio**
Location: **London, England**
Photography: © **Tim Soar**

The brightly colored kitchen animates the living room of this renovated apartment in a prestigious period building in London. The shape and scale of the house's generous gable were no problem in this design, and the tall cabinets adapted to it perfectly. The living room is warm and cozy, even on gray London days. The role of the kitchen in this home is obvious.

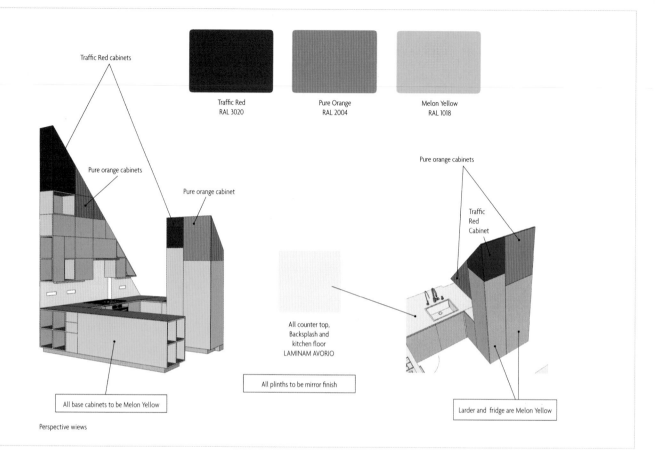

Traffic Red cabinets

Pure orange cabinets

Pure orange cabinet

Traffic Red
RAL 3020

Pure Orange
RAL 2004

Melon Yellow
RAL 1018

Pure orange cabinets

Traffic
Red
Cabinet

All counter top,
Backsplash and
kitchen floor
LAMINAM AVORIO

All plinths to be mirror finish

All base cabinets to be Melon Yellow

Larder and fridge are Melon Yellow

Perspective wiews

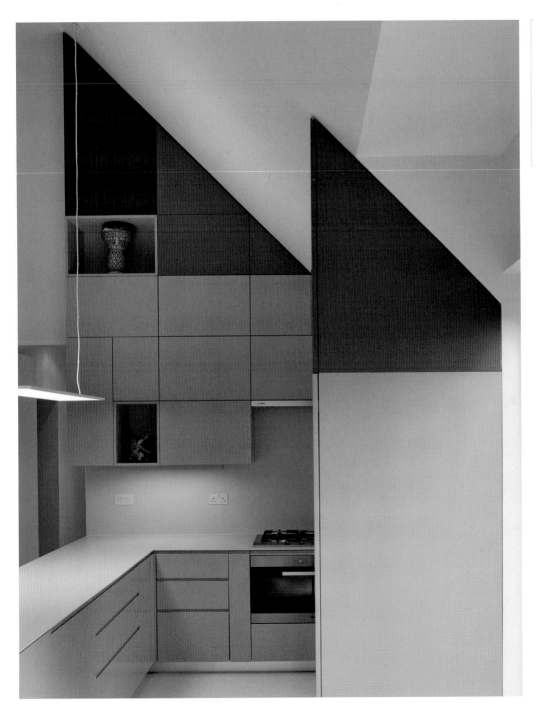

Custom kitchens can create unique and original aesthetic solutions while losing none of their functionality.

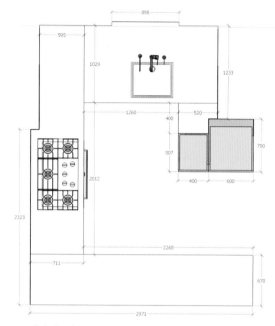

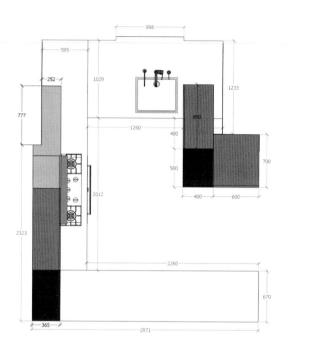

Kitchen floor plans

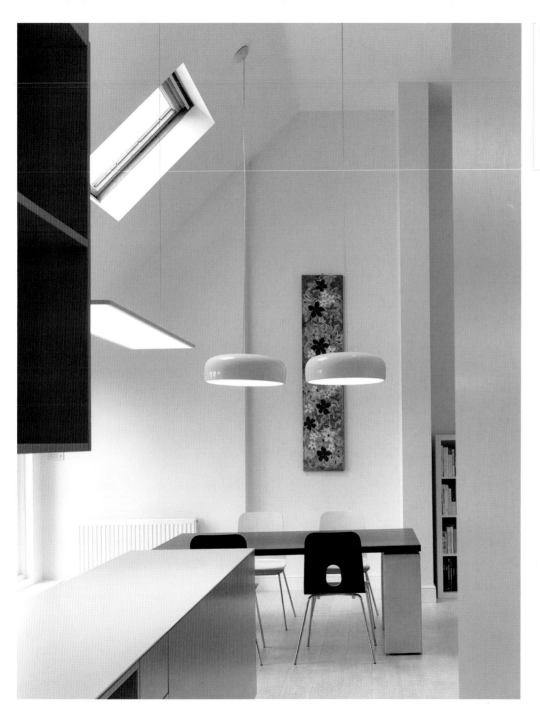

The fine porcelain of the kitchen floor and work surface combines with the white wooden flooring of the rest of the house.

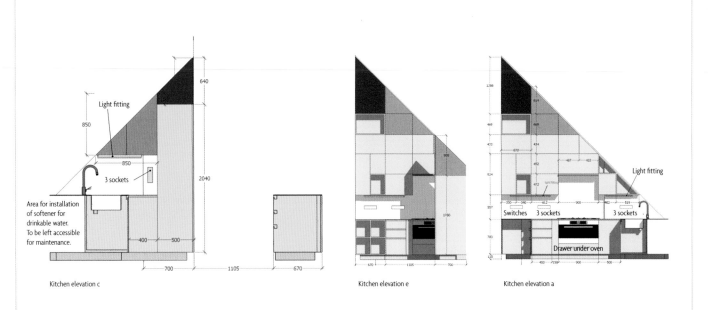

Kitchen elevation c

Light fitting

850

640

850

2040

3 sockets

Area for installation of softener for drinkable water. To be left accessible for maintenance.

400 500

700 1105 670

Kitchen elevation e

959

1780

670 1105 700

Kitchen elevation a

1786

619

469 469

433 434

670 467 412

924 452

472 Light fitting

Light fitting

557 130 340 612 900 402 519

Switches 3 sockets 3 sockets

783

120 450 150 900 500

Drawer under oven

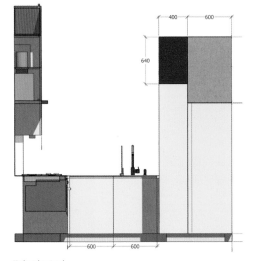

Kitchen elevation d

400 600

640

600 600

Kitchen elevation b

Light fitting

460 600 900 300

900

711

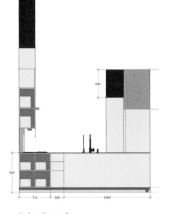

Kitchen elevation f

640

900

711 300 1960

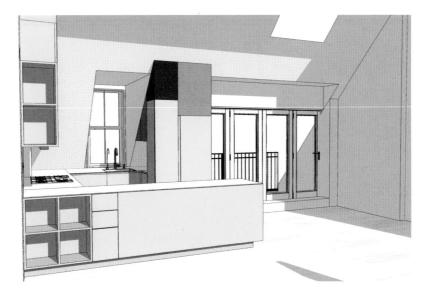

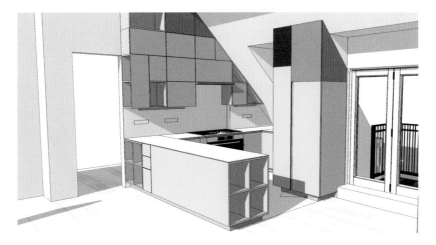

Perspective views

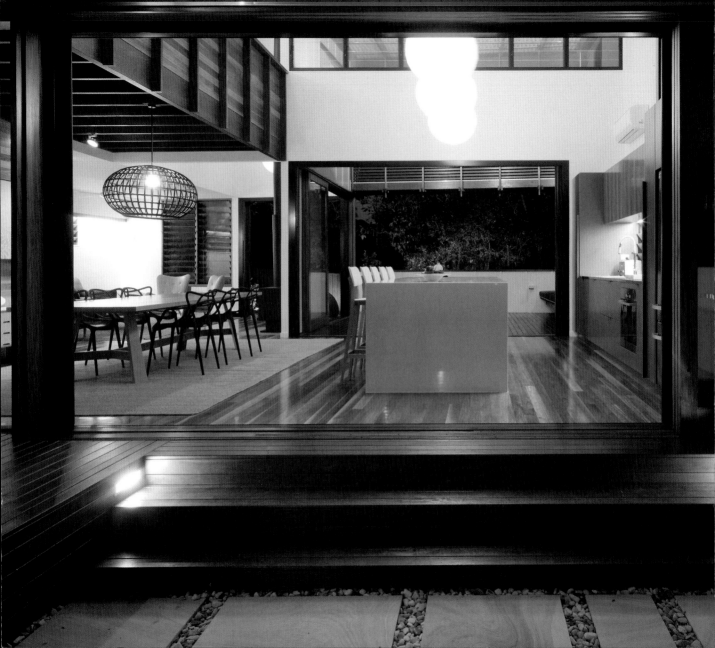

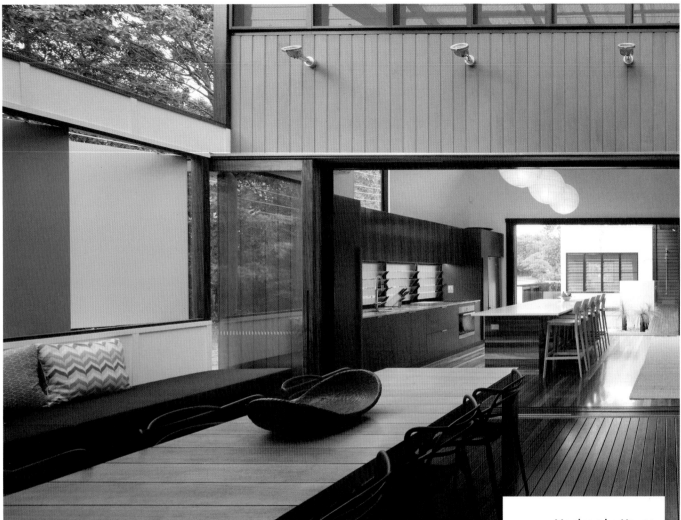

Mooloomba House

Architect: **Shaun Lockyer Architects**

Location: **Point Lookout, Australia**

Photography: © **Scott Burrows**

Designed by Shaun Lockyer Architects, this house is structured using a series of pavilions that are distributed around a courtyard that is open to the east, each pavilion having its own function and distinct character. Like the rest of the house, the large kitchen that occupies one of the pavilions pays homage to eclecticism, both through its use of materials and through its choice of colors.

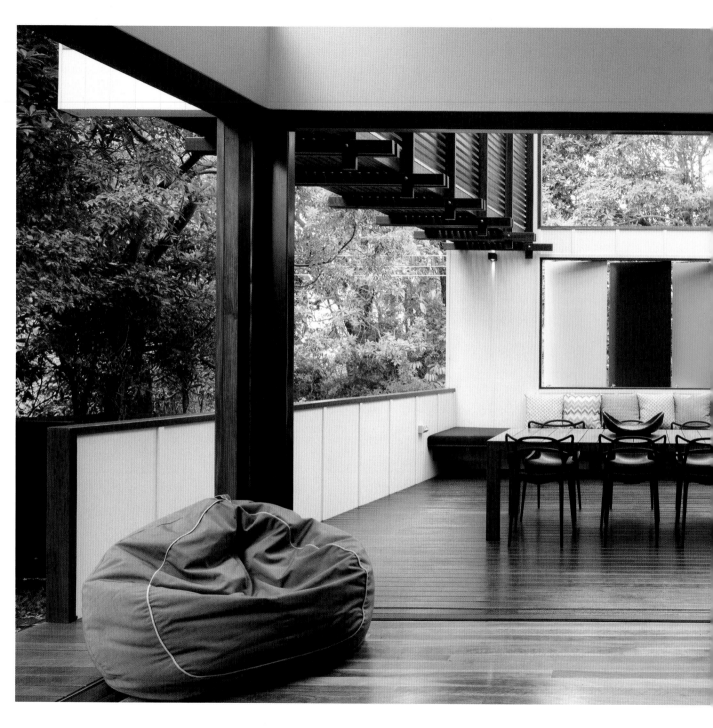

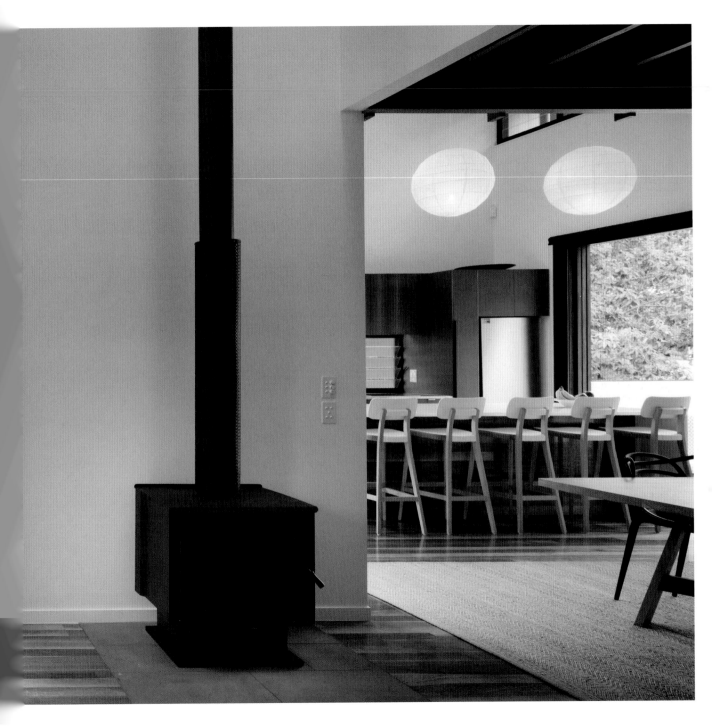

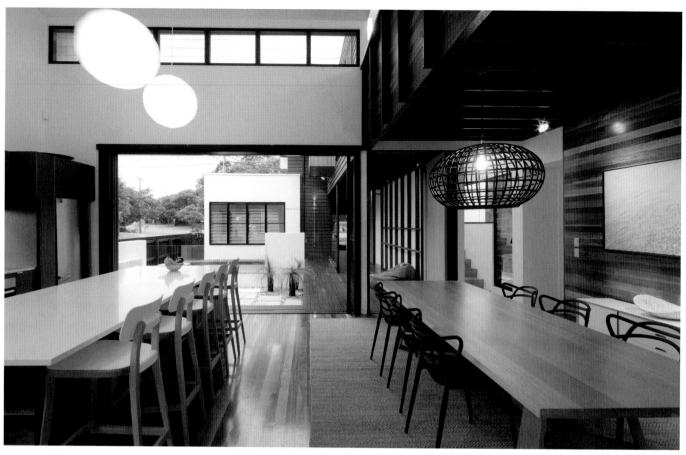

043

The use of hardwood, white cedar, cement and playful color references their environment in a very modern way.

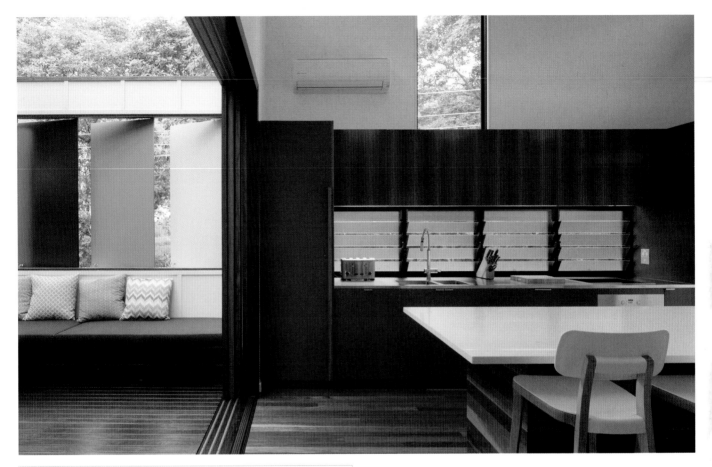

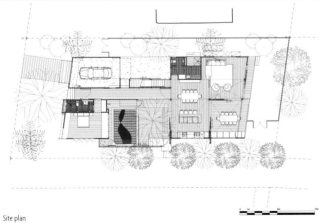

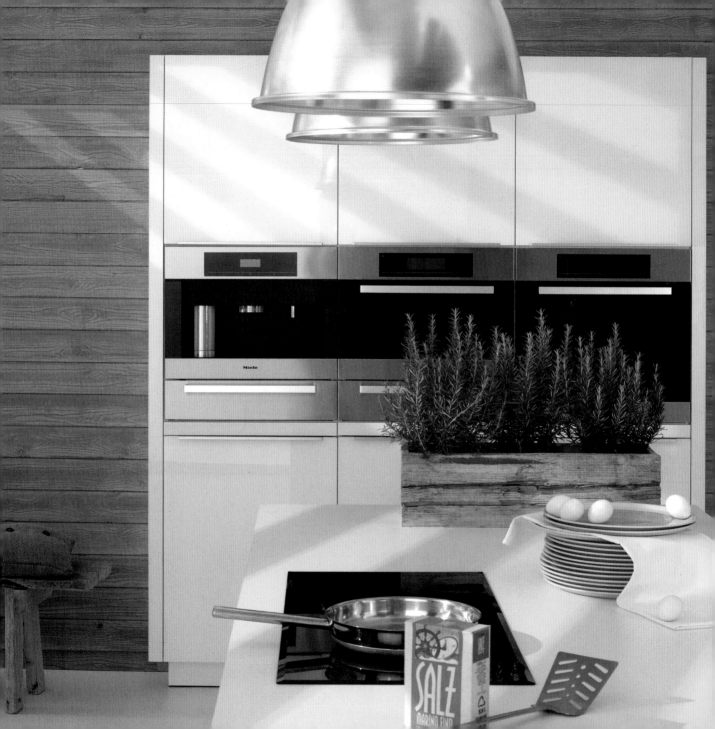

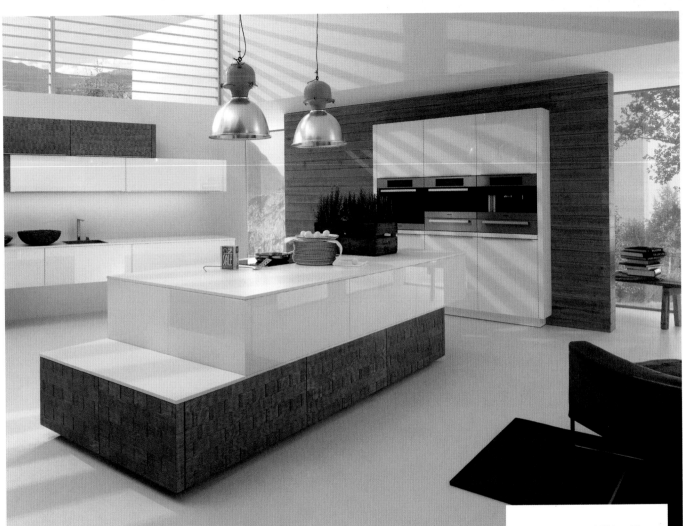

This kitchen combines to perfection the brilliant white and the distinguished effect of the stone, which becomes the focal point of the entire room. The interaction between the strongly grained wood and the smooth surfaces of the glass stands out clearly thanks to the lights that are embedded in each of the segmented shelves.

White Glass

Model: Vitucina Alnosplit/
Alnovetrina

Manufacturer: **Alno**

Photography: © Alno AG

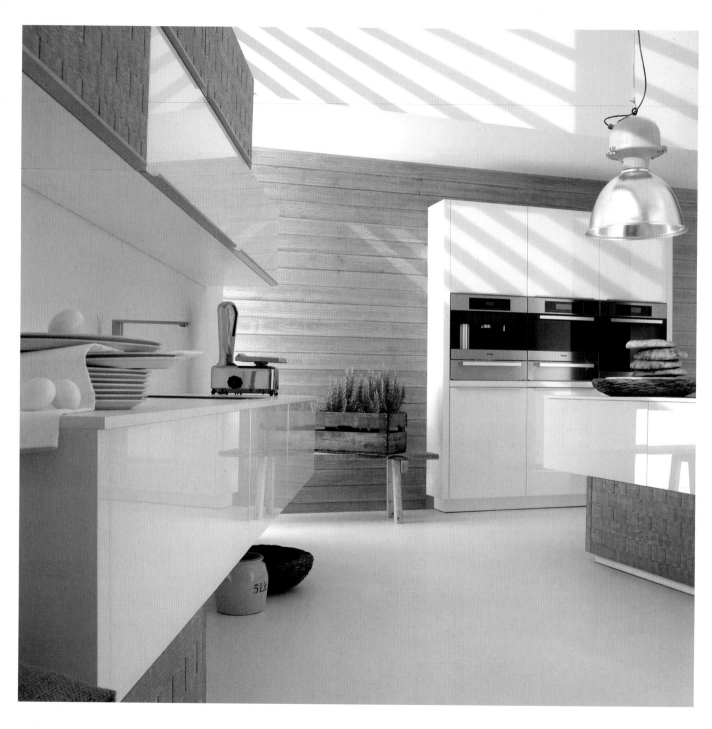

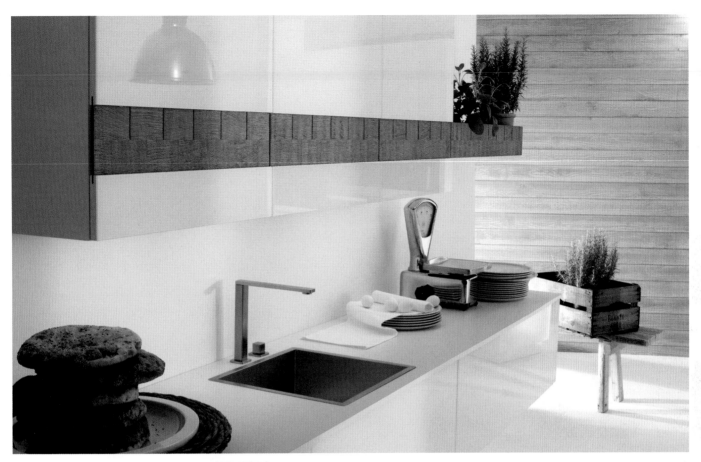

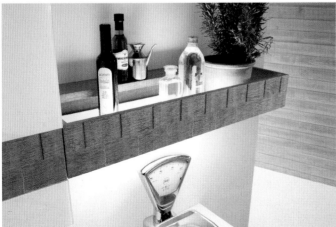

044

The lighting strip along the base of the upper cabinets creates interesting illumination effects and contrasts as shown in the image to the left.

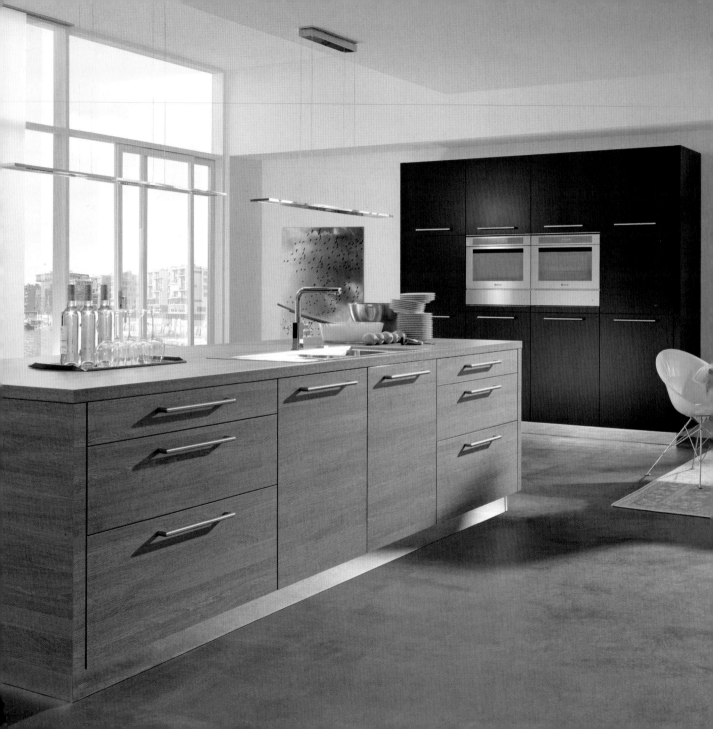

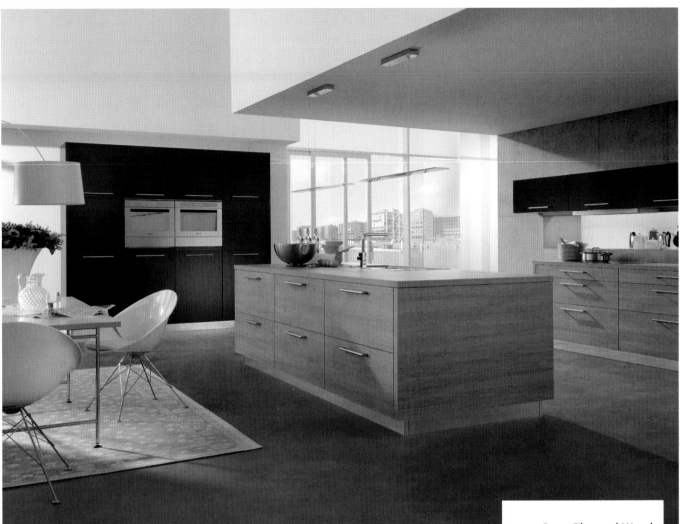

Deep Blue and Wood

The floating effect of the bottom cabinets and column gives this kitchen a real feeling of lightness. The interaction between the contrasting colored surfaces also adds to the sense of weightlessness—the brilliant white of the walls and ceiling contrasts with the grayish blue wall unit and floor in a modern chromatic combination which is augmented by the belt of light that Alno has embedded near the base.

Model: **Alnofine**
Manufacturer: **Alno**
Photography: © **Alno AG**

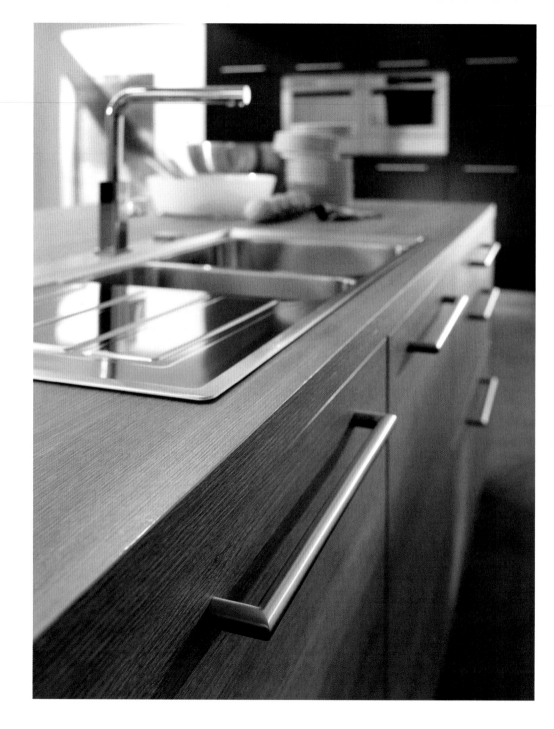

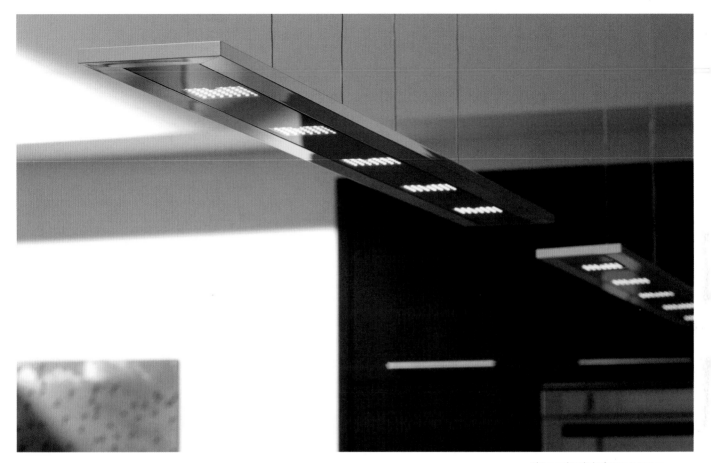

This pendant light fixture is just as striking as it is practical and efficient. Its steel cable pendant mounting emphasizes the sense of lightness.

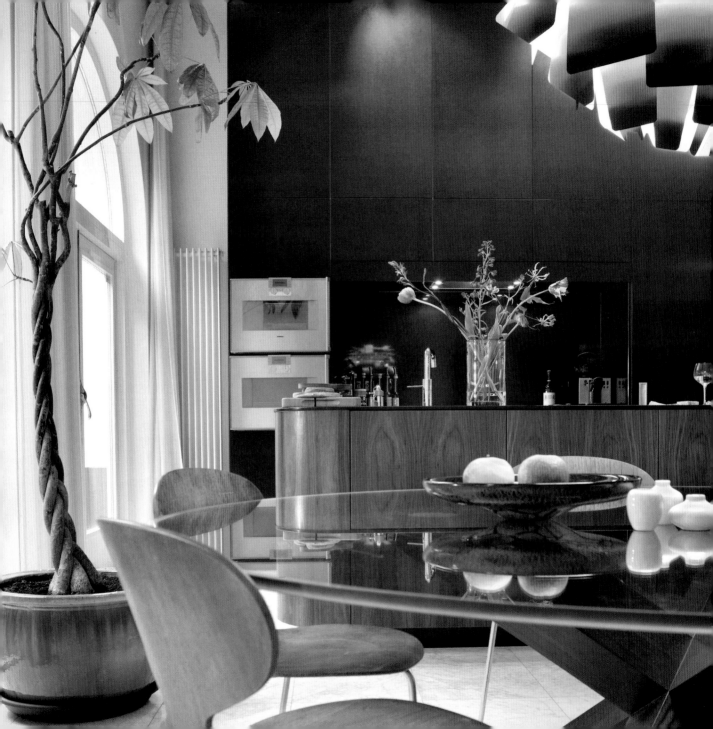

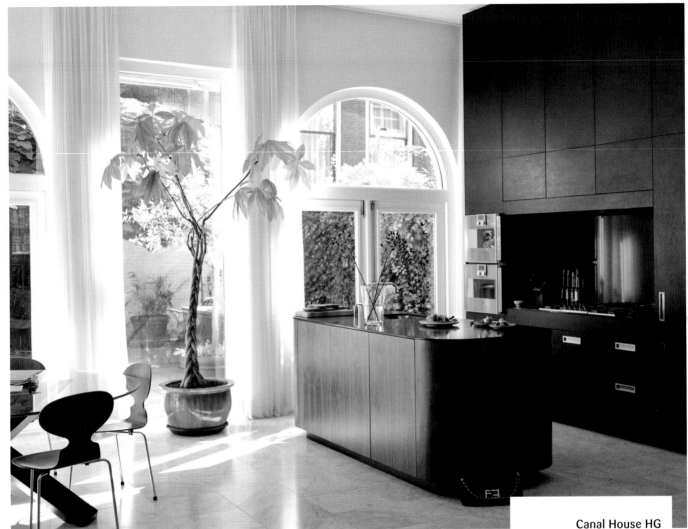

In order to maximize the spatial experience of this elegant apartment, the Powerhouse Company's redesign takes advantage of the high ceilings, opening the floor to the light provided by the large windows. The space within the other rooms is reduced in favor of the kitchen-living room, which has been completely remodeled to bring a sense of warmth, elegance and serenity to this private home.

Canal House HG

Architect: Powerhouse Company

Location: Amsterdam, The Netherlands

Photography: © Powerhouse Company

045

A table is an essential element in a kitchen design and should be chosen in line with the room's elected style.

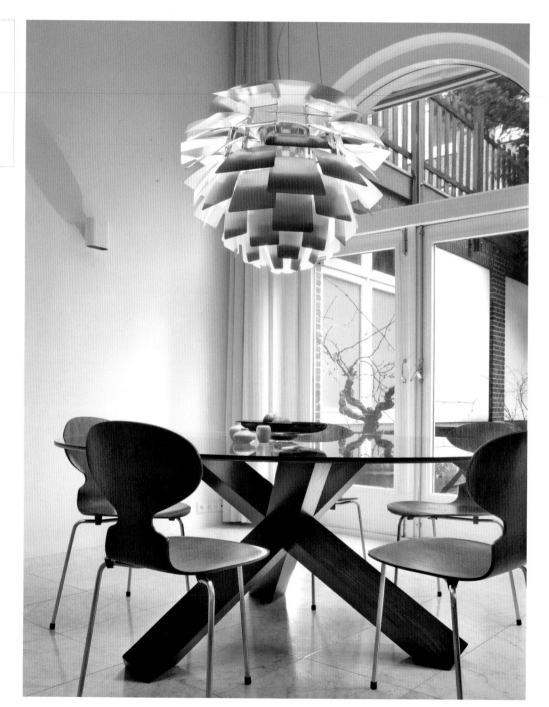

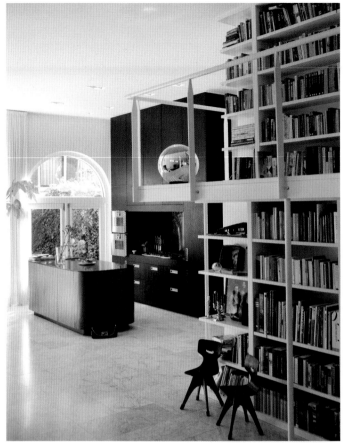

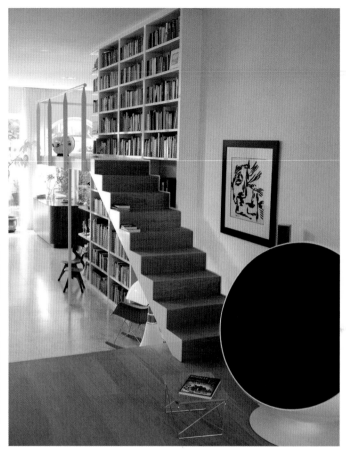

As well as having a functional role, the central island is integrated seamlessly within the entire room.

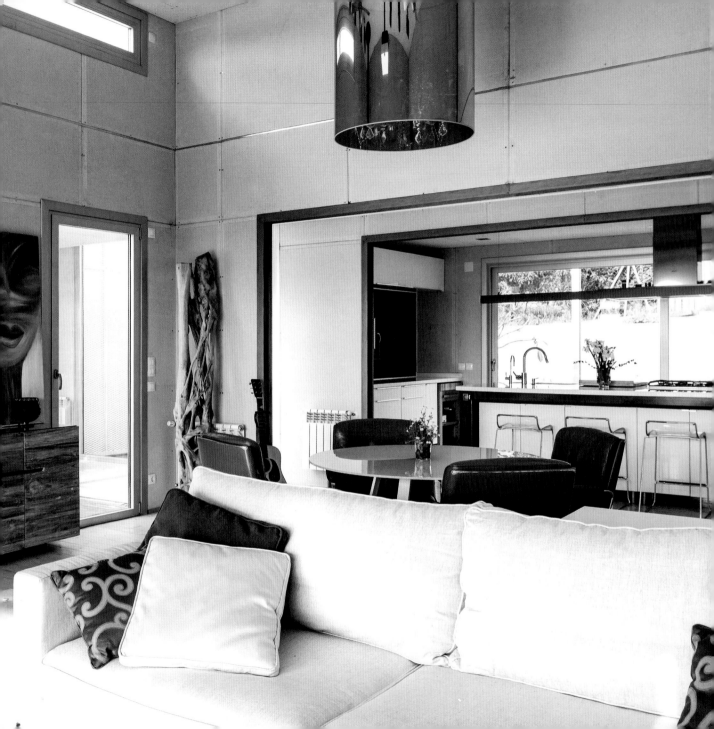

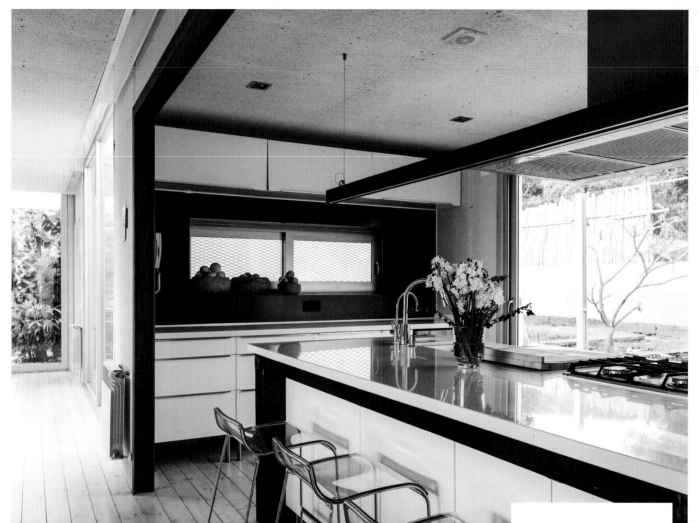

Tarifa House

Architect: James & Mau
Location: Tarifa, Spain
Photography: © Erika Mayer

The design of this kitchen is adapted perfectly to the concept that James & Mau are exploring here. "The modular estate" is a contemporary farmhouse in the style of an Andalusian white village, condensed into 3230 square feet of environmentally friendly, prefabricated building. In line with this premise, the kitchen makes the most of the space it occupies, supporting the continuous dialogue that is established between the interior and exterior areas of the house.

047

Do not be afraid of space.
Modern kitchens are
completely adaptable,
even in modular homes.

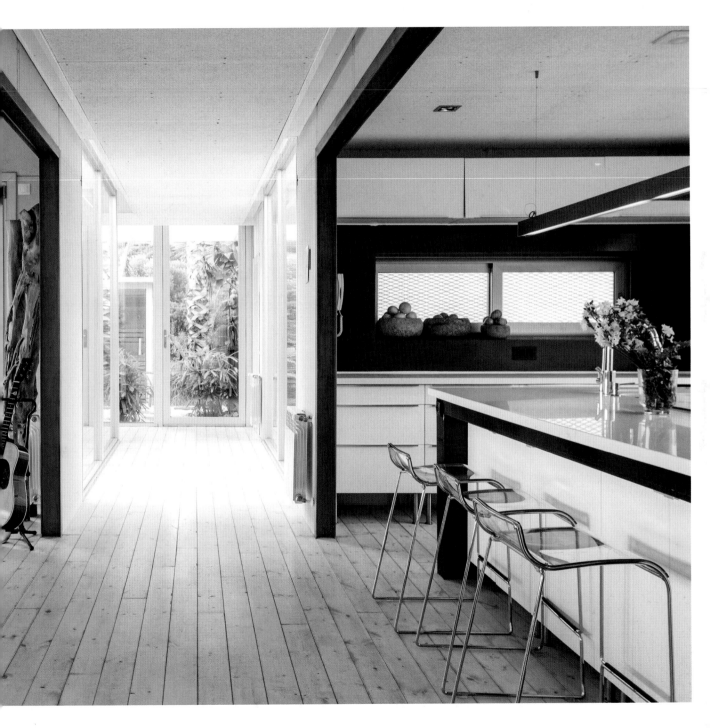

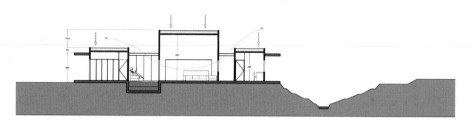

Section

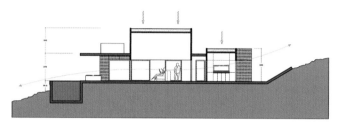

Section

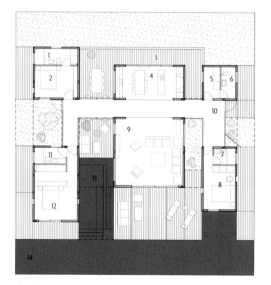

Floor plan

1. Bathroom
2. Bedroom
3. Terrace
4. Kitchen/Dining room
5. Closet
6. Toilet
7. Bathroom
8. Bedroom
9. Living room
10. Foyer
11. Bathroom
12. Bedroom
13. Reflective pool
14. Pool

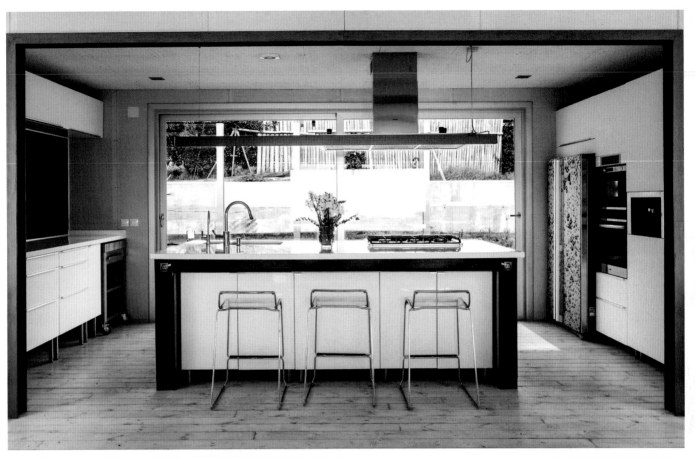

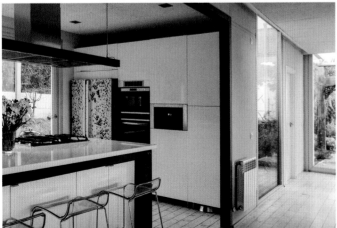

048

The contrast between the dominant white and the black frames and moldings helps to mark out the openings and cupboards.

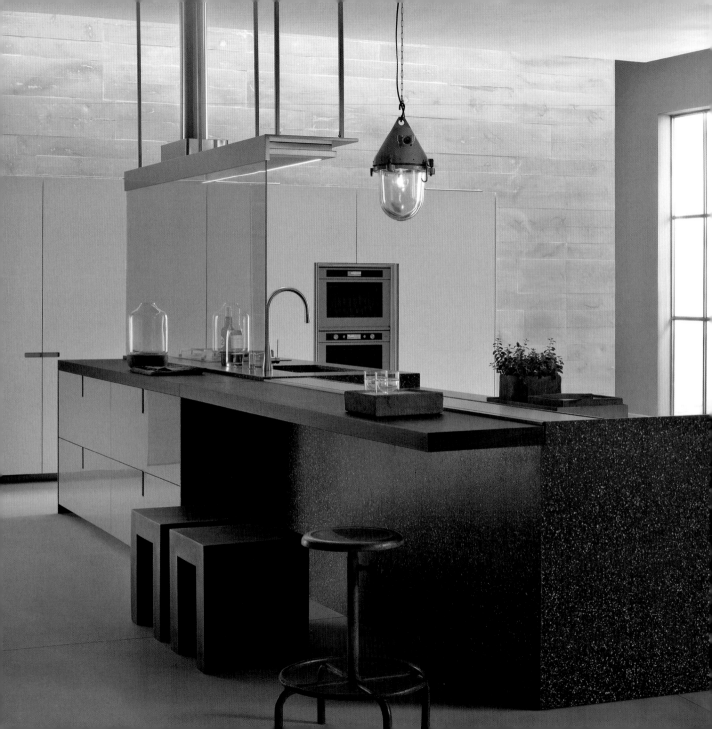

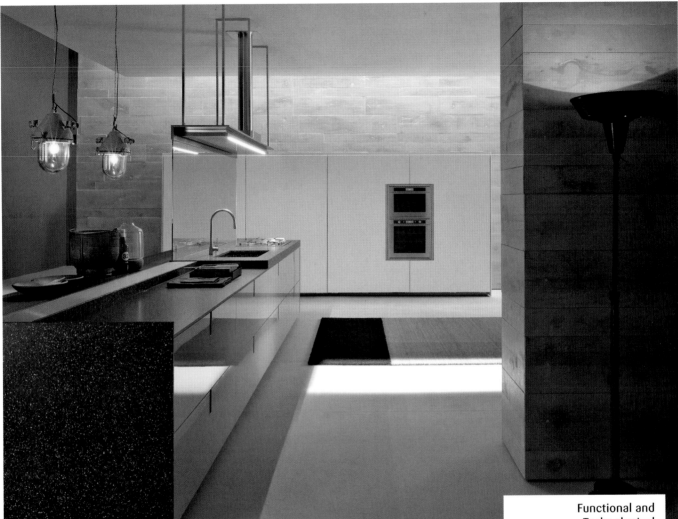

Model: Icon
Manufacturer: Ernestomeda
Photography: © Ernestomeda

The objectives of this Icon design were functionality, a clean aesthetic and technical performance. This is a kitchen concept that, far from lacking in personality, is a charming minimalist space with the simplicity and expressive emotional strength it needs in order to meet the diverse expectations of its users.

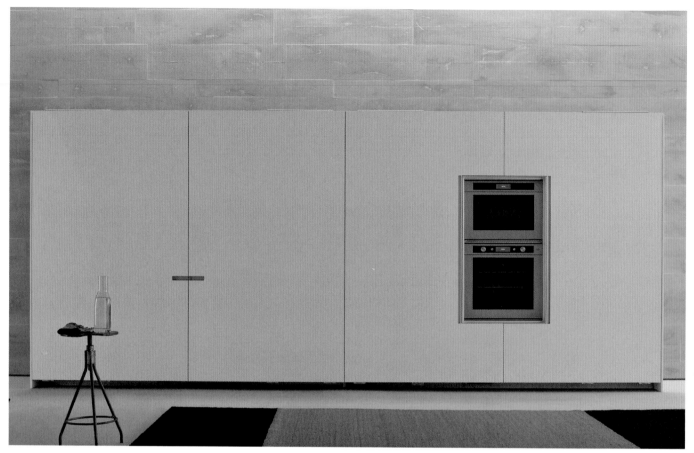

049

Cabinets with retractable doors, once open, do not clutter the kitchen nor detract from the space.

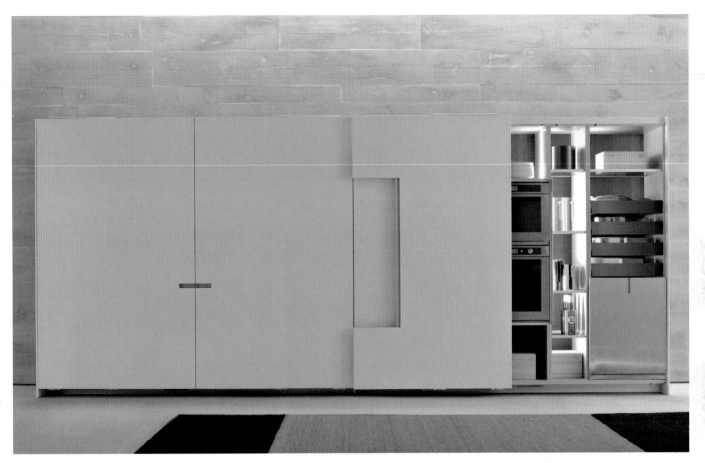

050

The cabinets can house
a multitude of items inside:
tables and pull-out drawers,
aluminum, steel, wood or glass
shelves, a wine rack, etc.

051

Clever use of minimal space can prove helpful for the optimization of storage space. The image above shows a shelving unit rising from the countertop by a push to a release mechanism.

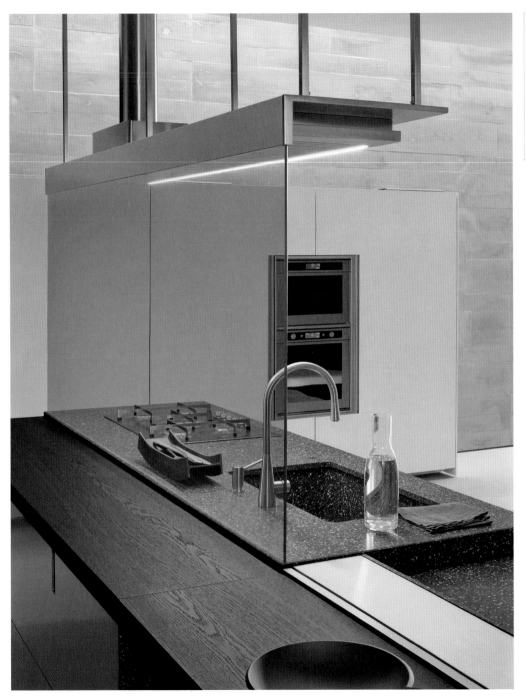

The glass of the ventilation hood isolates the cooking area of the central island without losing visibility.

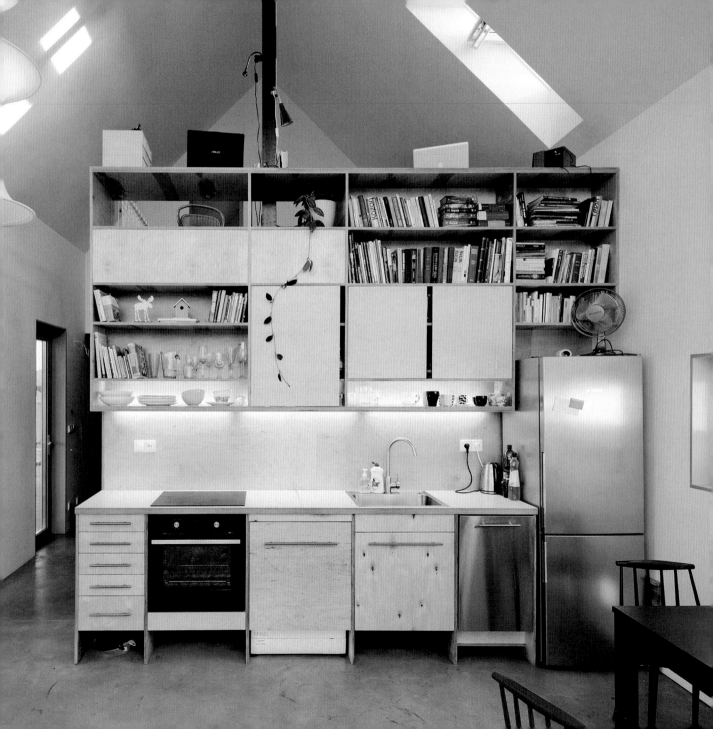

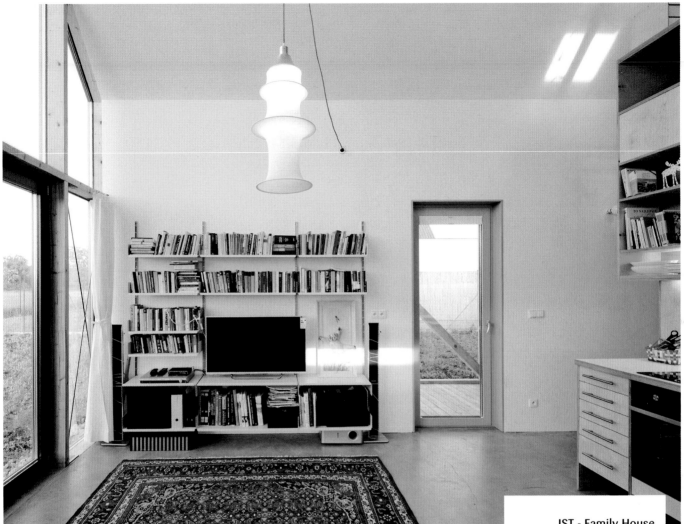

The design of this Slovakian home is a nod to the past, an accomplished fusion between ancient architecture and contemporary design. The ground floor of this small home is organized into a central "service box" made of plywood, containing bathroom, toilet, stairs and storage area. A full kitchen is integrated seamlessly within.

IST - Family House

Architect: Peter Jurkovič, Lukáš Kordík, Števo Polakovič. JRKVC

Location: Čunovo, Slovakia

Photography: © Peter Jurkovič

Sketches

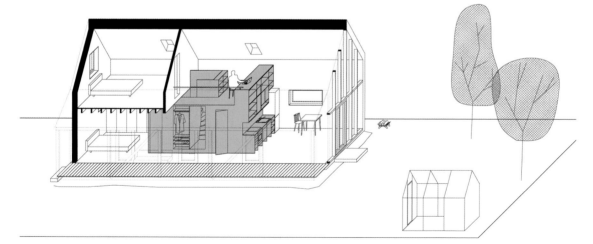

Axonometric view

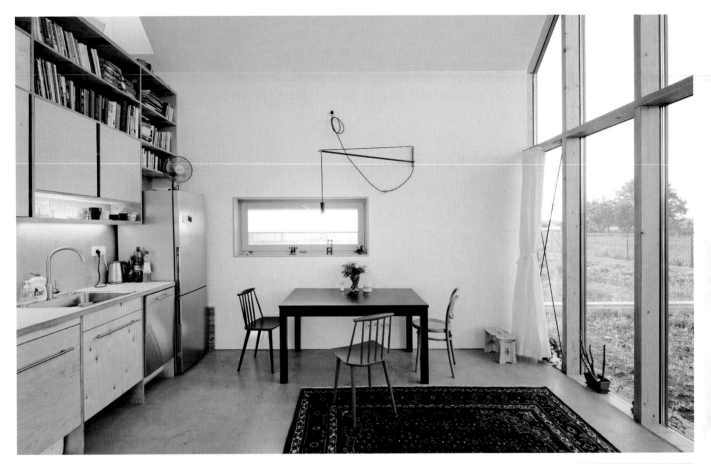

A well-organized, compact kitchen can accommodate everything you need, including book cases that link it to the living room.

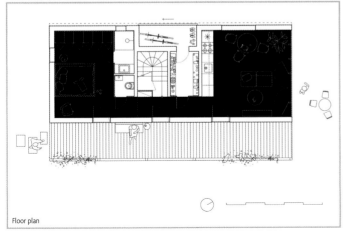

Floor plan

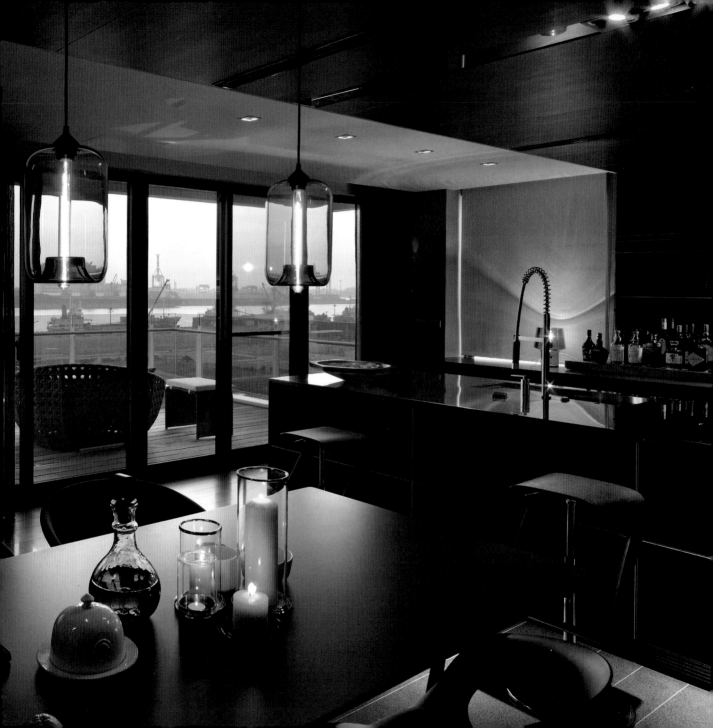

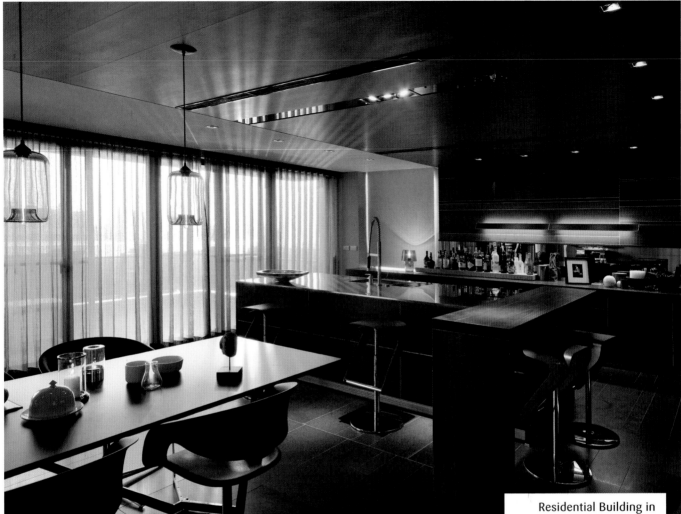

The top floor of this building in the port of Kaohsiung in Taiwan is dedicated to cooking, eating and living. The LEICHT kitchen forms the focal point of this space, contributing to the perfection of the welcoming environment that is the ideal place for relaxation. Together with the living room, the kitchen opens out to the terrace, establishing a close link between the interior and exterior.

Residential Building in Kaohsiung City

Architect: Keng-fu Lo. LEICHT
Location: Kaohsiung City, Taiwan
Photography: © LEICHT
Küchen AG

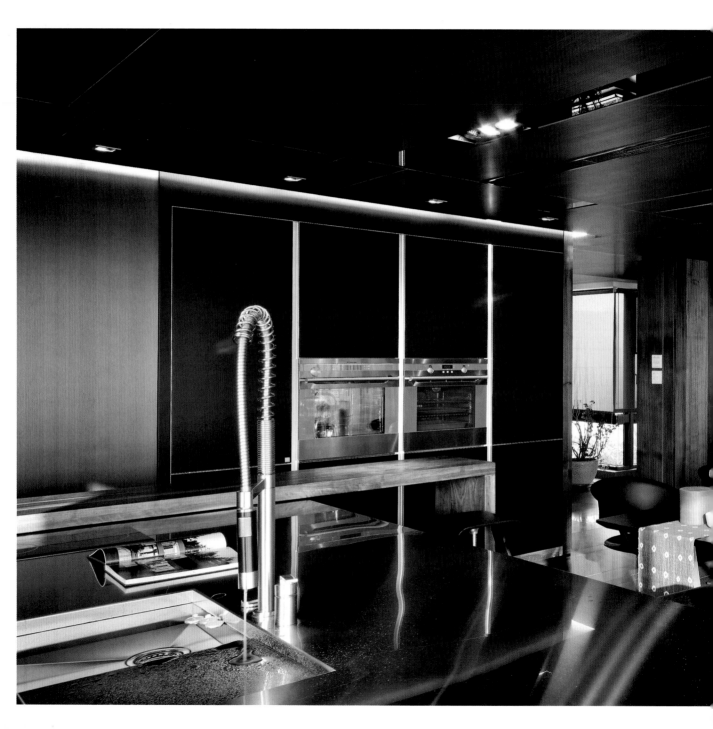

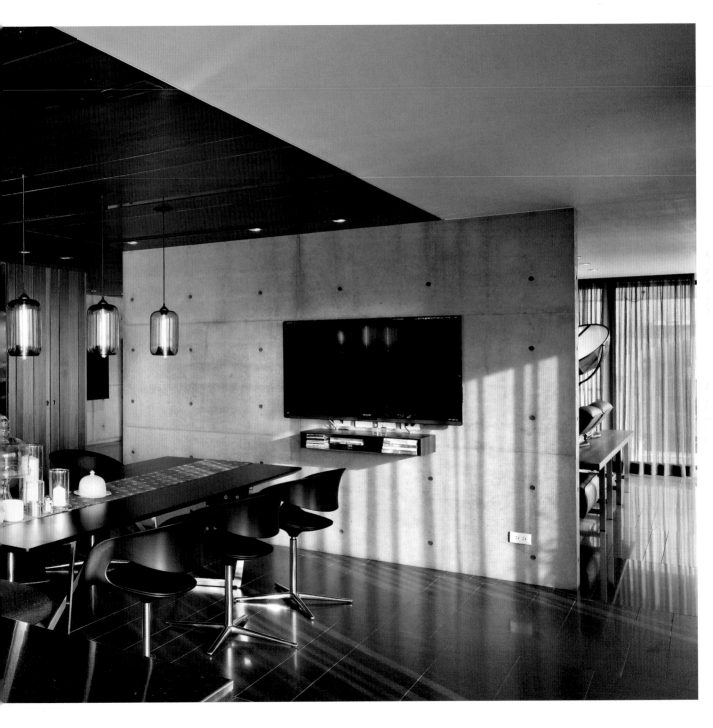

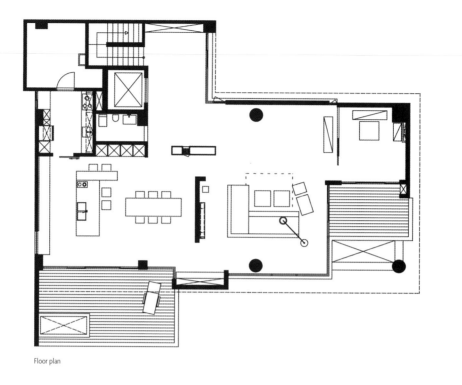

Floor plan

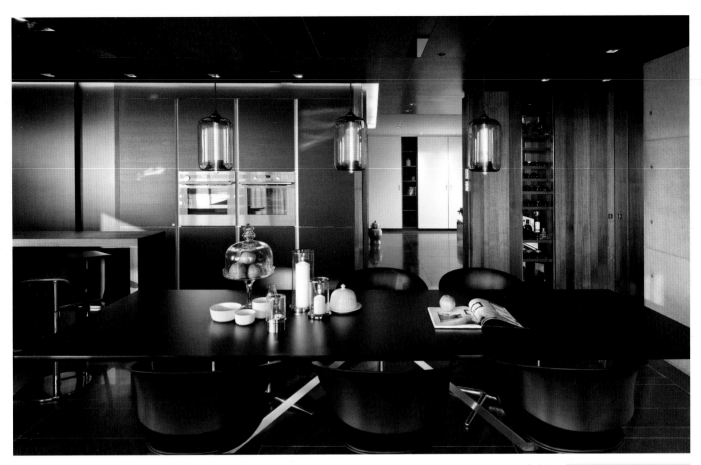

Wood adds a natural touch
to an interior space dominated
by glossy finishes. It also
contributes in the creation
of a relaxing atmosphere.

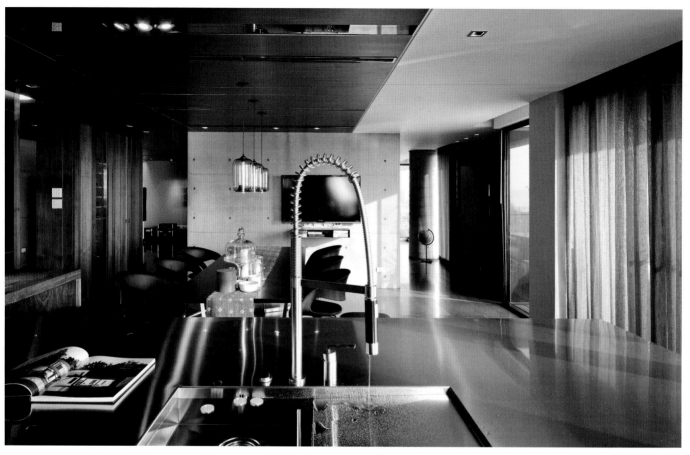

055

Faucets with an extendable hose are attractive and practical, enabling water to be directed in different directions with ease.

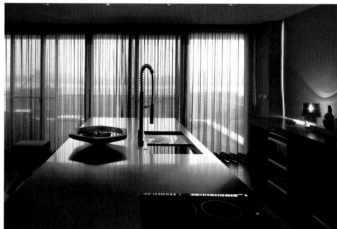

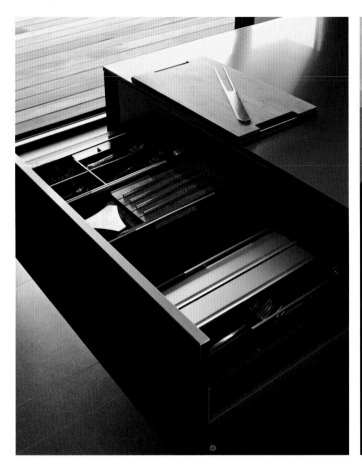

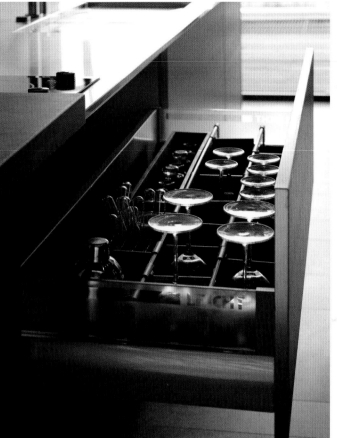

Drawer inserts are convenient devices that keep kitchen utensils organized and easily accessible. These functional items are a step toward making the kitchen more pleasant and comfortable.

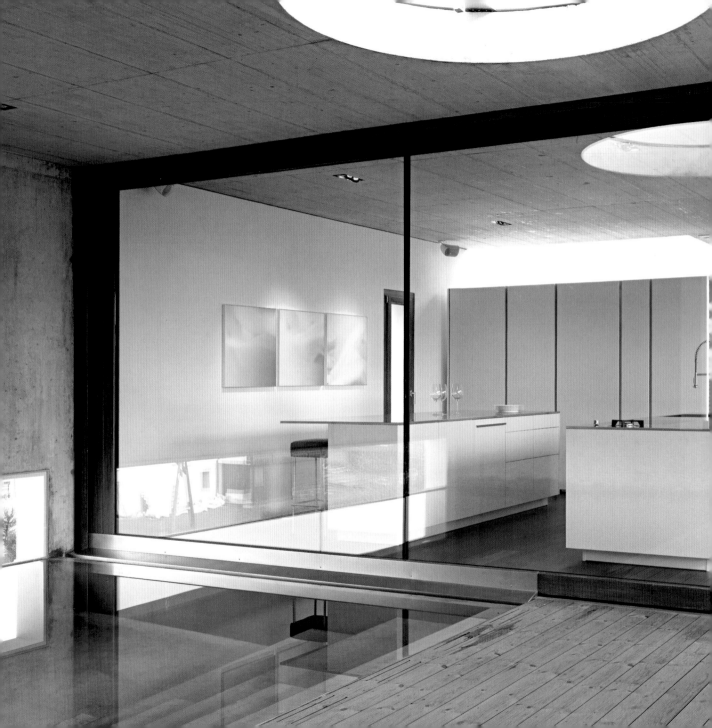

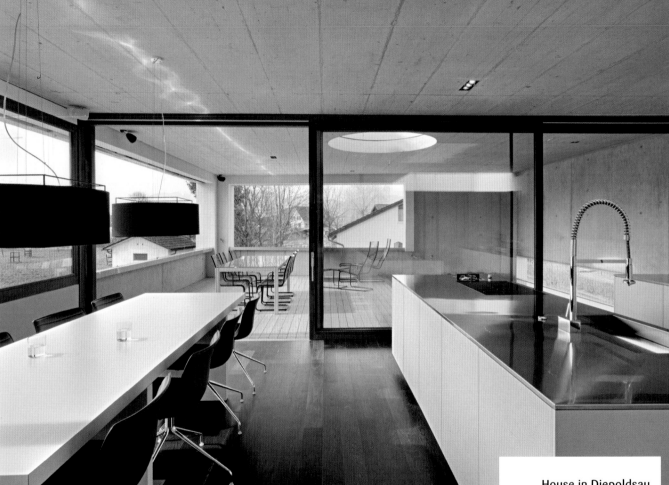

House in Diepoldsau

Architect: **Martin Gepp**
Location: **Diepoldsau, Switzerland**
Photography: © **LEICHT Küchen AG.**

Architect Martin Gepp built his own home against the spectacular backdrop of the Swiss mountains. The clear and simple organization of the house is reflected in the design of the kitchen, which overlooks the pool outside and has identically sized islands installed parallel to the dining table. The dining area continues on the terrace with another table that is shaped, styled and placed identically to that of the interior.

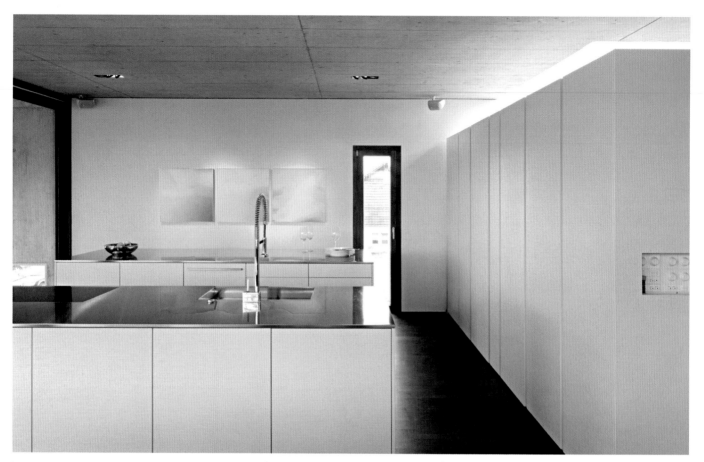

056

The uninterrupted horizontal texture of kitchen surfaces creates a relaxed feel.

Kitchen floor plan

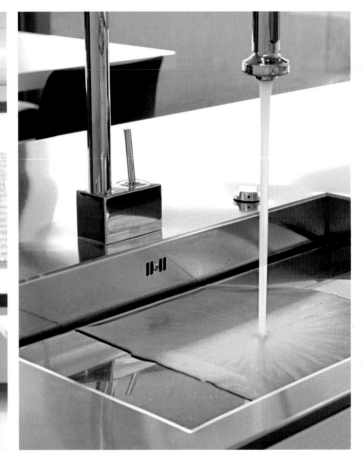

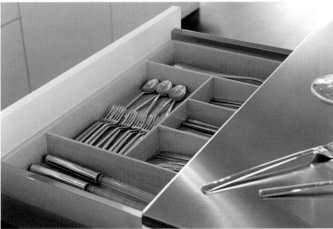

057

The cooktop and sink are integrated into the 17 milimeters (11/16 of an inch) steel worktop, providing easy visual contact with guests.

North elevation

West elevation

East elevation

South elevation

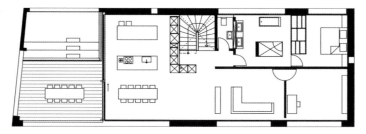

Floor plan

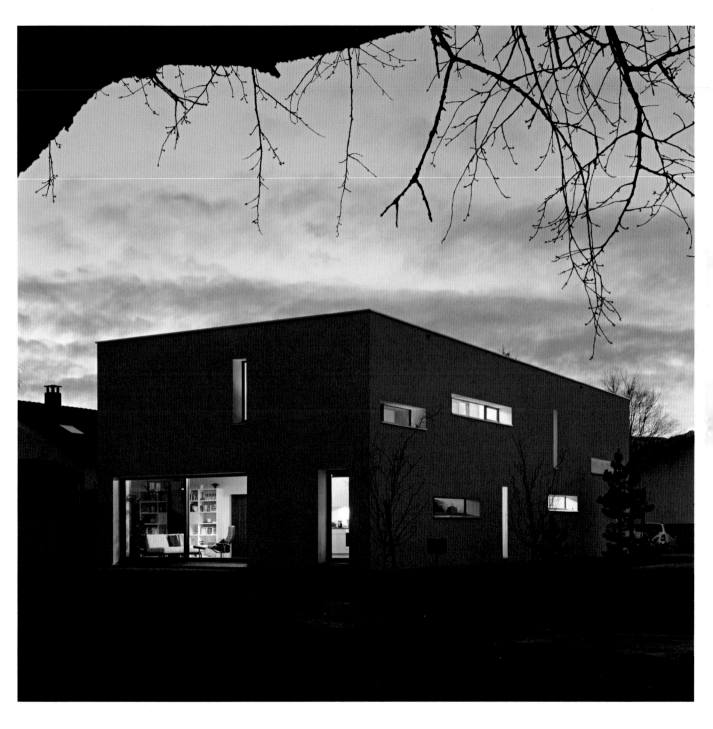

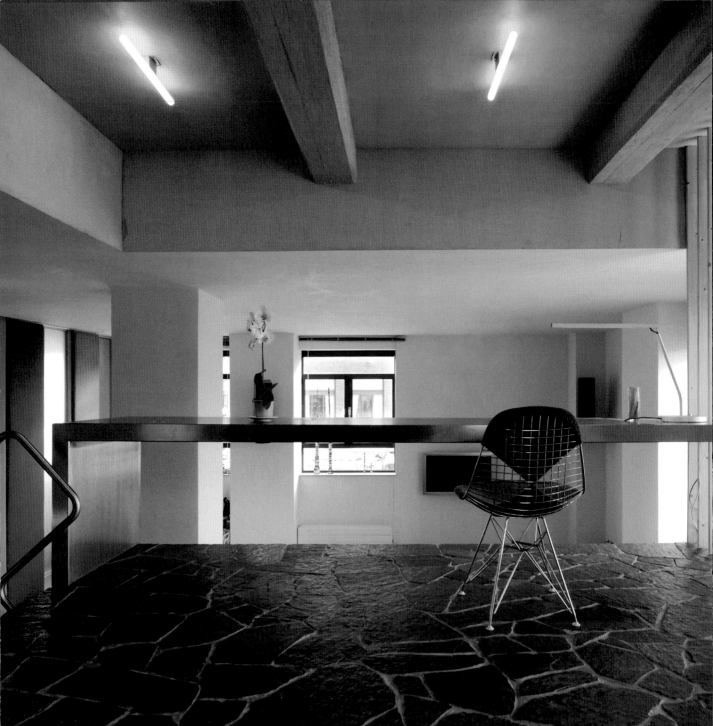

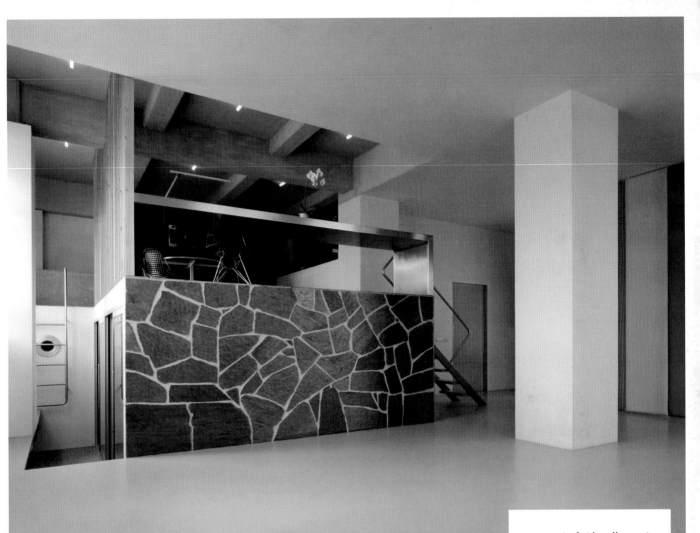

Loft Lloydkwartier

Architect: 123DV Modern Villas

Location: Rotterdam,
The Netherlands

Photography: © Christiaan
de Bruijne

Built in an old warehouse in the port of Rotterdam, the key feature of this loft apartment is space. This has been achieved by creating two different areas, each with its own look and layout. So while the other rooms are sunk into the ground and clad in natural stone, the kitchen occupies a higher level, a podium that dominates the space and the views to the harbor.

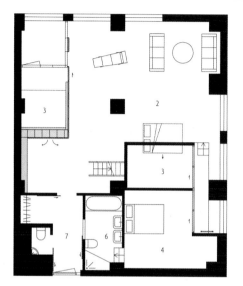

Lower level

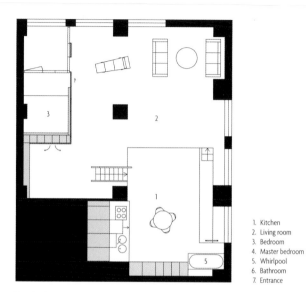

Upper level

1. Kitchen
2. Living room
3. Bedroom
4. Master bedroom
5. Whirlpool
6. Bathroom
7. Entrance

058

Open-plan kitchens offer a sense of space. With no walls separating them from adjacent spaces, open kitchens also promote social interaction.

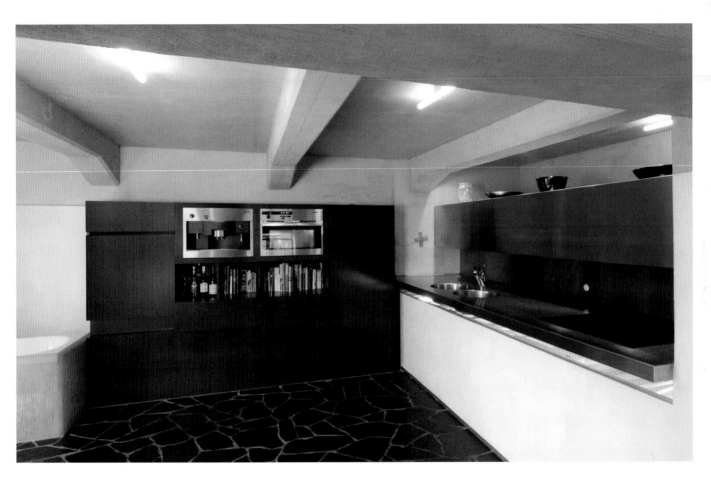

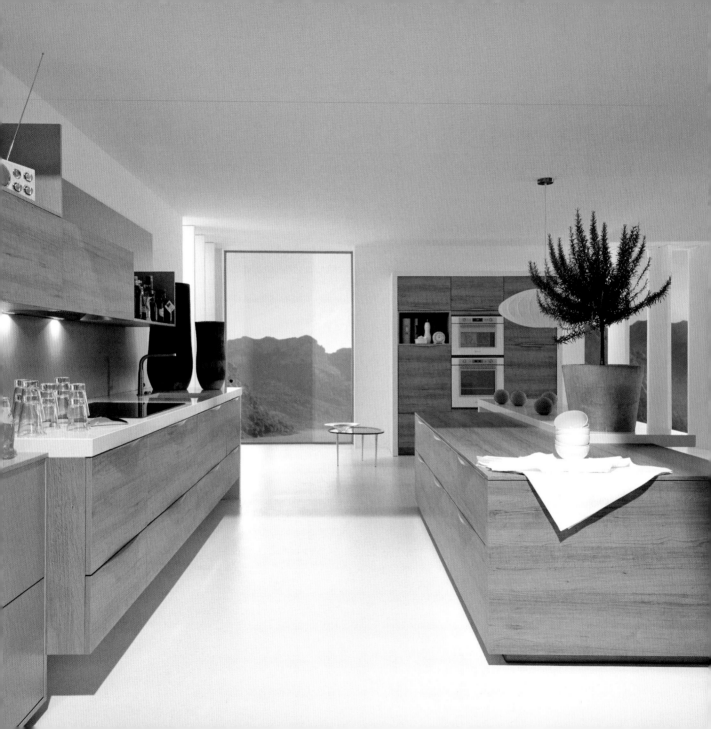

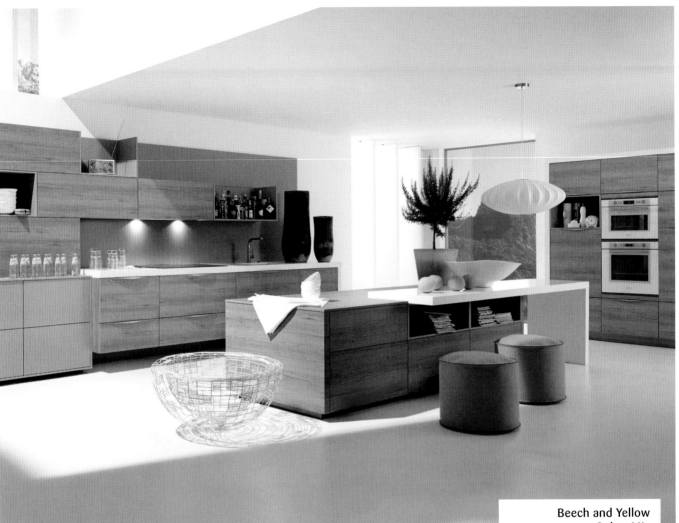

Model: Alnoplan/Sund
Manufacturer: Alno
Photography: © Alno AG

With its colorful geometry, this kitchen succeeds in capturing the spirit of
the latest trends. The island doubles as a work surface and as a dining table.
The combination of the beech wood décor and the yellow ochre structured
lacquer accents creates a welcoming atmosphere. This room is designed for
more than cooking—it is for living in.

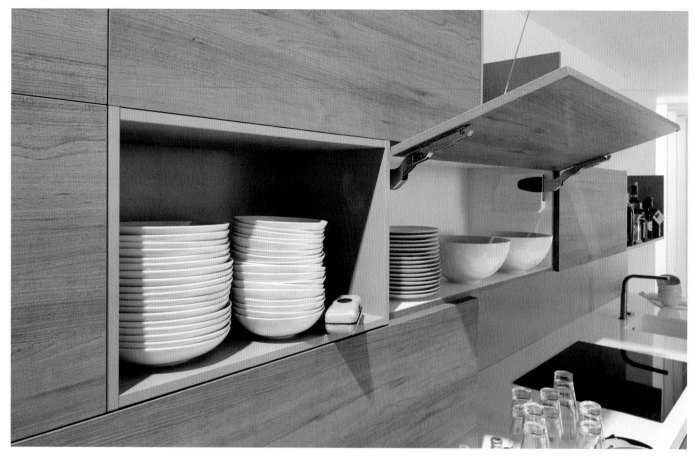

059

A touch of color can transform a nondescript kitchen into a lively room boosting the ambiance.

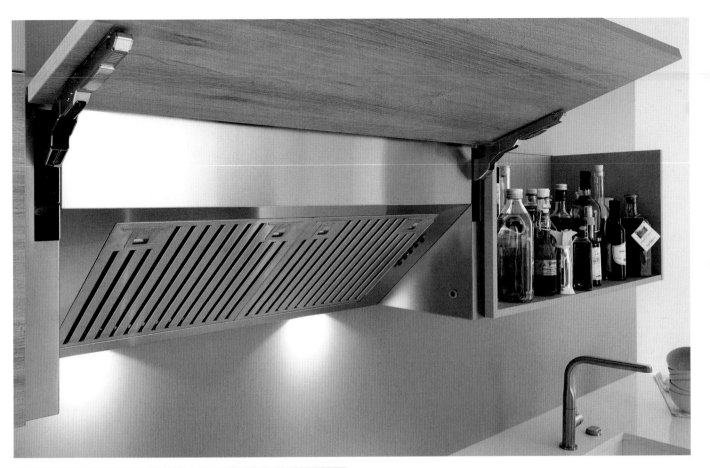

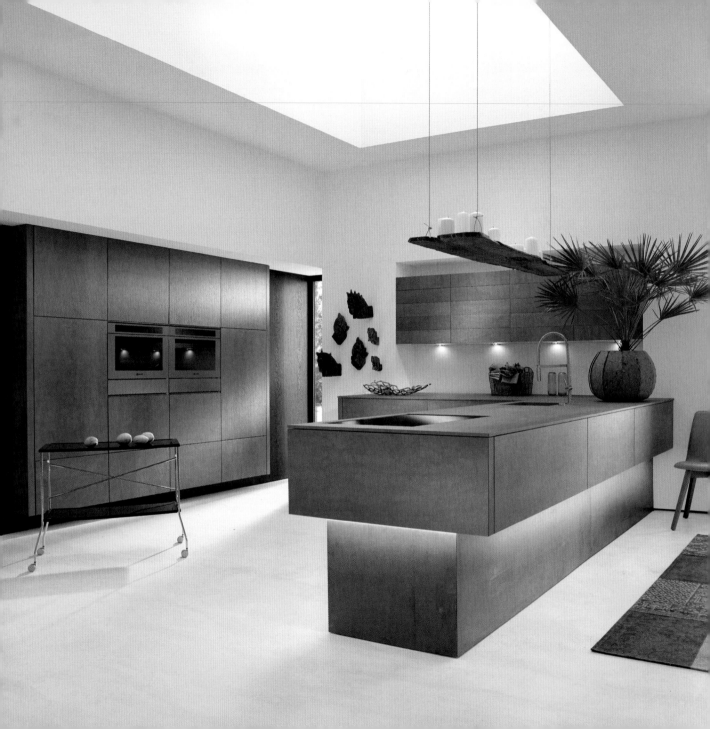

Gray Ceramic

Ceramic is the latest material to have been put to use in kitchen design and is perfect for creating a welcoming living environment. The unique characteristics of the ceramic are highly convincing: it is both attractive and resistant, so much so that it has even been used in space exploration. With this material Alno has created a whole new generation of kitchens for present and future.

Model: **Alnofine**
Manufacturer: **Alno**
Photography: © Alno AG

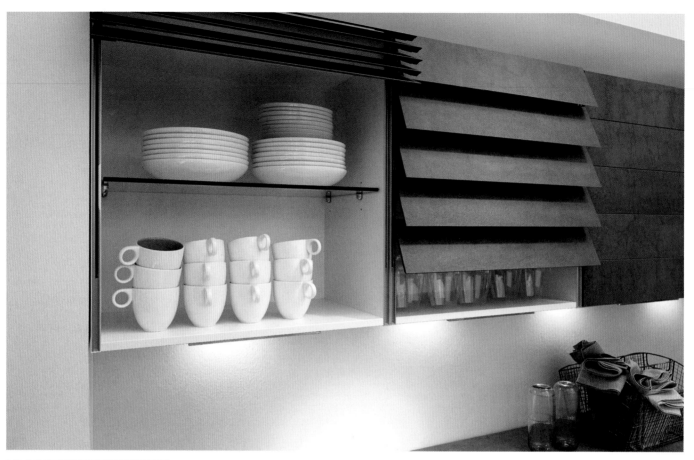

060

The versatility of ceramic
allows for novel and original
solutions such as shutter doors.

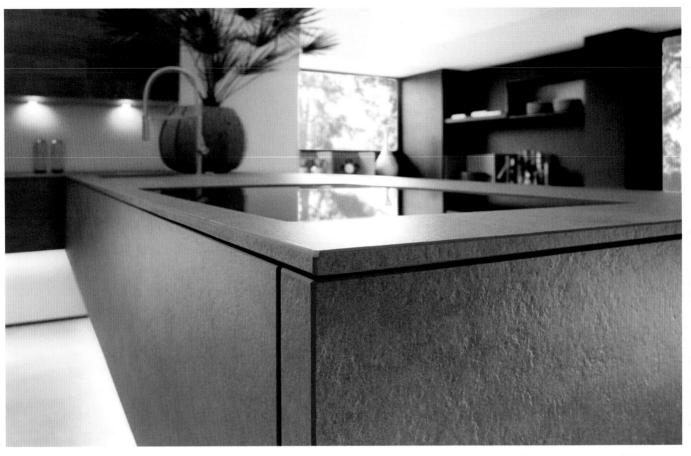

The latest technologies in kitchen design bring efficient and practical equipment fabricated with durable and high-quality materials.

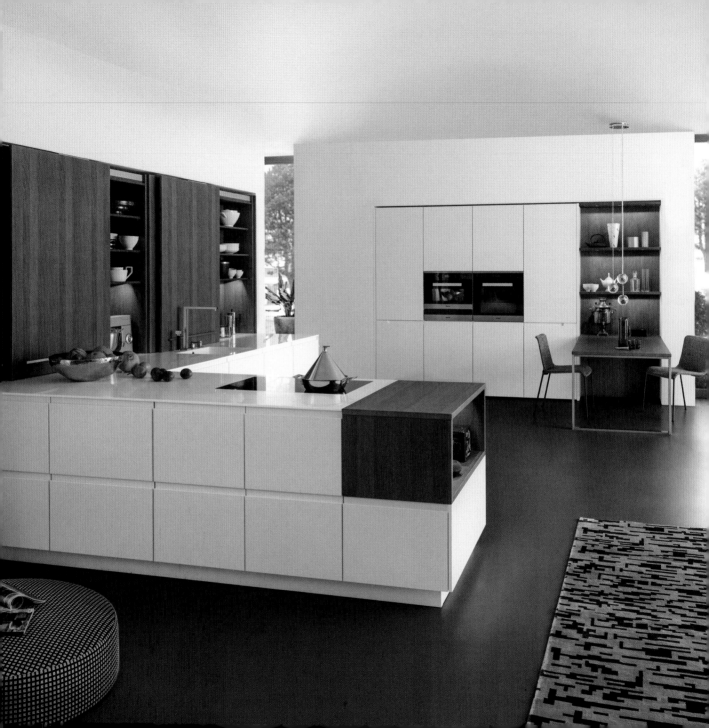

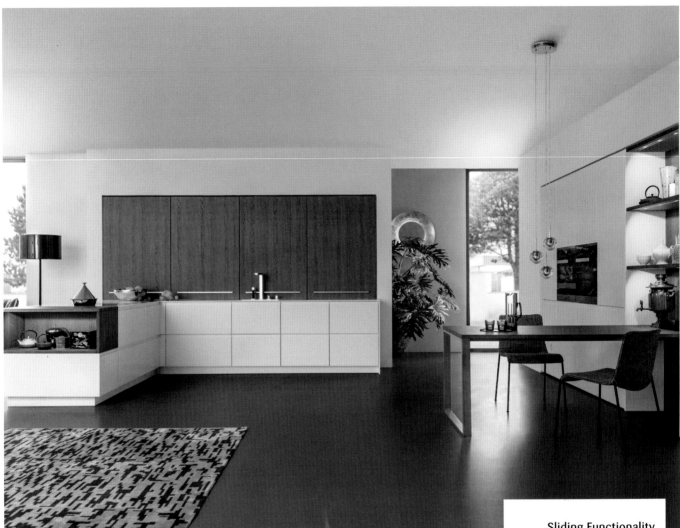

Sliding Functionality

Model: **PUR-FS I TOPOS**
Manufacturer: **LEICHT**
Photography: © **LEICHT**
Küchen AG

This LEICHT kitchen is composed of white-lacquered low units, which combine perfectly with the eye-catching ash wood that acts as a means of connecting the different areas. Combining wood with monochrome shades creates great visual effect, so designers turn to it time and again as their material of choice when it comes to creating kitchens.

061

Opened up to the space, the shelving creates a defined line to the free-standing furniture.

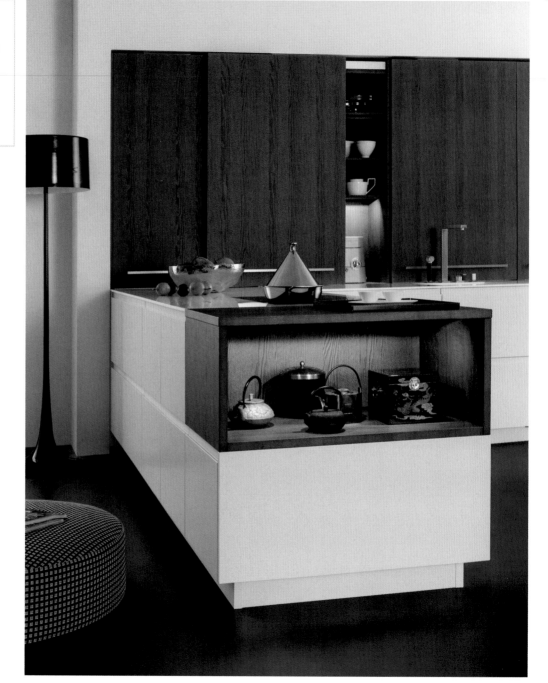

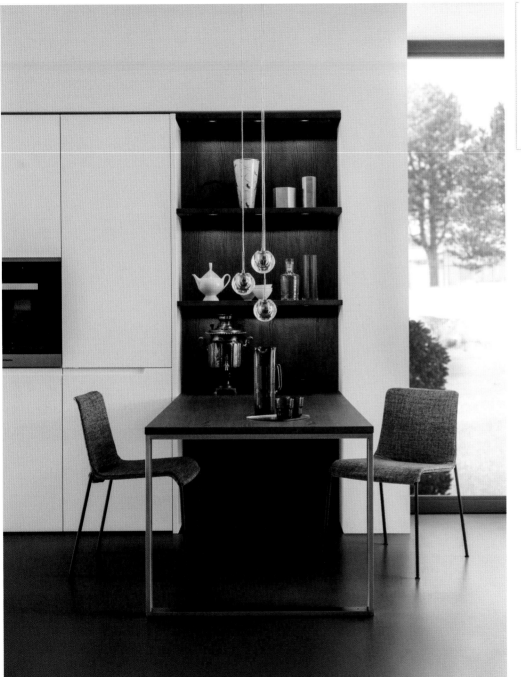

With its LED lights, the shelving is the backdrop against which the dining table rests.

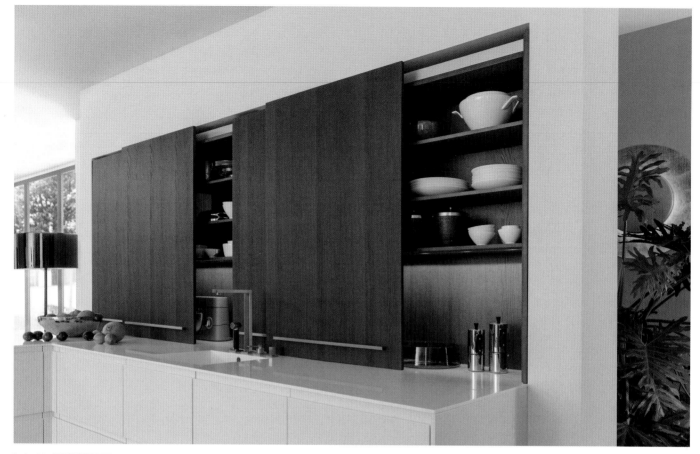

063

The ash hardwood unfolds its beauty and elegance in the large, flush sliding doors of this loft.

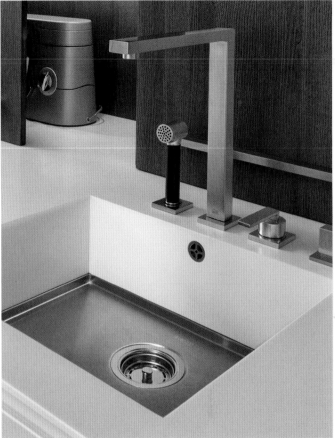

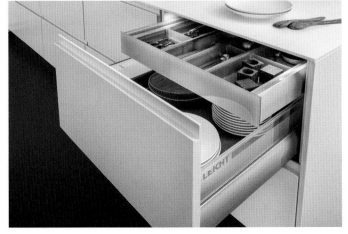

Cooking utensils are better stored close to where they are used. For instance, pots and pans are near the cooktop, and knives close to the chopping area. This should optimize your tasks around the kitchen.

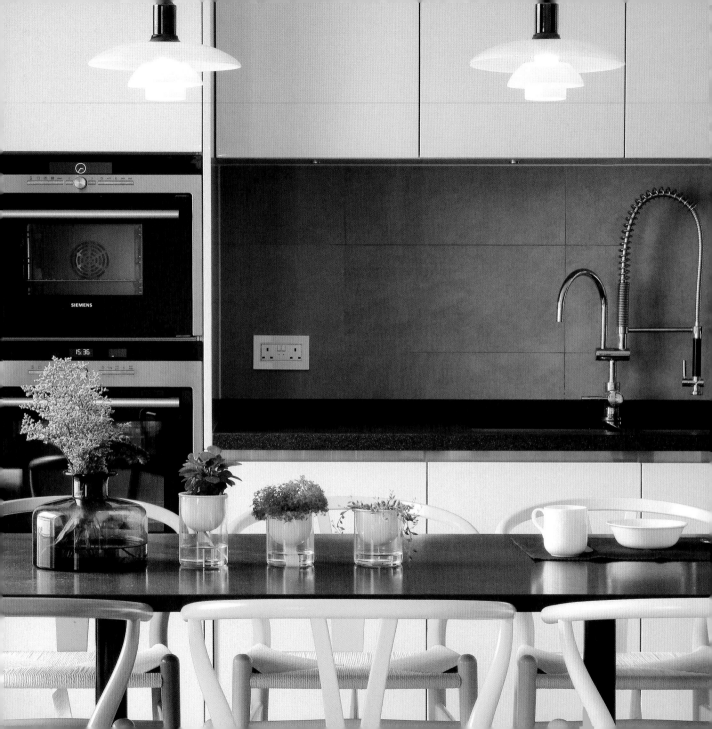

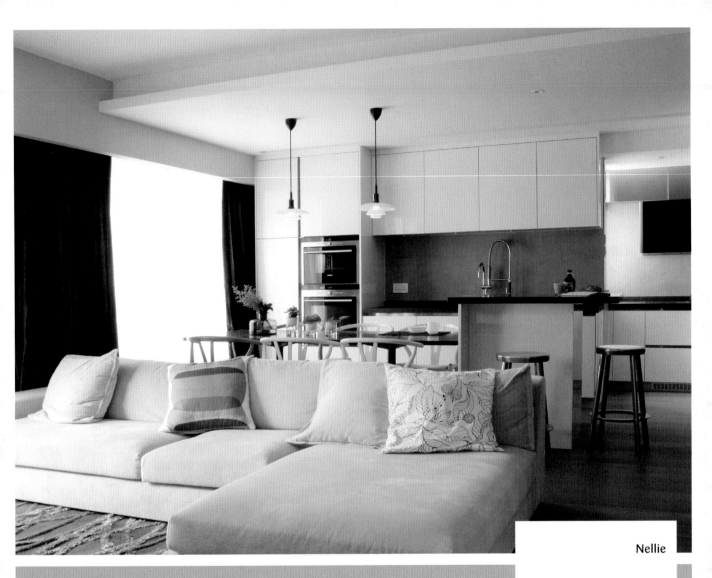

Welcome to a happy home, full of bright and cheerful colors. The original living and dining rooms have been combined and expanded to create a large space, while the open kitchen flows into the living room, helping to increase the feeling of spaciousness in this part of the house. The result is a nice and friendly space that is perfect for gatherings of family or friends.

Nellie

Architect: hoo
Location: Hong Kong, China
Photography: © hoo

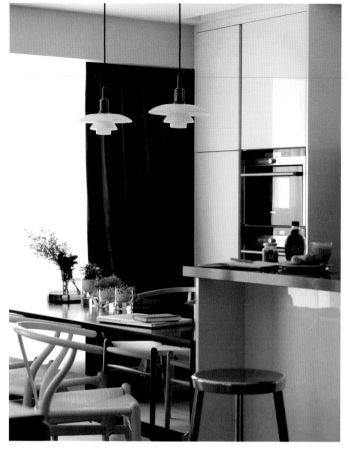
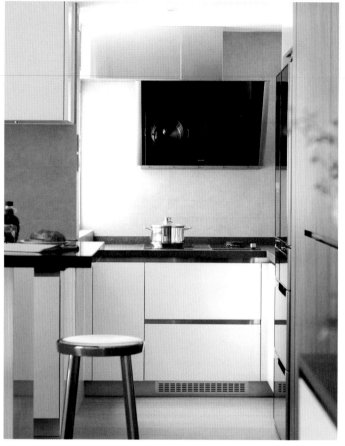

064

One or two steps to the side, turn round... the small distances between each of the work zones is a great time saver.

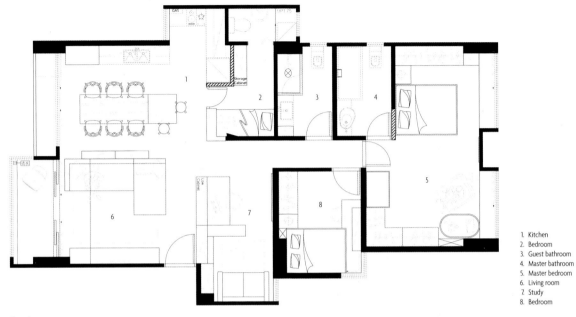

Floor plan

1. Kitchen
2. Bedroom
3. Guest bathroom
4. Master bathroom
5. Master bedroom
6. Living room
7. Study
8. Bedroom

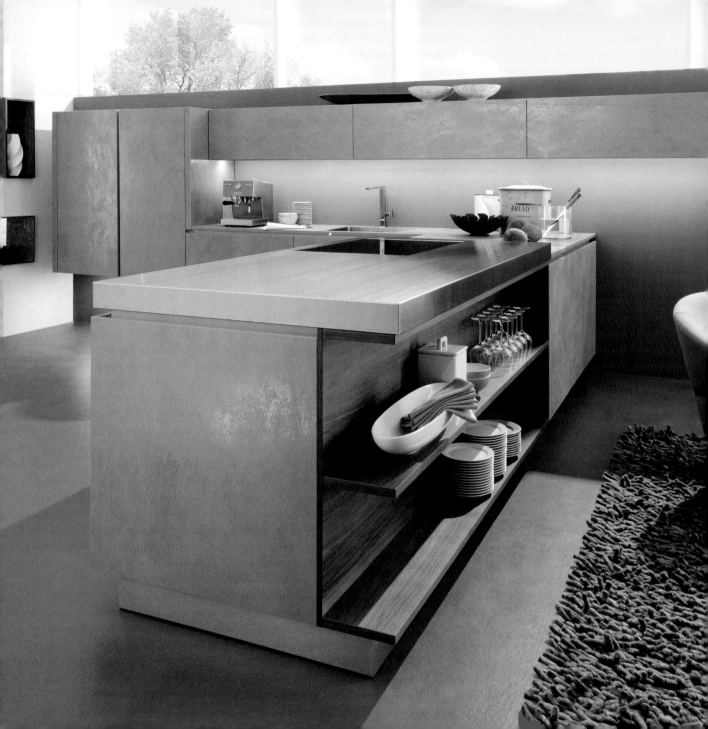

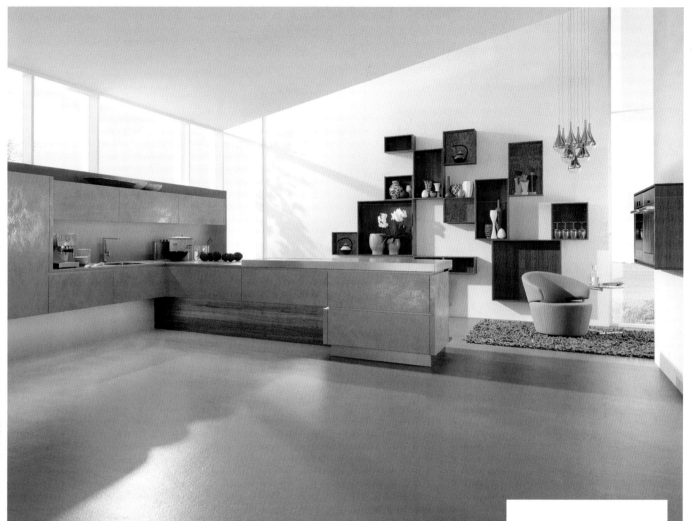

Oxide Grigio

Model: **Alnostar Cera**
Manufacturer: **Alno**
Photography: © **Alno AG**

The obvious contrasts in the design of this kitchen dissolve harmoniously, creating a comfortable balance between the different materials and textures. Stainless steel, the beauty of the high-quality ceramic and the warm wood tones blend in a unique handle-free design, creating an integrated sensory concept to be explored, not just visually but also by touch.

065

Stainless steel, wood and
ceramic. This combination
of materials takes the kitchen
away from its traditional look.

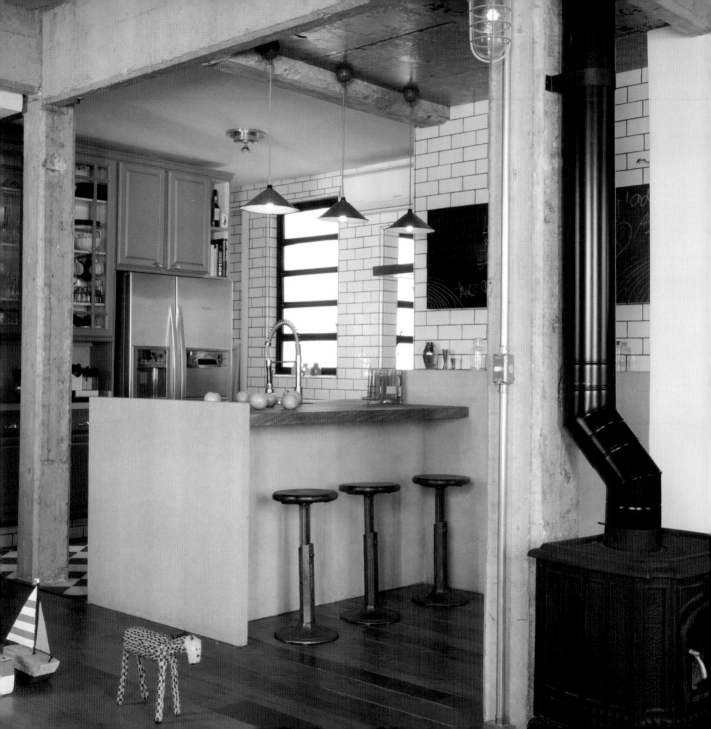

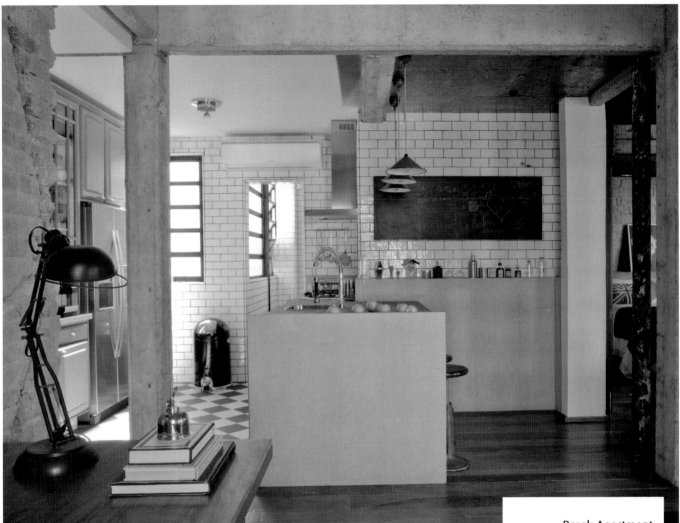

Break Apartment

Architect: Tavares Duayer
Arquitetura
Location: Rio de Janeiro, Brazil
Photography: © André Nazareth,
© João Duayer

The Tavares Duayer project prioritizes the restoration and conservation of the original features of this typical 1940s São Paulo apartment. With this in mind, walls were removed to increase the space within the kitchen and give it a central role in the layout of the home. In line with the rest of the house, the new kitchen has an open, urban and industrial feel.

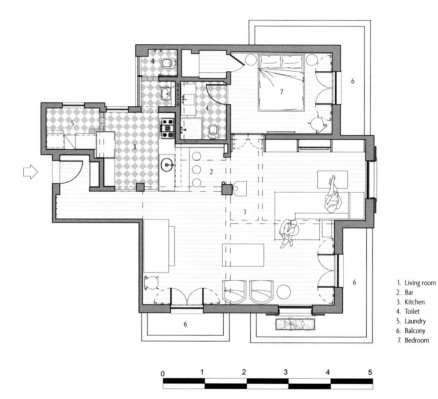

1. Living room
2. Bar
3. Kitchen
4. Toilet
5. Laundry
6. Balcony
7. Bedroom

0 1 2 3 4 5

Floor plan

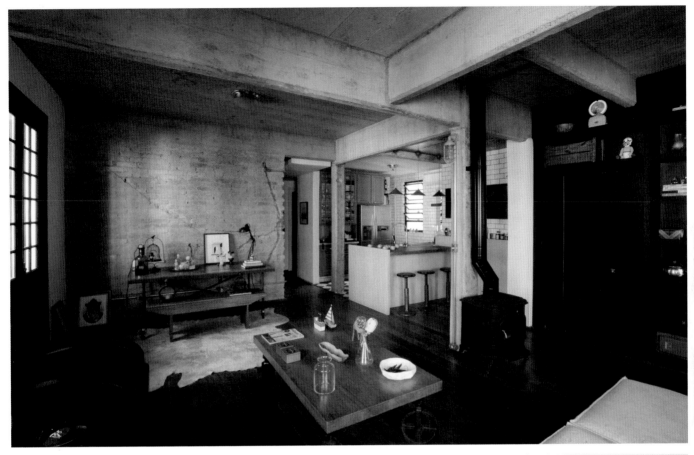

066

A kitchen office is an efficient solution for gaining space and connecting the kitchen to the living room.

As well as having a practical
use, installing slate creates an
interesting chromatic contrast.

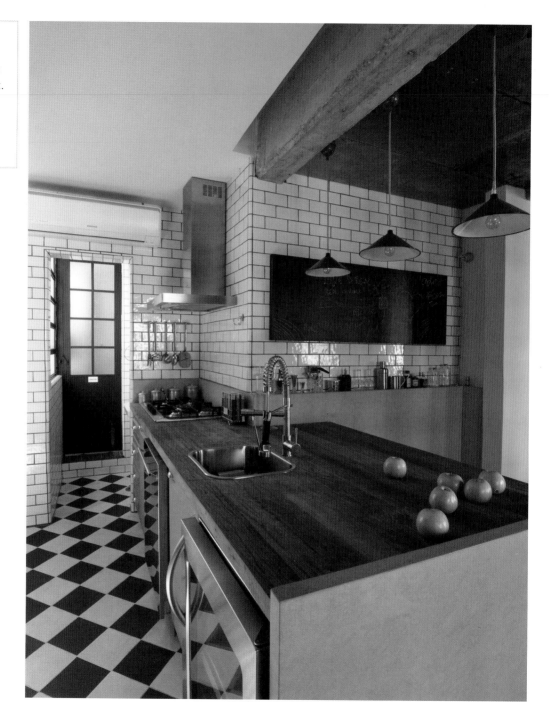

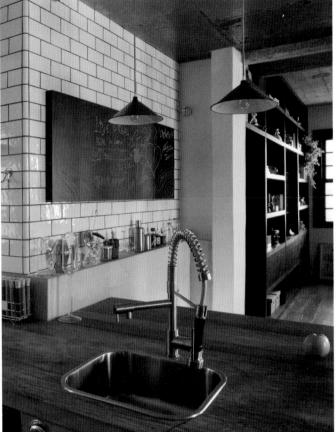

068

Horizontal tiles, brass accessories or iron furniture are indispensable in an urban-style kitchen.

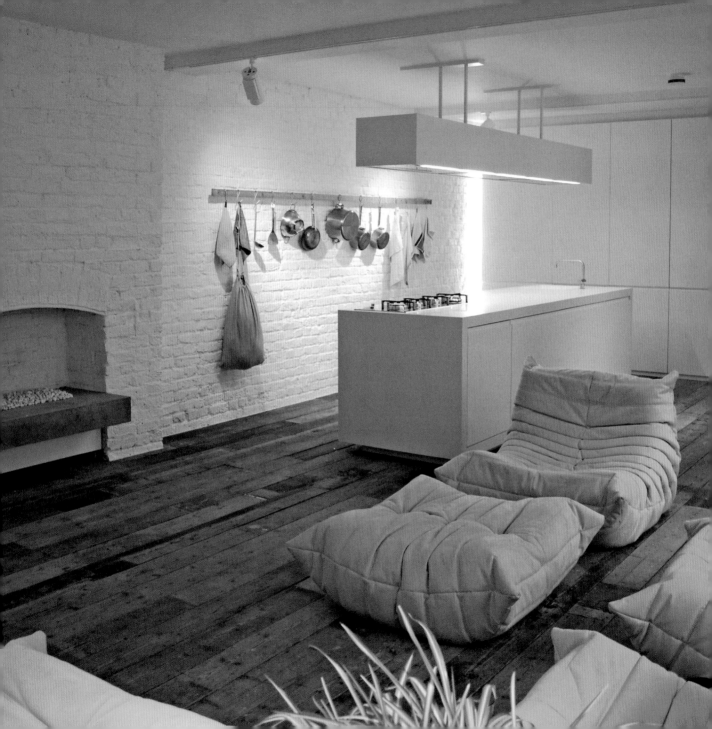

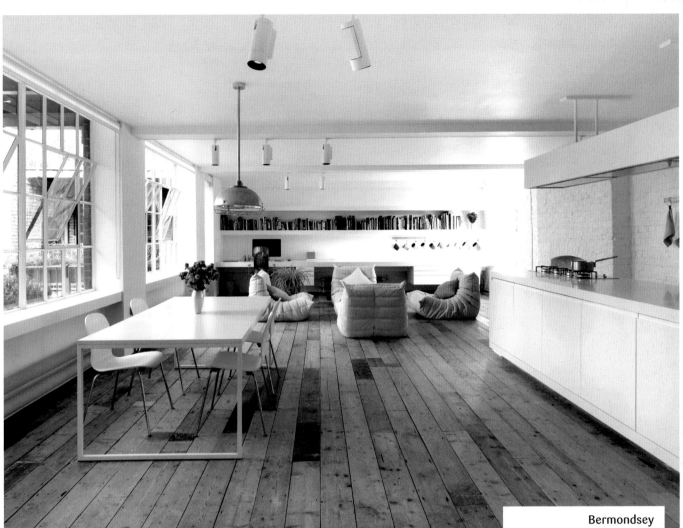

Architect: FORM Design
Architecture

Location: London,
United Kingdom

Photography: © Charles Hosea,
© Mike Neale

This FORM Design Architecture design transforms an old warehouse into a modern loft that is structured with flexible zones in which to eat, relax and exercise. The layout also includes a service area hidden within a block of solid-surfaced white acrylic, which contains a bath, dressing room and various utility spaces. The kitchen is integrated to perfection within this careful configuration.

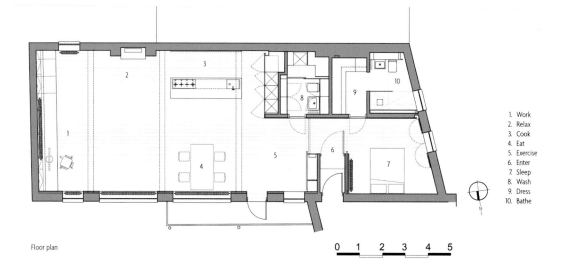

Floor plan

1. Work
2. Relax
3. Cook
4. Eat
5. Exercise
6. Enter
7. Sleep
8. Wash
9. Dress
10. Bathe

0 1 2 3 4 5

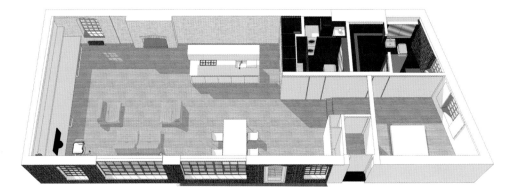

Axonometric view

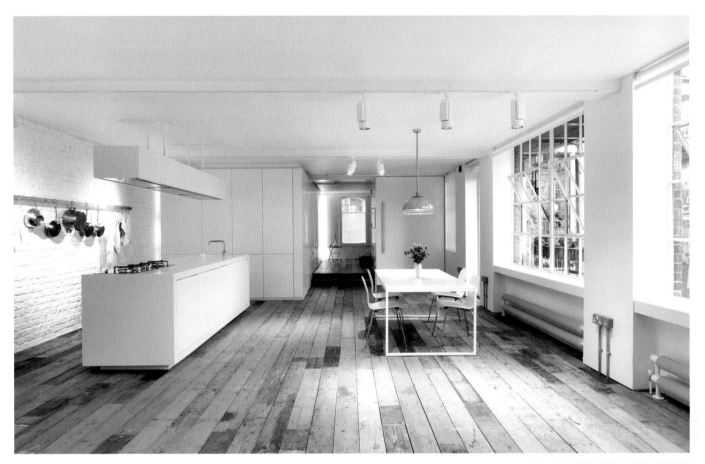

069

Display the most used items on shelves or hanging rods and store the rest away. Hiding some of the kitchen elements in a large column lends the room a minimalist style.

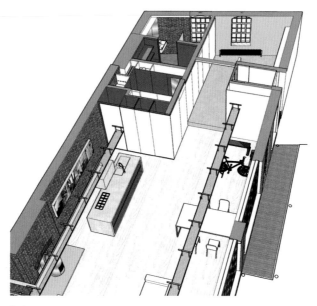

Sketch

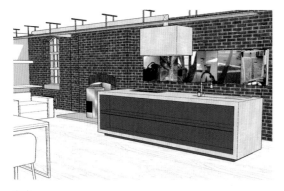

Sketch

Sketch

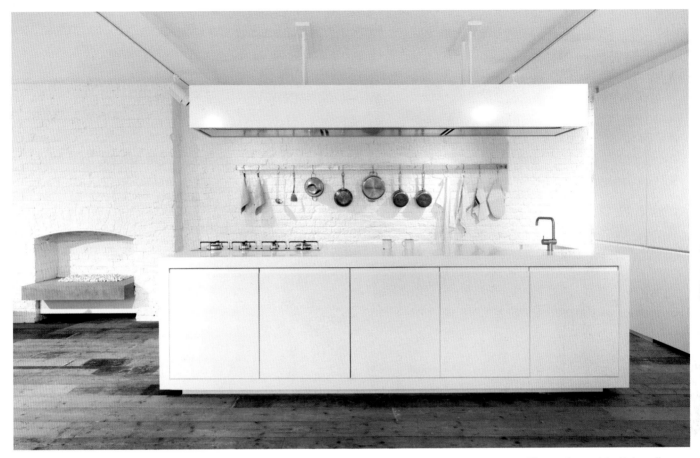

The open layout of the kitchen offers
a better connection with the adjacent
living and dining areas. The kitchen is not
simply a utilitarian space, but an inspiring
corner for cooking and socializing.

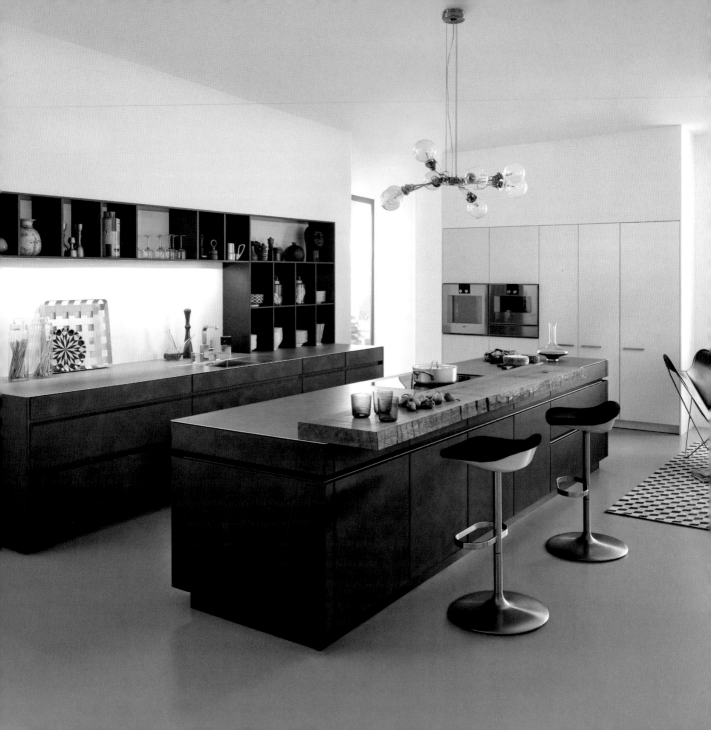

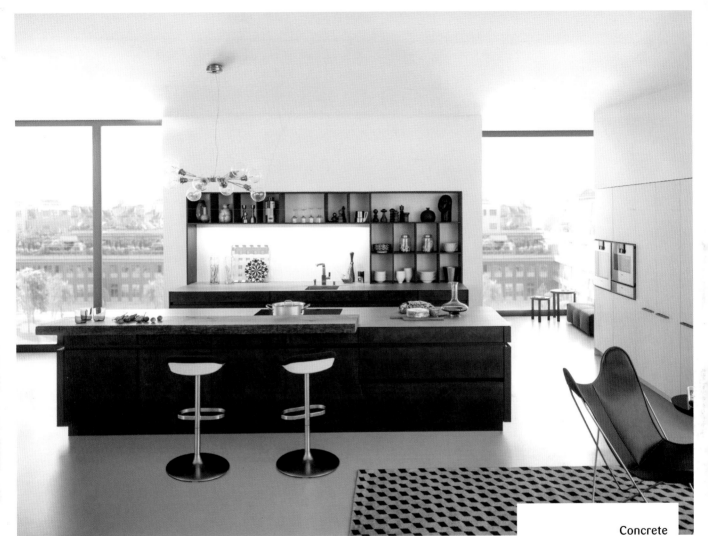

Concrete is not only the preferred construction material for modern architecture, it also creates a purist aesthetic in this kitchen. A lightweight concrete composite was used in the fabrication of the cabinets expressing the aesthetic characteristics of this material. A protective lacquer renders it an utterly suitable material for the modern kitchen.

Concrete

Model: **TOCCO I CONCRETE-A**
Manufacturer: **LEICHT**
Photography: © **LEICHT**
Küchen AG

070

From hanging rods and racks to pull-out baskets, kitchen cabinet fittings optimize storage capacity.

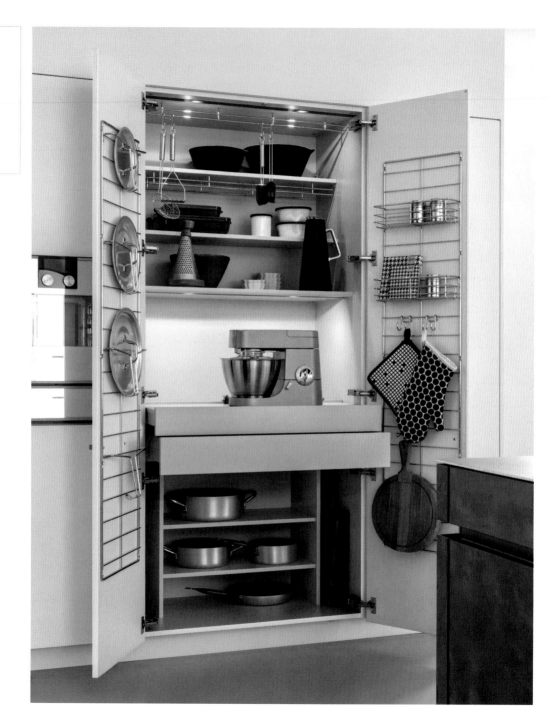

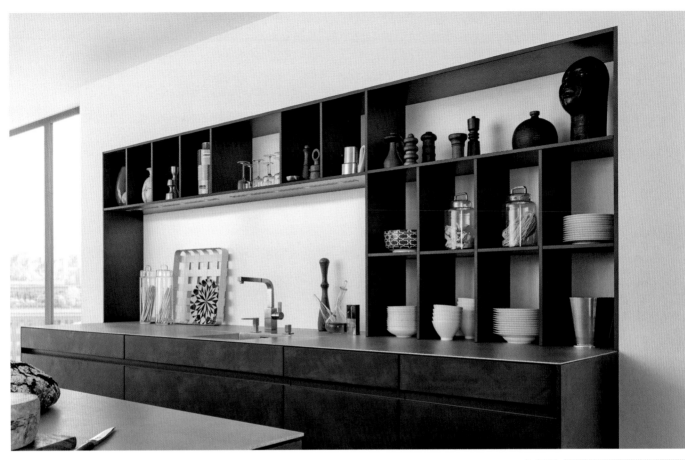

071

The asymmetric shelving design lightens the strict layout of this kitchen design.

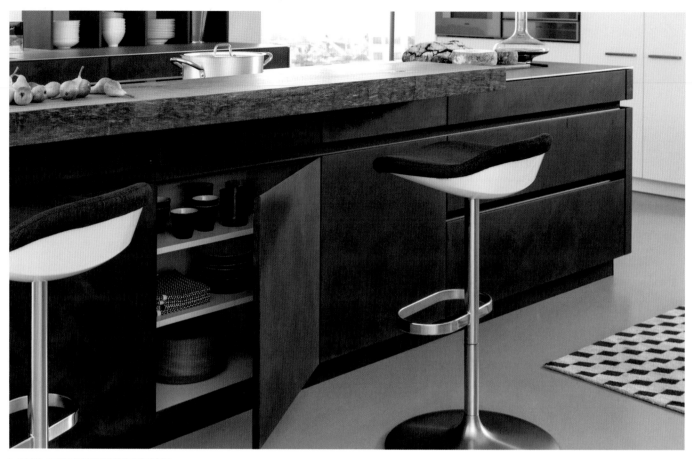

072

The more different the materials, the more interesting and intense the resulting combination.

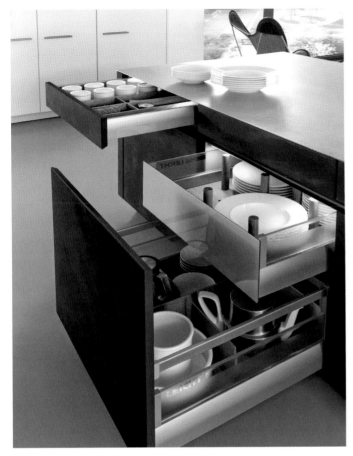
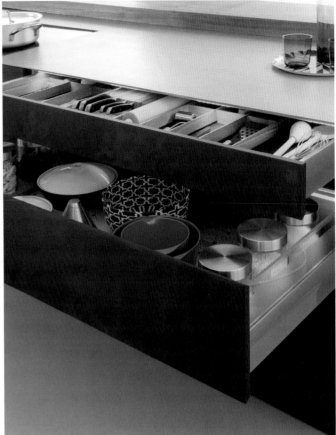

073

Interior drawers in the top
of a cabinet provide optimum
use of the available space.

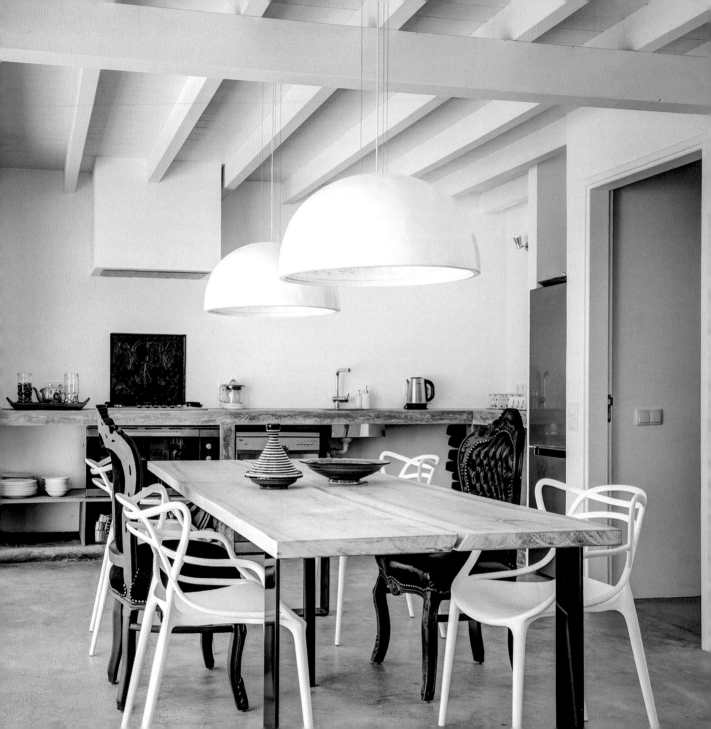

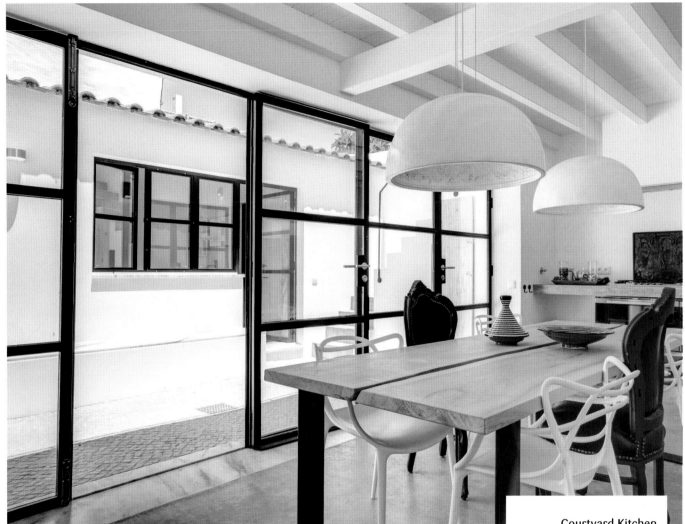

Courtyard Kitchen

Beauty can often be found in the smallest and most attractive of ideas, and be expressed through simple and intelligent solutions. Studio Arte achieves this with their minimalist design that comprises a comfortable, functional kitchen with living room that extends to the adjacent outdoor courtyard. The wall opens to the outside and the bright rays of the sun flood the entire kitchen space.

Architect: **Studio Arte**

Location: **Silves, Portugal**

Photography: © **First Stop Photography**

Sketch

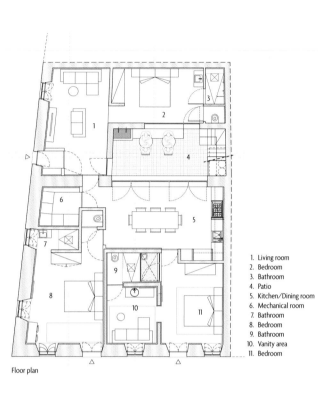

Floor plan

1. Living room
2. Bedroom
3. Bathroom
4. Patio
5. Kitchen/Dining room
6. Mechanical room
7. Bathroom
8. Bedroom
9. Bathroom
10. Vanity area
11. Bedroom

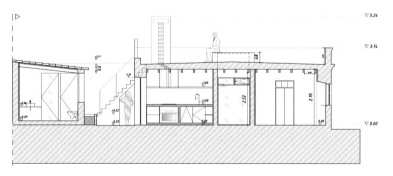

Section

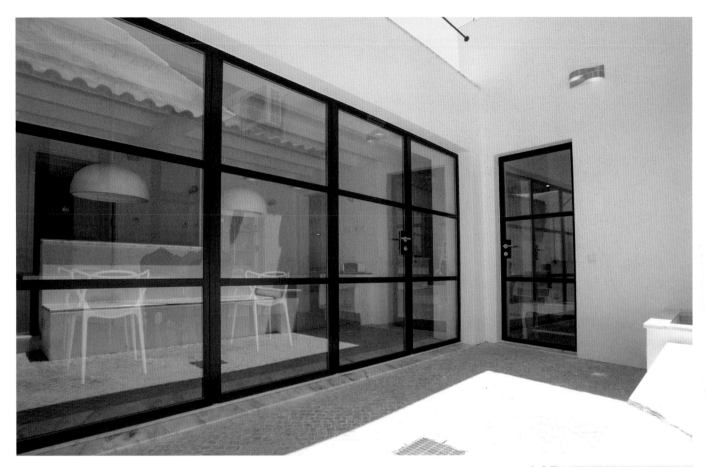

074

Good lighting is essential in the kitchen. If the light is natural, the atmosphere is unbeatable.

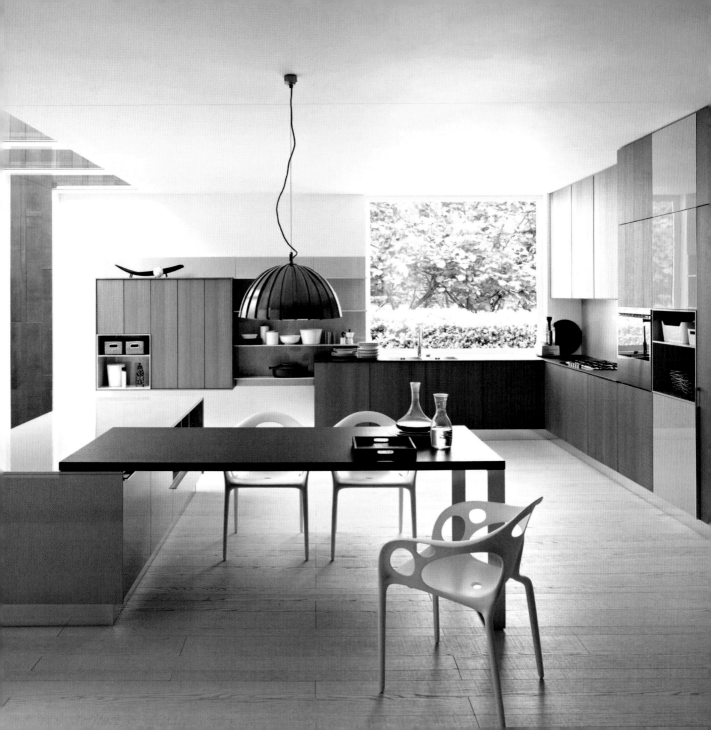

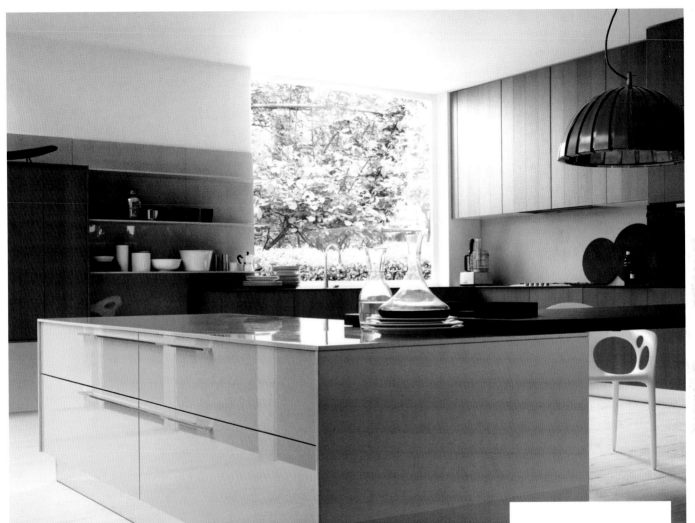

Model: **Kalea**

Manufacturer: **Cesar Arredamenti**

Photography: ©Cesar Arredamenti

The Kalea kitchen designed by Cesar focuses on creative and elegant decorative solutions, establishing new measurements and sizes. Doors that are just 1.4 centimeters (½ inch) thick, cabinets that vary in height and width, versatile open shelves, tonal and contrasting finishes—these are the original and unprecedented architectural guidelines for this design that joins the kitchen to the living room.

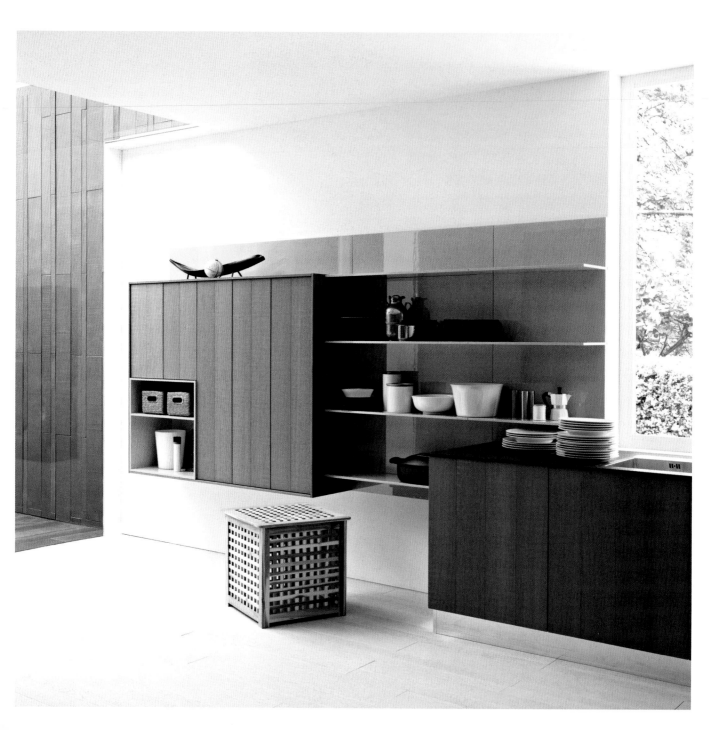

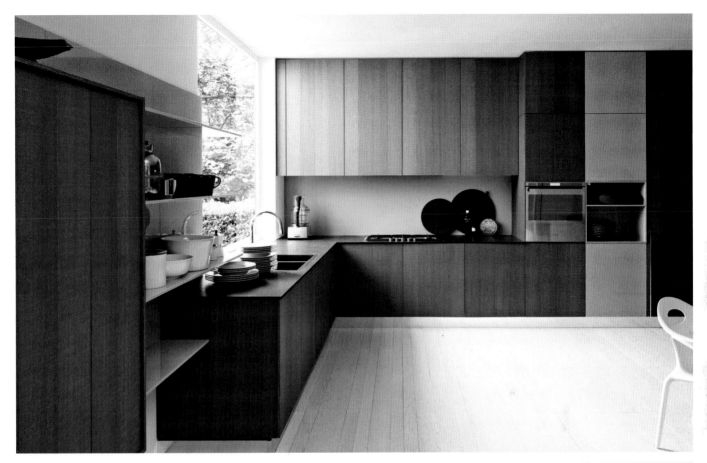

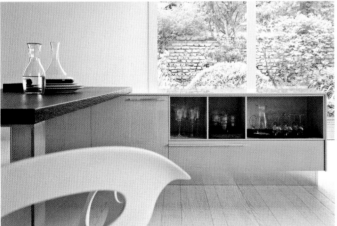

075

The use of open containers within the island is as unconventional as it is aesthetic and original.

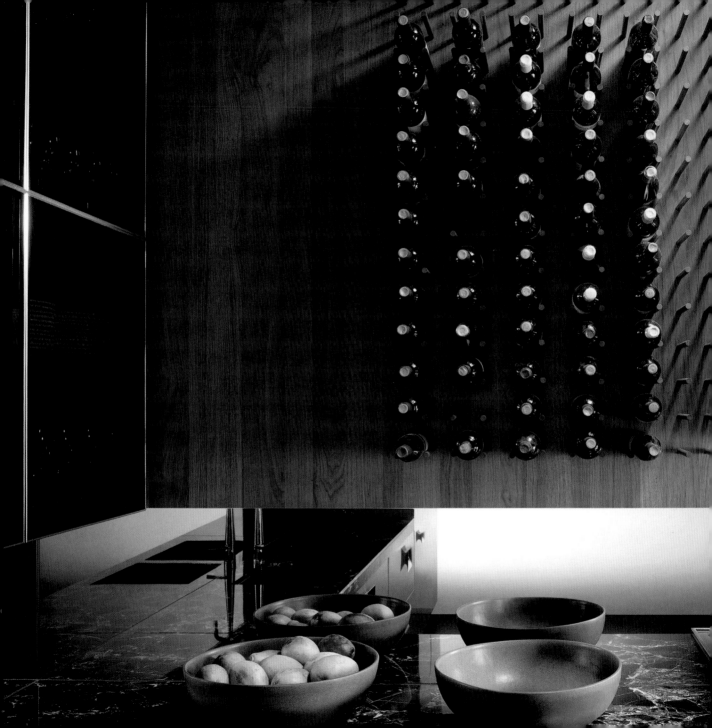

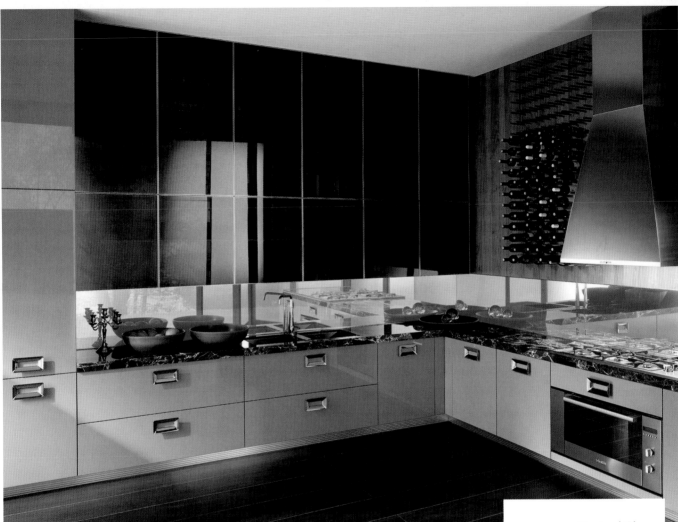

Model: Barrique
Manufacturer: Ernestomeda
Photography: © Ernestomeda

The use of wood does not necessarily demand classic styling, just as using marble and steel does not always create a cold effect. In the Barrique kitchen, the modernity of the room turns its back on an antiseptic image and on extravagant designs to create a highly original balance between the satisfaction of "living in elegance" and the desire for a house whose function is as impeccable as its appearance.

The wine rack is an attractive decorative solution, but should be fully accessible and not lose its primary function as a storage space.

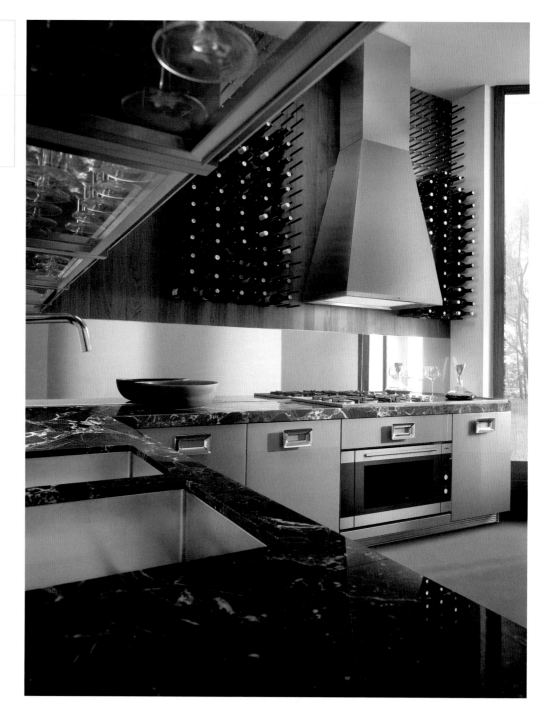

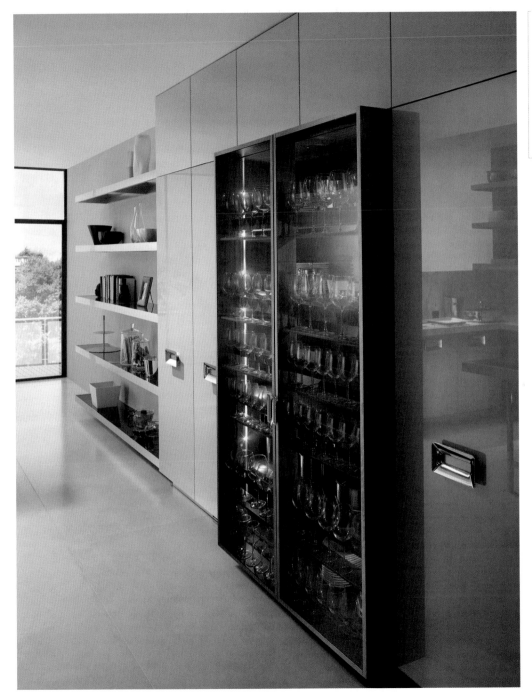

Wall units with glass doors
and interior lighting are
aesthetically perfect if they
are used to house glassware.

The cabinets, with their stained-glass doors, enable us to see inside as well as combining nicely with the rest of the kitchen.

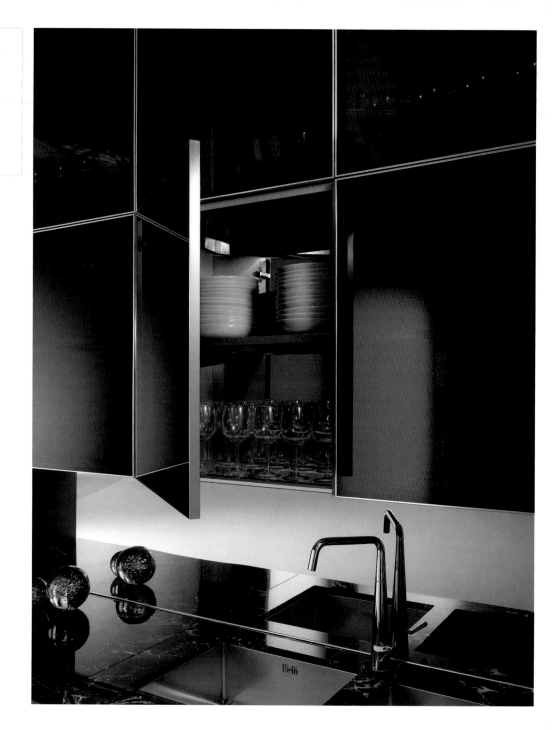

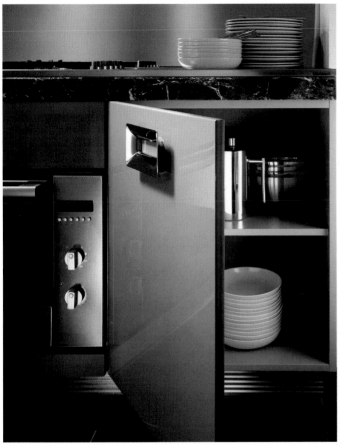

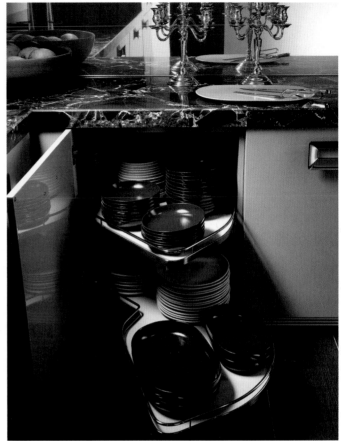

Cabinet accessories are designed to optimize storage capacity and facilitate access into difficult corners.

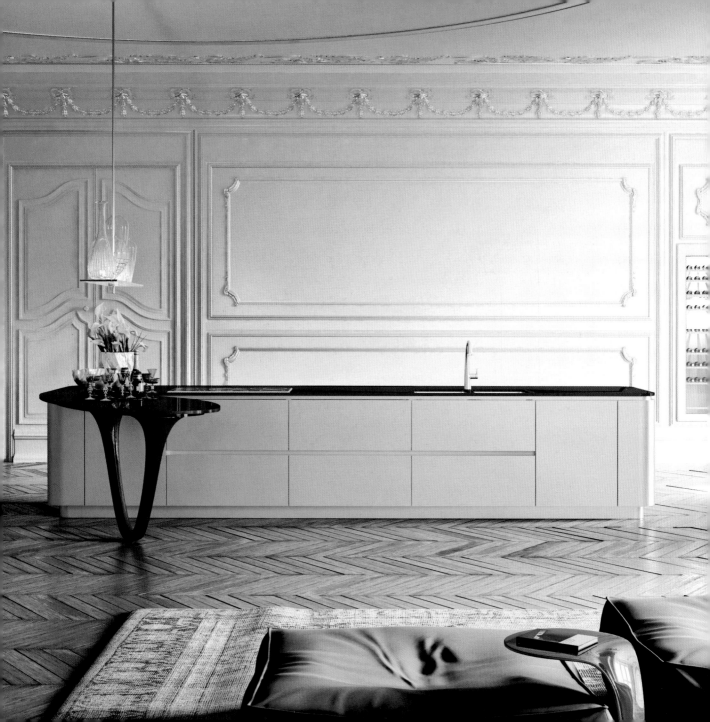

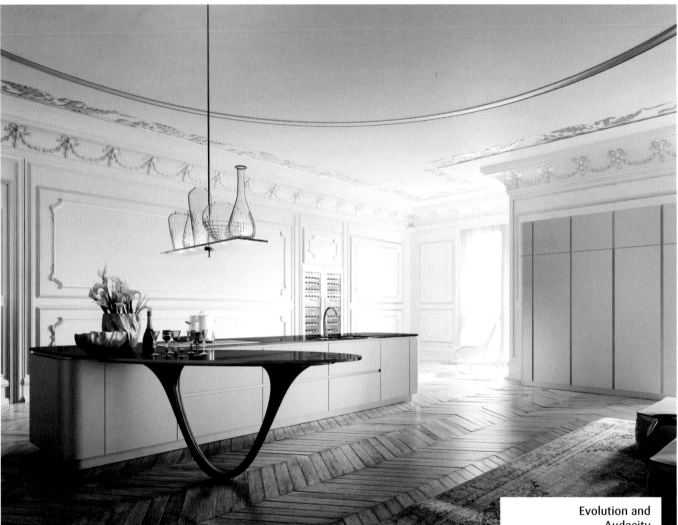

As the first kitchen born of the collaboration between Pinifarina and Snaidero in 1990, the Ola design has a strong architectural impact. It is able to bring together all aspects of functionality through technologically innovative solutions with the greatest attention to detail. In 2010, Snaidero invested anew in Ola, mixing the unmistakable signs of a classic with elements of strong contemporary design.

Model: Ola 25
Manufacturer: Snaidero
Photography: © Snaidero

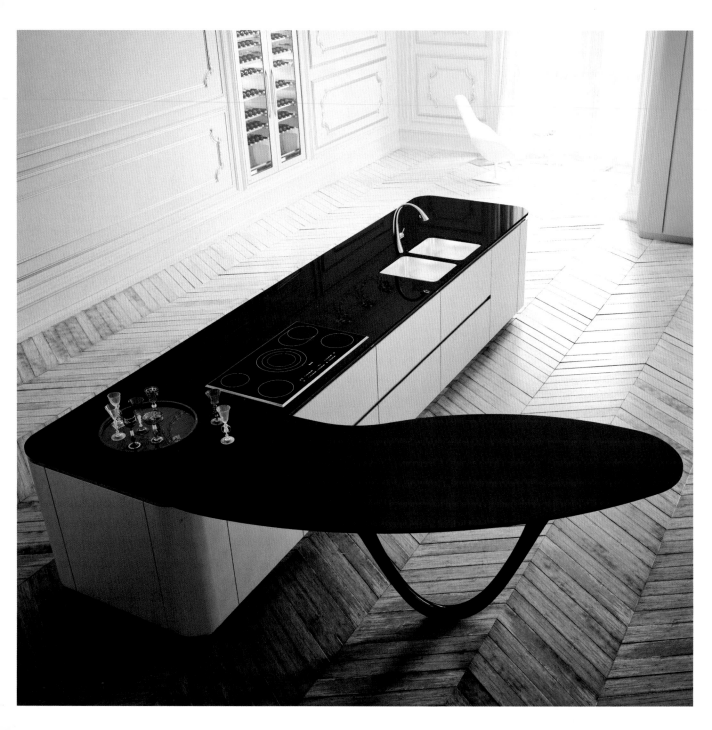

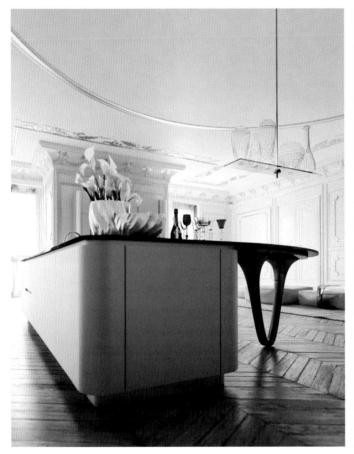

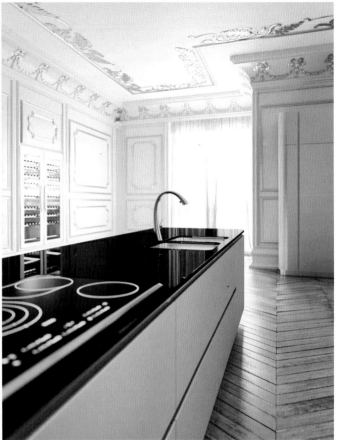

The light and iconic
composition enhances in
an almost sculptural way the
carbon-fiber worktop support.

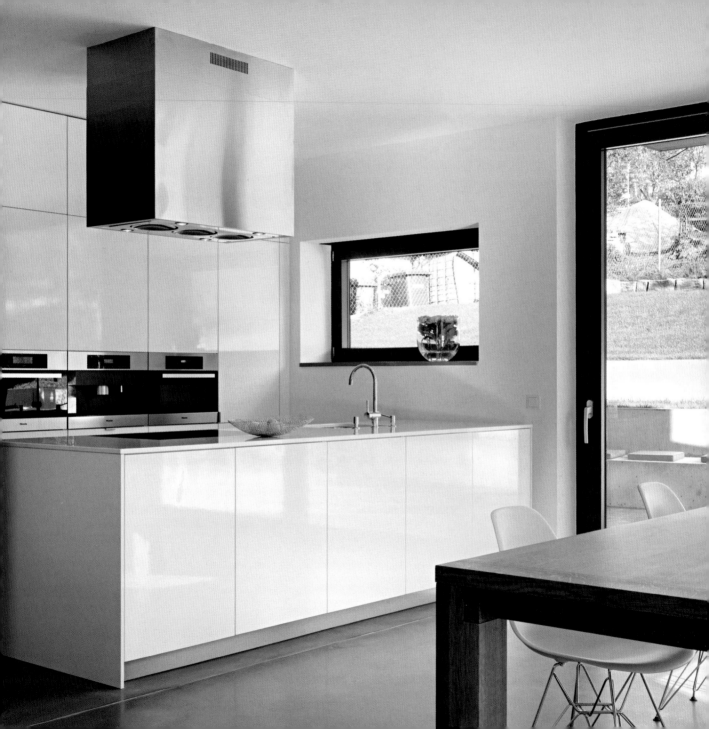

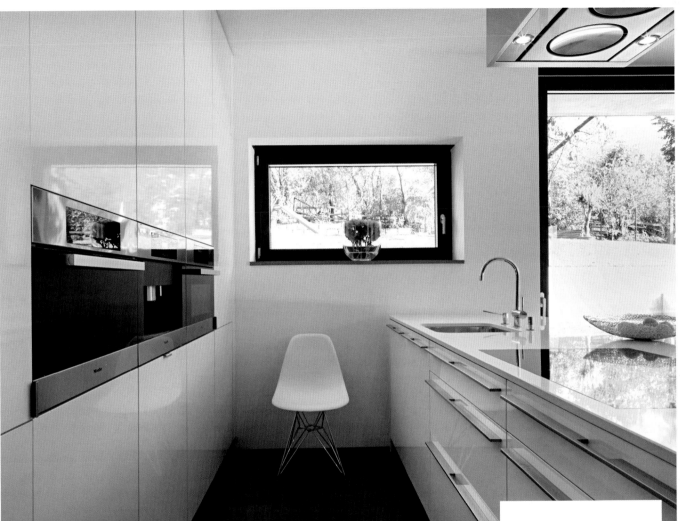

Kitchen in Dekendorf

Architect: ippolito fleitz group.

Location: Dekendorf, Germany

Photography: © LEICHT
Küchen AG.

The view over the town of Denkendorf from the L-shaped panoramic window captures everyone's attention. The glass structure adds a generous space to the living room without increasing the surface area of the house and, consequently, without adding to the construction costs. Free from the interruption of columns or walls, the kitchen flows into the living room and becomes a part of the resulting flowing space.

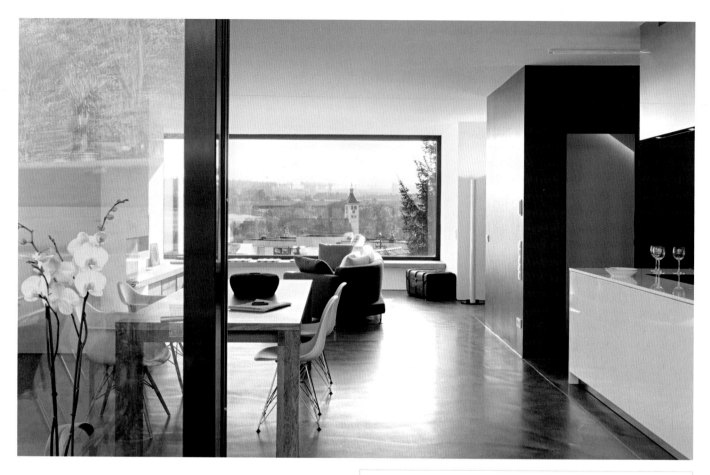

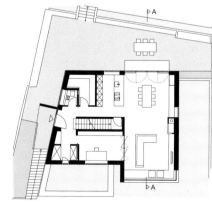

Ground floor

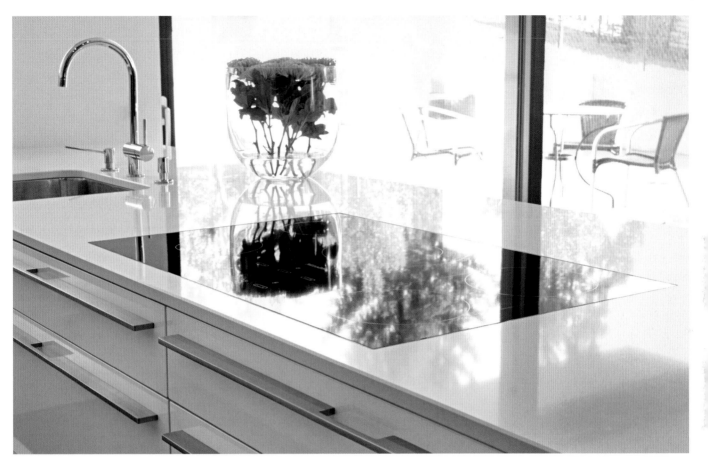

081

The stove and sink are installed, respectively, flush with and recessed into the worktop and highlight its horizontalness.

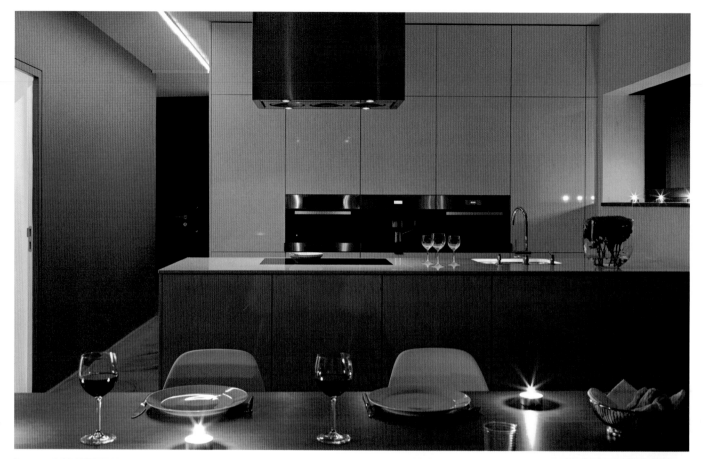

082

The changing color of the LED lights reflects on the white walls and kitchen units, creating a sriking chromatic effect.

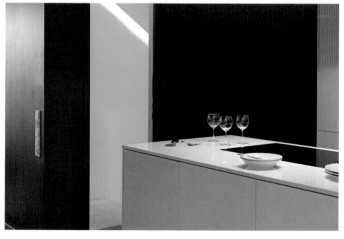

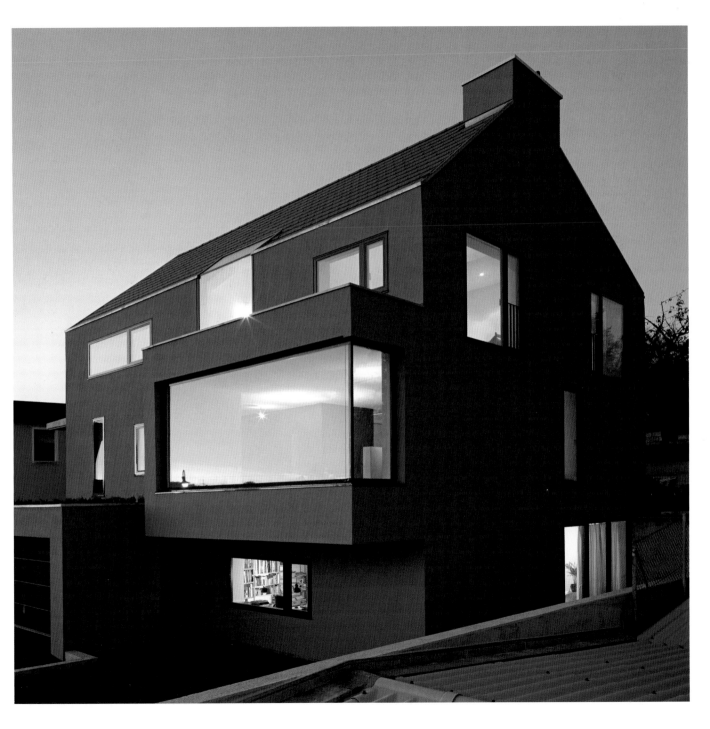

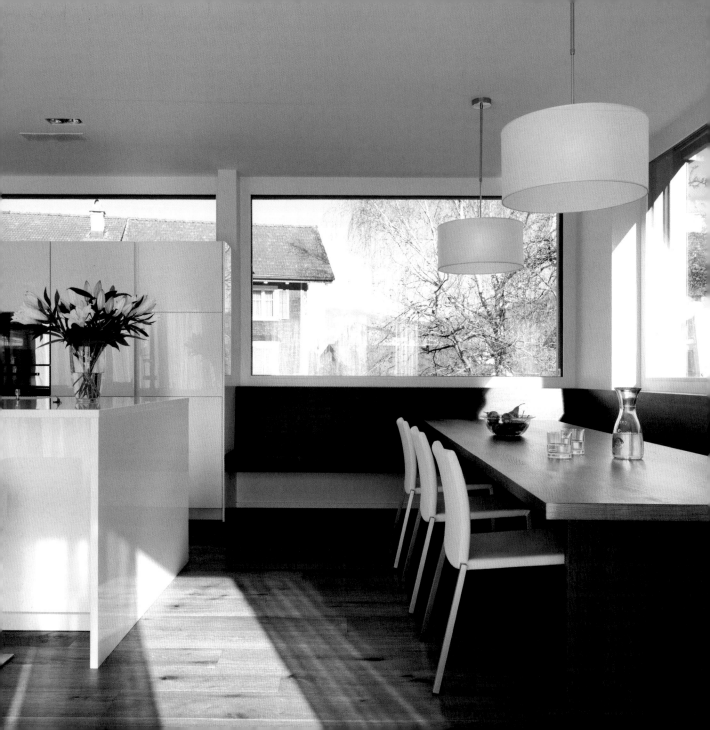

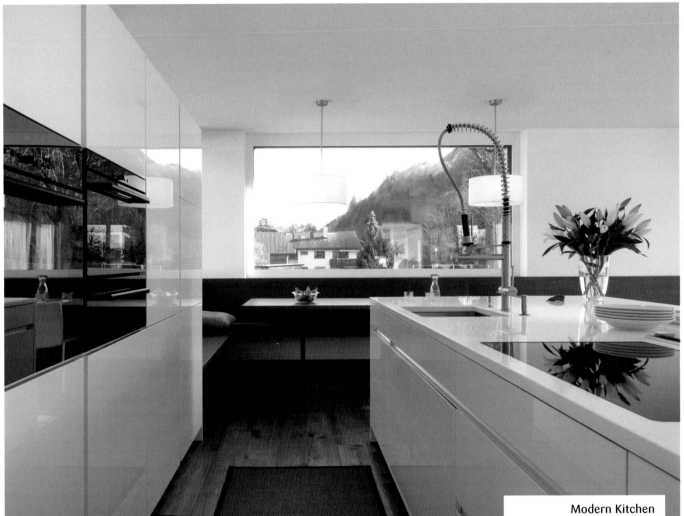

Modern Kitchen in Vilters

Architect: Roger Kurath

Location: Vilters, Switzerland

Photography: © LEICHT Küchen AG

With its clean and simple shapes, the home plays on its rural setting and the context of its surrounding buildings. The simplicity of the architectural language, between form and function, is evident both in the exterior and inside. Situated next to each other, the kitchen and dining area are linked by a long wooden bench.

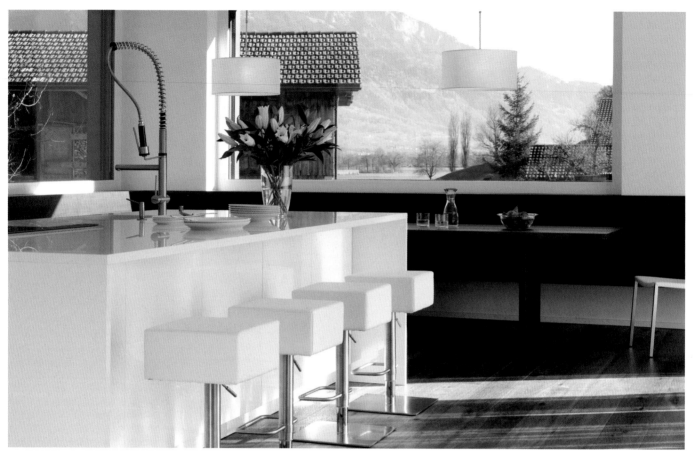

083

By installing the island worktop at a higher level it can be used as a bar.

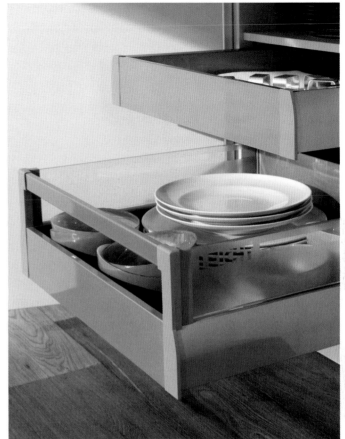

084

The perfect combination of cabinets, drawers, appliances and shelving maximizes the use of space.

Ground floor

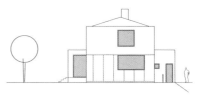

Kitchen floor plan

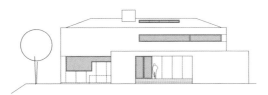

South elevation

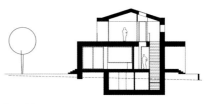

West elevation

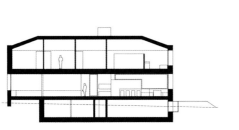

Section A-A

Section B-B

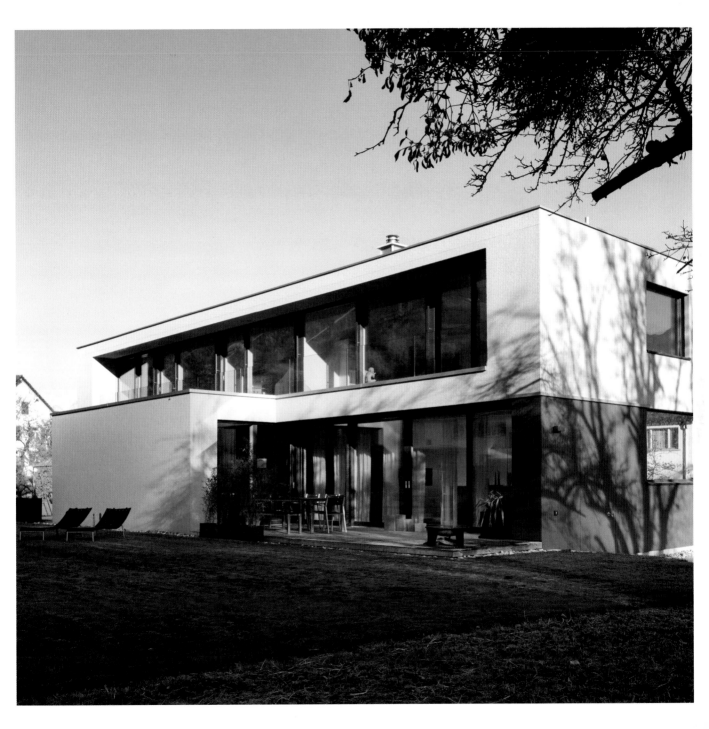

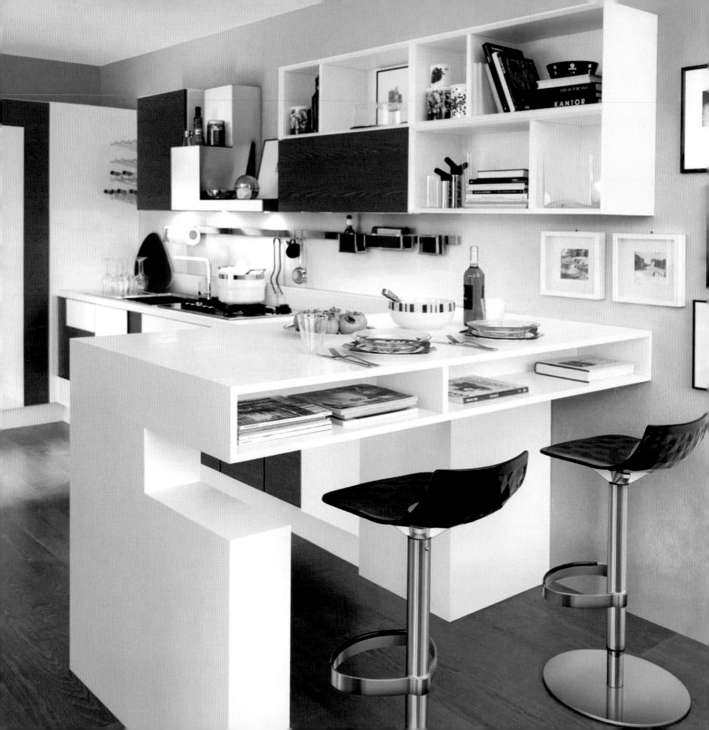

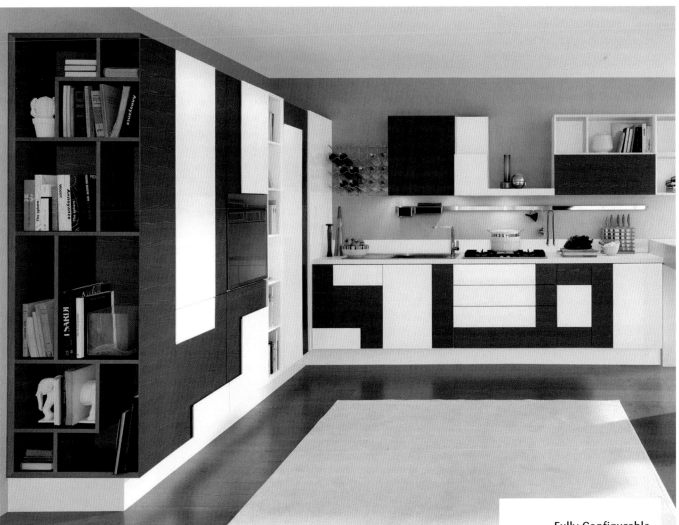

The Lube kitchen is unique thanks to its geometric movements. Creativa is a design system in which multiple configuration options enable every kitchen to be special and completely adapted to the tastes of its owner, thereby being perfect for those who aspire to have a unique and exclusive home. Materials and shapes play on color for creativity without end.

Fully Configurable

Model: **Creativa**
Manufacturer: **Lube**
Photography: **©Lube**

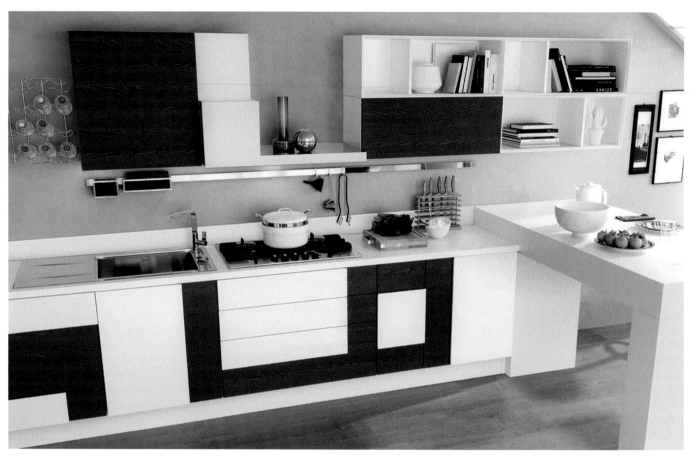

085

The ventilation plate of the
brilliant white glass stove hood
converts into a practical shelf.

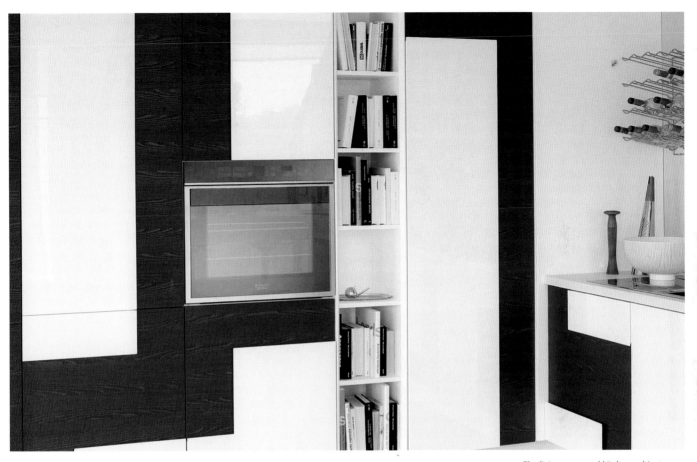

The living room and kitchen cabinets blend into a single and unique design, eliminating any visual separation between the two spaces. Likewise, bookshelves and kitchen appliances mix to further emphasize this blend.

Open shelving is used to display
unique items, adding visual interest
and personality to the space.

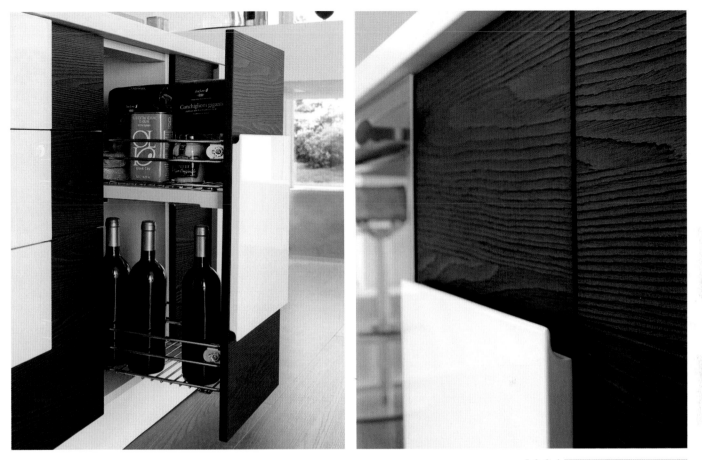

086

The handle is blended into the right-angled shape of the snow-white door panel.

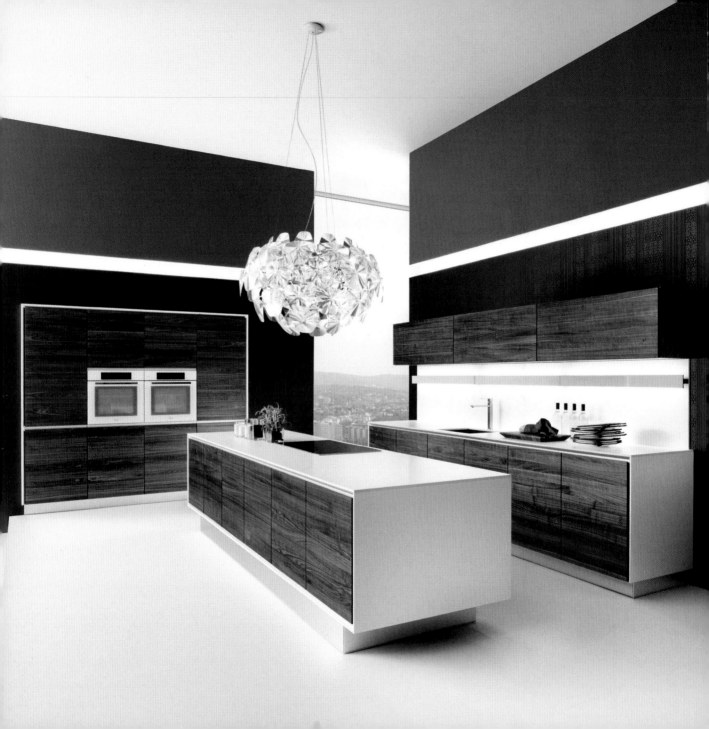

Natural Walnut Wood

The Vao design is the perfect example of how a love of wood can be tangible. Passion for wood and carpentry are the fundamental elements of the design of the award-winning TEAM7. Furthermore the work surface material is minimal at the front, highlighting the beauty of the wood in a delicate montage that creates a visual effect similar to a painting.

Model: Vao
Manufacturer: **TEAM7**
Photography: ©**TEAM7**

Contemporary kitchens are a blend of technology and aesthetics. Durable and resistant surfaces like mineral compounds and high-tech plastics combine with richly grained wood, creating well-balanced compositions.

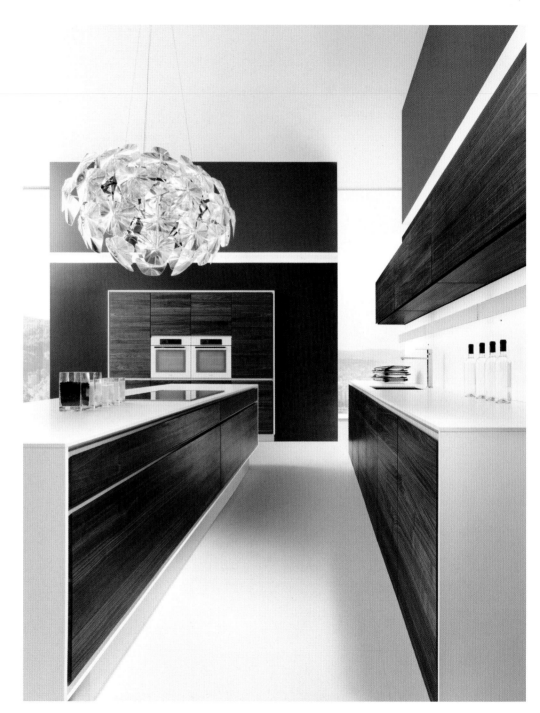

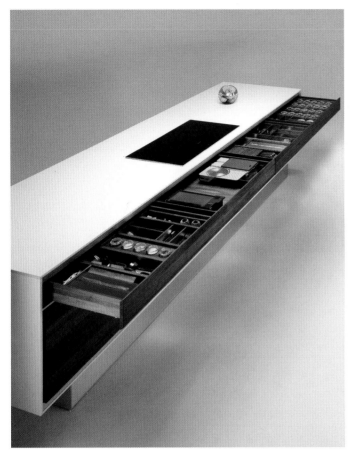

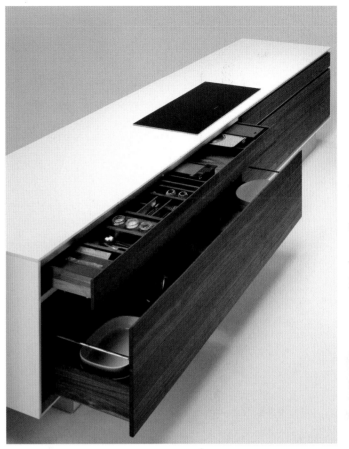

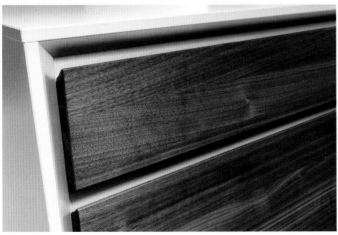

Oversized drawers can be used to store a toaster or a blender.

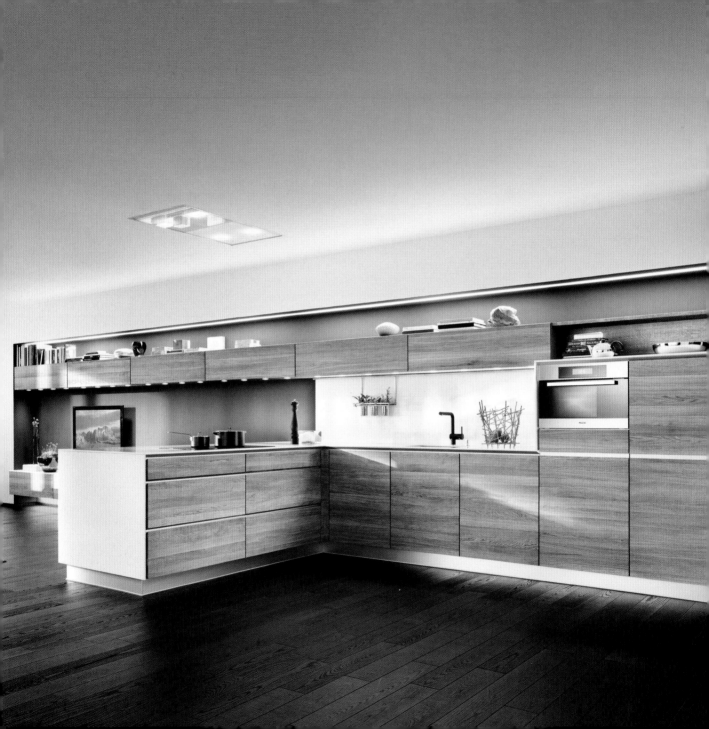

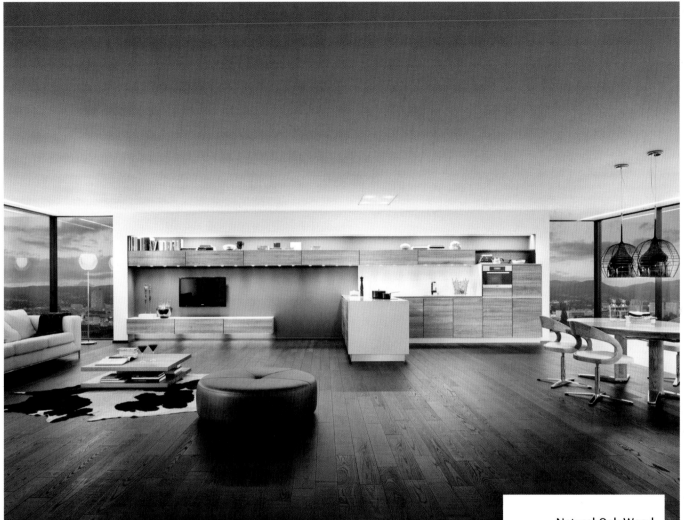

Model: Vao
Manufacturer: TEAM7
Photography: ©TEAM7

The special characteristics of the color of the oak wood core, which range from grayish-yellow to yellowish-brown, allow for a wide range of finishes on TEAM7's Vao design. Furthermore, the positioning of the wood grains, running in parallel, create a strong sensation of horizontalness and help with the integration of the handles, so that the wood can be easily grabbed hold of.

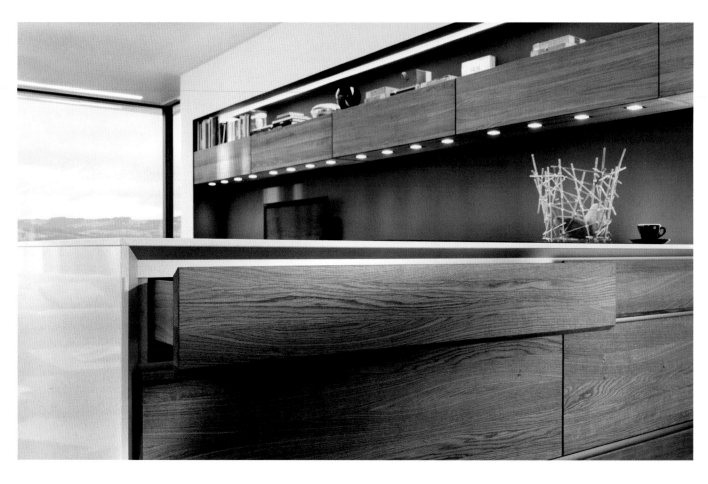

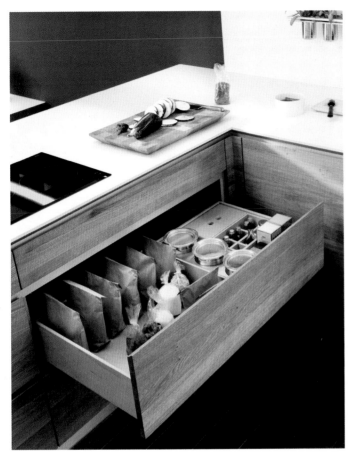
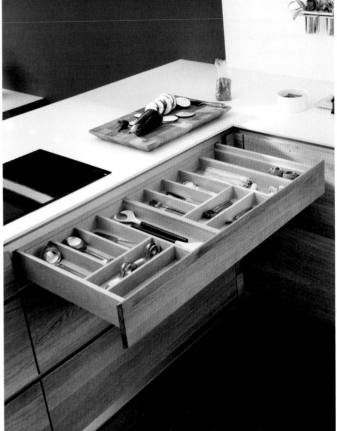

The durability of cabinets made of solid wood cannot be surpassed by those finished with wood veneer. Solid wood has the advantage of being more resistant to moisture damage than a veneer.

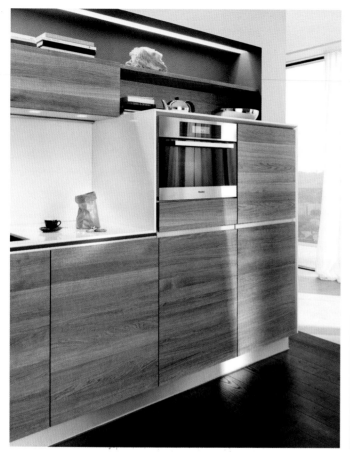

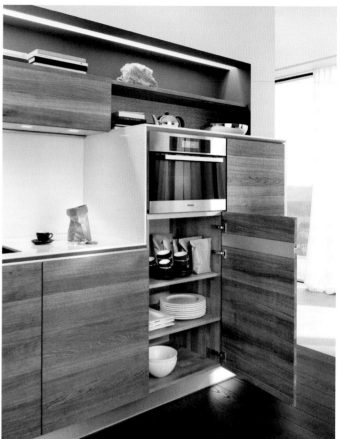

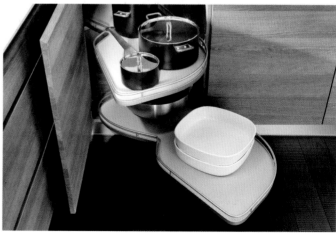

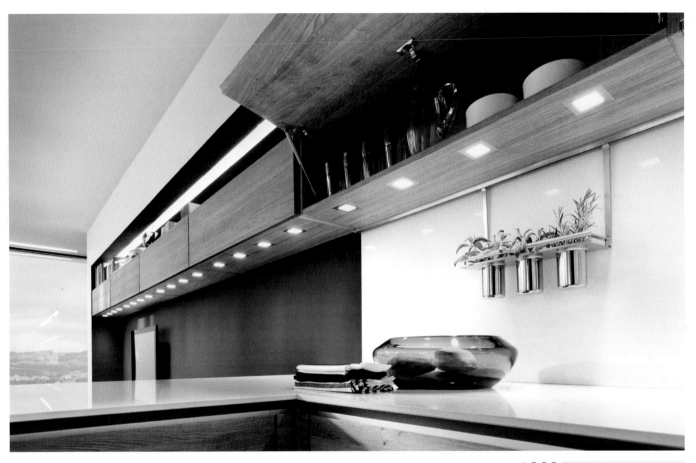

088

If appliance spaces are designed individually the loss of storage space is minimized.

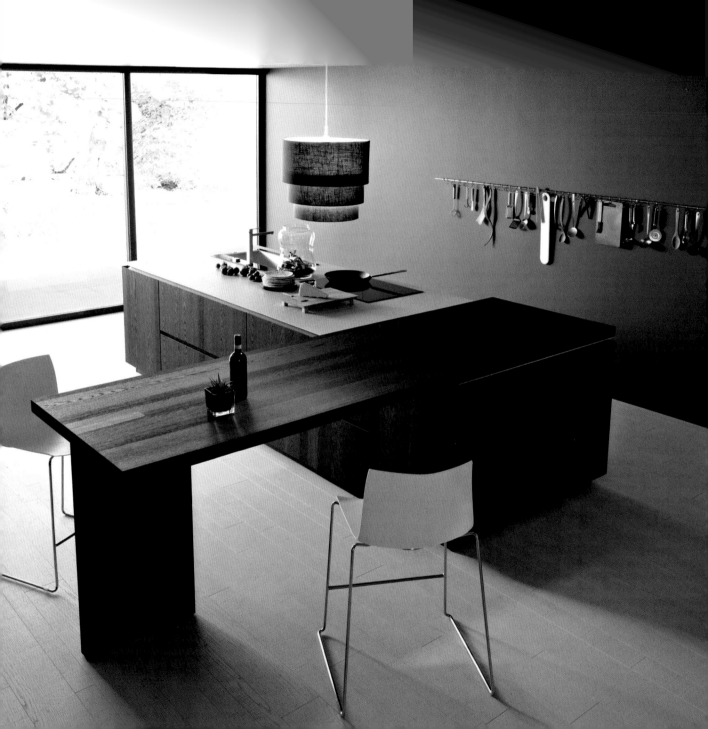

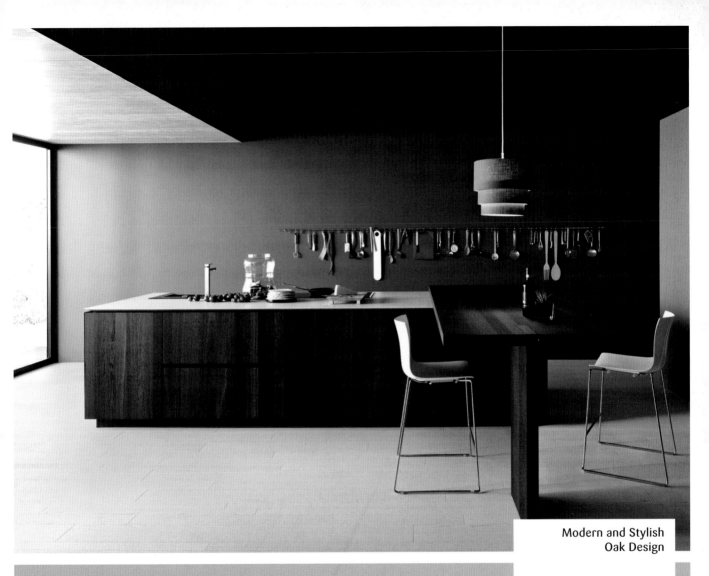

Model: Elle

Manufacturer: Cesar
Arredamenti

Photography: ©Cesar
Arredamenti

Three adjectives can be used to perfectly describe Elle: contemporary, elegant and essential, starting with the careful choice of 45-degree profile on the work surfaces, sides and doors. Elle is expressed with refined and highly developed taste so that its design may be appreciated all the more when it enriches our everyday life with its elegant details and exquisite simplicity.

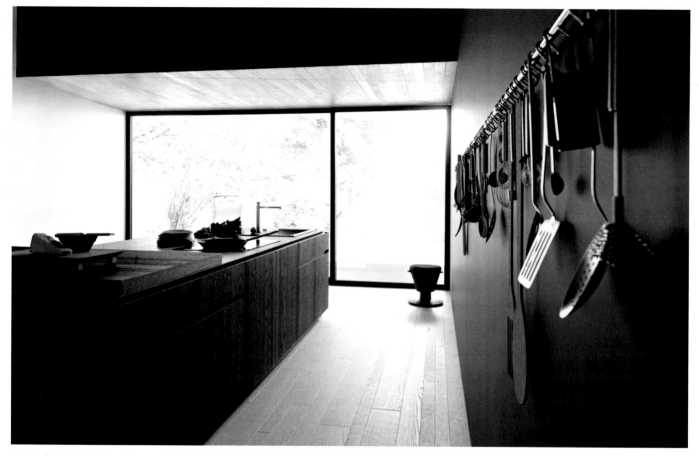

Keeping kitchen utensils easily accessible is key for the good flow of tasks. The utensils that are frequently used can be displayed on a hanging rod.

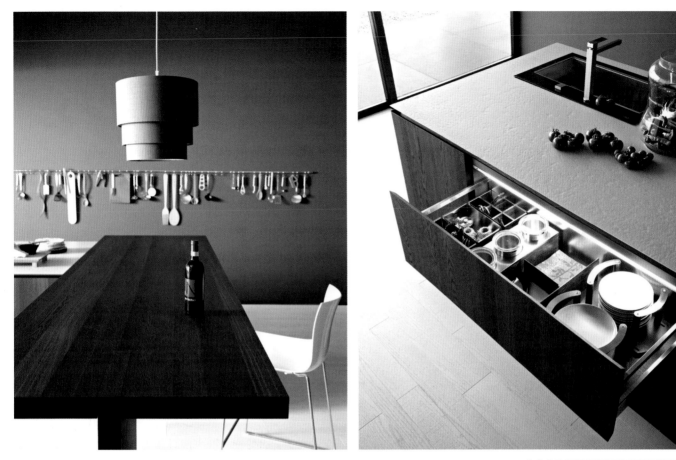

089

LED technology is so practical and simple that it can even be used to provide lighting inside drawers and cabinets.

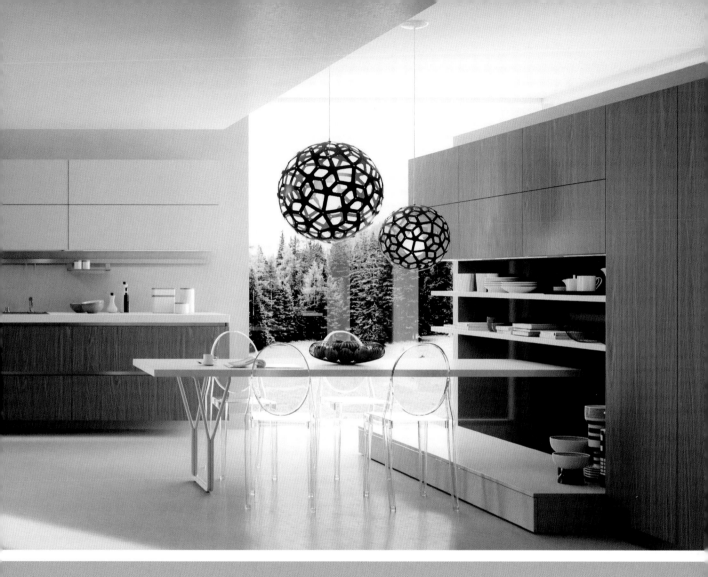

INSPIRATIONS

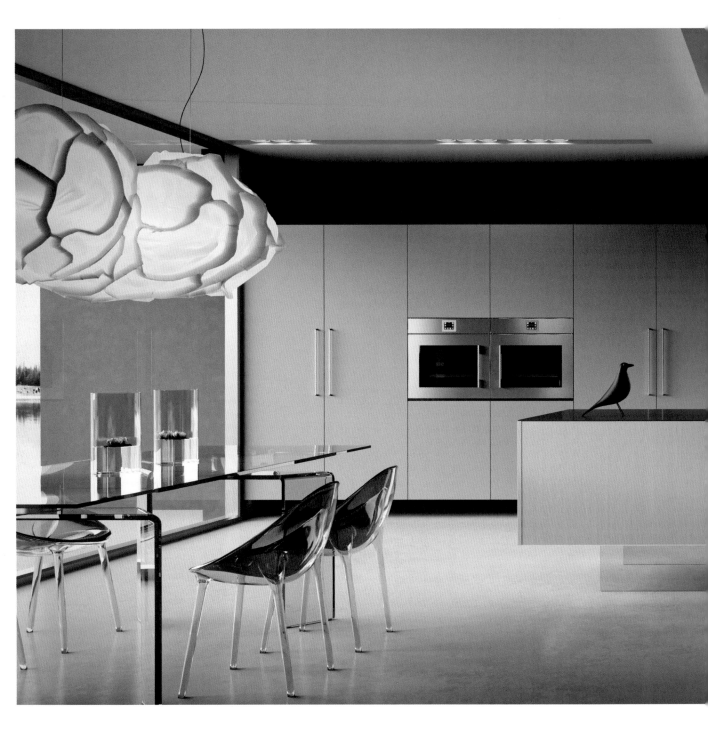

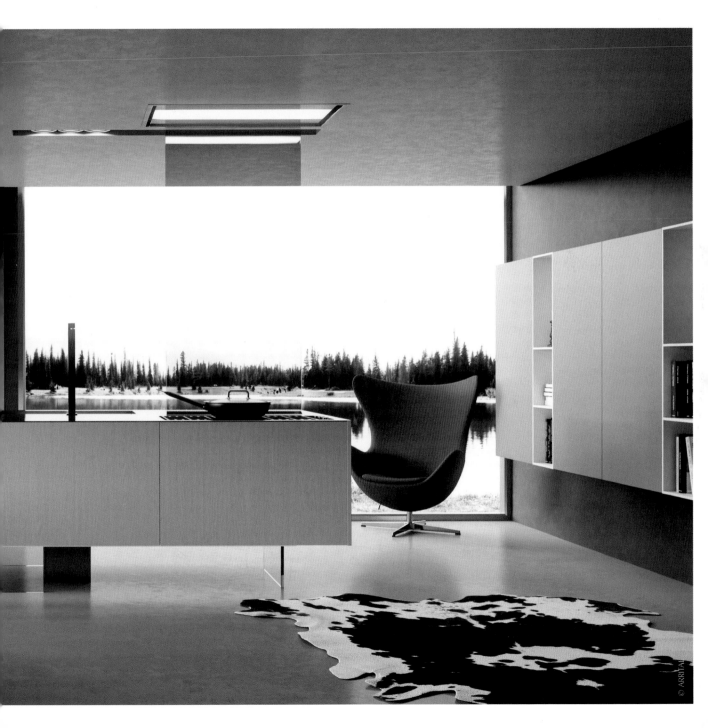

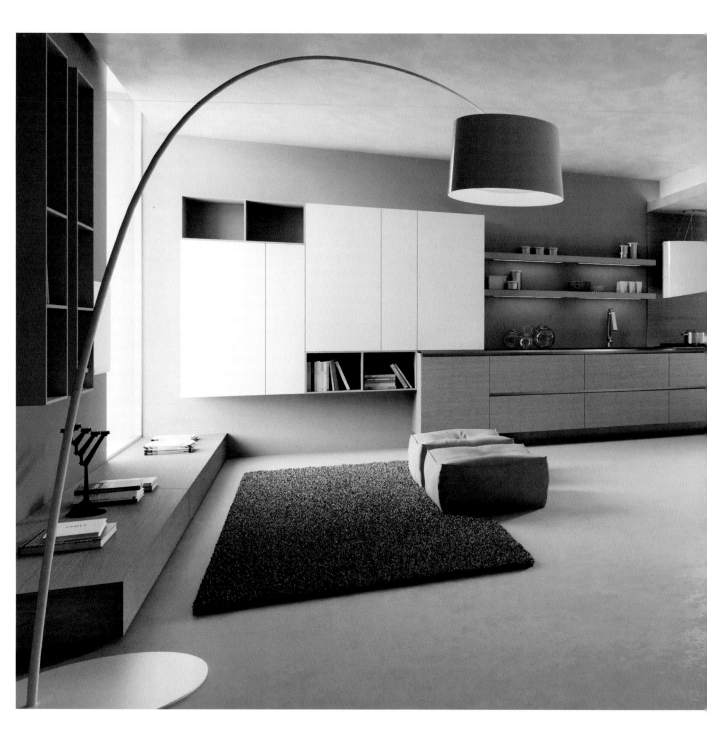

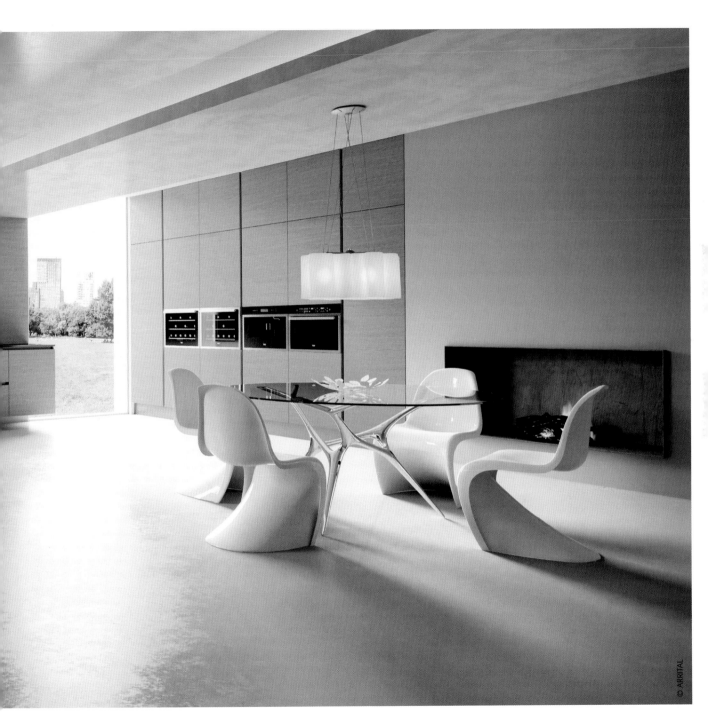

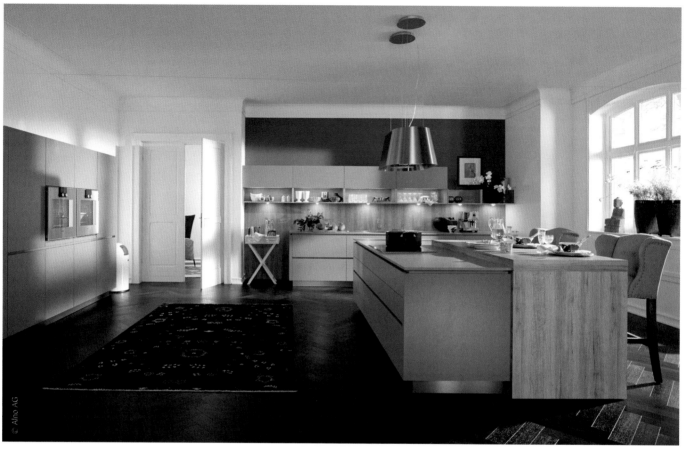

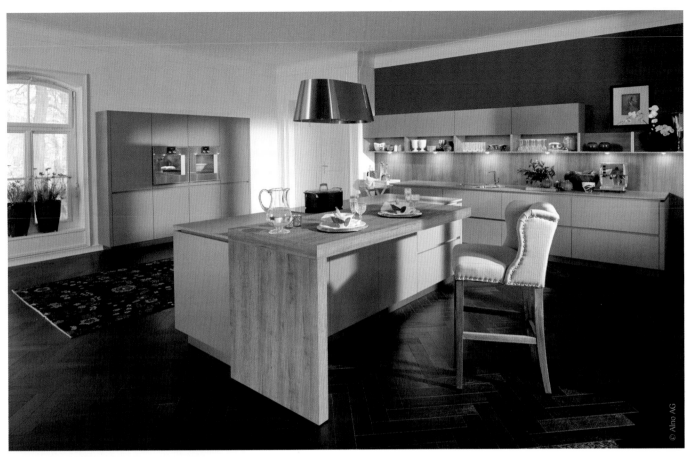

© Alno AG

© Alno AG

090

Open shelving can be used to display the most frequently used items. They facilitate an easy reach.

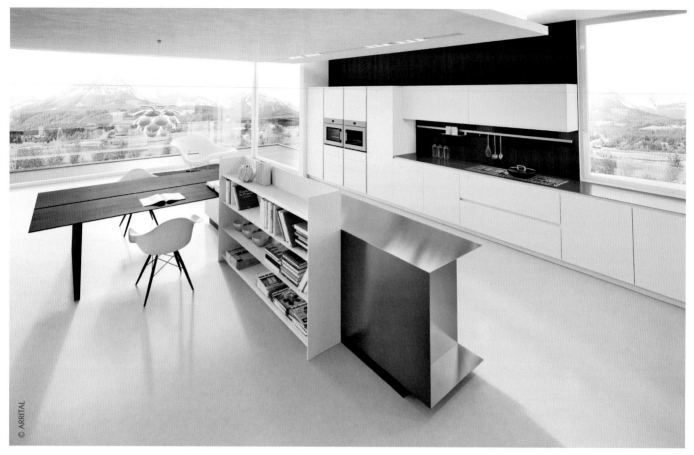

© ARRITAL

091

The elements made from
thin steel plates lighten the
composition while maintaining
strength.

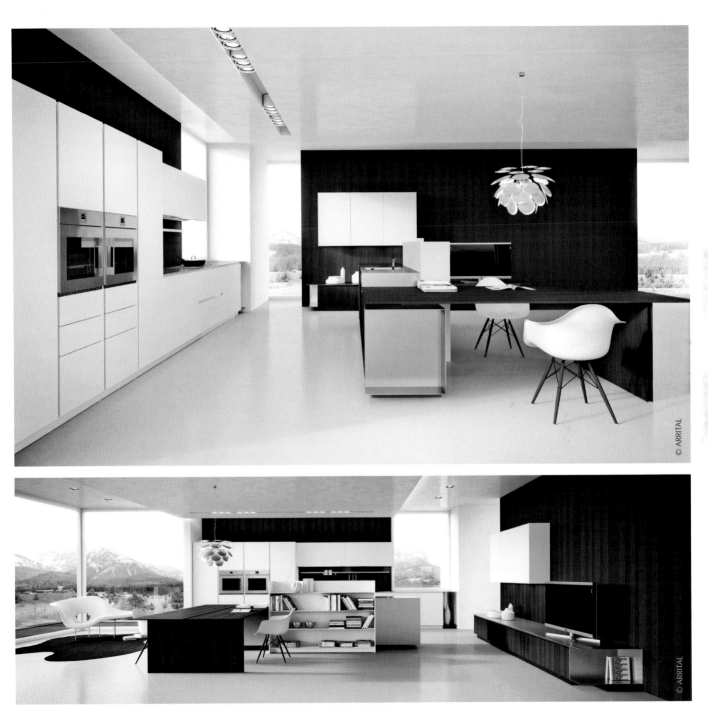

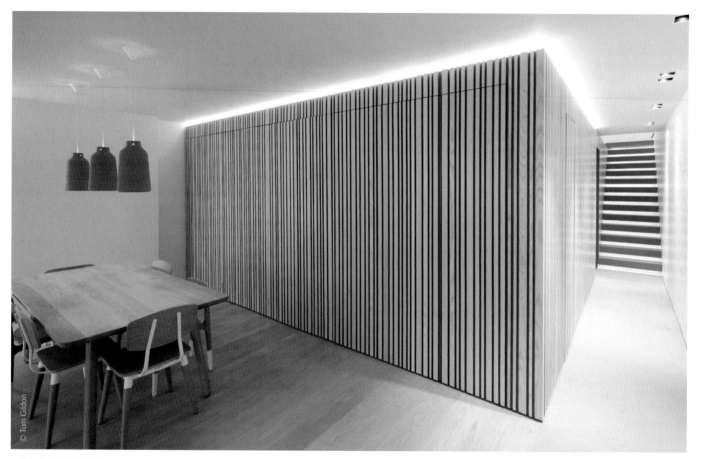

092

The design uses a palette of soft neutral colors and fresh natural materials, wood and stone.

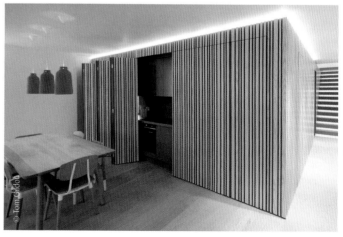

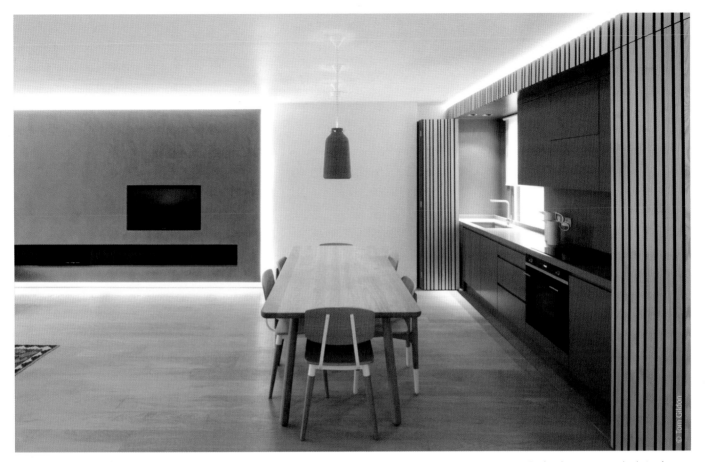

Pocket doors are a good solution for small spaces. In this case, they fold and slide to one corner, hiding or showcasing the kitchen.

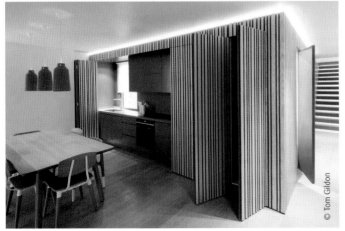

© Tom Gildon

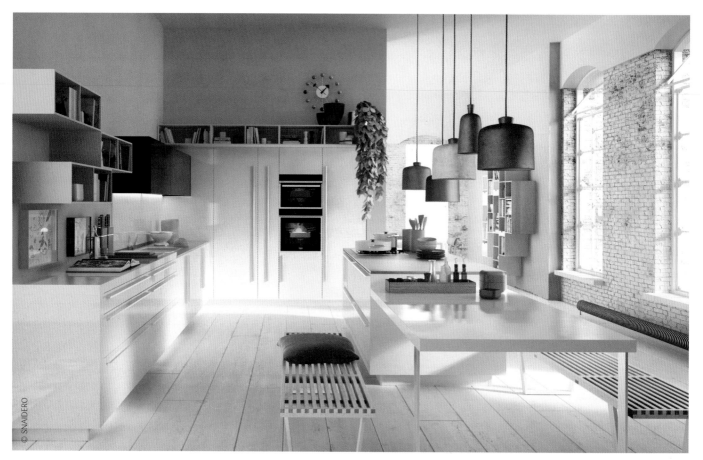

093

Modular furniture allows numerous composition options. They can easily be adapted to any space to suit users' needs.

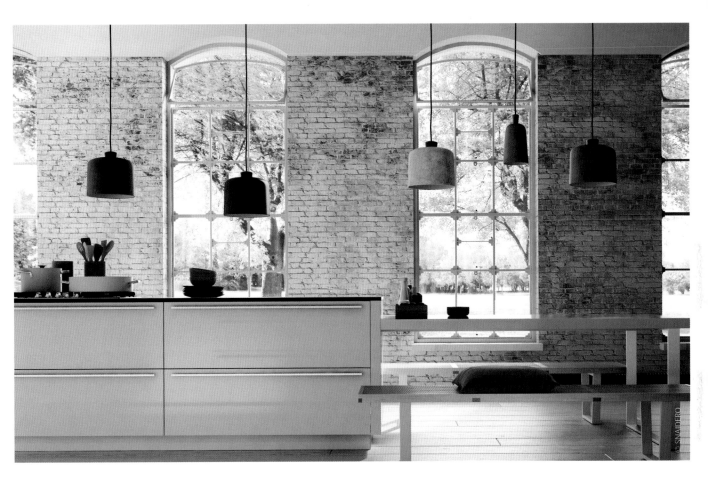

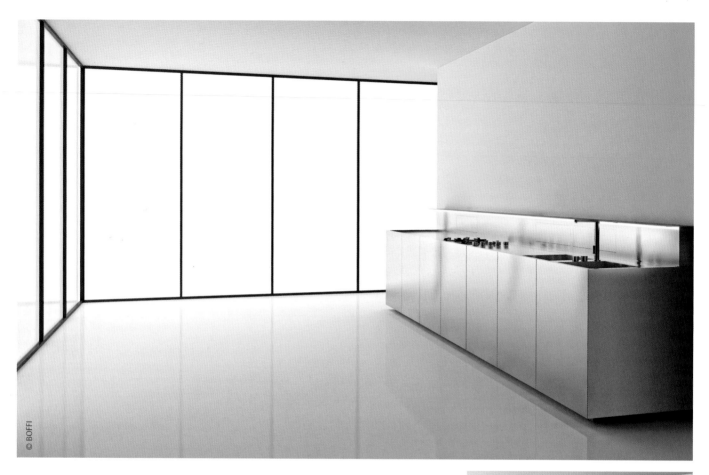

© BOFFI

094

The stainless steel kitchen has a strongly professional aesthetic, is very clean and is easy to maintain.

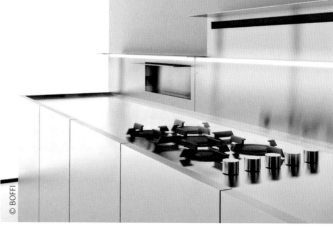

© BOFFI

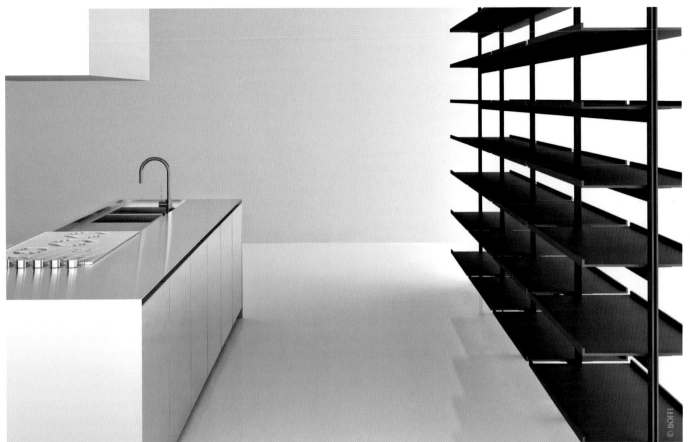

These stylish cabinets are manufactured in heavy-gauge stainless steel for durability and resistance to scratching and chipping, while their smooth clean lines give the kitchen an air of sophistication.

© BOFFI

© BOFFI

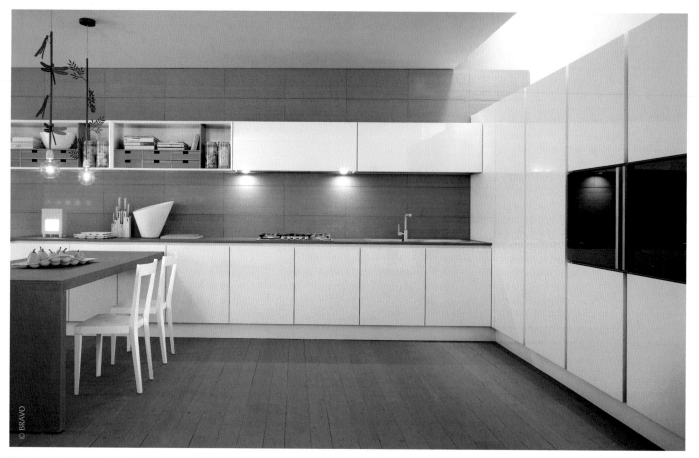

The size and proportion of a kitchen determines the layout of storage and work space. The goal is to optimize the space available and make tasks around the kitchen as efficient as possible.

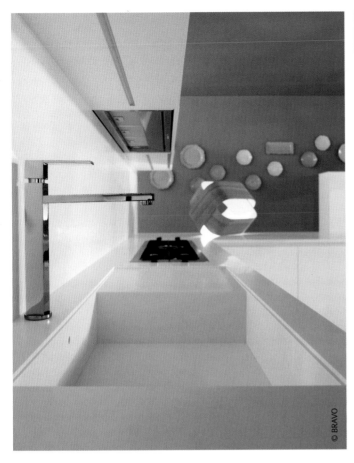

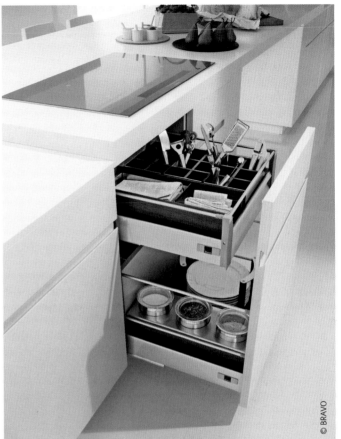

Faucets and storage accessories are items that cannot be disregarded. The lack of attention to these elements can interfere in the efficient use of a kitchen.

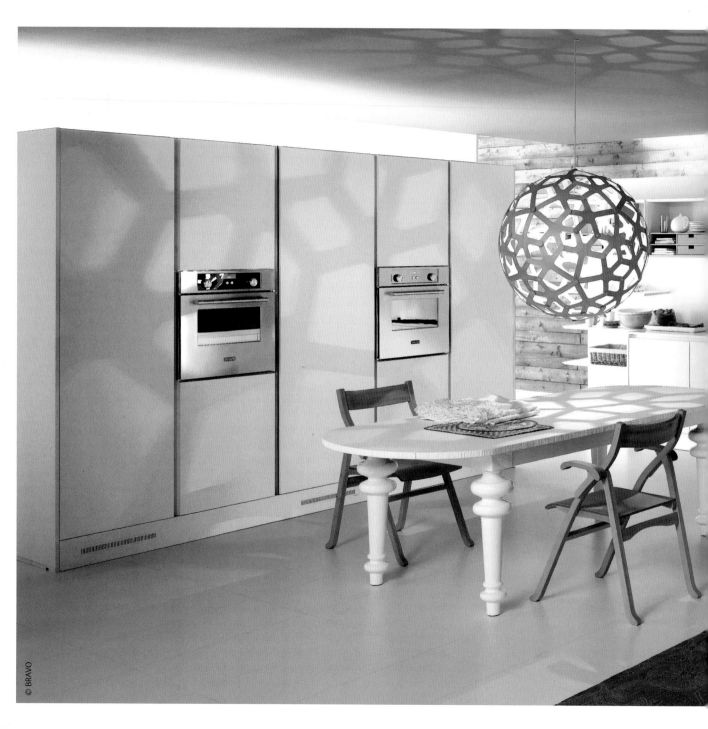

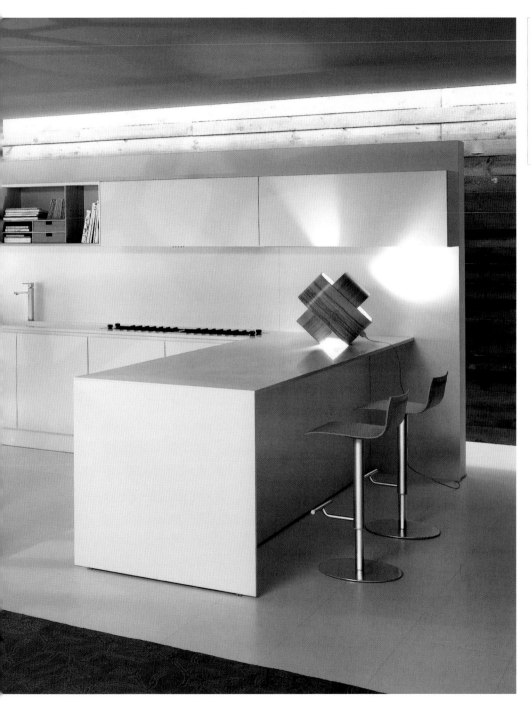

095

As well as providing light within the design, a table lamp is an ideal decorative accessory in the kitchen.

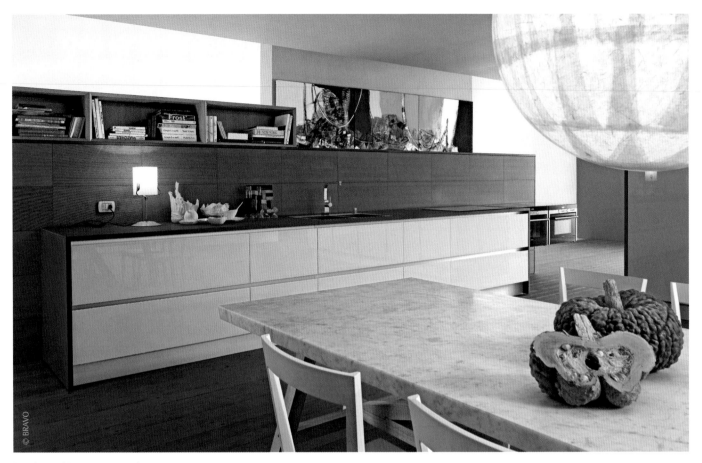

© BRAVO

Low, long cabinets accentuate the
horizontality of a space. Pieces of tall
furniture make a room look higher and
when placed in the middle of a room,
they can act as space dividers.

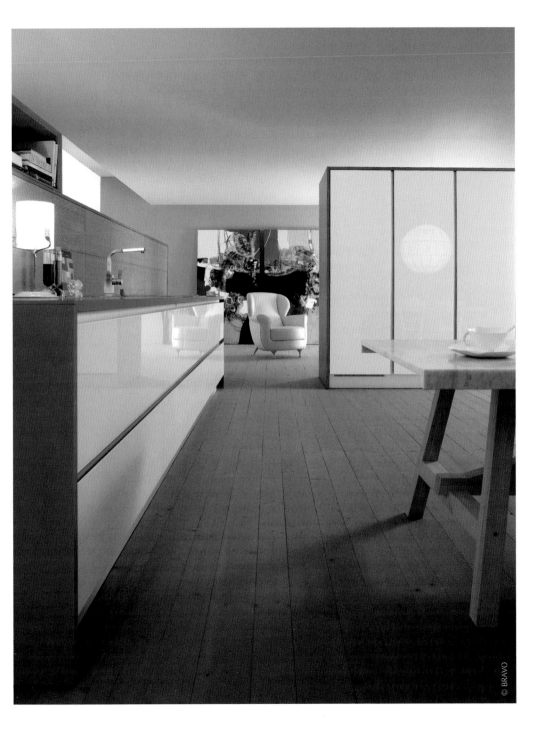

© BRAVO

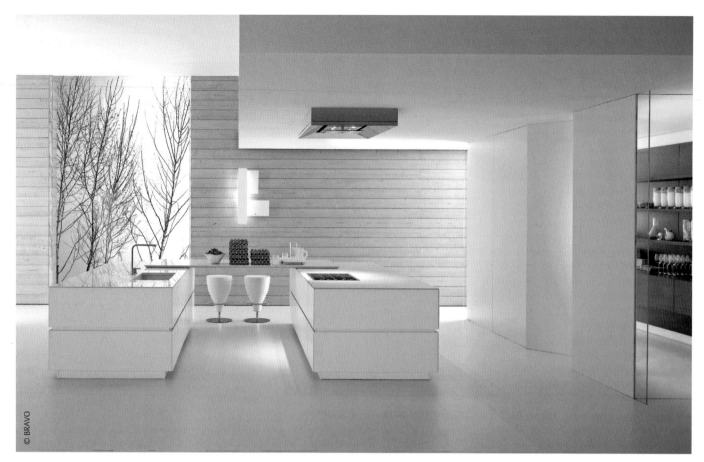

096

Installing two islands with different functions makes work easier and frees up space on the walls.

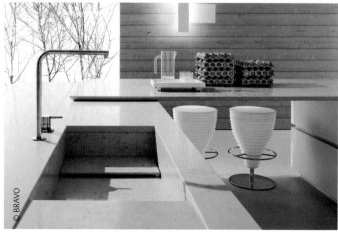

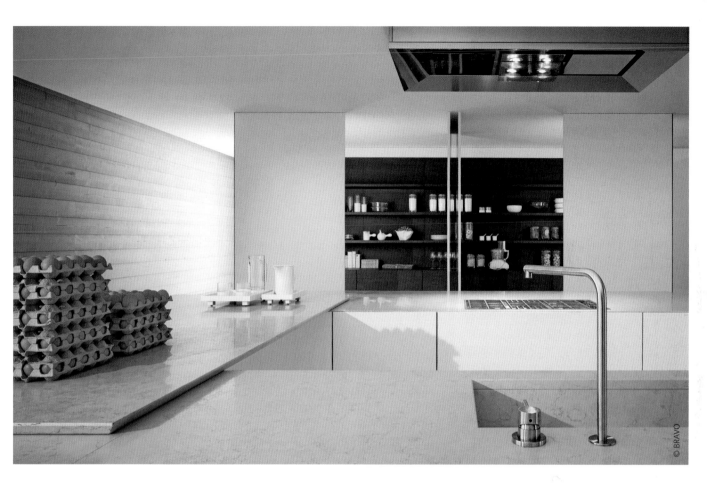

© BRAVO

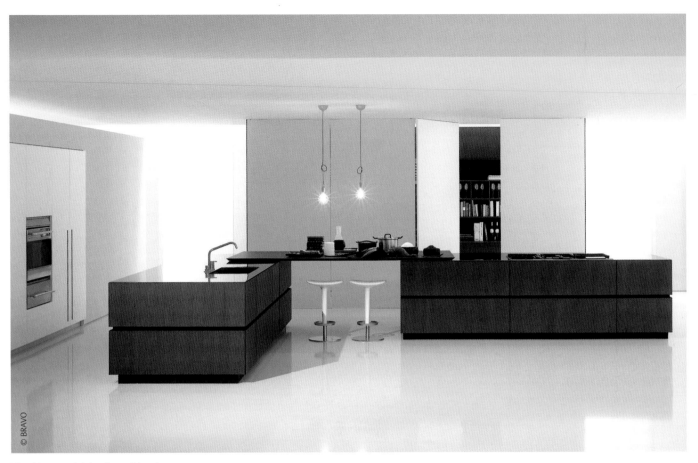

Wood is a material that fits traditional
and contemporary kitchen design.
The richness of its grain adds warmth
to a monochromatic scheme, while
creating a striking effect.

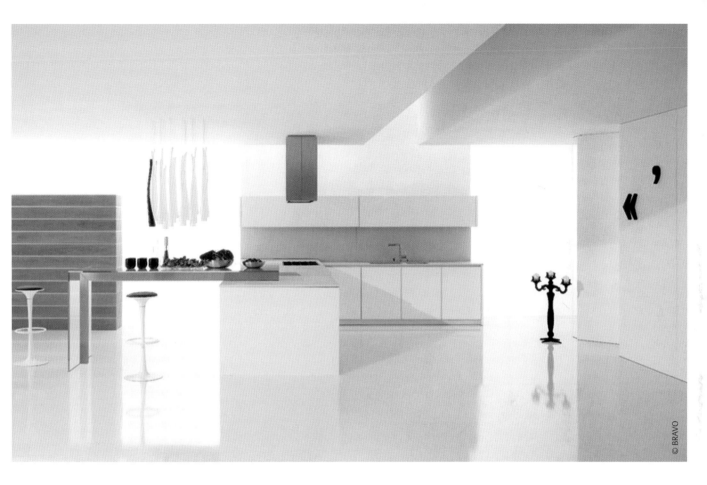

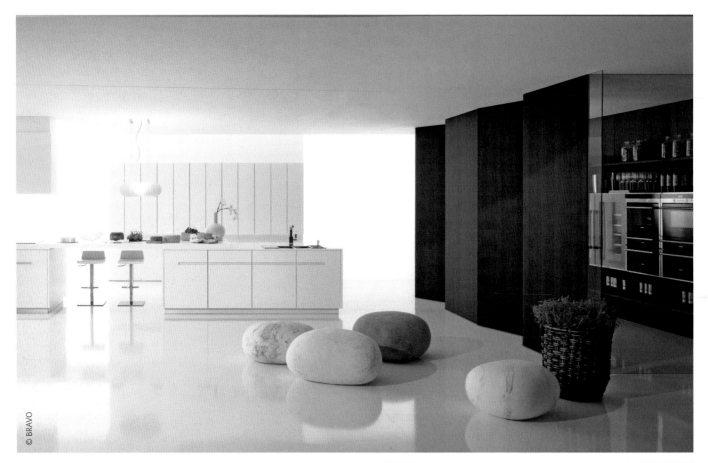

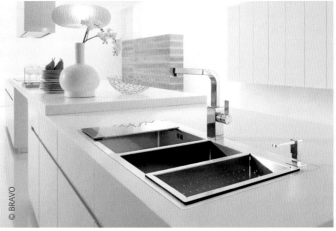

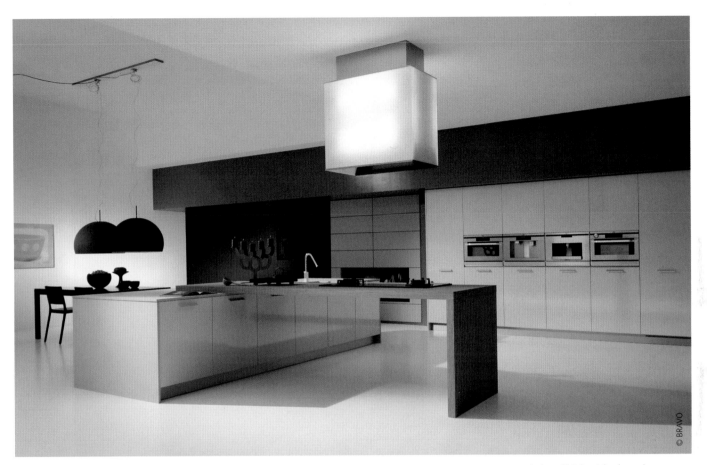

© BRAVO

L-shaped kitchen islands can be a study of creative composition. Heavy versus light or solid versus open pair with material combinations. The result is a piece of kitchen equipment that is as sleek as it is functional.

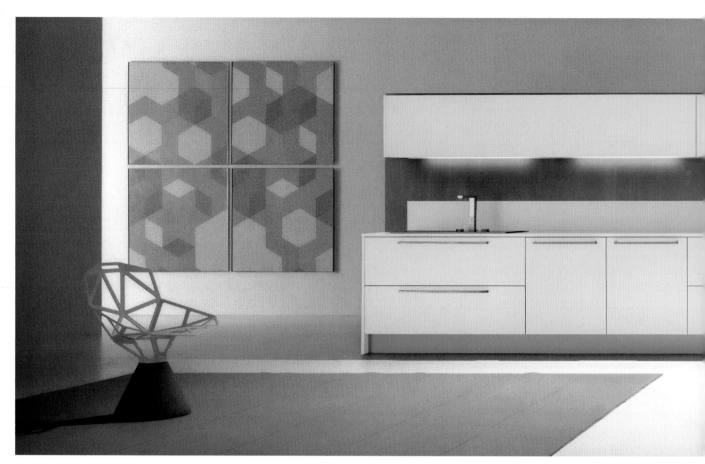

097

Fine classic materials such as marble also have a place in the modern kitchen, lending an air of sophistication.

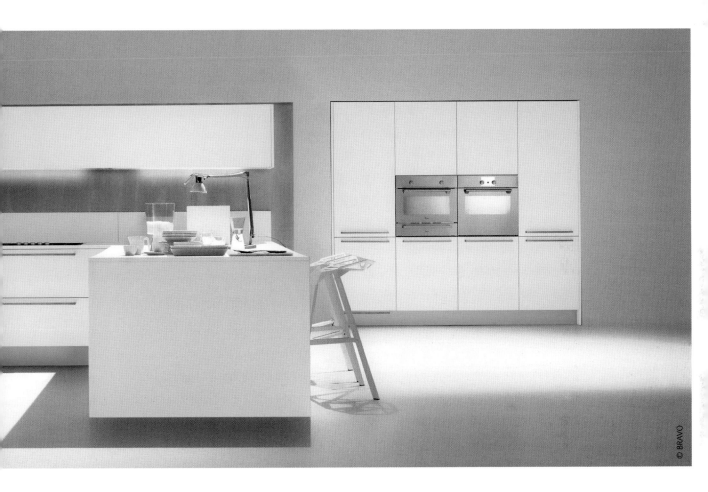

Dark colors are becoming increasingly common in the kitchen, although knowing how to combine them is key.

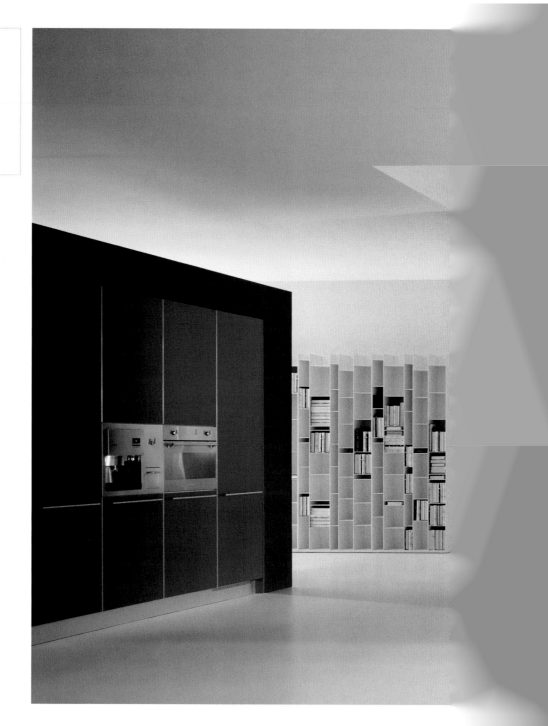

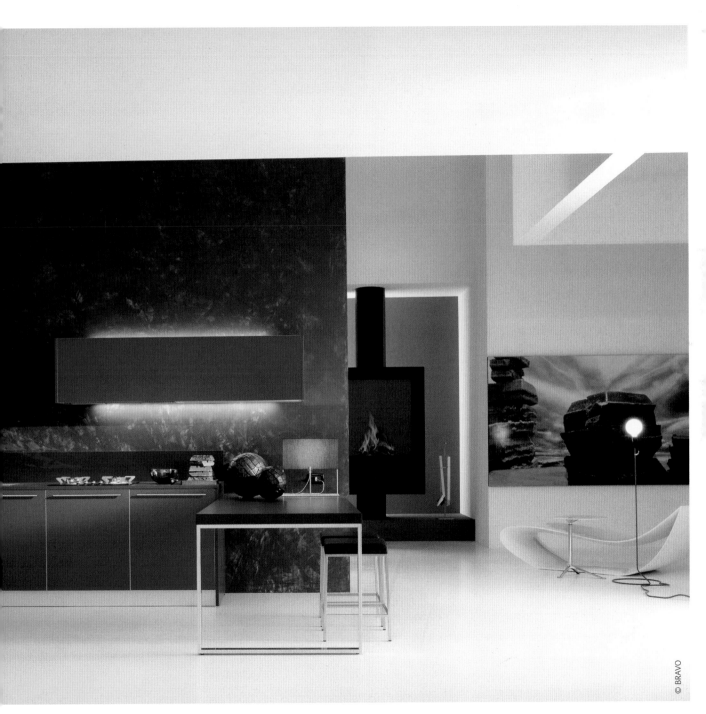

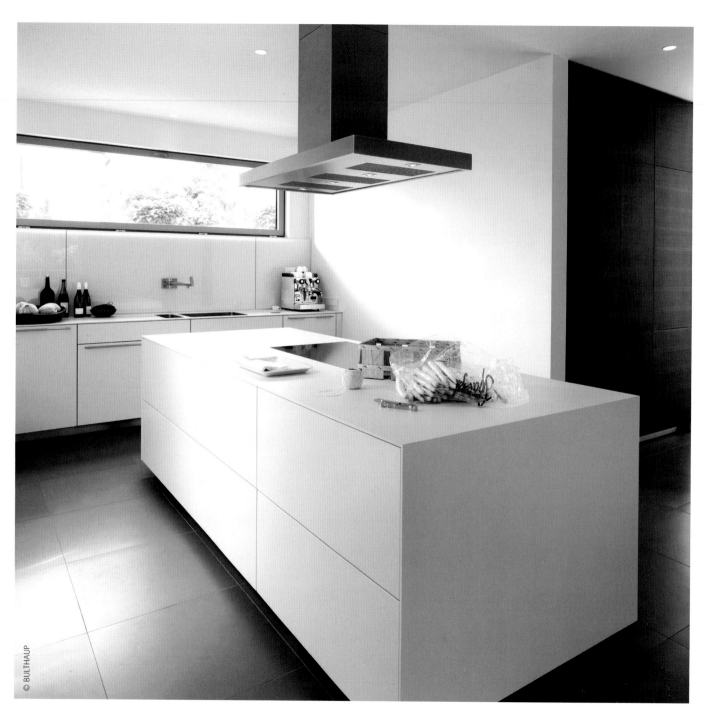

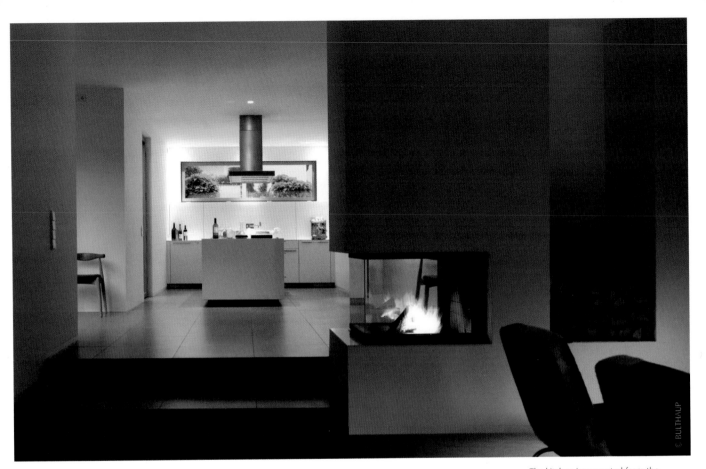

The kitchen is separated from the
living room by two steps. The functions
are therfore separated, but visually
connected. The fireplace at one side
of the steps acts as a focal point
between the two spaces.

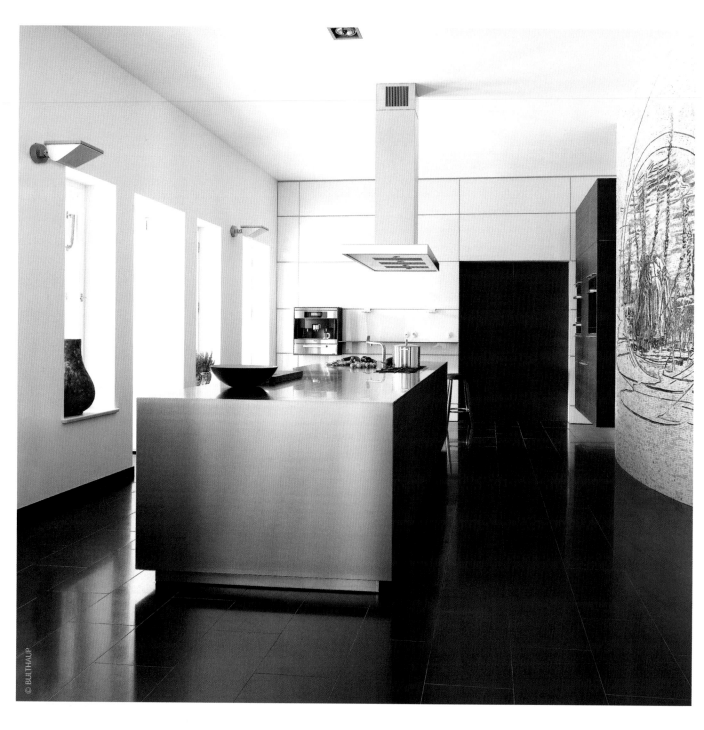

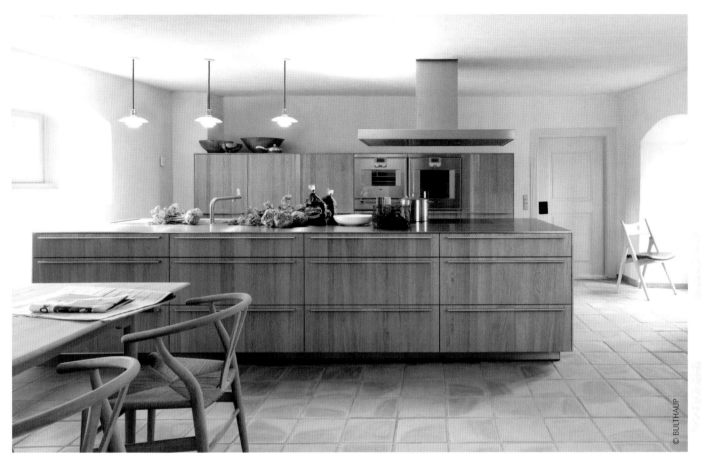

© BULTHAUP

The light wood of the kitchen cabinets adds a natural touch to the rustic look of the room. The classic Wishbone chairs by Hans Wegner in the same natural wood tone complement the decor.

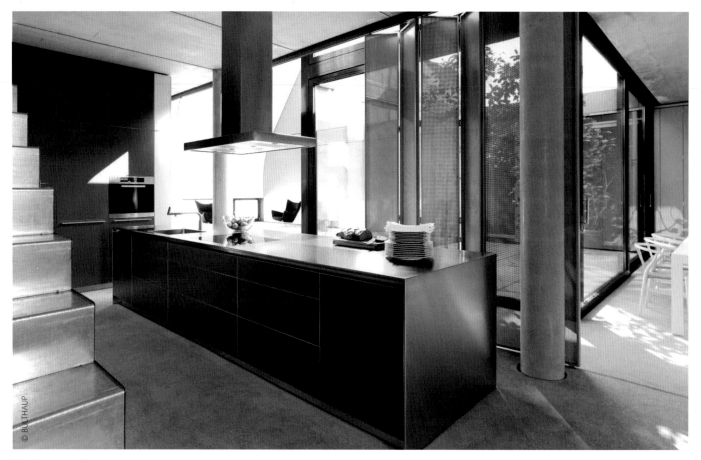

This kitchen benefits from abundant
natural light, which can be filtered by
means of a folding screen to avoid glare.

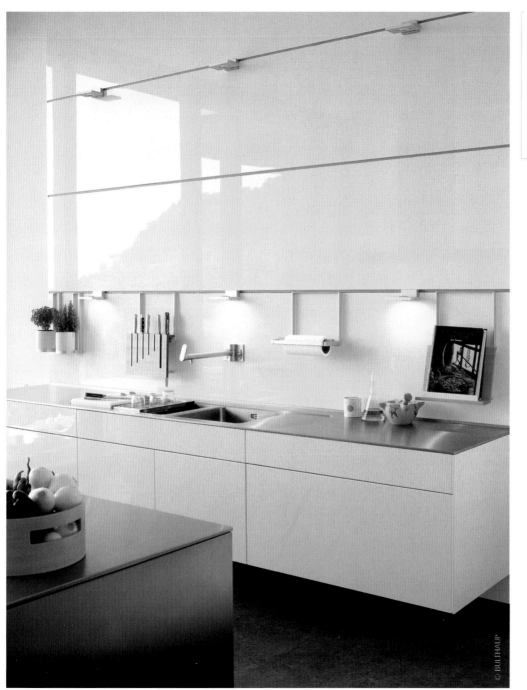

099

Units, worktop, faucets, appliances and accessories can be hung on the functional wall.

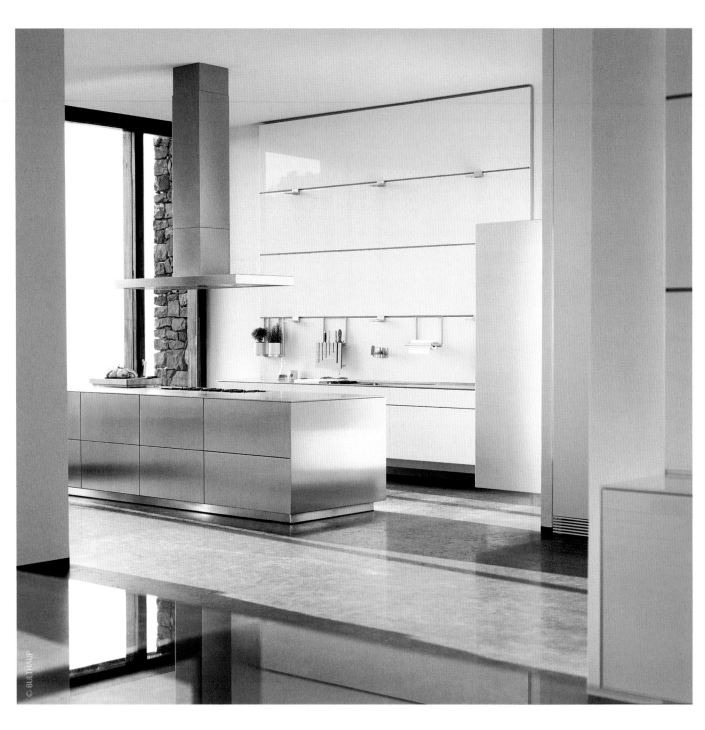

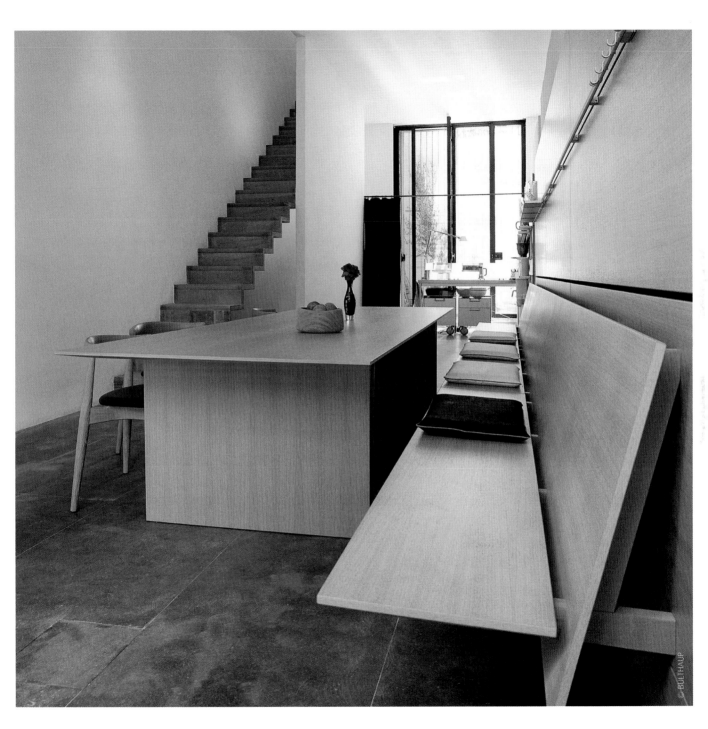

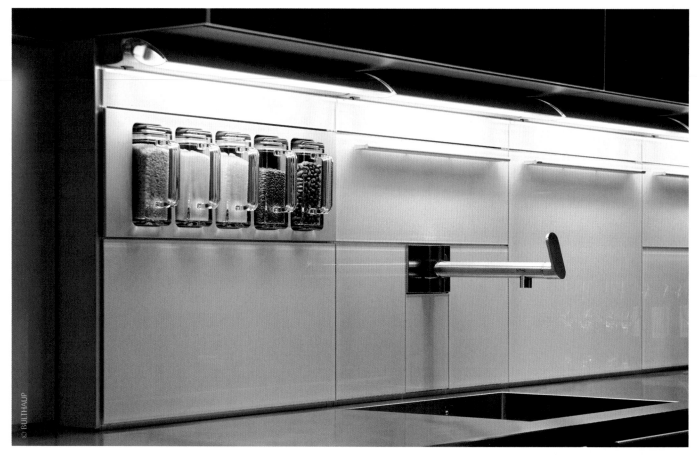

© BULTHAUP

100

Everything is ordered and nothing distracts attention from the pure and elegant shapes of these functional Bulthaup boxes.

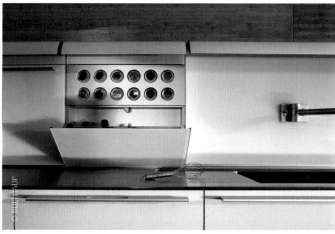

© BULTHAUP

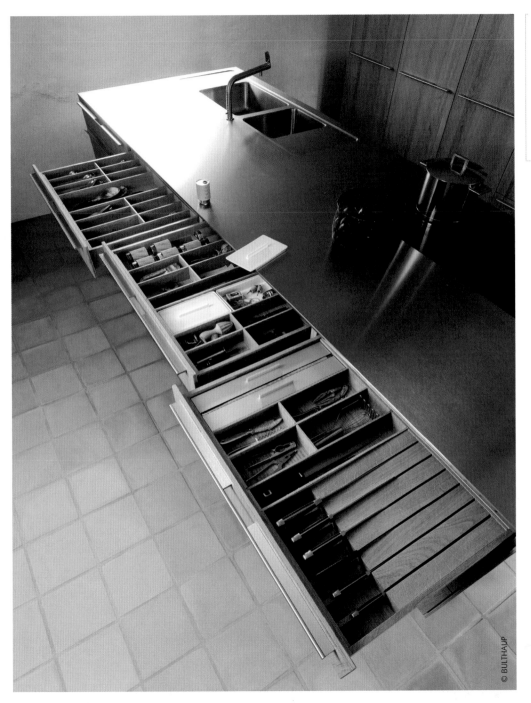

Add a touch of stylish functionality to your kitchen with convenient drawer fittings. An organized kitchen contributes to making tasks easier and more efficient.

© BULTHAUP

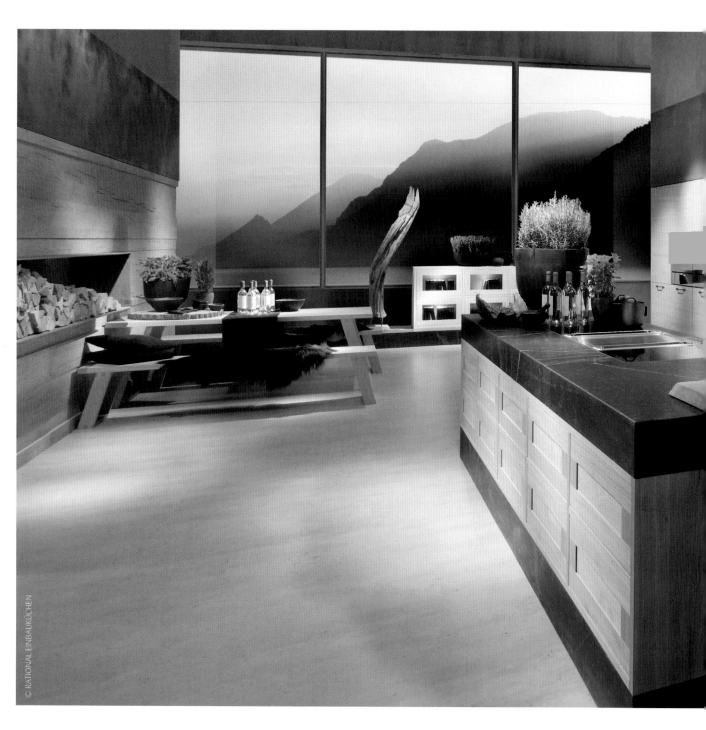

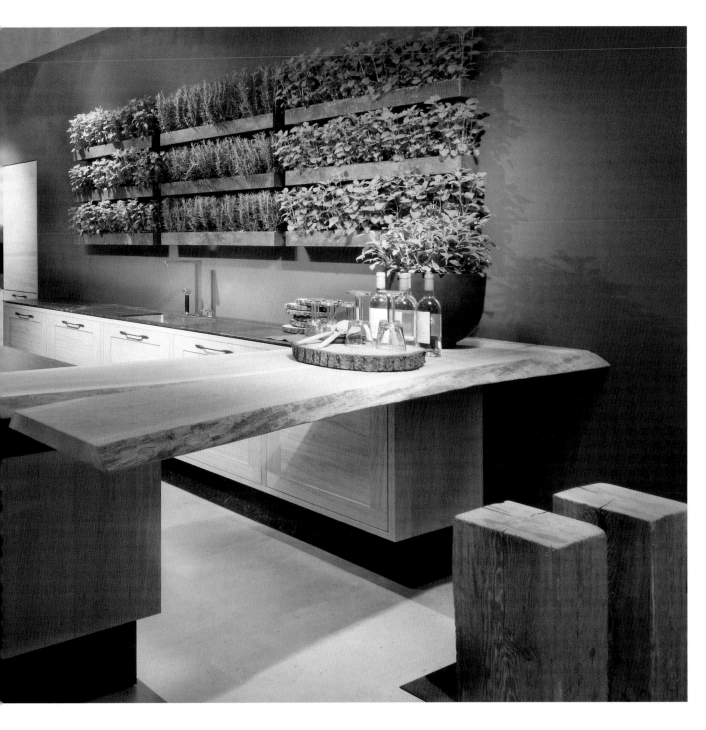

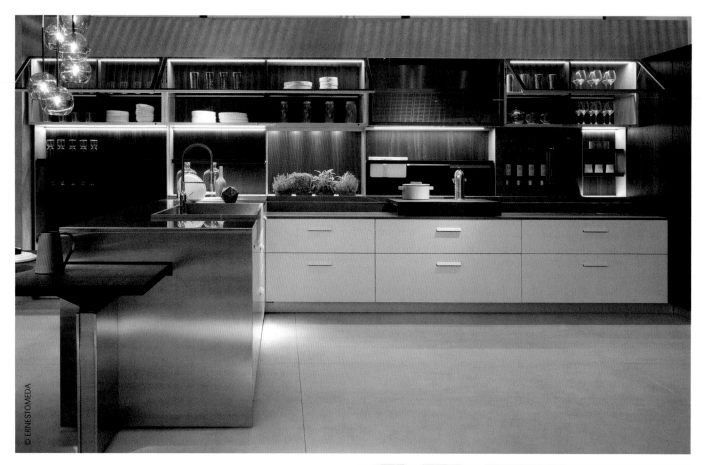

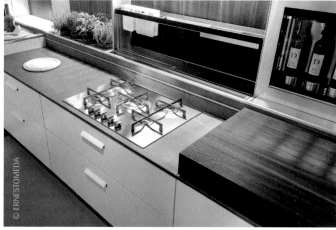

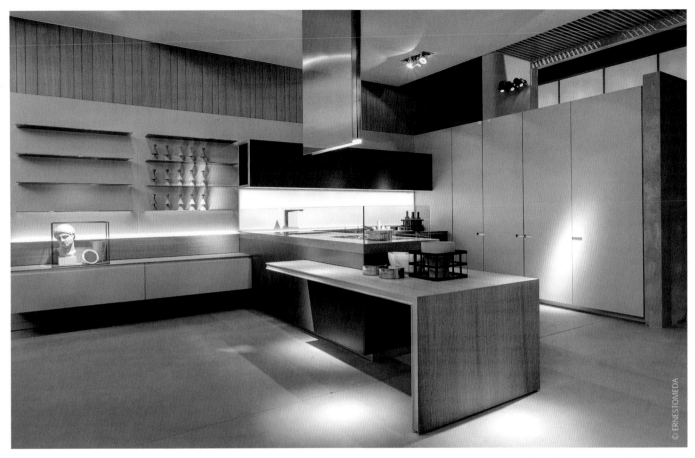

The kitchen countertop is fitted with a glass backsplash on two sides. This solution avoids splashing and spillage on the attached dining/work table without blocking the view.

A kitchen island with an attached dining table is a space saver since the table can also be used as an extra work surface. This makes it an excellent solution for small apartments, but also large goumet kitchens often feature this design option.

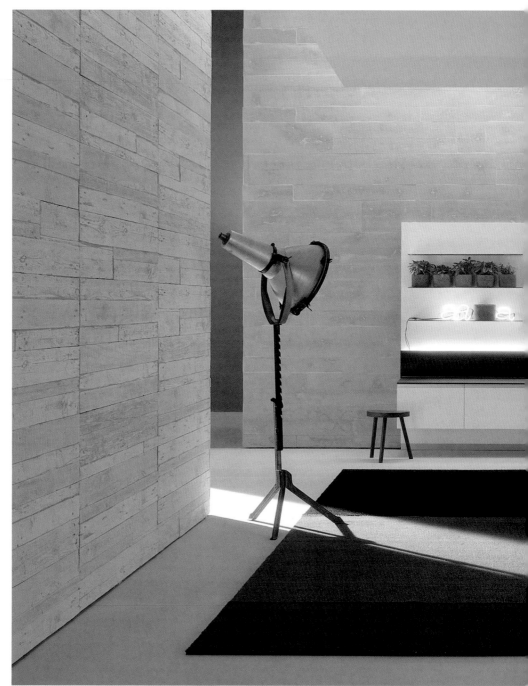

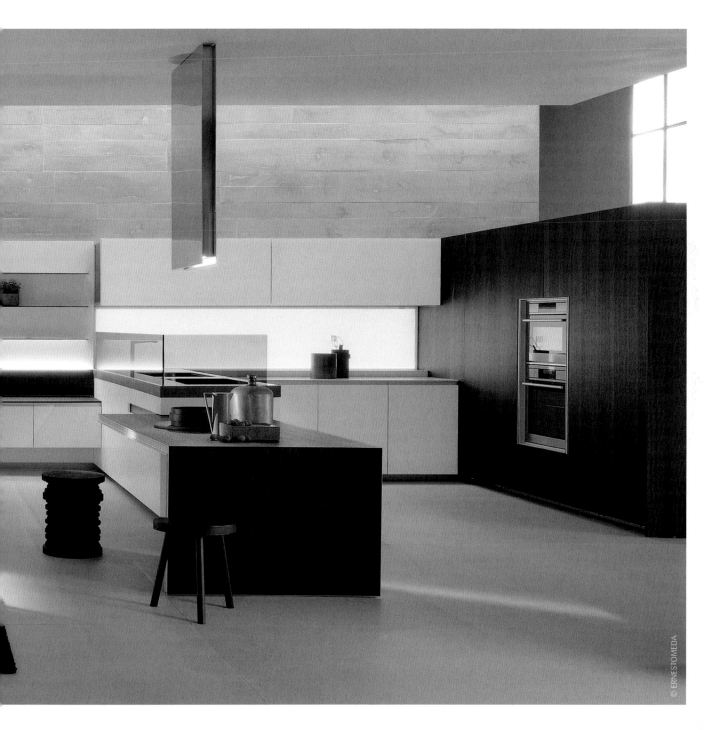

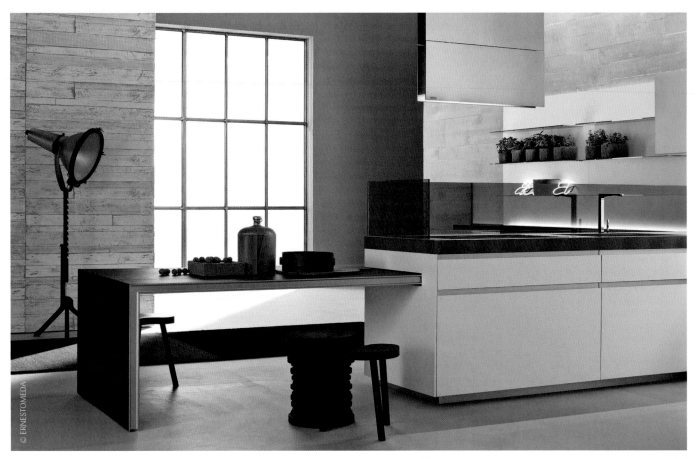

102

Concrete countertops can be cast to incorporate a sink seamlessly. Made in one piece, countertops with sinks are fully sealed and watertight.

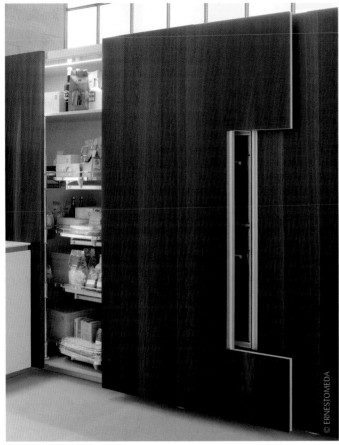

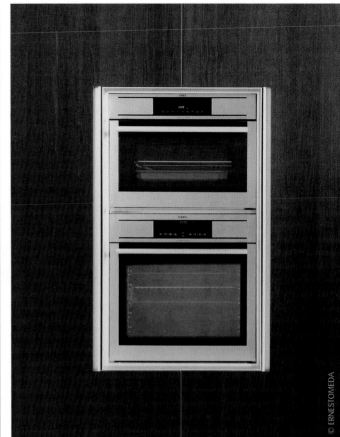

© ERNESTOMEDA

© ERNESTOMEDA

103

Cabinets with trellis doors allow for the installation of appliances that are visible within a particular section of the unit.

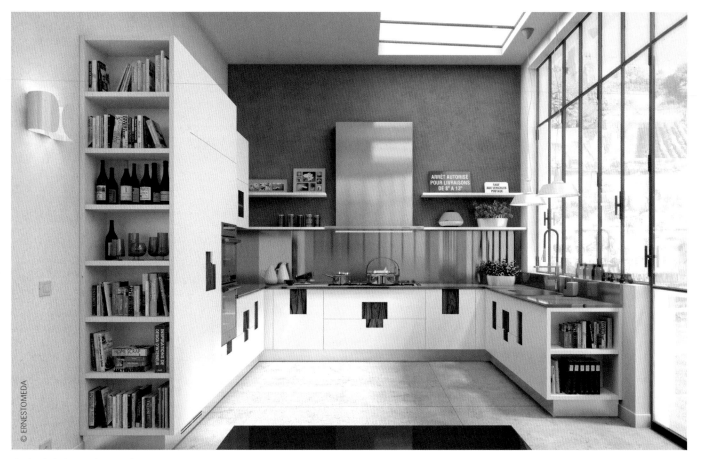

The book shelves at the end of these kitchen cabinets make for a good transition between the kitchen and the living area. Note the natural wood insets on the cabinet fronts.

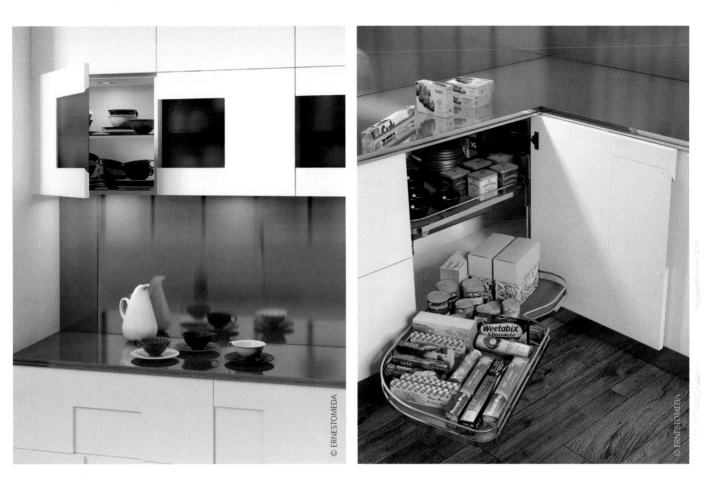

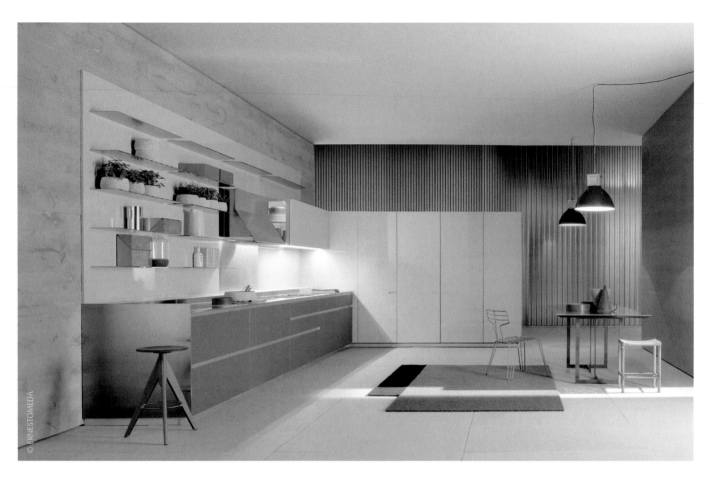

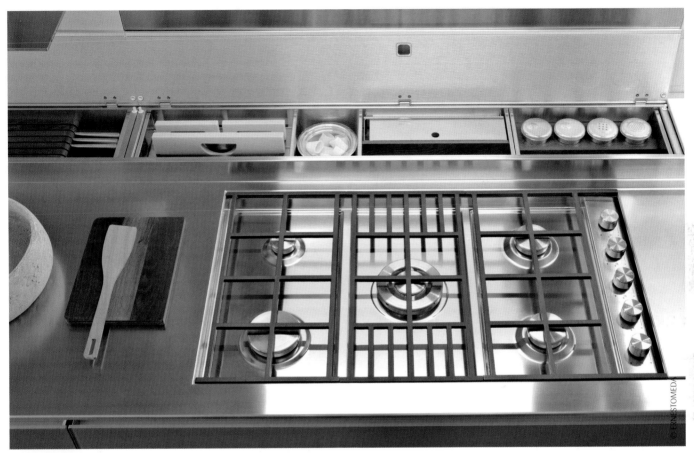

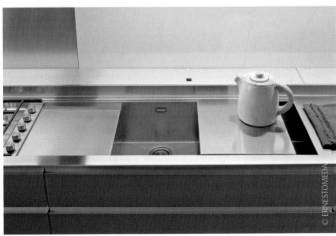

104

Besides optimizing the space, the rear organizer provides easy access to everything you need to use.

Large built-in wine coolers are available for the wine connoisseurs who don't have a cellar or simply want to have their collection within easy reach.

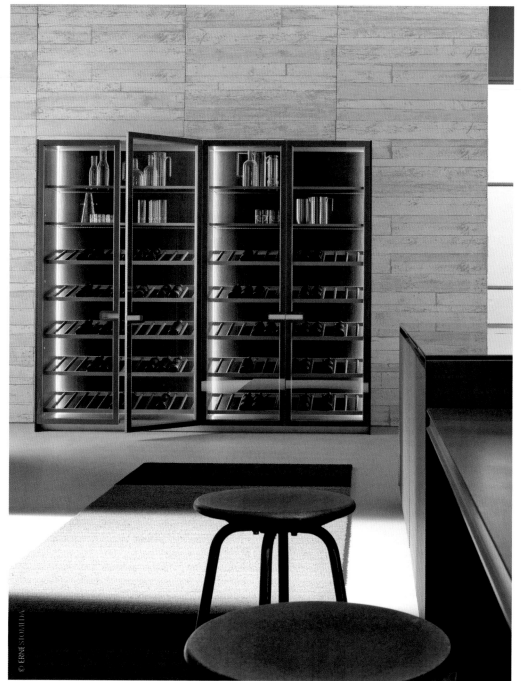

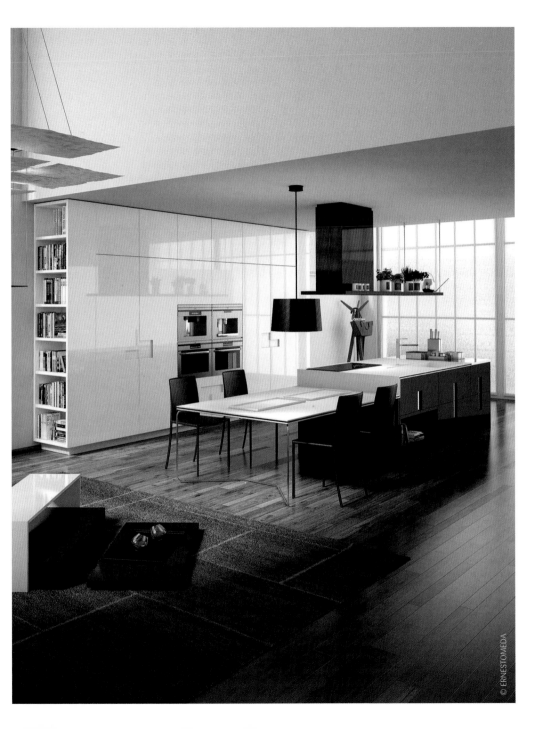

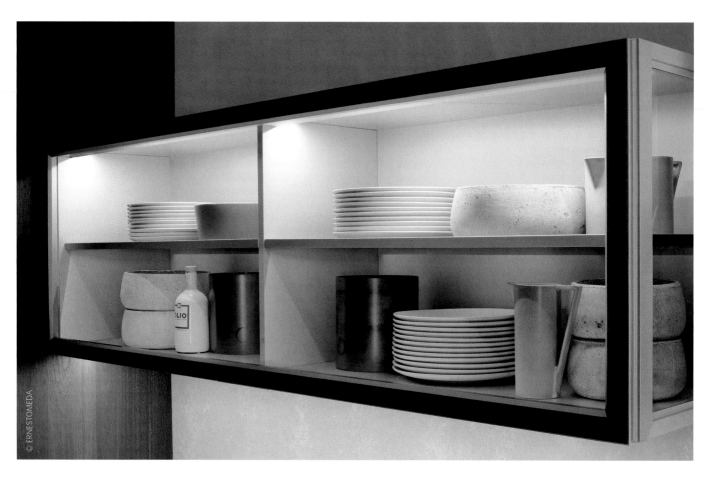

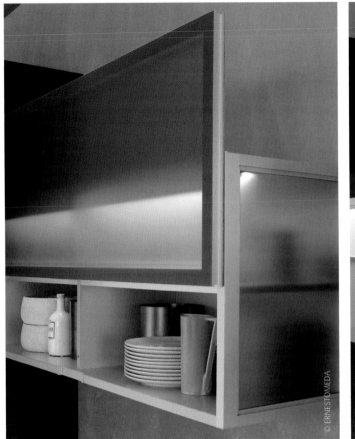
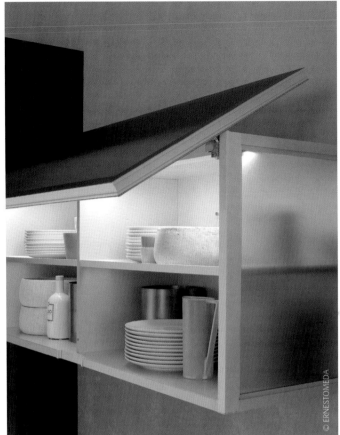

105

The natural movement of working in the kitchen is not inhibited thanks to the door's combination of sliding and rotational opening.

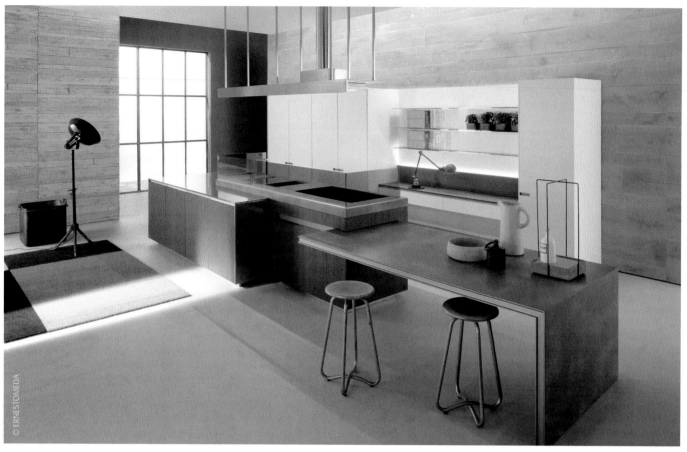

© ERNESTOMEDA

106

The extendable bar is ideal for snacking when closed or as a long dining table when open.

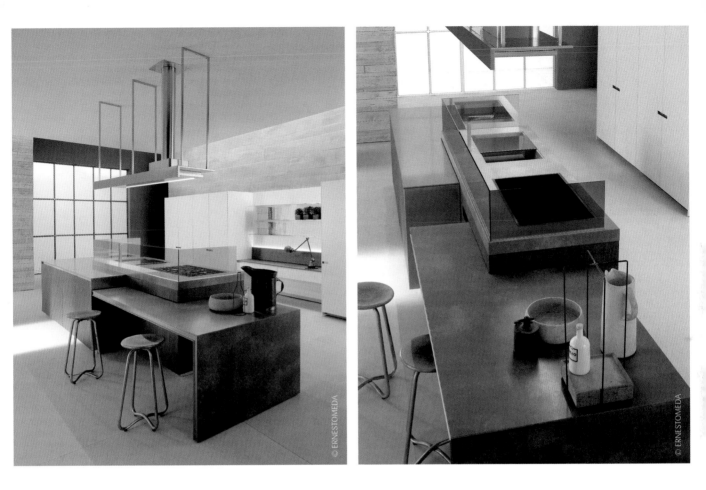

© ERNESTOMEDA

© ERNESTOMEDA

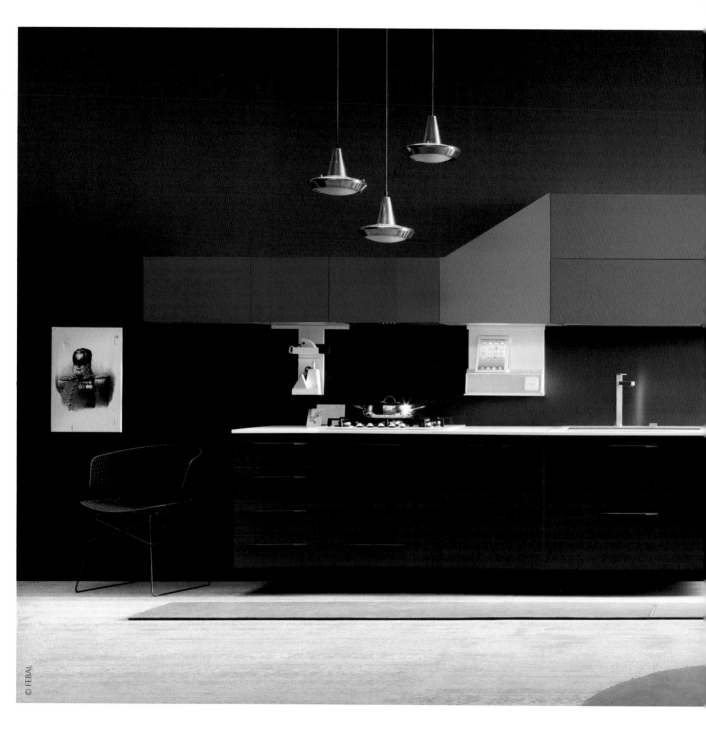

© FEBAL

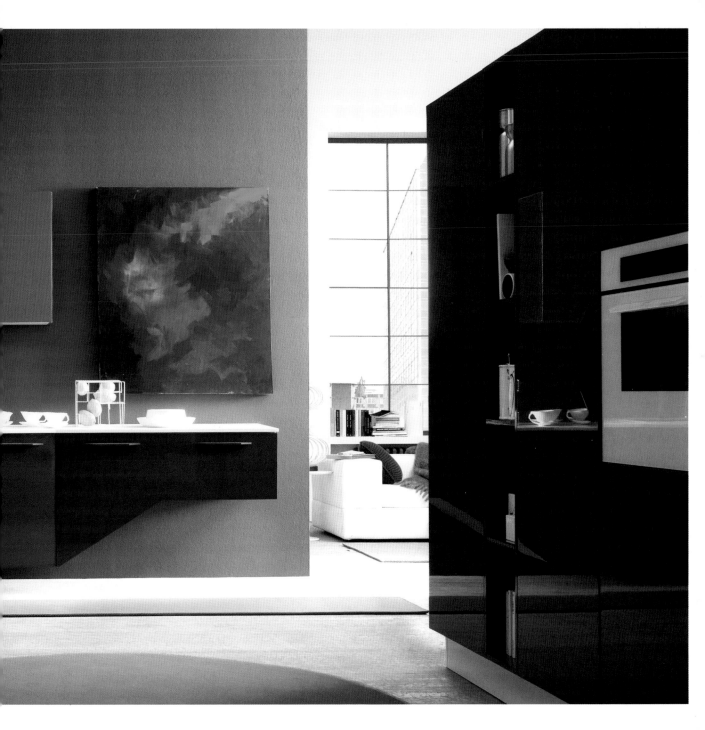

Color is synonymous with fun.
With creativity and imagination
you can create elegant and
bold color combinations.

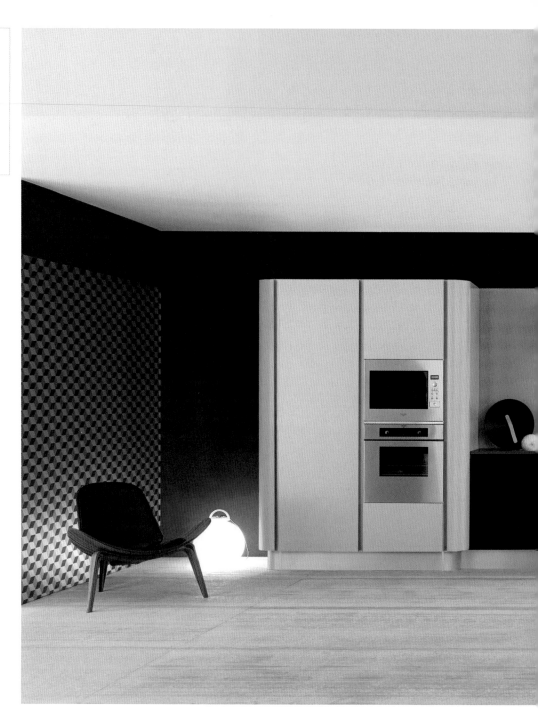

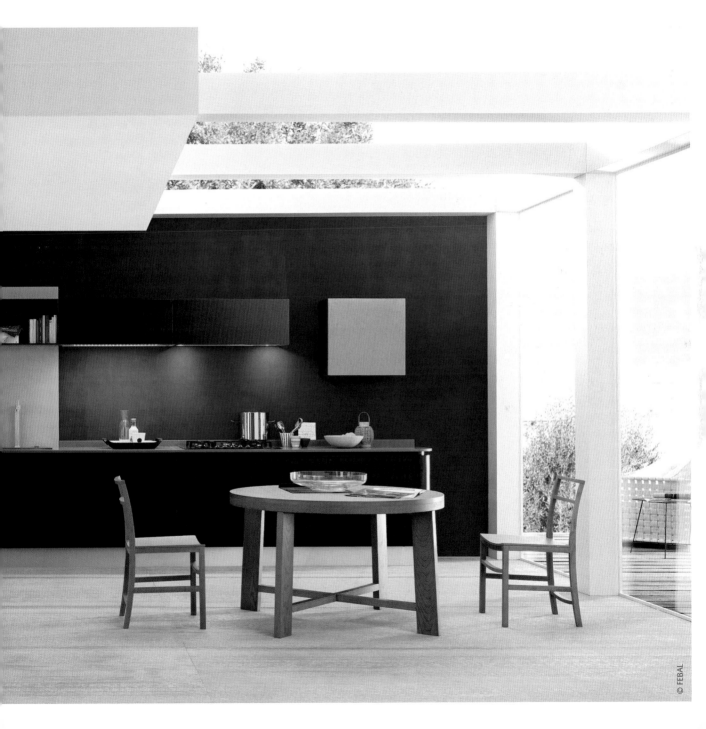

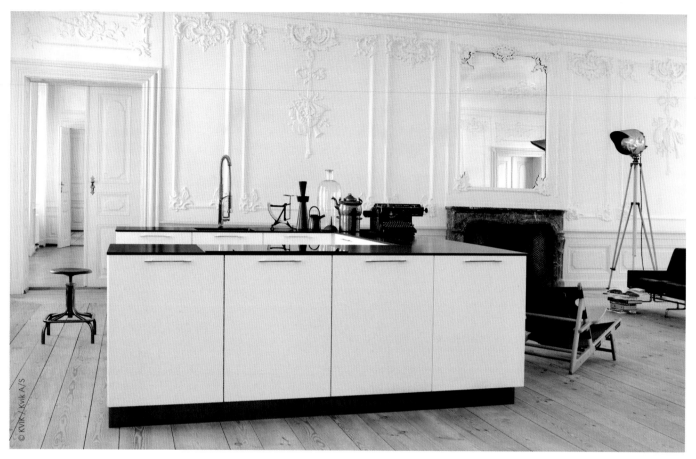

© KVIK / Kvik A/S

108

Everything you need in the
kitchen can be accommodated
in this U-shaped island while
leaving the walls free
of furniture.

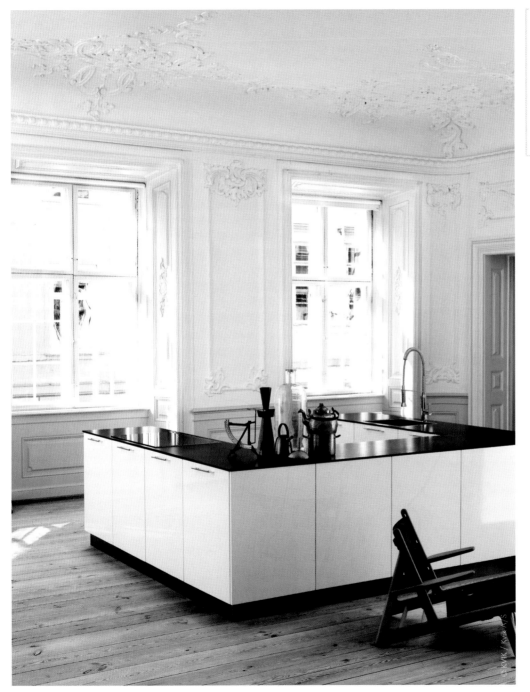

The contrast between the white of the kitchen and the black of the worktop is perfect in classic environments.

This black-and-white color scheme creates a bright and lively atmosphere. It is accented by the warm touch of the table underside.

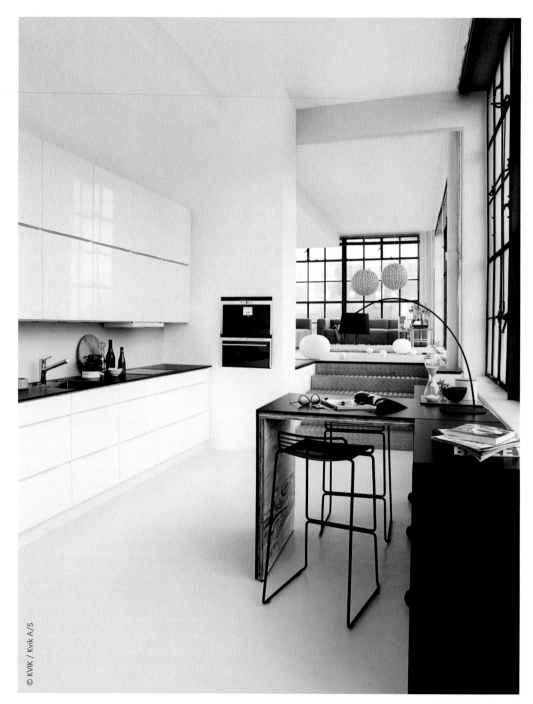

© KVIK / Kvik A/S

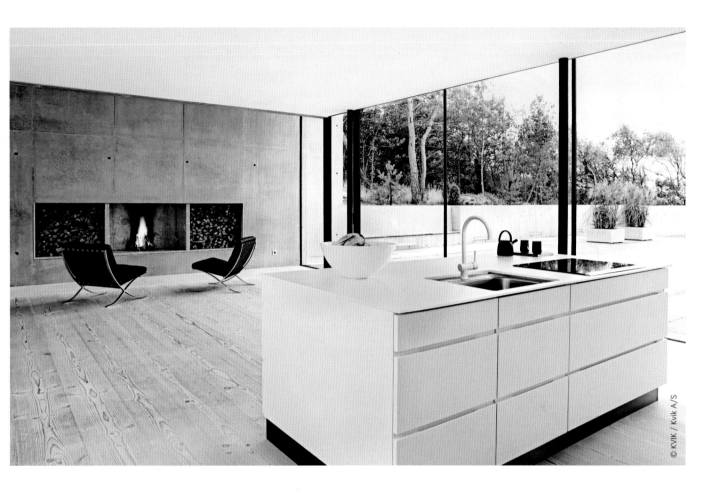

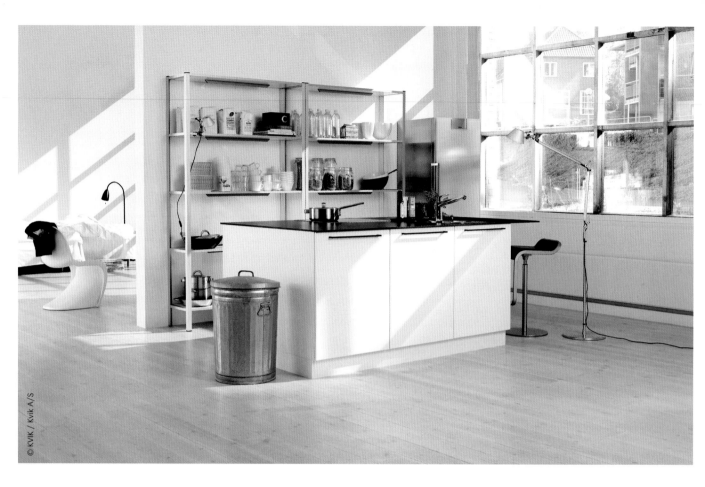

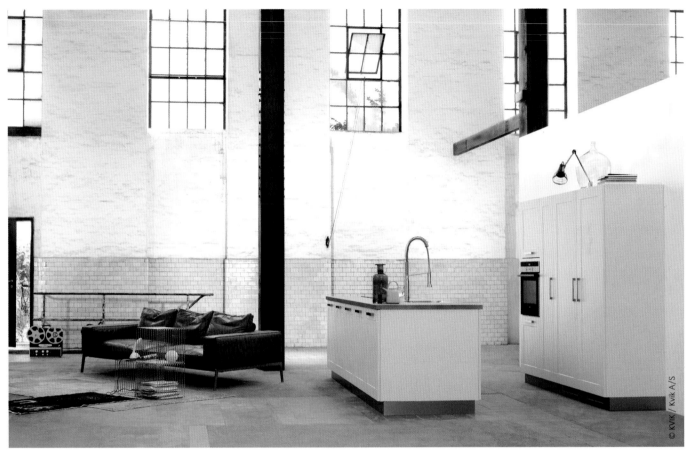

© KVIK / Kvik A/S

The sleek design of the kitchen furniture contrasts with the rough industrial look of the space. The off-white subway tile wainscot is a material often found in kitchens that in this context helps the integration of the furniture.

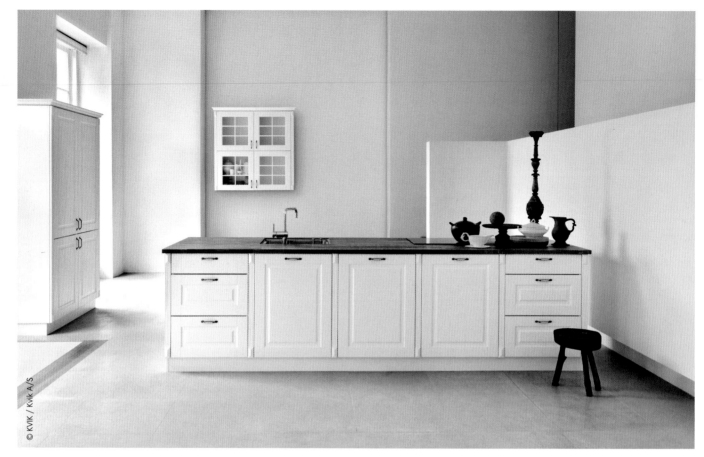

110

Space is essential in an open kitchen: a few well-placed elements will ensure the décor is not visually compromised.

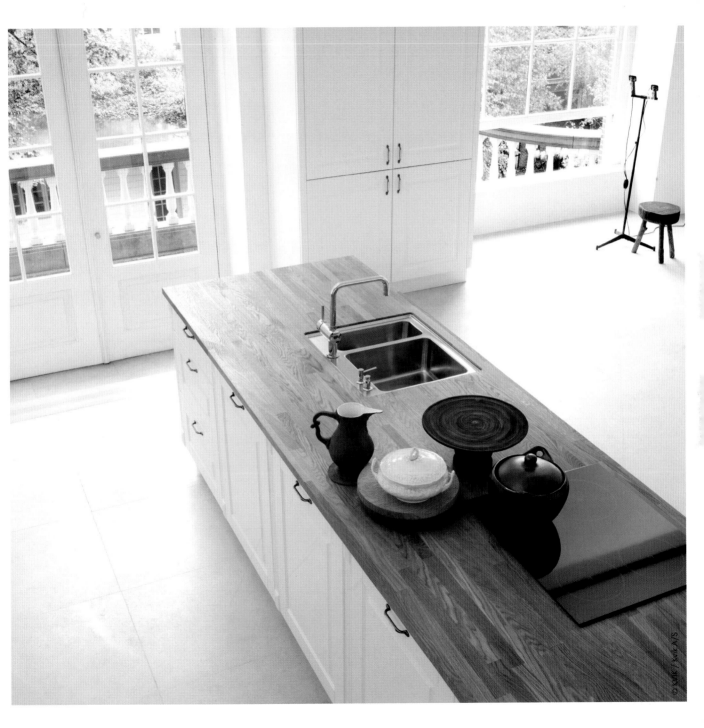

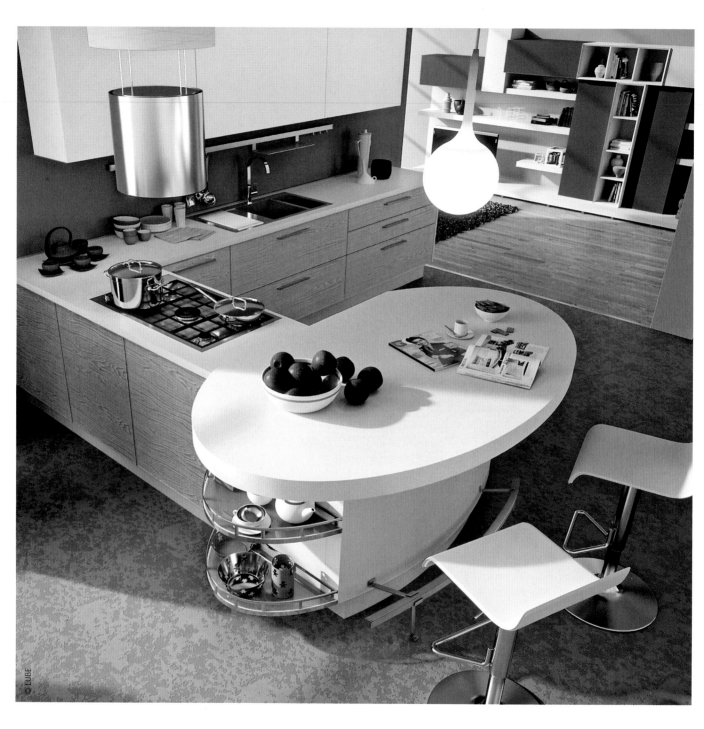

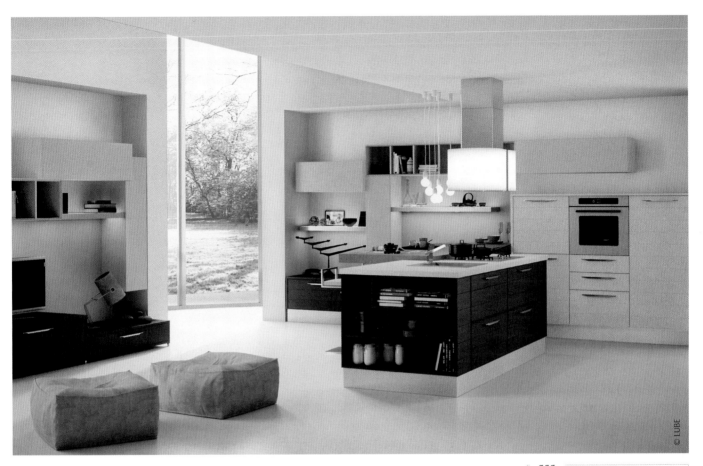

© LUBE

111

Islands and peninsulas offer great versatility and come in any imaginable shape to fit into any space.

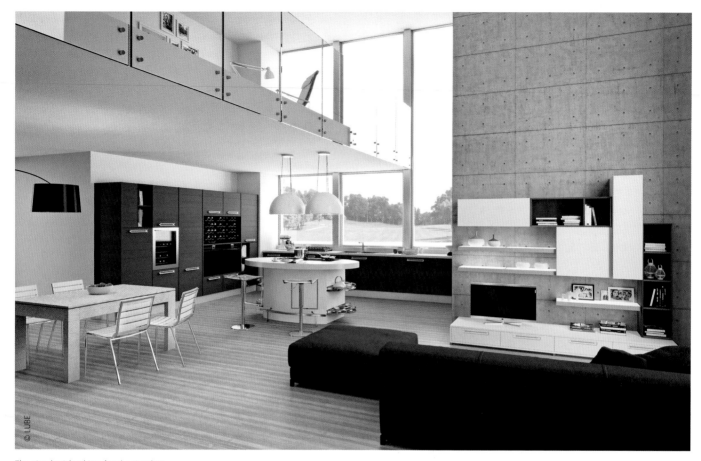

The circular island is a focal point that articulates the kitchen, the dining area and the living room.

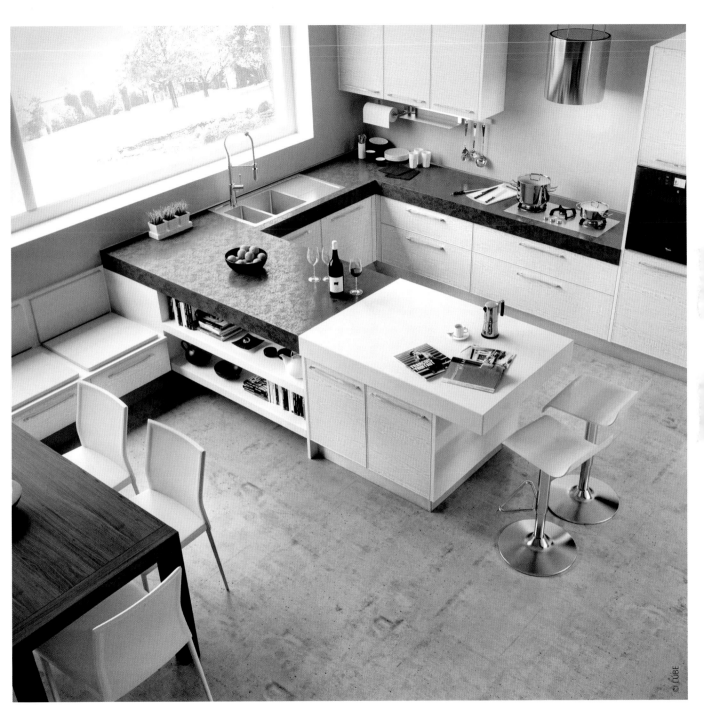

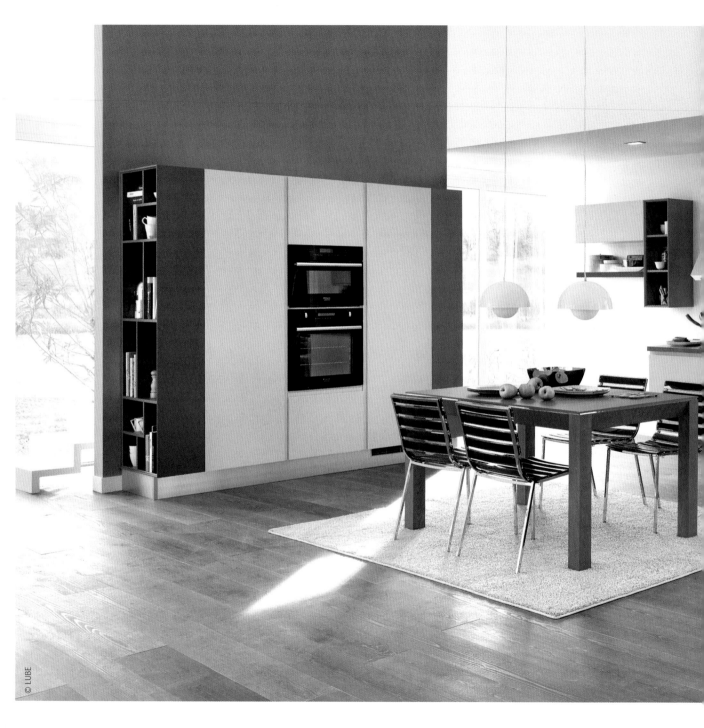

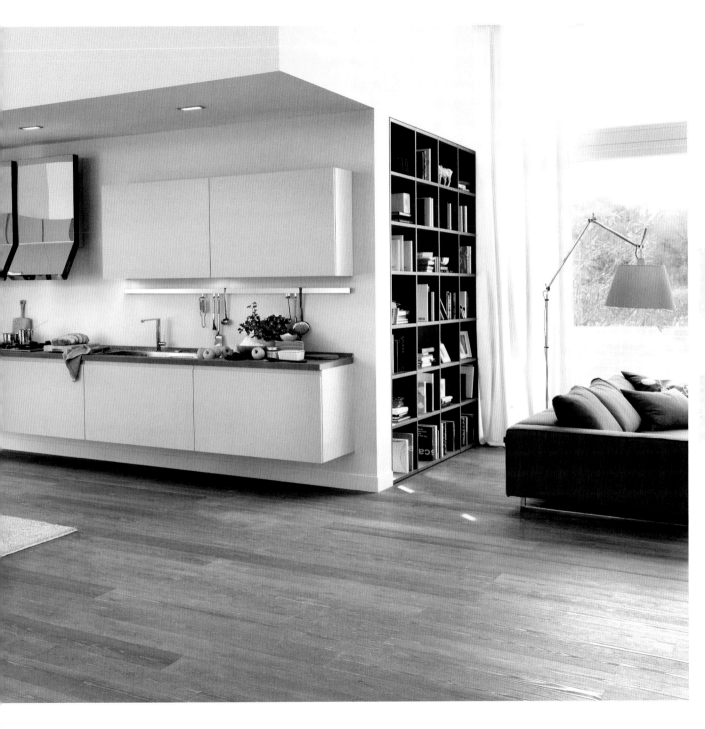

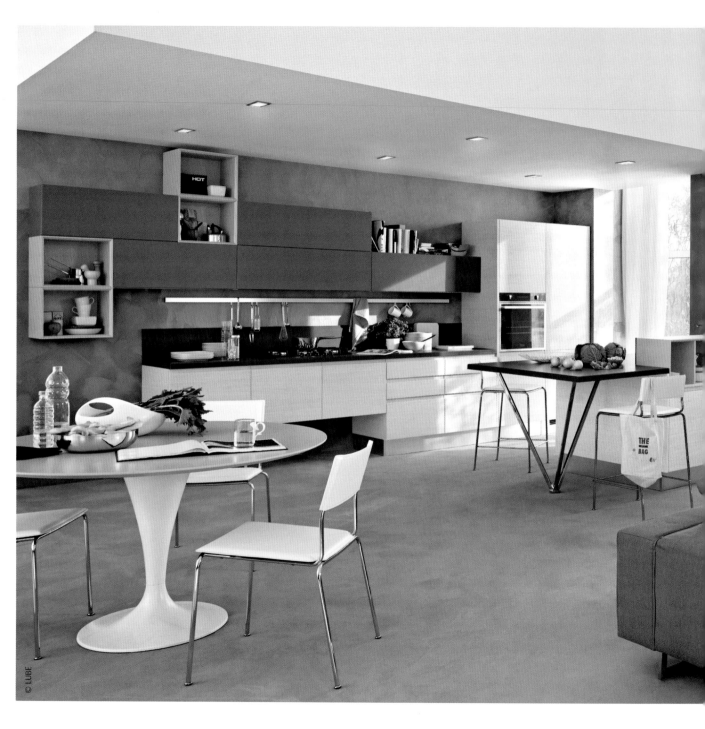

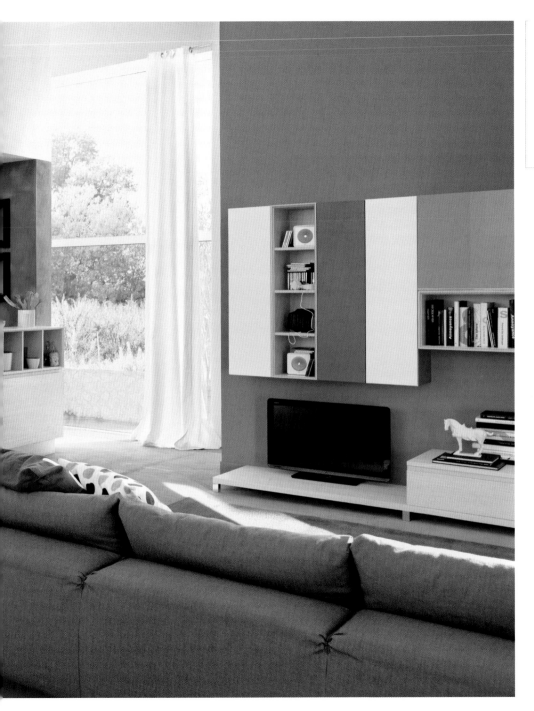

Wall units and open
compartments at different
heights create a decorative
effect and cater to every need.

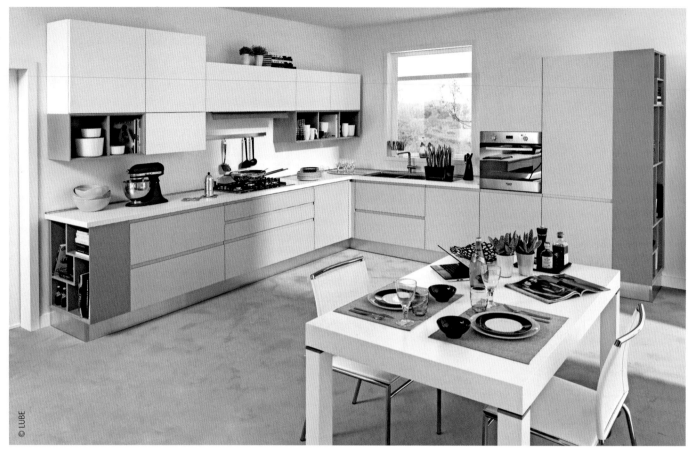

© LUBE

113

When a bar or island cannot be accommodated, a table is the perfect complement for the modern kitchen.

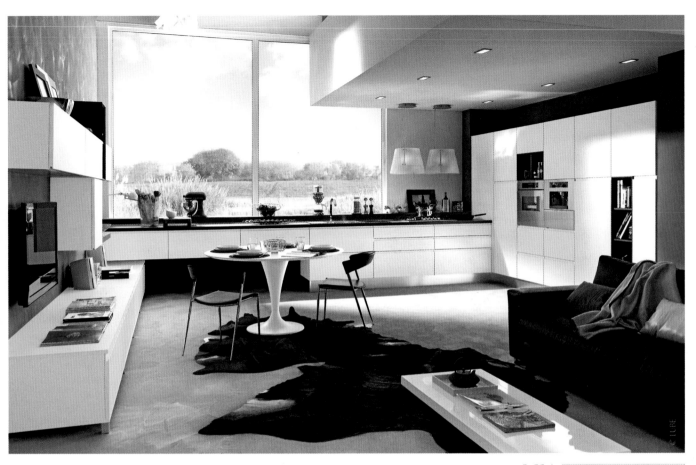

114

Designs that link kitchen and living areas create extremely functional environments.

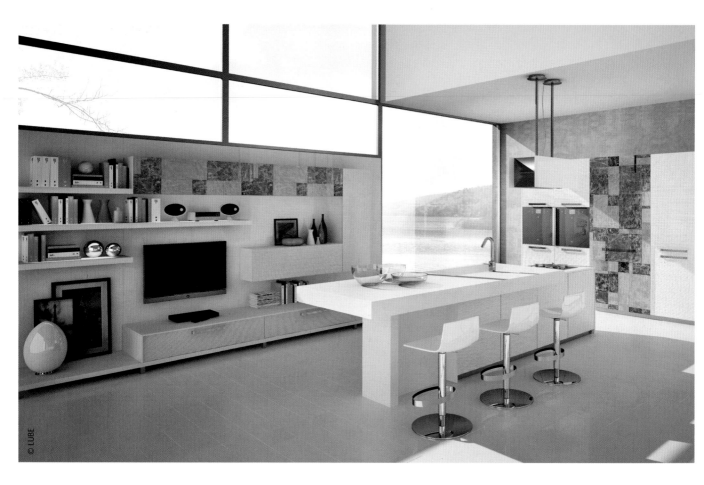

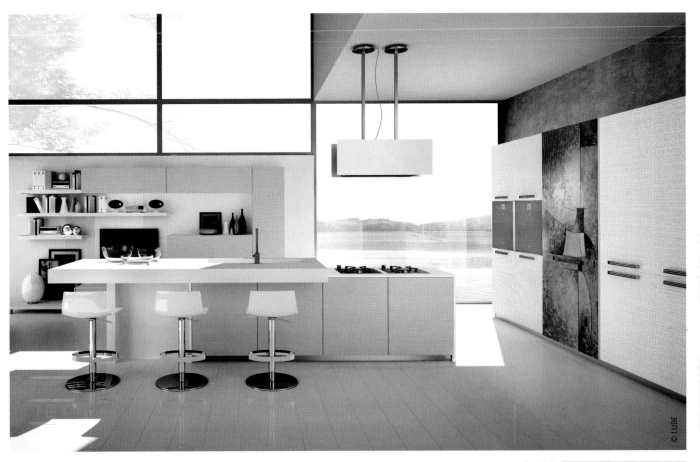

© LUBE

115

The door is decorated with an acrylic-and-silver leaf design, finished with transparent protector.

116

The dual function of a lamp and ventilation hood is especially useful for islands and peninsulas.

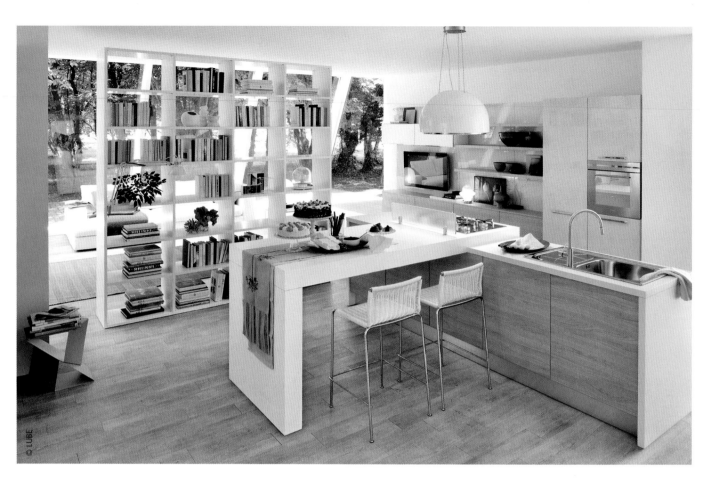

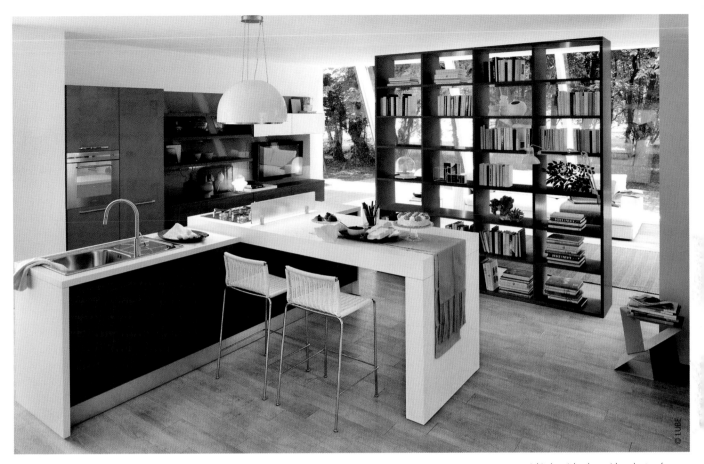

A kitchen island provides plenty of
storage as well as additional workspace.
It can also contribute to organizing the
circulation around the living area.

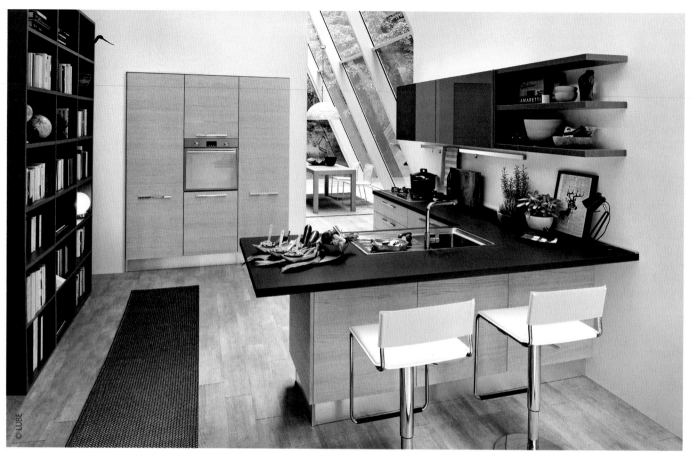

Contemporary island design transforms
a kitchen into a zone suitable for
interaction. Members of a family
or guests can gather around the
island, whether or not they help with
the cooking.

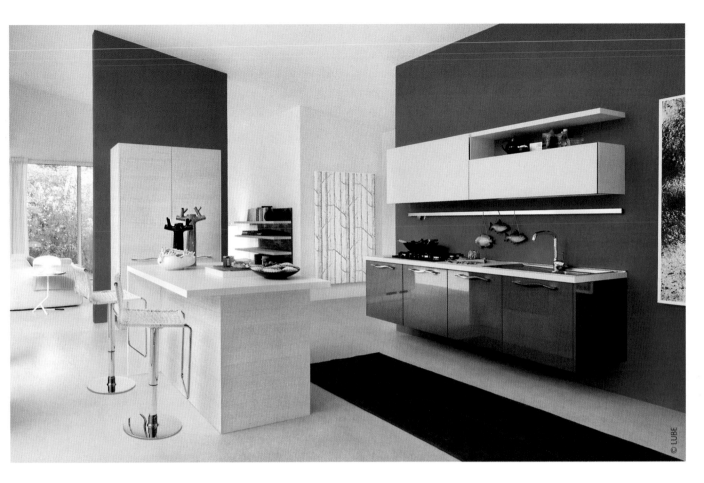

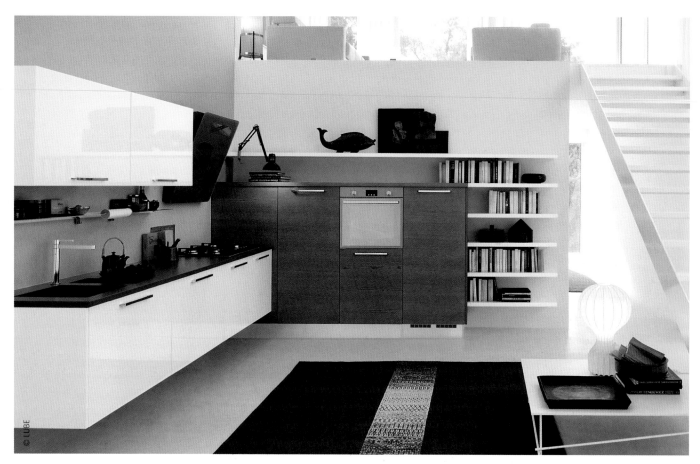

© LUBE

117

Suspended units, with enough space between the floor and the base, allow one to clean every corner of the kitchen.

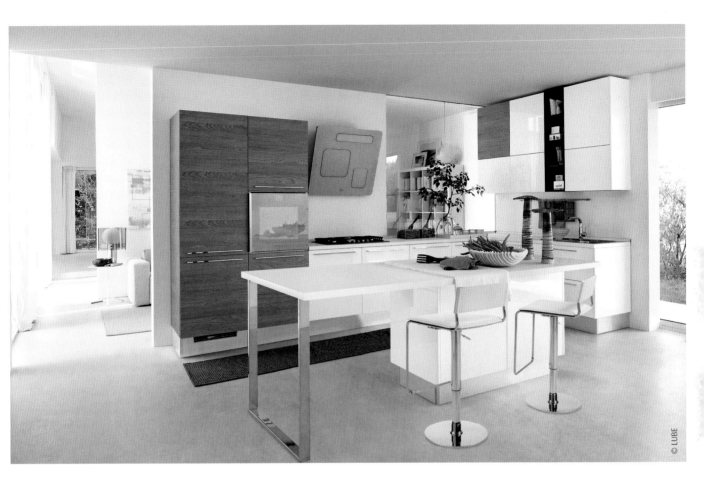

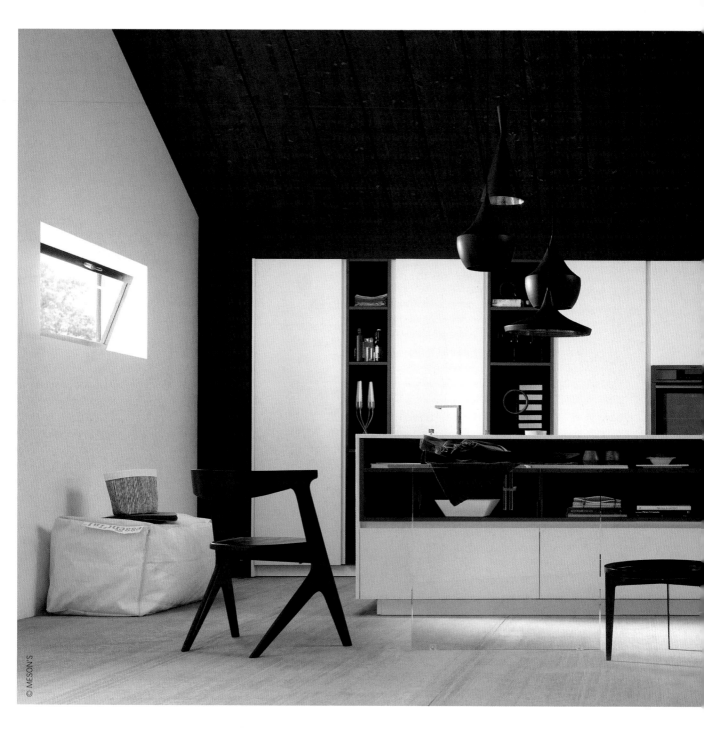

A glass peninsula is an
attractive and original solution
that gives the whole kitchen
an air of weightlessness
and delicacy.

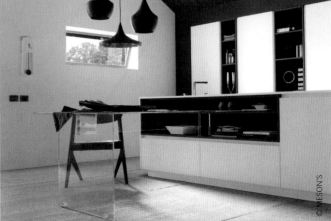

©MESON'S

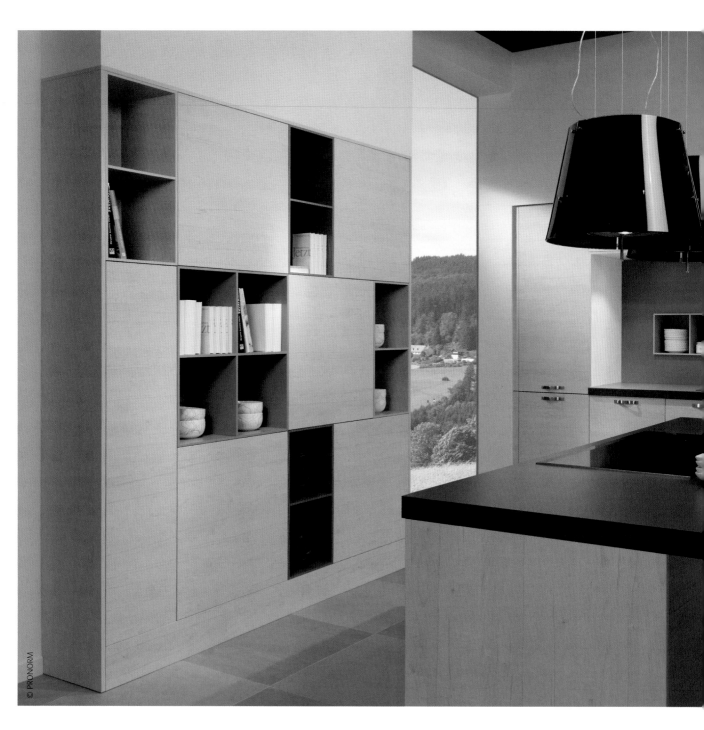

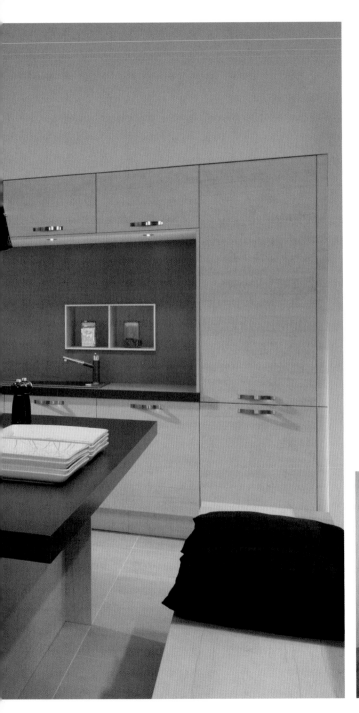

119

Open units can be used in
the kitchen to create spaces
for showcasing favorite
special items.

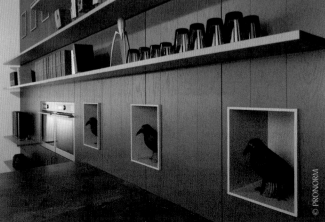

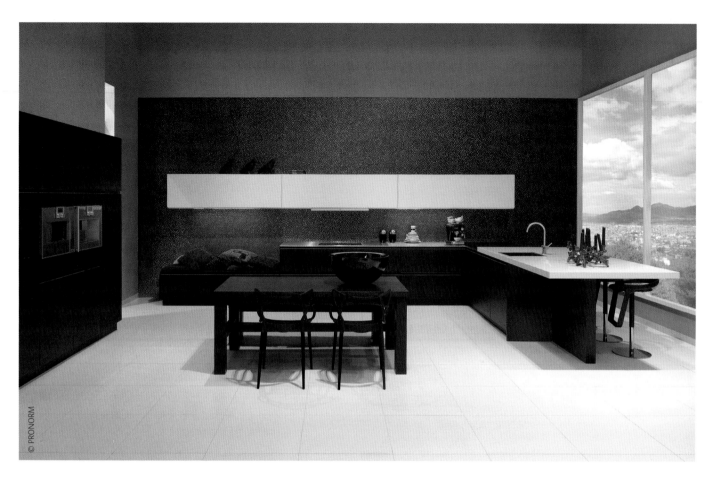

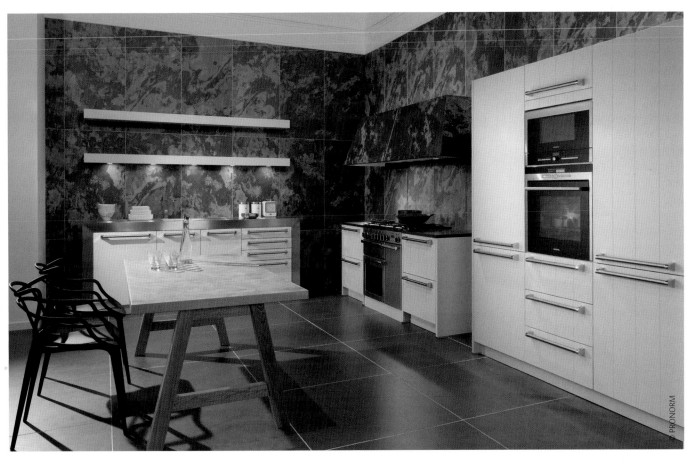

Wall finishes can enliven a kitchen and make it a pleasant room to be in, adding color and texture.

© PRONORM

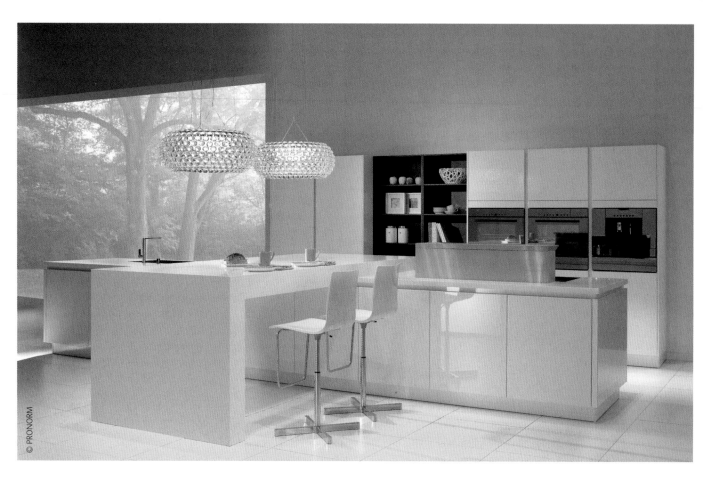

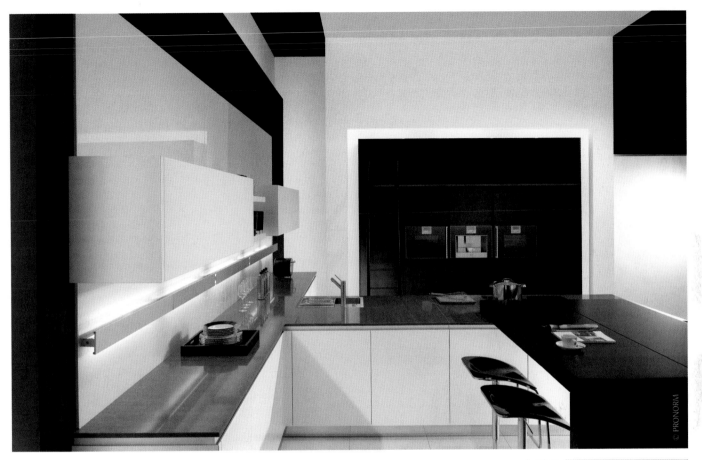

© PRONORM

120

All configuration concepts fit into the modern kitchen and are a reflection of the lifestyle of those who use them.

A kitchen with tempered-glass doors stands out for the subtle play of light and reflections, and for its elegance and clean lines.

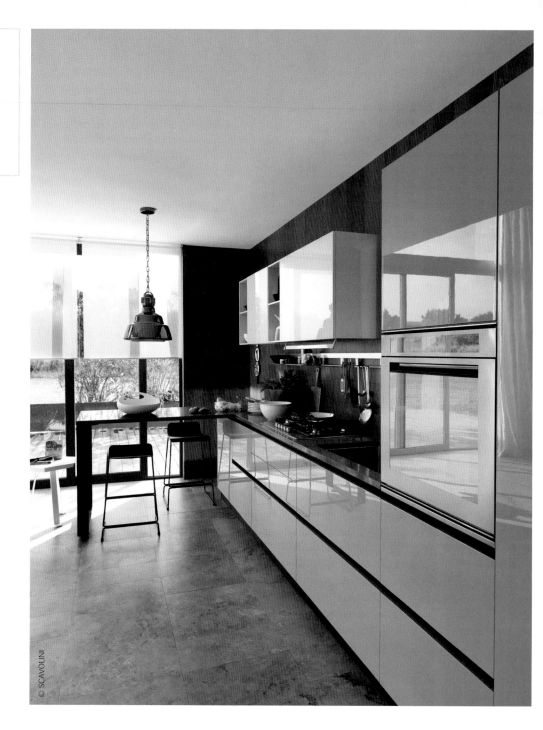

© SCAVOLINI

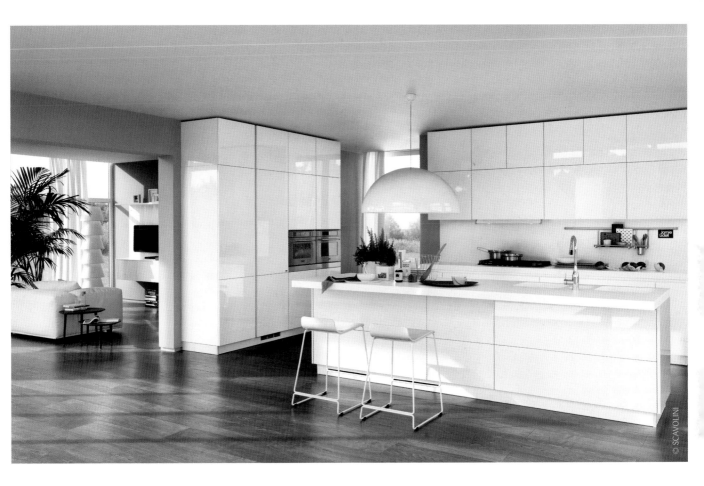

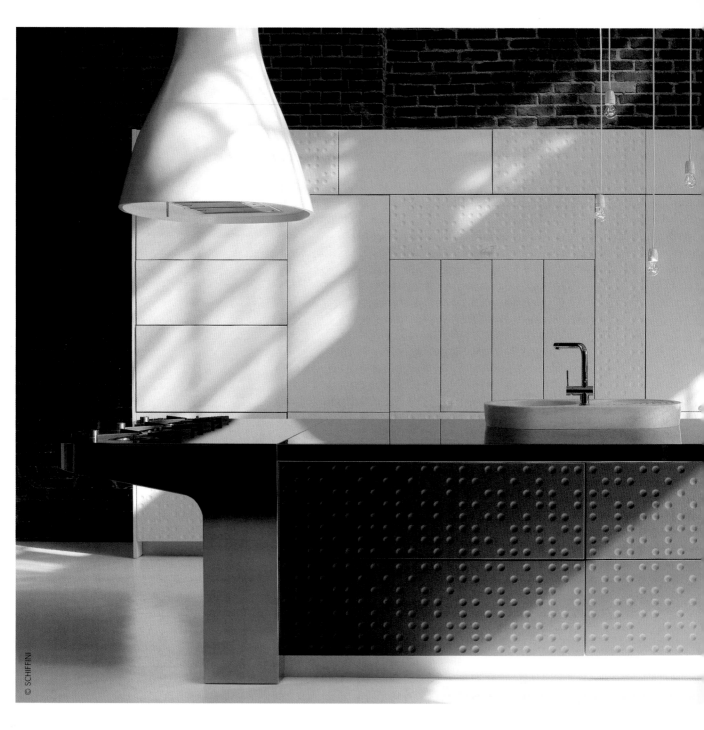

The combination of different materials and textures adds visual interest. For instance, the embossed copper front of the island shown in the image creates a focal point.

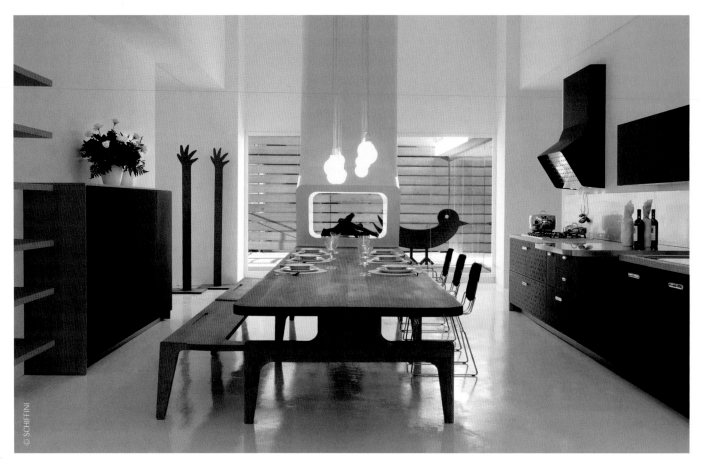

123

In a meeting space such as the kitchen, a long table with benches encourages sociability.

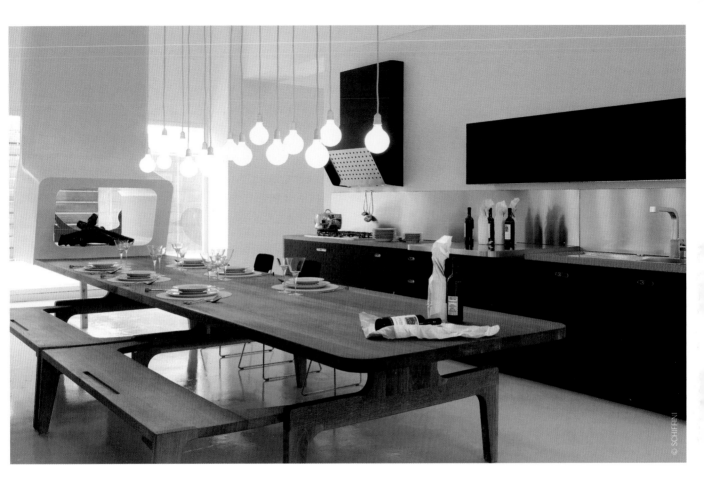

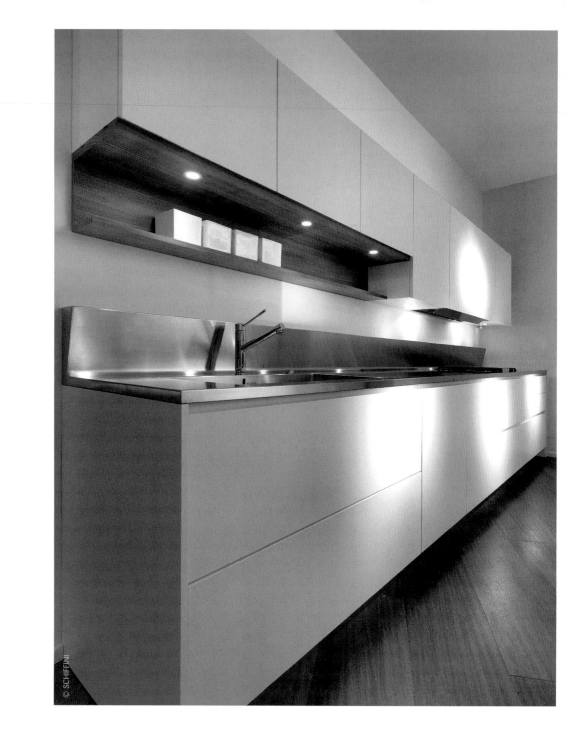

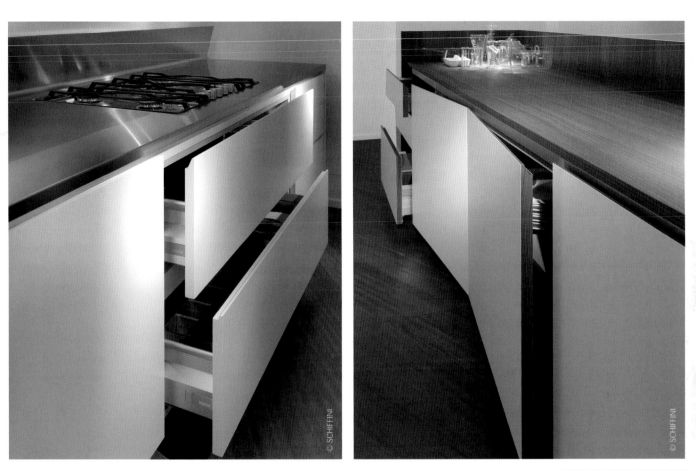

124

Subtle grooves and push-open door systems are a streamlined alternative to doors with handles.

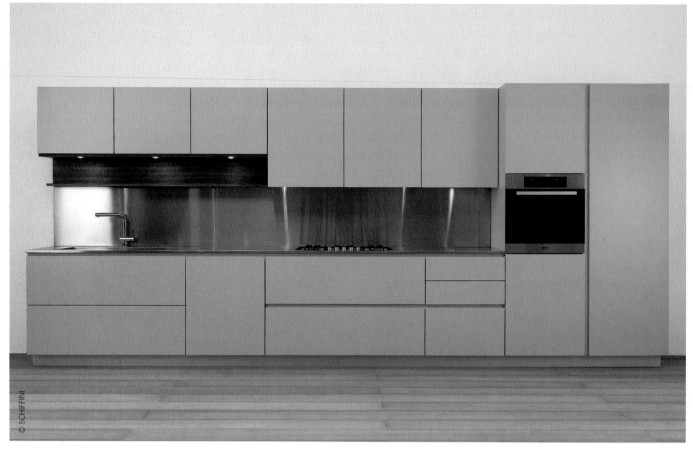

125

Matte-lacquered finishes combine perfectly with shiny surfaces such as on the stainless steel of this worktop.

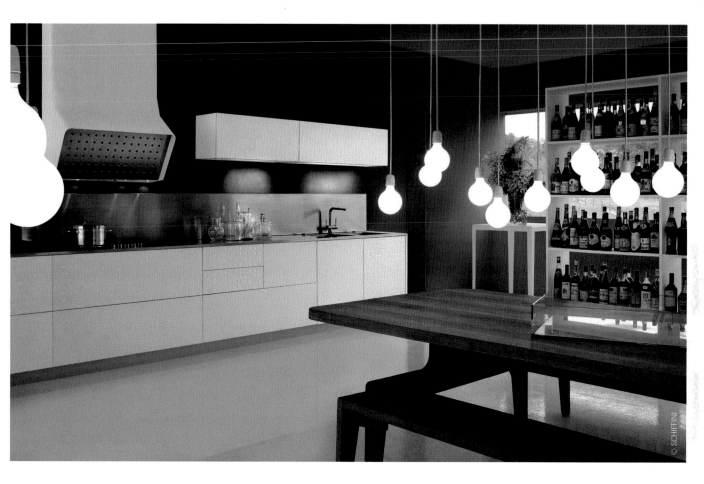

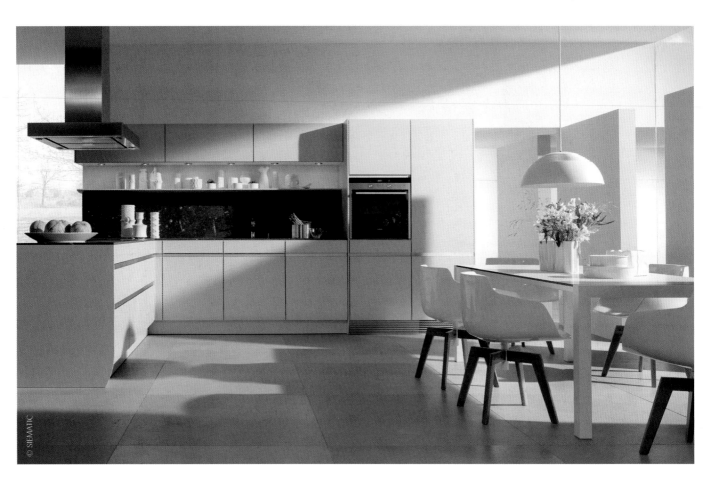

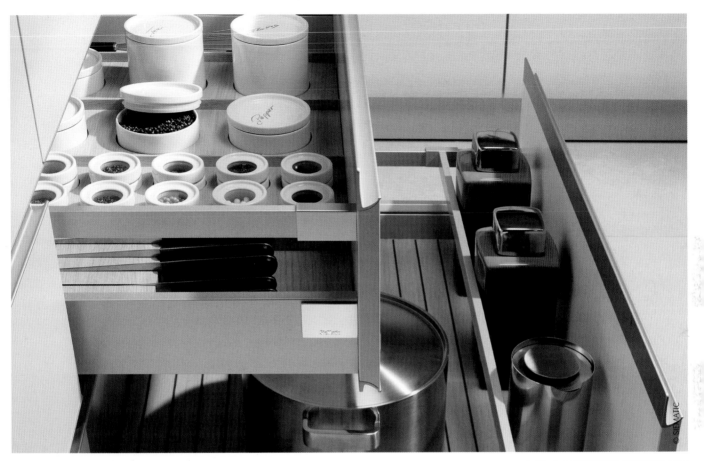

126

Drawer inserts and anti-slip surfaces prevent the movement of stored items and the resultant scratches.

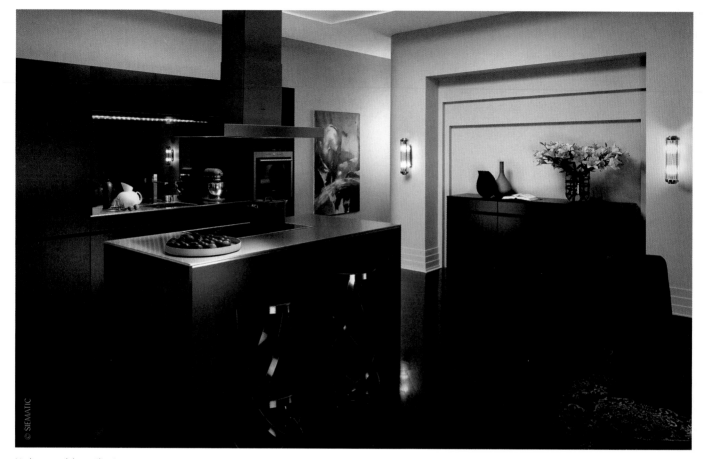

No longer solely a utilitarian room
in the house, the kitchen reflects
personality and lifestyle.

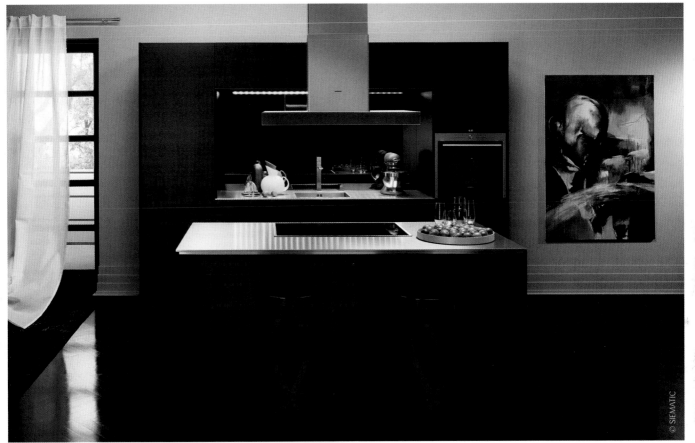

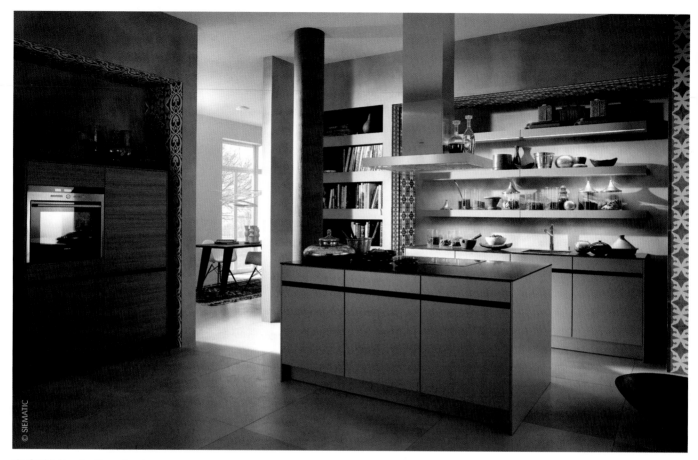

The flexible layout options of modern
kitchens and the change in people's
attitude toward the function of this
utilitarian room create plenty of design
opportunities in the general layout
of a home.

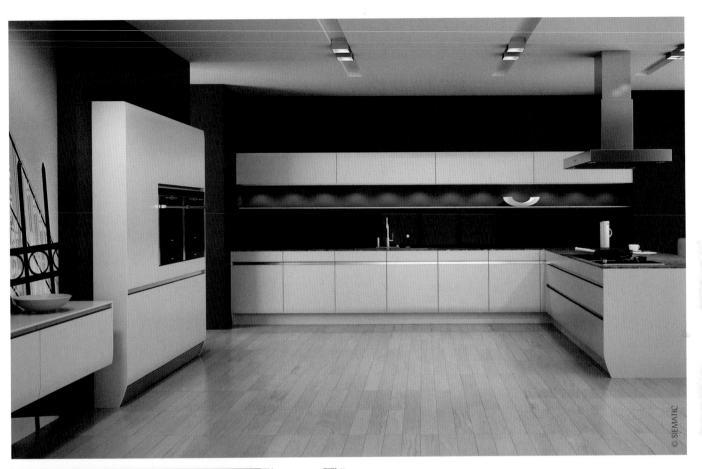
© SIEMATIC

© SIEMATIC

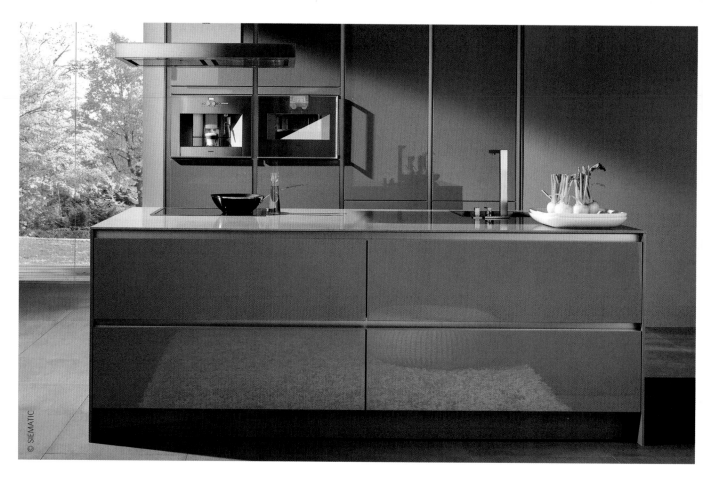

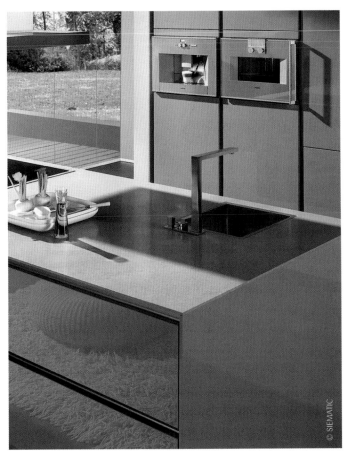

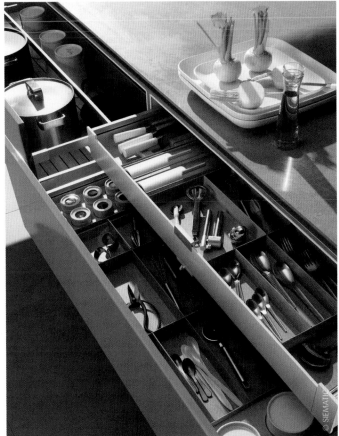

127

Light oak, aluminum and porcelain are brought together in an interior unit that accommodates a wide range of accessories.

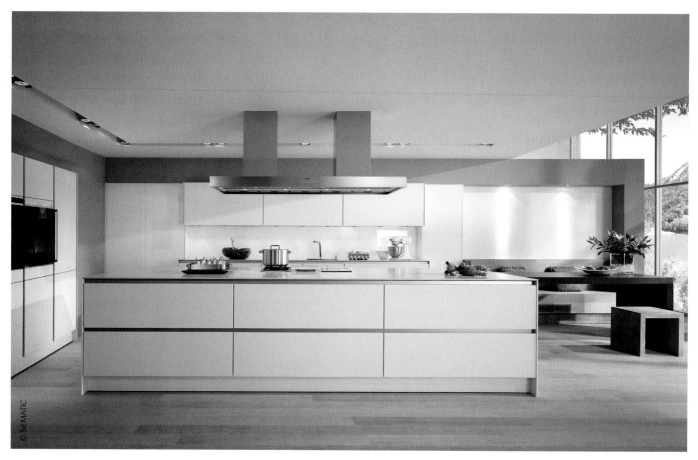

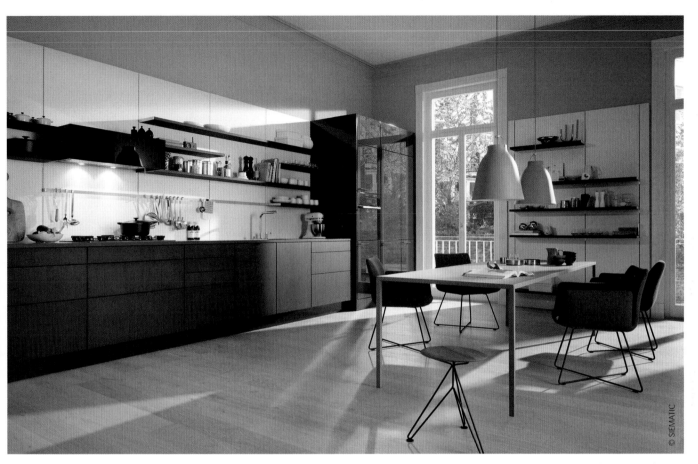

© SIEMATIC

Open shelves provide a space with a sense of airiness. They work well in large bright rooms. On the contrary, they can create visual clutter in small rooms.

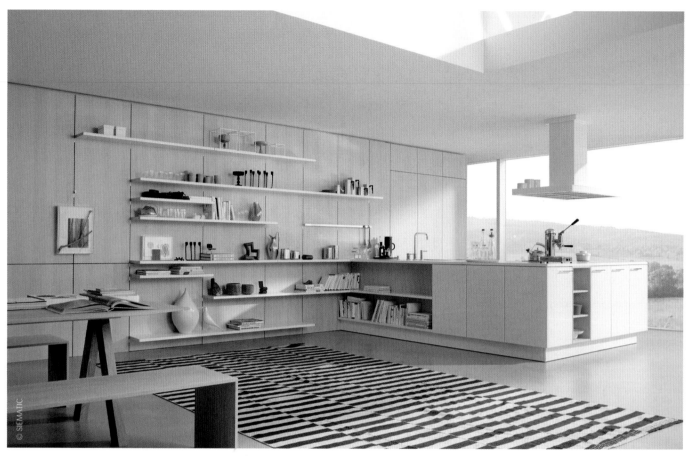

© SIEMATIC

128

A system of panels provides many elegant ways to blur the boundaries between environments and functions.

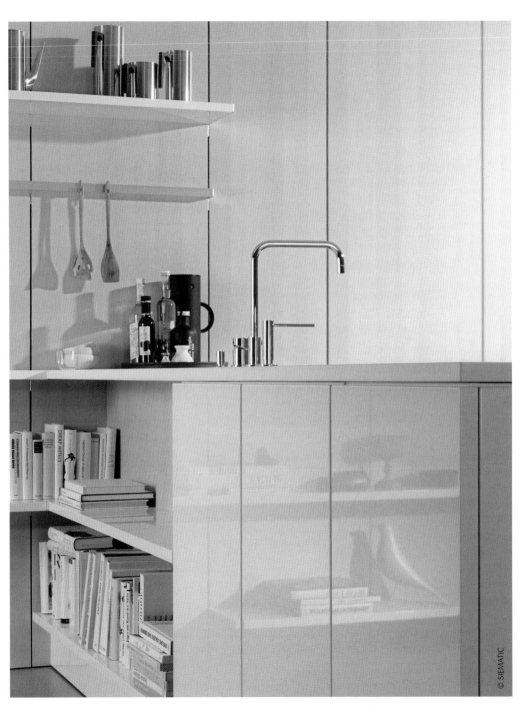

Kitchen design has evolved beyond the limits of the traditional utilitarian room. Nowadays, a modern kitchen opens up to other parts of the home and is no longer tucked in a dark and gloomy corner.

© SIEMATIC

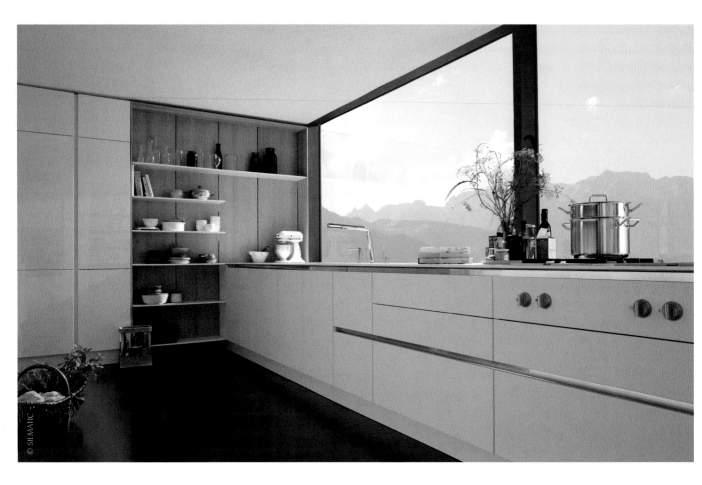

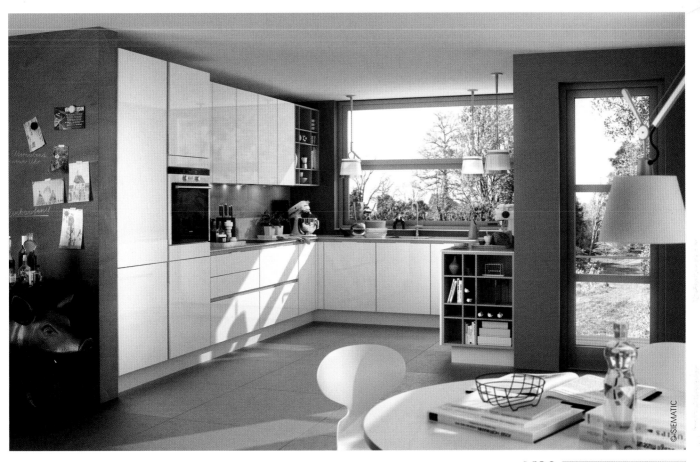

129

The olive green of the shelves, panels and grip grooves are the focus of attention against the white of the rest of the design.

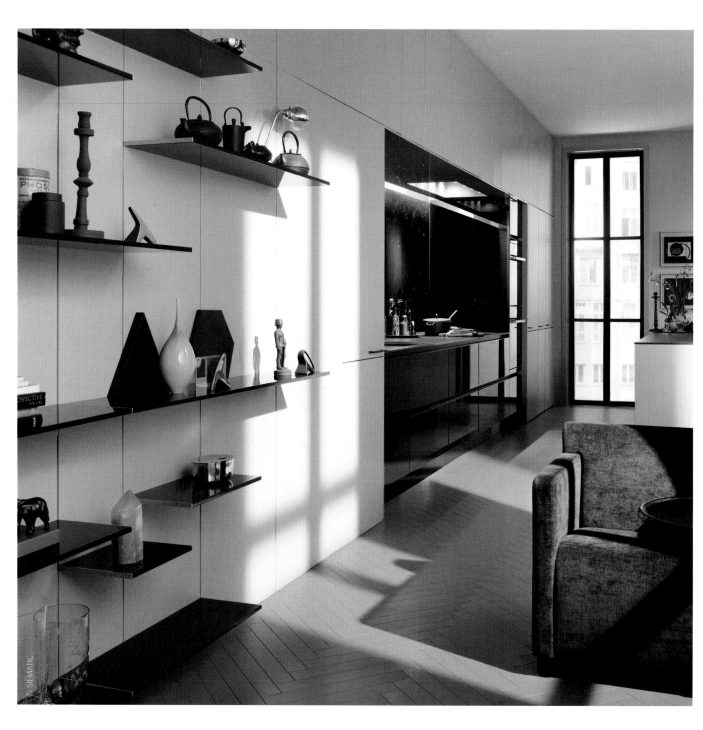

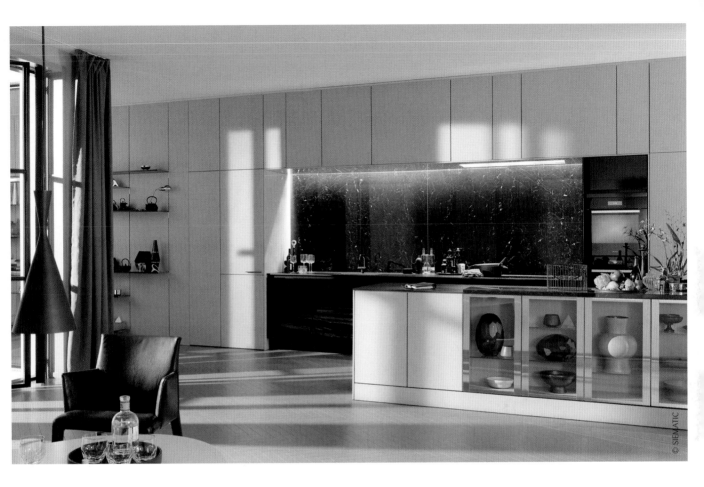

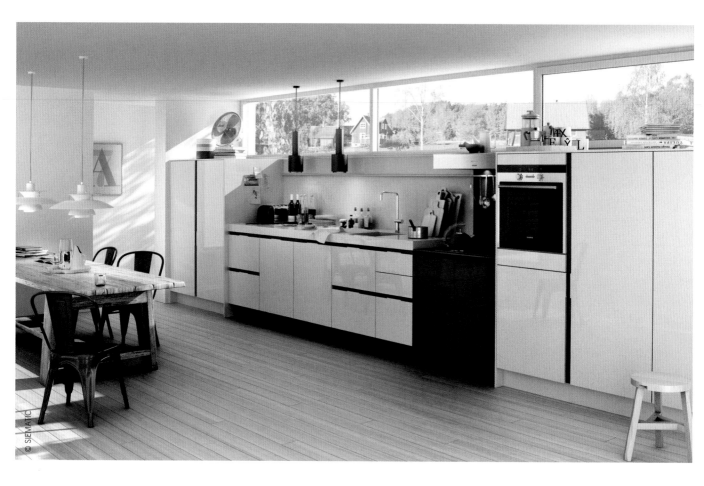

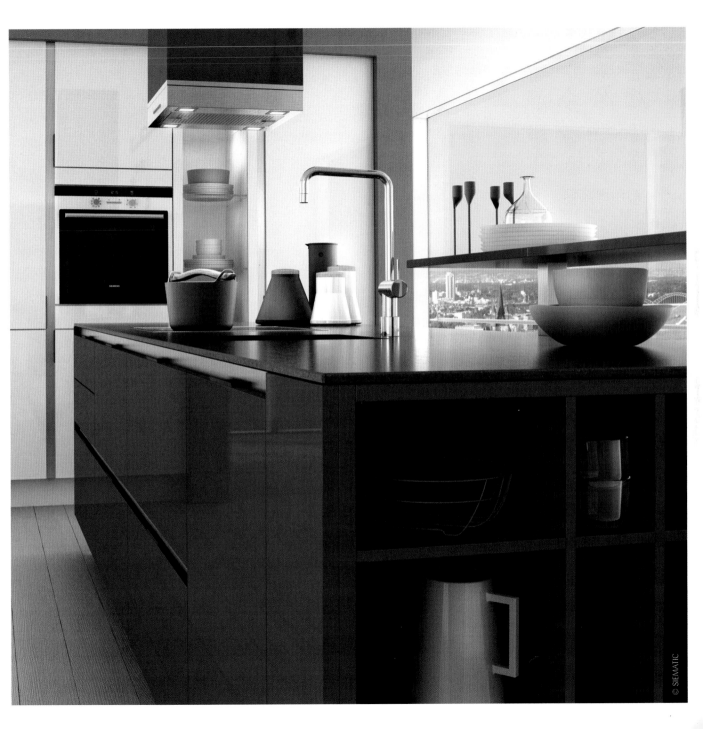

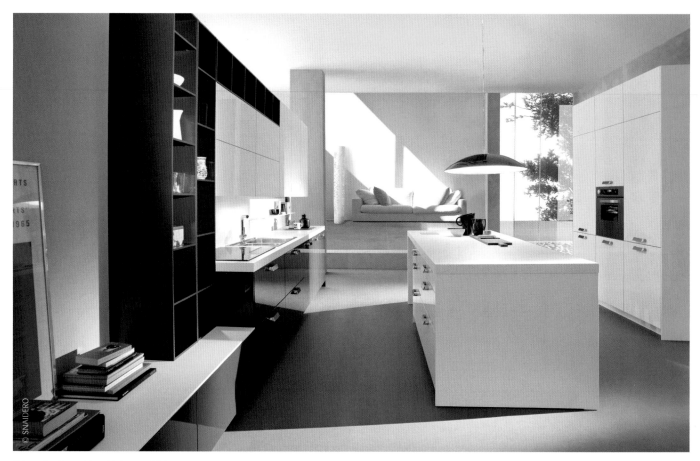

This wall unit combines kitchen and living room equipment seamlessly. The kitchen area is defined by a central island and another piece of furniture containing the refrigerator and the wall oven opposite the wall unit.

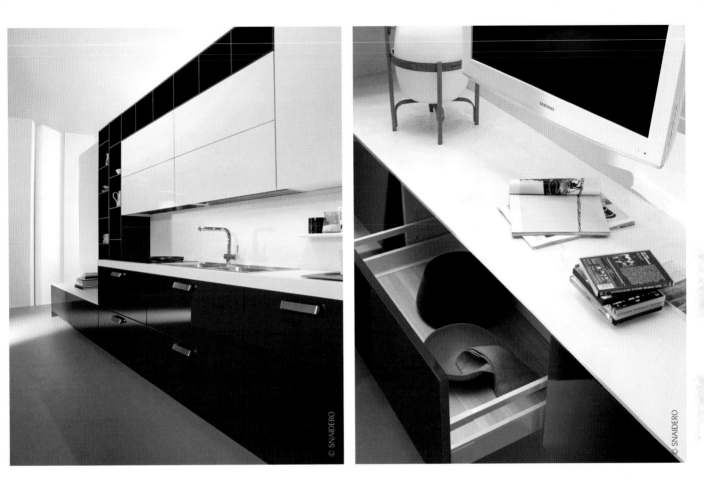

© SNAIDERO

© SNAIDERO

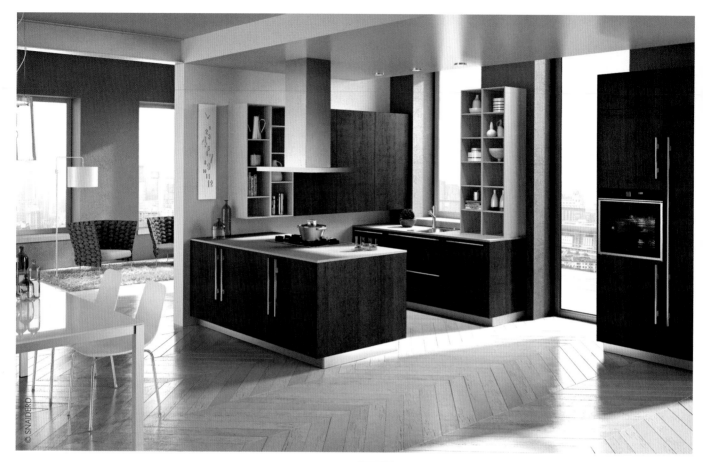

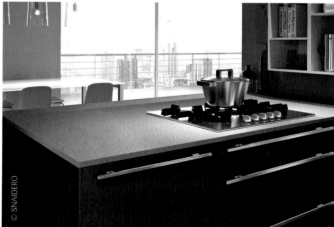

Equipment walls and
freestanding compositions
promote freedom of activity
in the kitchen.

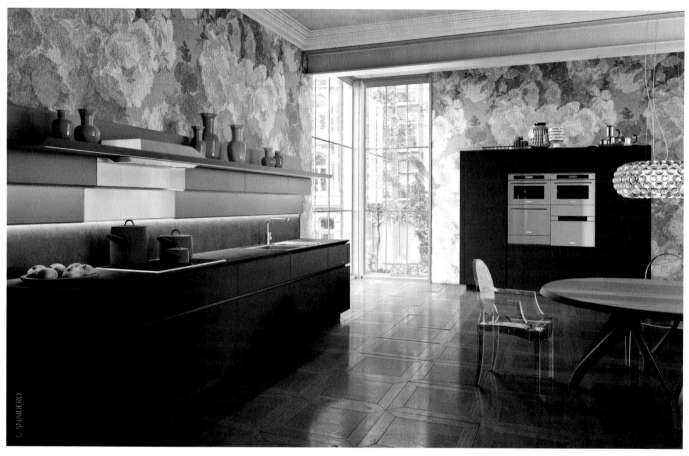

131

The lighting integrated into the paneling of the tall units illuminates perfectly the entire working area.

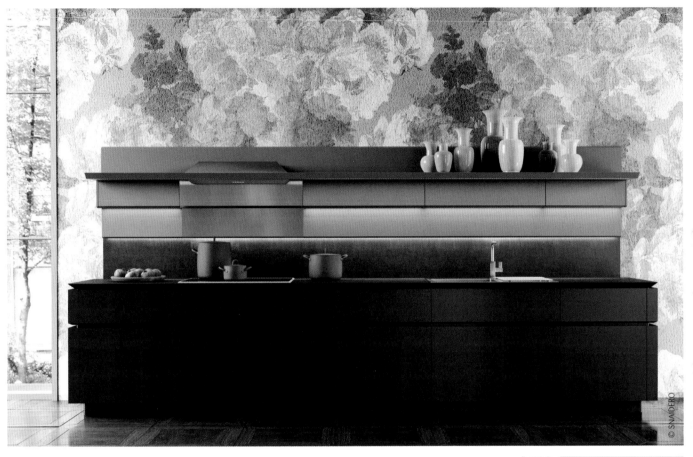

© SNAIDERO

132

The aluminum-framed storage system incorporates plugs and switches for small accessories and lighting.

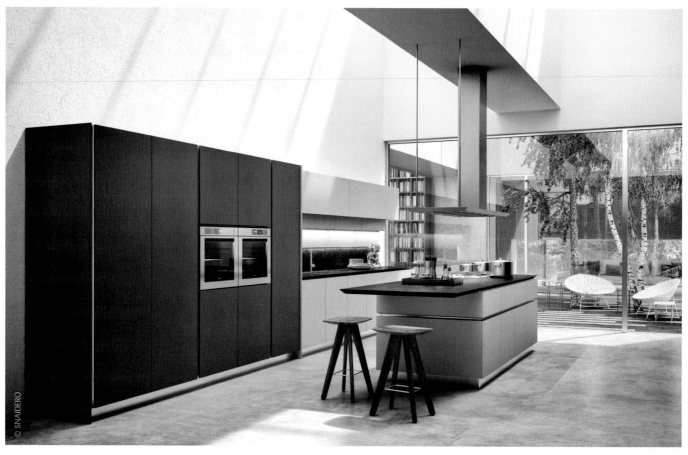

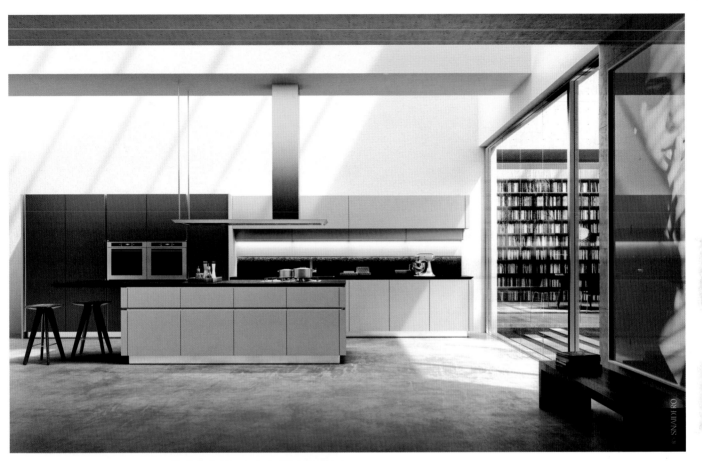

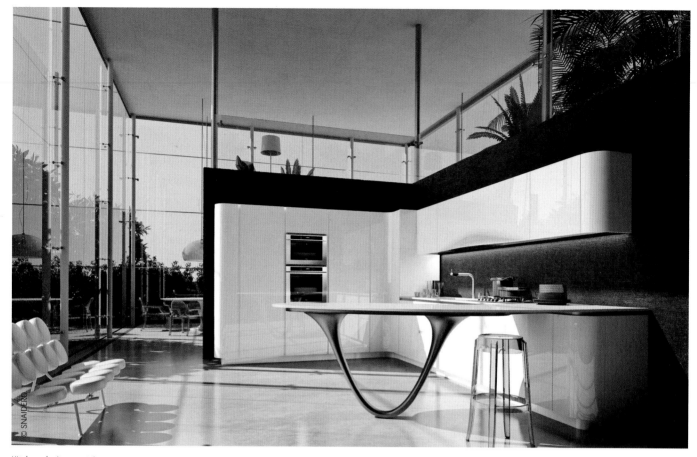

© SNAIDERO

Kitchen designers strive to create smart
environments without compromising
functionality, taking into account
efficiency and ergonomics.

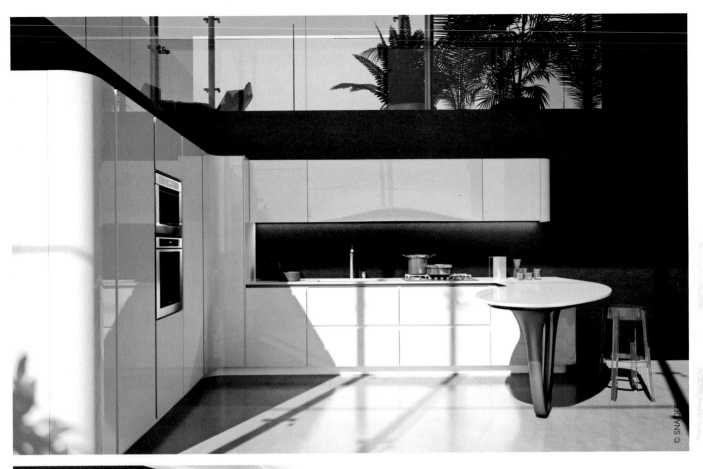

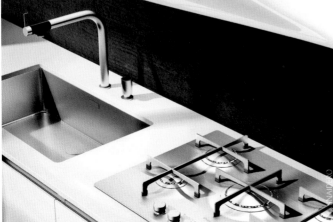

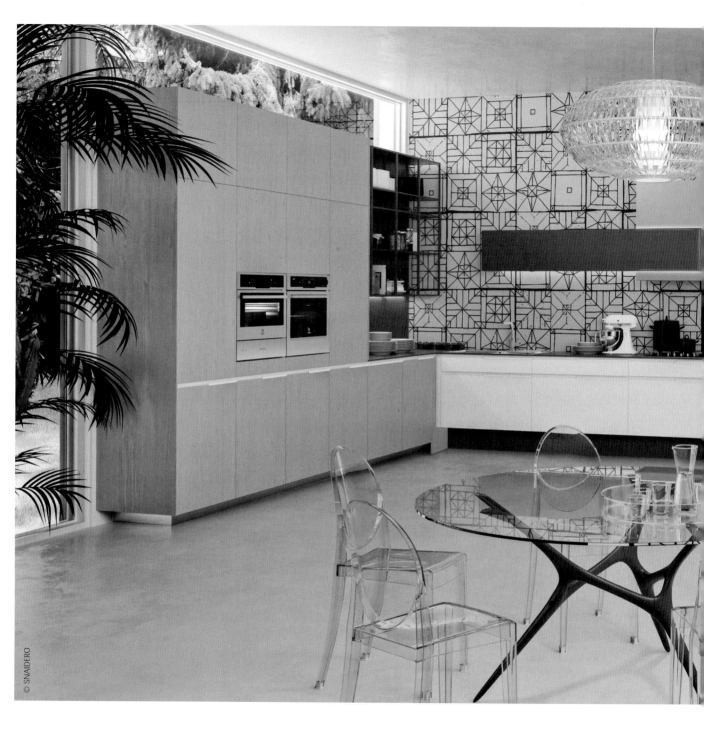

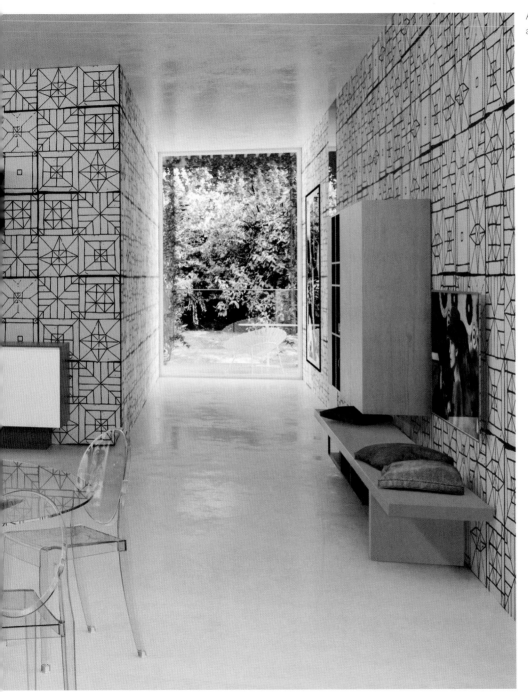

Adding style to a kitchen can be as easy as bringing in color and pattern.

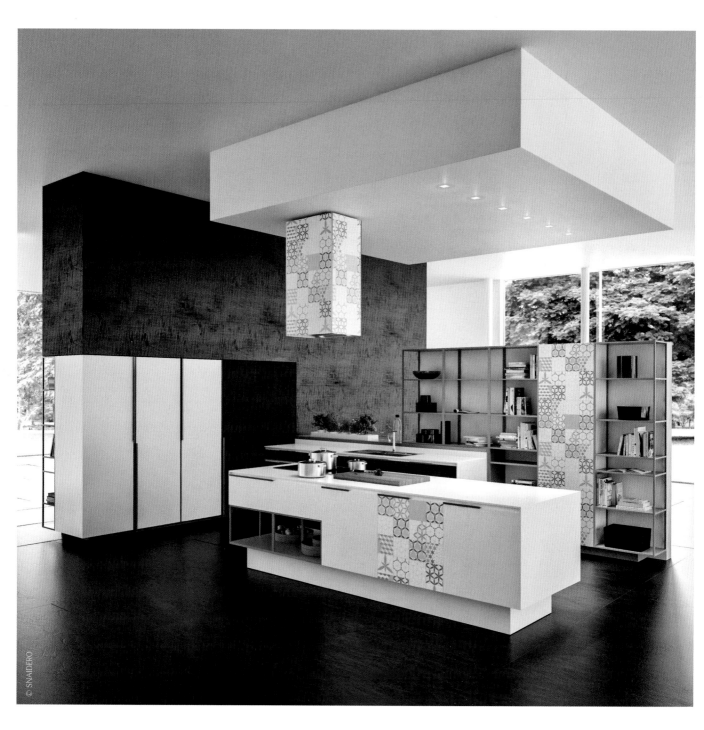

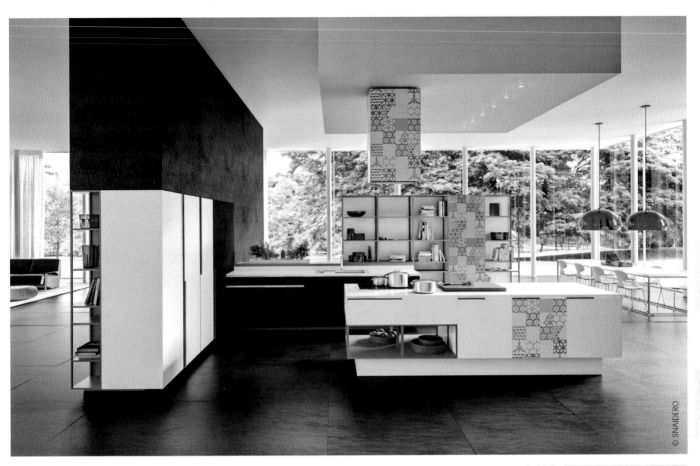

© SNAIDERO

133

Kitchens require materials that are practical, resistant and nice to look at. Aluminum offers all these advantages and paves the way for highly efficient and original designs.

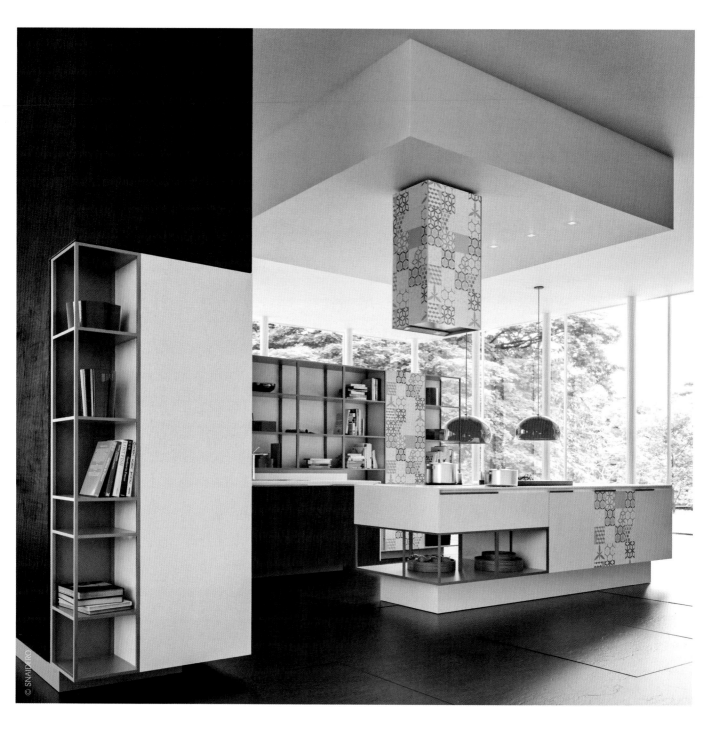

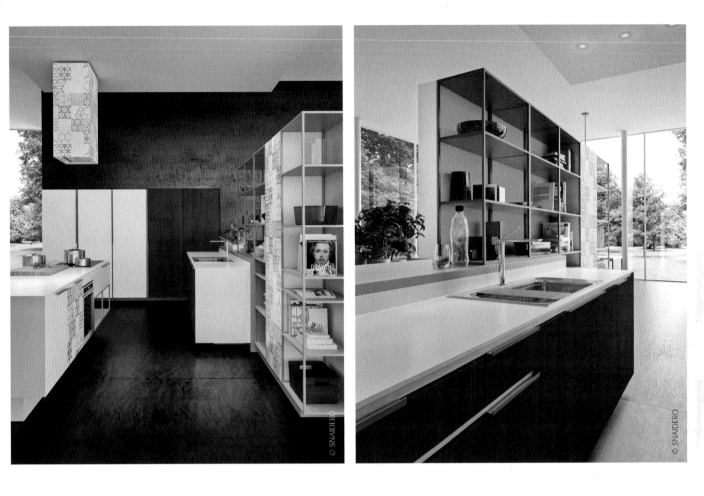

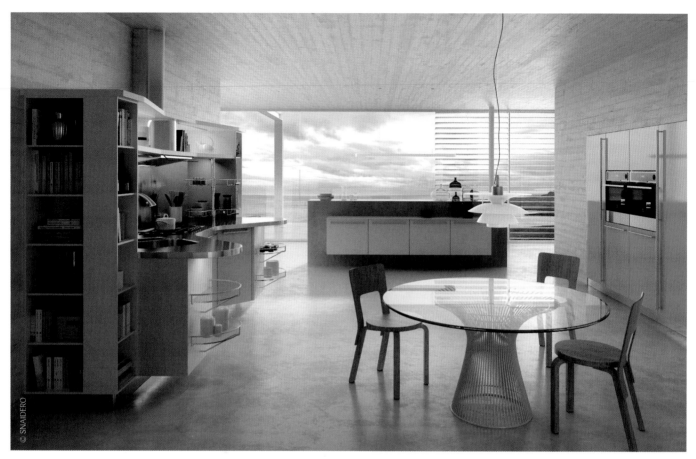

134

A chromed wire rail can be used to easily rotate the shelves and change the position of objects with no risk of them falling.

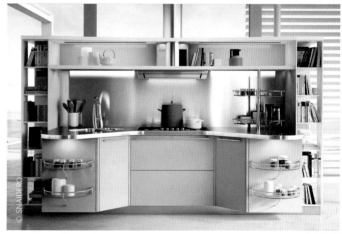

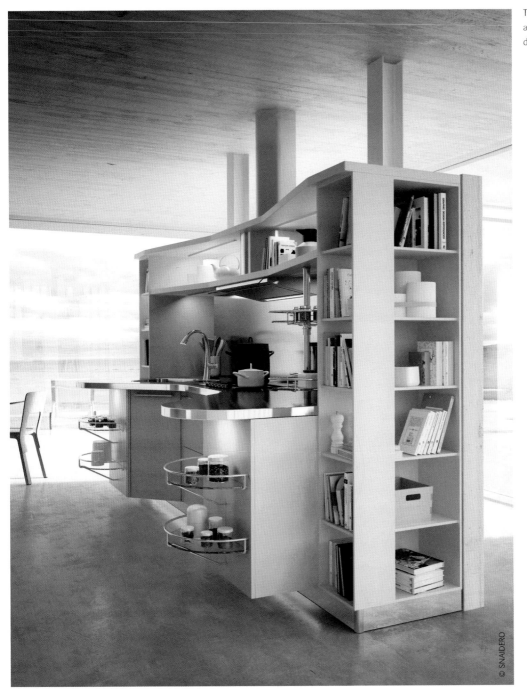

This innovative kitchen incorporates all the necessary features in a compact design exploring form and materiality.

© SNAIDERO

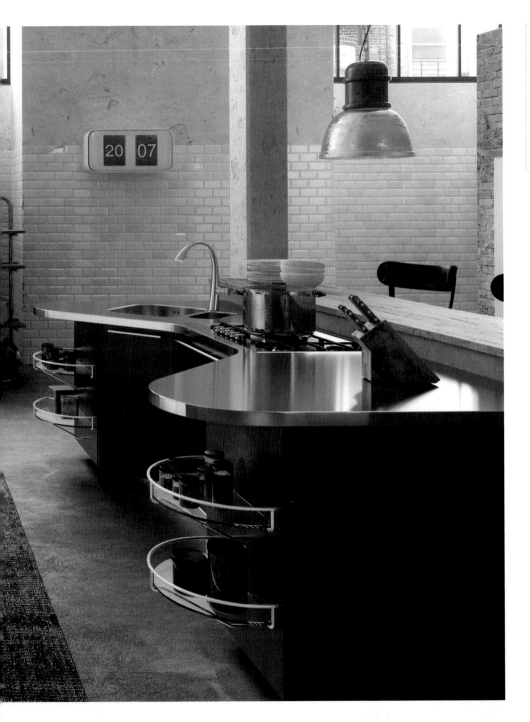

The surround worktop ensures you have everything you need without having to move far.

Innovative high-tech exhaust hoods are whisper-quiet and powerful. There are innumerable designs available. This slanted stainless steel hood breaks up the horizontality of the surrounding elements.

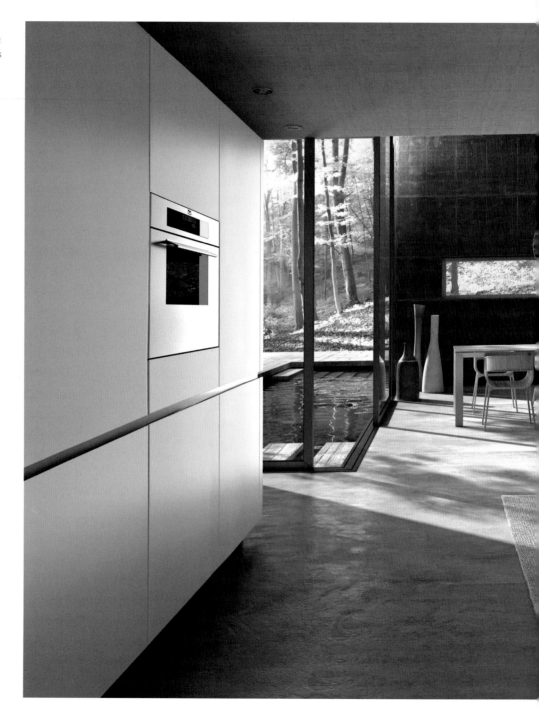

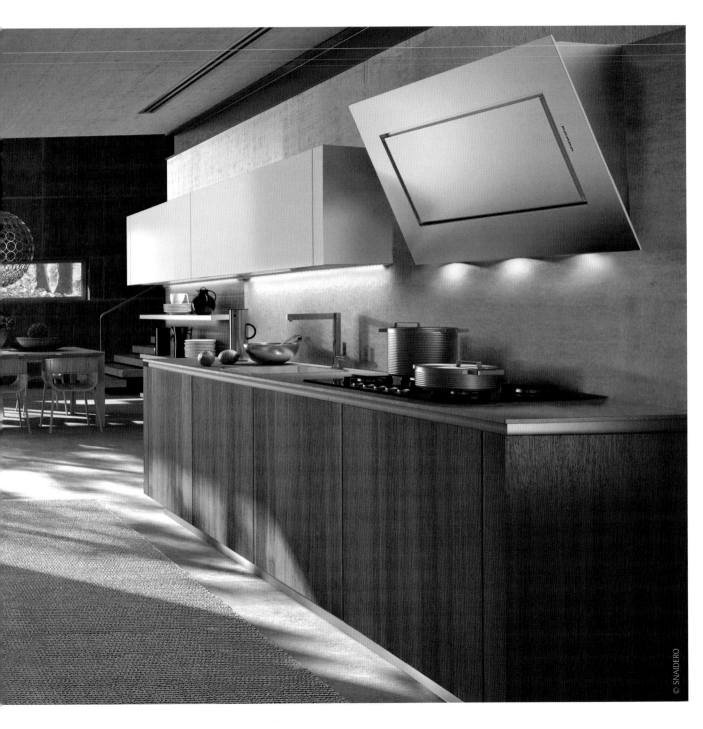

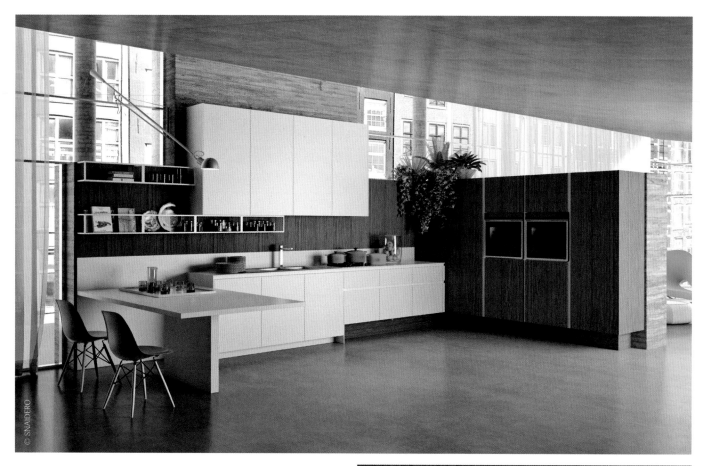

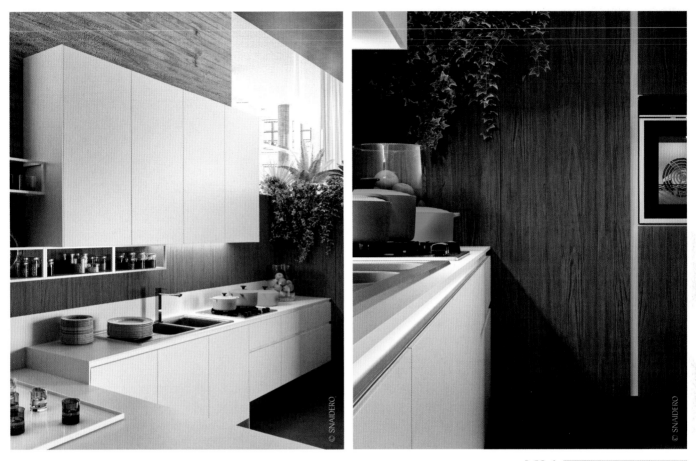

136

The perfection of the finish of the varnished aluminum units validates the primary geometry of the shapes.

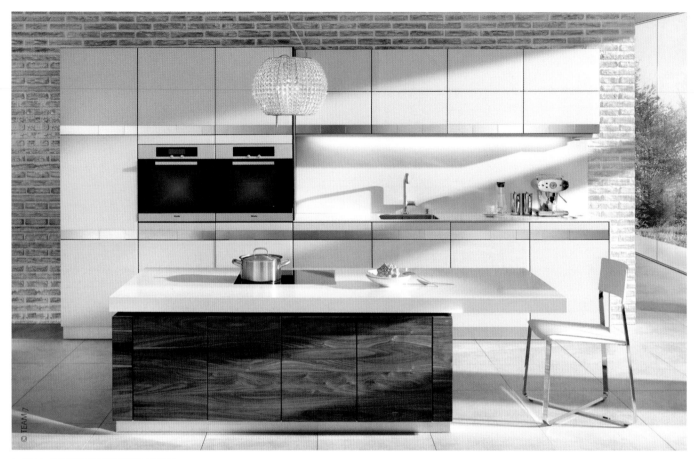

137

Worktop, table or bar:
everything in the k7 kitchen
island can be adjusted with
a single touch of a button.

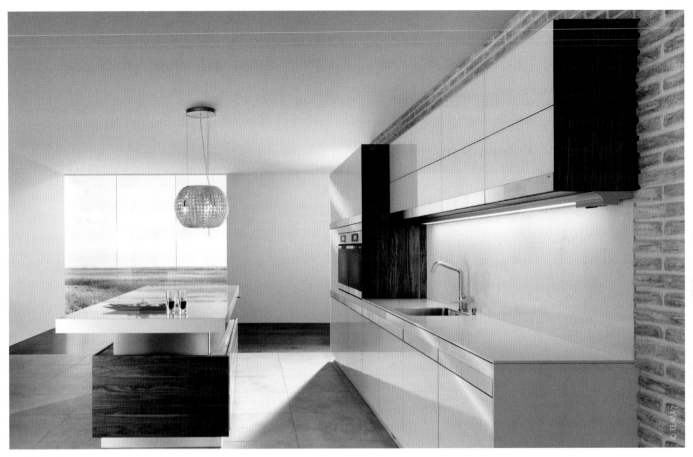

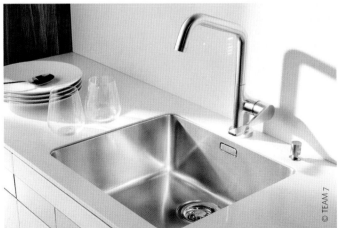

138

The combination of wood and steel is unquestionably successful thanks to its strong sophistication.

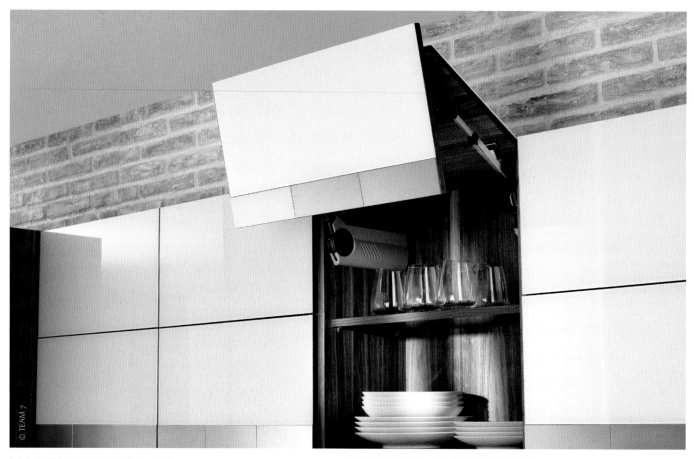

139

The large hinged doors allow convenient and easy access to the entire contents of the wall units.

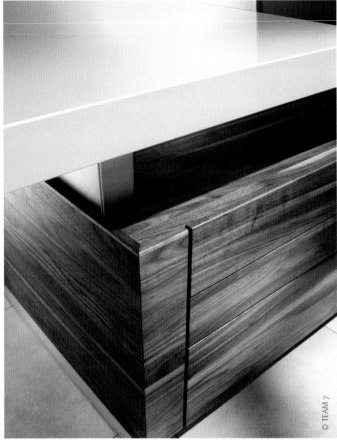

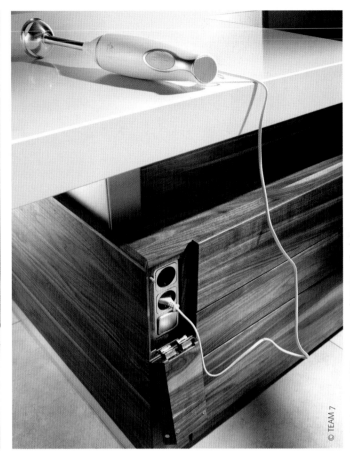

140

Covered switches and plugs in the island make the connection of kitchen appliances easy.

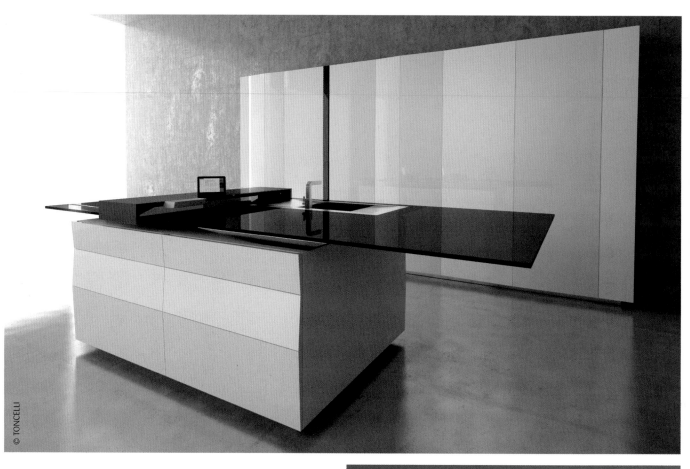

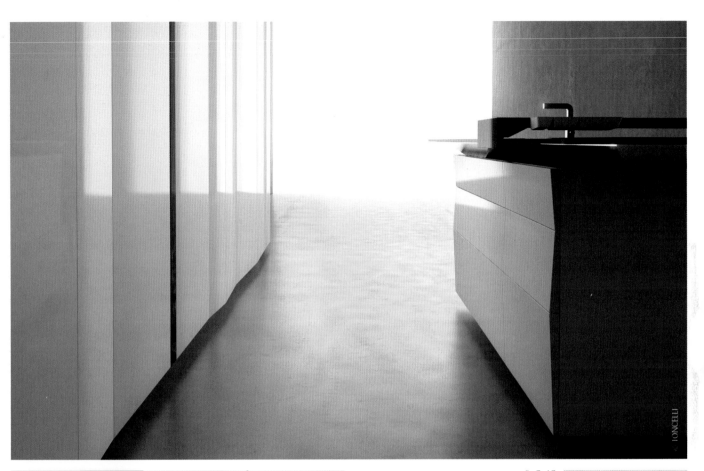

141

The faceted design of the cabinets' doors and drawers is enhanced by the glossy finish, which reflects light, creating interesting visual effects.

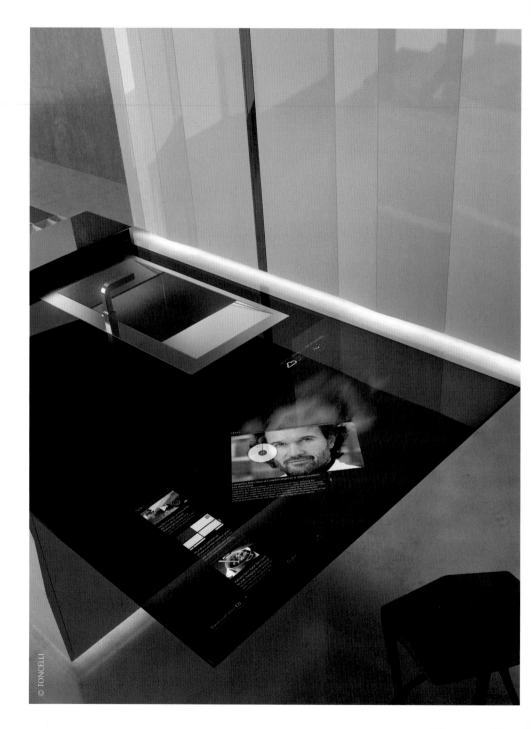

142

The island's glass worktop is equipped with an interactive touch screen with internet connection.

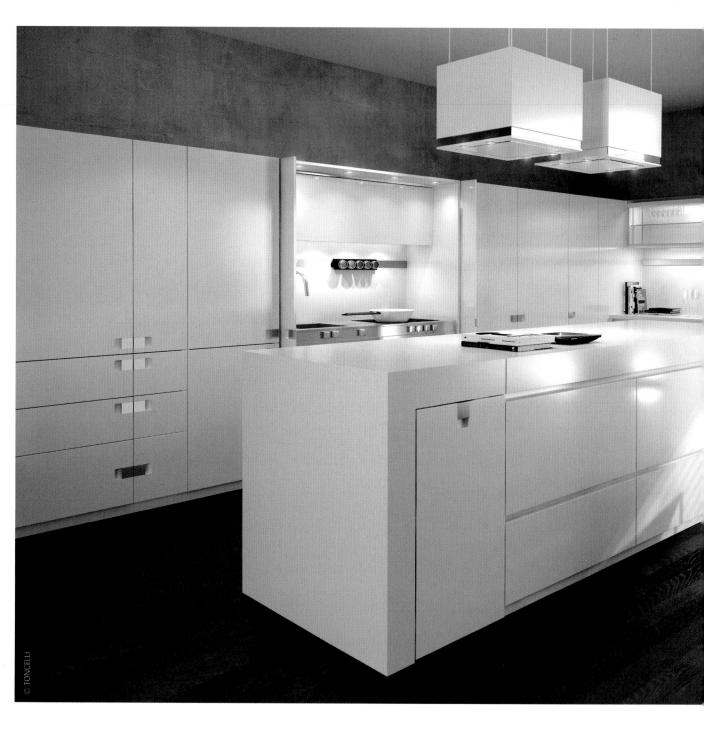

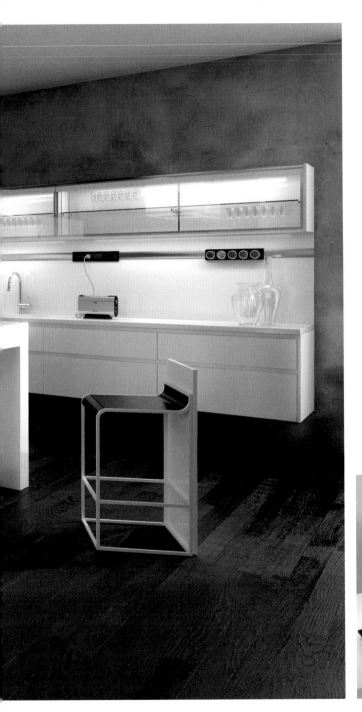

Metal stools with leather seats and backs that reach the floor fit under the island to form a perfectly rectangular Corian® box.

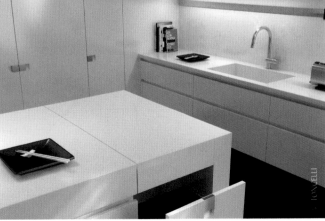

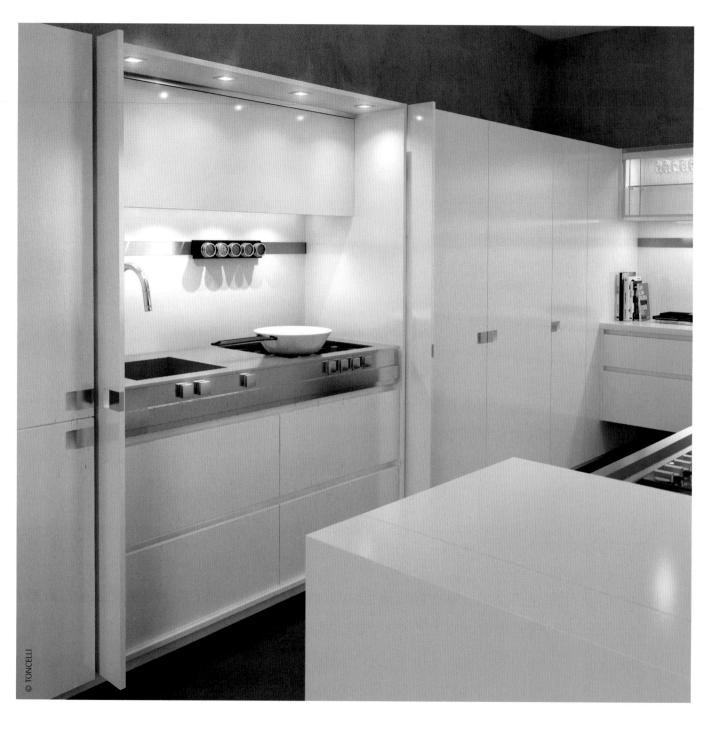

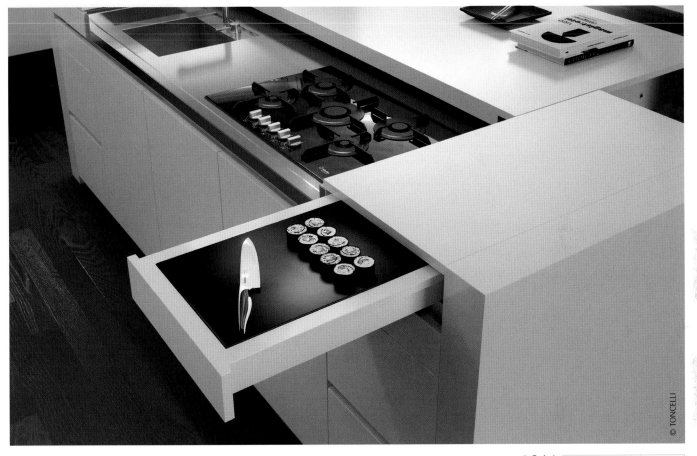

© TONCELLI

144

Retracting doors open up
this compact multipurpose
unit which houses sink,
faucets and worktop.

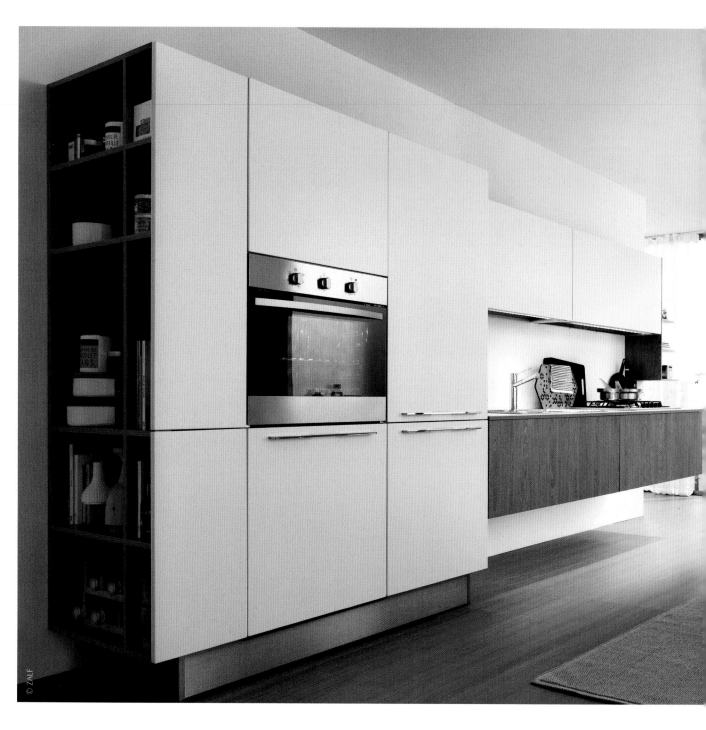

Tables and chairs are
indispensable in the kitchen:
their simple lines enable
the space to be shared
and personalized.

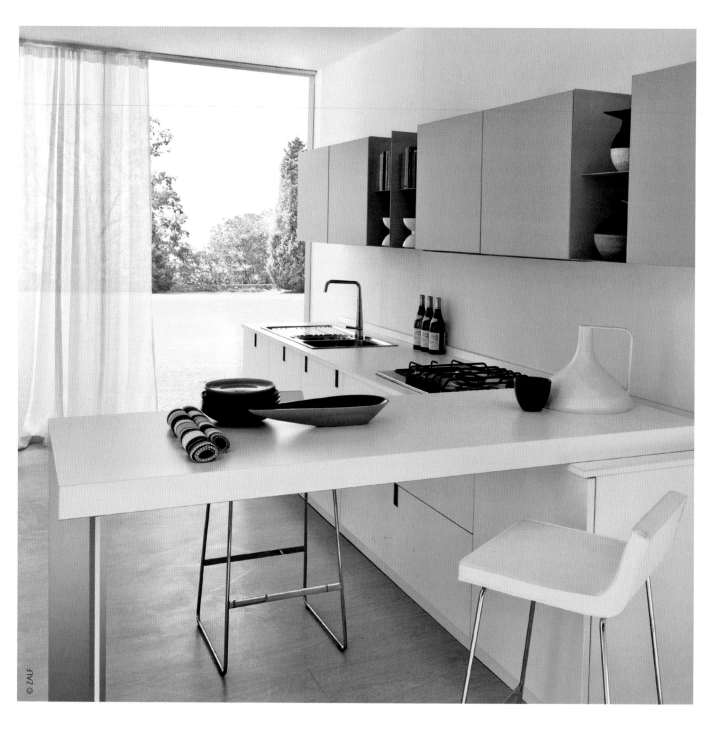

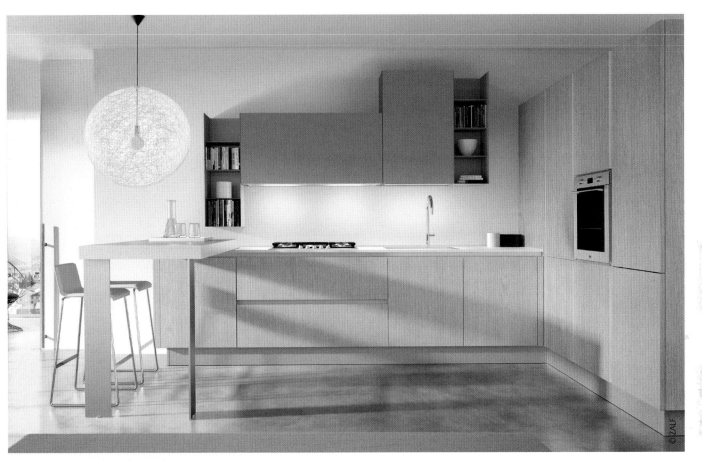

146

The color contrast between the different surfaces breaks up the traditional chromatic monotony of the kitchen.

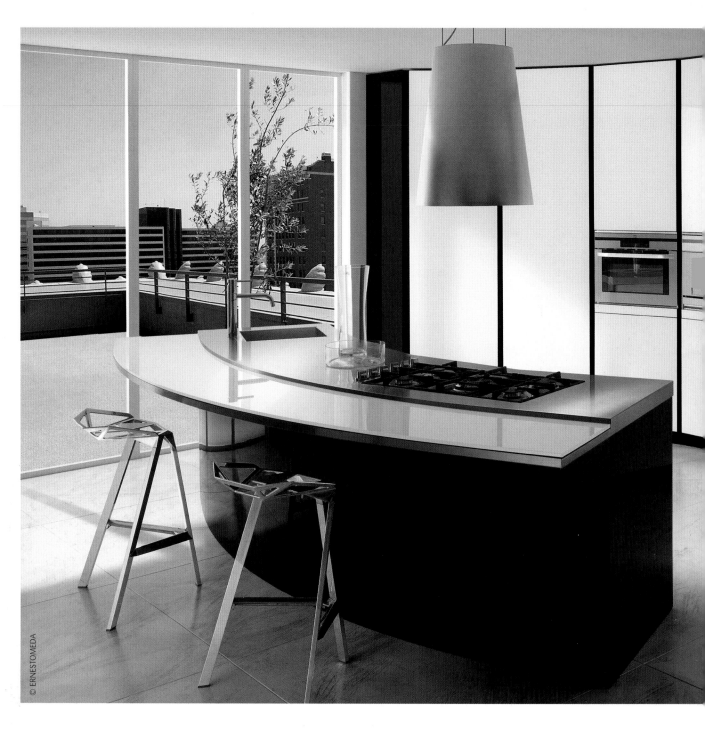

The curved design of the island mirrors that of the wall unit. This design is meant to reduce distances between ends.

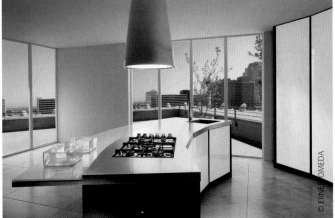

© ERNESTO OMEDA

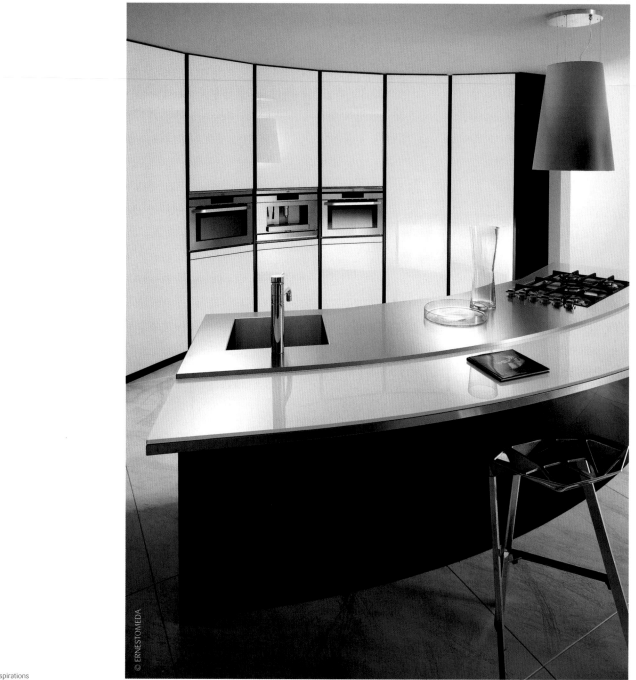

© ERNESTOMEDA

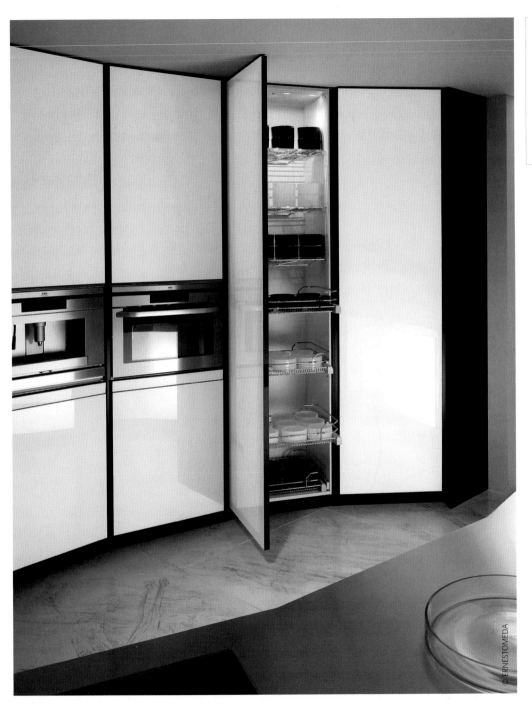

This storage system is both an elegant backdrop and a valuable tool in the effective use of the space.

© ERNESTOMEDA

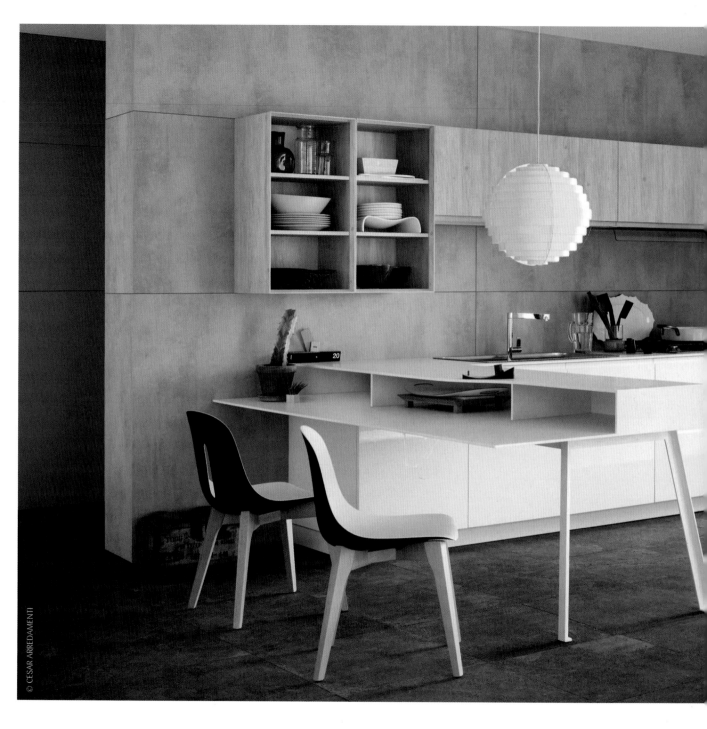

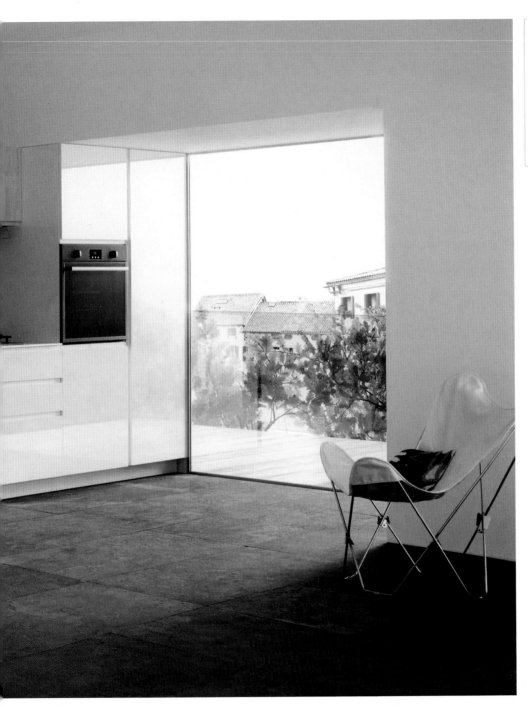

An island with countertops at two different heights can be used as a workstation and as a dining table or a desk.

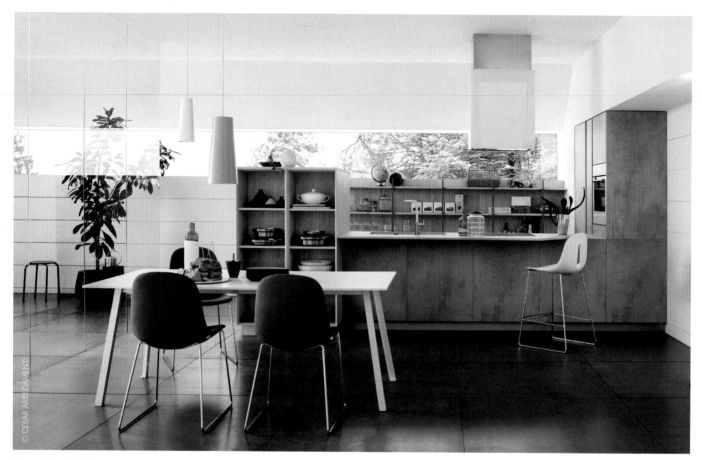

149

Simple finishes and maximum
functionality in the smallest
of spaces are a kitchen's key
elements in the modern home.

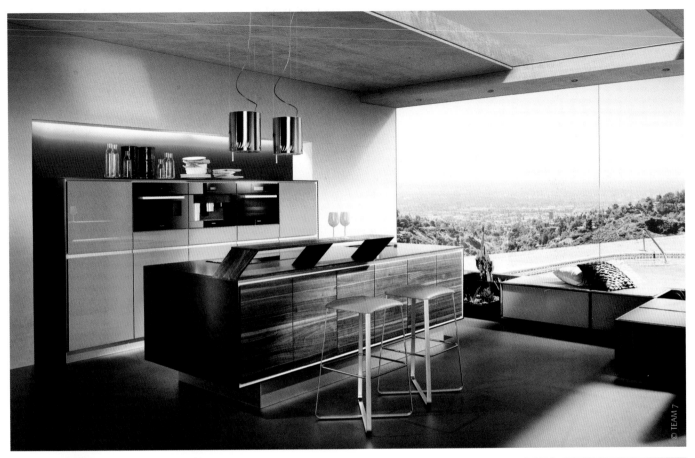

150

The bar that protrudes from the island provides plenty of legroom when seated.

Directory

ARCHITECTS AND DESIGNERS

123DV Modern Villas
Rotterdam, The Netherlands
www.123DV.nl

BAK Arquitectos
Buenos Aires, Argentina
www.bakarquitectos.com.ar

Bercy Chen Studio
Austin, Texas
www.bcarc.com

Brooks + Scarpa
Los Angeles, California
www.brooksscarpa.com

Draisci Studio
London, UK
www.draisci.com

Eva Bradáčová
Prague, Czech Republic
www.ebarch.cz

FORM Design Architecture
London, UK
www.form-architecture.co.uk

FORM/Kouichi Kimura Architects
Shiga, Japan
www.form-kimura.com

hoo
Hong Kong, China
www.hoo-residence.com

Jacopo Mascheroni - JM Architecture
Milan, Italy
www.jma.it

James & Mau
Madrid, Spain
www.jamesandmau.com

**JRKVC. Peter Jurkovič, Lukáš Kordík,
Števo Polakovič.**
Bratislava, Slovakia
www.jrkvc.sk

JUMA Architects
Ghent, Belgium
www.jumaarchitects.com

k-studio
Athens, Greece
www.k-studio.gr

MARC architects
Amsterdam, The Netherlands
www.marcarchitects.nl

Nook Architects
Barcelona, Spain
www.nookarchitects.com

OTD Design & Development
Malibu, California
www.owendalton.wix.com/otd-portfolio

Powerhouse Company
Rotterdam, The Netherlands
www.powerhouse-company.com

Shaun Lockyer Architects
Brisbane, QLD, Australia
www.lockyerarchitects.com.au

Silva Studios Architecture
San Diego, California
www.silvastudios.com

Studio Arte
Silves, Portugal
www.studioarte.info

Studio Garneau
New York, New York
www.studiogarneau.com

Tavares Duayer Arquitetura
Rio de Janeiro, Brazil
www.tavaresduayer.com.br

SUPPLIERS

Alno
Leeds, UK
www.alno.de

Arrital
Fontanafredda, PN, Italy
www.arritalcucine.com

Boffi
Lentate sul Seveso, MB, Italy
www.boffi.com

Bravo
Cimavilla di Codognè, TV, Italy
www.bravobravo.it

bulthaup
Bodenkirchen, Germany
www.bulthaup.com

Cesar Arredamenti
Pramaggiore, VE, Italy
www.cesar.it

Ernestomeda
Montelabbate Pesaro, PU, Italy
www.ernestomeda.com

Febal
Falciano, Repubblica di San Marino
www.febalcasa.com

Kvik
Vildbjerg, Denmark
www.kvik.com

LEICHT
Waldstetten, Germany
www.leicht.com

Luce
Treia, MC, Italy
www.cucinelube.it

Meson's
Pasiano, PN, Italy
www.mesons.it

Pino
Coswig, Germany
www.pino-kuechen.de

Ponorm
Vlotho, Germany
www.pronorm.de

Rational
Melle, Germany
www.rational.de

Scavolini
Montelabbate, PU, Italy
www.scavolini.com

Schiffini
Ceparana, SP, Italy
www.schiffini.com

Siematic
Löhne, Germany
www.siematic.us

Snaidero
Majano, UD, Italy
www.snaidero.it

TEAM7
Ried im Innkreis, Austria
www.team7.at

Toncelli
Peccioli, PI, Italy
www.toncelli.it

Zalf
Maser, TV, Italy
www.gruppoeuromobil.com/eng/zalf